MEDIEVAL AND RENAISSANCE CLOTHING AND TEXTILES

TEXTILES AND TEXTILE IMAGERY IN EARLY
MEDIEVAL ENGLISH LITERATURE

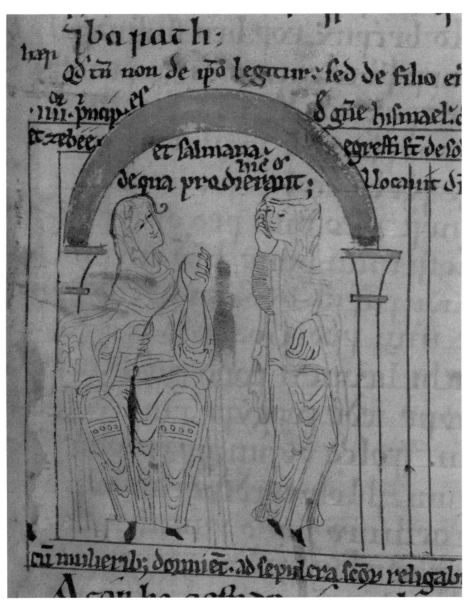

Frontispiece: Sarah spinning while chastising Hagar, detail from London, British Library, MS Cotton Claudius B. IV, fol. 28r, mid-eleventh century.

TEXTILES AND TEXTILE IMAGERY IN EARLY MEDIEVAL ENGLISH LITERATURE

TRADITIONS AND CONTEXTS

MAREN CLEGG HYER

D. S. BREWER

© Maren Clegg Hyer 2025

All Rights Reserved. Except as permitted under current legislation
no part of this work may be photocopied, stored in a retrieval system,
published, performed in public, adapted, broadcast,
transmitted, recorded or reproduced in any form or by any means,
without the prior permission of the copyright owner

The right of Maren Clegg Hyer to be identified as
the author of this work has been asserted in accordance with
sections 77 and 78 of the Copyright, Designs and Patents Act 1988

First published 2025
D. S. Brewer, Cambridge

ISBN 978-1-84384-744-1

D. S. Brewer is an imprint of Boydell & Brewer Ltd
PO Box 9, Woodbridge, Suffolk IP12 3DF, UK
and of Boydell & Brewer Inc.
668 Mt Hope Avenue, Rochester, NY 14620–2731, USA
website: www.boydellandbrewer.com

Our Authorised Representative for product safety in the EU is Easy Access System Europe –
Mustamäe tee 50, 10621 Tallinn, Estonia, gpsr.requests@easproject.com

A CIP catalogue record for this book is available
from the British Library

The publisher has no responsibility for the continued existence or accuracy of URLs for external
or third-party internet websites referred to in this book, and does not guarantee that any content
on such websites is, or will remain, accurate or appropriate

For Catherine Corman Parry, Roberta Frank, and Gale R. Owen-Crocker, three of the most influential women in my life: teachers, mentors, and friends. Thank you for laying the warp threads of this work.

MEDIEVAL AND RENAISSANCE
CLOTHING AND TEXTILES

ISSN 2044–351X

Series Editors
Robin Netherton
Gale R. Owen-Crocker

This series focuses on the study and interpretation of dress and textiles throughout England and Europe, from the early medieval period to the sixteenth century. It seeks to bring together research from a wide variety of disciplines, including language, literature, art history, social history, economics, archaeology, and artifact studies. The editors welcome submissions that combine the expertise of academics working in this area with the more practically based experience of re-enactors and re-creators, offering fresh approaches to the subject.

The series is associated with the annual journal
Medieval Clothing and Textiles.

Proposals or queries should be sent in the first instance to the editors or to the publisher, at the addresses given below; all submissions will receive prompt and informed consideration.

Ms. Robin Netherton, robin@netherton.net

Professor Gale R. Owen-Crocker, gale.owencrocker@ntlworld.com

Boydell & Brewer Limited, PO Box 9, Woodbridge, Suffolk

Previous volumes in this series are listed at the back of this volume

Contents

List of Illustrations	viii
Acknowledgments	ix
Abbreviations	x
Introduction	1
1 Process and Product: Spinning, Weaving, and Finishing Garments	8
2 Weaving Peace, Weaving Life	36
3 Spinning, Binding, and Weaving: Magic and Death	73
4 Spinning, Weaving, and Forces of Nature	117
5 Woven Words	182
Conclusion	210
Bibliography	217
Index	236

Illustrations

Frontispiece: Sarah spinning while chastising Hagar, detail from London, British Library, MS Cotton Claudius B. IV, fol. 28r, mid-eleventh century

1	Textile fibers and tools from Anglo-Saxon and Anglo-Viking York	10
2	From the Age of Woman, detail from Cambridge, Gonville and Caius College, MS 428/428, fol. 28v, probably mid-twelfth century	12
3	Warp-weighted loom with beams, heddle, weft, and beater pictured in use by a re-enactor	14
4	Tablet-woven borders, from the Maaseik textiles, probably eighth century	16
5	Maniple from the tomb of St Cuthbert, tenth century	18
6	The Franks Casket, right panel, early eighth century	149

Full credit details are provided in the captions to the images in the text. The author and publisher are grateful to all the institutions and persons for permission to reproduce the materials in which they hold copyright. Every effort has been made to trace the copyright holders; apologies are offered for any omission, and the publisher will be pleased to add any necessary acknowledgment in subsequent editions.

Acknowledgments

It is difficult to know where to begin in listing all of those who have been a help across the thirty years of research that inform this work. I owe a great debt to my patient advisors on different iterations of this project over the years, Catherine Corman Parry (Brigham Young University) and Roberta Frank (University of Toronto). I likewise thank the inspired minds who read the work and provided critical feedback at different stages of the process: Antonette di Paolo Healey, David Klausner, David Townsend, Gale R. Owen-Crocker, Jill Frederick, and again recently, Roberta Frank and Sarah Anderson. To Gale, as well as Jill, Roberta, and Sarah, go important and heartfelt thanks for their friendship, good advice, support, and encouragement to finish this book. To Caroline Palmer, who has been both editor and friend, go the same.

Course reassignments through my former colleagues at Valdosta State University allowed for much of the later drafting of this work; assistance from former graduate students Michael Antonoff, Shannon Tyme, and Mary Nikki Roop was critical for the sorting of the notes, bibliography, and index (respectively). My current colleagues at Snow College have provided unfailing encouragement and support in the book's final stages. I owe additional thanks to Thomas Henderson, a great Latinist and kind friend, for his assistance and listening ear when I encountered thorny translation issues. It goes without saying that all errors that remain in this work are my own.

I close with my thanks to two additional groups of people. I express particular gratitude to the pioneering community of textiles scholars who ultimately made this book possible, Grace and Elisabeth Crowfoot, Penelope Walton Rogers, Gale R. Owen-Crocker, Elizabeth Coatsworth, and many of the other DISTAFF scholars writing today. As references in this work will attest, I truly "stand on the shoulders of giants." They are a significant part of the inspiration and audience for this work, and I thank them for both their groundwork and their unfailing support.

I express my final thanks to the members of my amazing and supportive family, J. Halvor and Miriam W. Clegg, Paul and Karen Hyer, our siblings and children, with special gratitude for my husband David and my sons Joel, Chad, and Ethan. I could not have asked for more loyal cheerleaders. David and I began and end this work together; our sons have shared me with this project for most of their lives. I am grateful for their loyal, active, and loving encouragement.

Abbreviations

ASE	*Anglo-Saxon England* (journal)
ASPR	The Anglo-Saxon Poetic Records
BAR	British Archaeological Reports
CBA	Council for British Archaeology
CCSL	Corpus Christianorum, Series Latina (Brepols, 1953–)
CSEL	Corpus Scriptorum Ecclesiasticorum Latinorum
EETS	Early English Text Society os = Original Series ss = Supplementary Series
MGH	Monumenta Germaniae Historica
PL	*Patrologia Latina*, ed. J.-P. Migne, 221 vols (Migne, 1844–64)
SUNY	State University of New York

Introduction

In saltu nascor ramosa fronde virescens,
Sed fortuna meum mutaverat ordine fatum,
Dum veho per collum teretem vertigine molam:
Tam longa nullus zona praecingitur heros.
Per me fata virum dicunt decernere Parcas;
Ex quo conficitur regalis stragula pepli.
Frigora dura viros sternant, ni forte resistam[1]

I was born in the forest, green on a leafy bough, but fortune changed my condition in due course, since I move my rounded shape twirling through the smooth-spun thread; from this is made the royal covering of a robe. No hero (anywhere) is girded by a belt as long as mine. They say that the *Parcae* decree the fates of men through me – yet severe cold would destroy men if I did not withstand it.[2]

In this Anglo-Latin poem by Aldhelm (*c.*639–709), famed Latin and Old English poet of early medieval England, the speaker describes the curious life it can call its own. Its story begins in a leafy forest, but the speaker moves away to a busy life, whirling about in thread and making robes, all to prevent cold from harming men. For modern readers, this imagery can be perplexing, but it would not have been for the people of Aldhelm's day, or many others who lived hundreds of years before or after his time. For them, this narrator's identity would have been clear and resonant because of their daily interaction with the material culture and the process of textile production, from the spinning threads of the riddle to finished webs in the loom.

[1] Aldhelm (Latin): *Aldhelmi Opera*, ed. Rudolfus Ehwald, MGH, *Auctorum Antiquissimorum* (Weidmann, 1919), vol. 15, p. 117, lines 1–7.

[2] Aldhelm (translation): *Aldhelm: The Poetic Works*, trans. Michael Lapidge and James Rosier (D. S. Brewer, 1985; repr. 2009), p. 79. I have not included the suggested, "[*scil.* the distaff]" after "a belt as long as mine" from the translation by Lapidge and Rosier; I would suspect the long "belt" of the riddle does not mean the distaff (which is a tall staff), but rather, the length of "smooth-spun thread" already wound around the spindle just above the whorl, parallel today to thread wrapped around a spool. No distaffs have yet been found of an age to mirror Aldhelm's time of writing, though they are very likely to have existed at the time, as early medieval English linguistic evidence from not long later reflects in abundance.

1

Aldhelm's audience would have been able to tell that the riddle describes the life of a common textile tool, the spindle, which was usually made of wood and accompanied by a stabilizing whorl near the bottom, and which rotated, suspended just above the ground, with fibers twisted from hand to thread along its spinning shaft (see Figure 1).[3] Long, gathered fibers around its middle (its *zona* or belt) would have slowly filled the spindle from above, as the spindle "helped" with the ubiquitous task of clothing humans against the cold. The ease of Aldhelm's audience in decoding the meaning of this riddle imagery might have turned on two simple facts: first, if they were looking at a textual version, in some riddle collections, the answer might be written in the manuscript margin, or even as the riddle's title.[4] Even if they were not supplied the answer when reading or hearing the text, however, the predominant reason they would have recognized the process described in the riddle is that they had seen spindles at work for their entire lives. The metaphor would have been resonant because of the material culture which surrounded its early medieval English audiences.

For the riddle's audiences today, generally removed from textile production as a cottage industry, such resonances are far more difficult to perceive. The understanding gap is significant, as textile imagery, particularly, the imagery of textile production, plays an important role in the imaginative corpus and social meaning of pre-industrial cultures. Such is certainly true of the peoples of early medieval England. Indeed, with an understanding of their textile process and the textile metaphors that relate to it, we may begin to "perceive" the texts they left behind with very different eyes.

The object of the present study is to diminish this "understanding gap" through close analysis of the corpus of textile metaphors in the written traditions of early medieval England. Chapter 1 begins with an examination of the bedrock for understanding the subtleties of textile metaphors: the archaeological, linguistic, and textual evidence for the process involved in the material culture of textile production among the early medieval English peoples, from preparation of fiber to the finished garment. But these textiles were not just process or product for the early medieval English: both the processes used and the textiles produced had profound sociocultural and economic meanings, and in the majority of cases, a strong connection to their makers, the women of early medieval England. In this first chapter, I explore the evidence for these social, economic, and gendered associations that relate so closely to each type of textile metaphor.

Textiles and textile production acquire additional meaning as thread and maker begin to symbolize something beyond themselves; they begin to be associated with and even

[3] Spindles have been found worked in other materials as well, such as metal, but wood would naturally be the most common and perishable form. Spindle whorls have been discovered in profusion, executed in a rich variety of materials: clay, lead, pottery, chalk, limestone, sandstone, bone, horn, and crystal, among other materials (see Penelope Walton Rogers, *Cloth and Clothing in Early Anglo-Saxon England* (CBA, 2007), pp. 23–6, as well as Gale R. Owen-Crocker, *Dress in Anglo-Saxon England: Revised and Enlarged Edition* (Boydell, 2004), p. 275).

[4] As, for example, in the late tenth to early eleventh-century copy of his riddles in London, British Library, Royal MS 12. C. XXIII. I am indebted to Sarah Anderson for this example.

equated to abstract ideas and social constructs. Most of the remaining chapters of this volume explore these kinds of metaphorical connections or constructions, from thread and maker to textile metaphors. In Chapter 2, I address a metaphor of some renown in the more famous poetic texts of the period: "peaceweaving." The "peaceweaver" of the Old English corpus has come to represent something far beyond a simple comparison of peace-maker and weaver, both to the early medieval English peoples and to scholars today. While examining the many literary, social, economic, and cultural currents that inform this metaphor, I add two new elements to the scholarly discussion. The first is a comprehensive analysis of the Old English and Anglo-Latin textual evidence for each metaphor, including poorly known and previously undiscovered parallels in Old English and Anglo-Latin works. The second is a perspective based squarely in the material culture included within the metaphor: weaving. While it is clear that there were a variety of contexts and "good" and "bad" behaviors associated with the metaphor, I assess both context and behavior through the lens of the early medieval English hands, threads, and looms that rendered each metaphor resonant.

The next chapter, Chapter 3, focuses on another set of textile metaphors, those associated with the spinning, binding, and weaving of magic and of violent death. Within a magical or magico-medical context, spinning tools and even simple cloth and thread, as well as simple binding and more elaborate weaving of threads, become connected in interesting ways with either the thwarting of harmful agents, or the invoking of them. Outside of a healing context, however, the binding and weaving of violence relates nearly exclusively to death and is always destructive rather than generative. Interestingly, these violent efforts at twisting the threads of destruction can be found intersecting and even interacting with peace-making attempts in the literature of the early medieval English, perhaps as opposing forces of both good and evil.

The mortal makers of magic and woven bonds, most often women, have an eerie similarity to the most powerful kinds of cosmic weaving found in the early medieval English tradition: the generative weaving of life and creation and the sinister weaving and spinning of fate found frequently throughout Old English and Anglo-Latin texts of the period. I discuss the links between textile production and these cosmic forces across both of the period's linguistic corpuses in Chapter 4. These cosmic forces personified as spinners and weavers of generation and death share the strongest links to both women and textiles of any metaphors yet discussed.

Not all of the textile metaphors of the early medieval English peoples relate to life-struggles that play out across the peace, death, magic, creation, and fate of human beings, however. Chapter 5 examines the beautiful tradition of wordweaving imagery in Old English and Anglo-Latin literature. As I there discuss, the Old English texts that connect the shaping of words to weaving are not isolated. Rather, they are a doorway to a rich literary tradition in which bilingual early medieval English authors took part. Wordweaving images in Anglo-Latin texts by early medieval English authors parallel those in Old English and connect them to a web of similar traditions across early medieval Europe. The wordweaving metaphors of the early medieval English peoples, as adapted to their understanding and their own material and authorial context, offer

insight not only on their perceptions of older textual traditions, but also into the ways they perceived their own textual and literary tradition.

The chapters in this volume thus identify and analyze a wide range of textile metaphors in use among the early medieval English peoples, a project that began with extensive examination of evidence for weaving and spinning metaphors in the Old English corpus, first addressed in book-length form in 1998 in my doctoral dissertation, "Textiles and Textile Imagery in Old English Literature" (University of Toronto). To that first body of evidence I add the metaphors from the sister texts of Old English literature: Anglo-Latin texts by early medieval English authors. Through the lens of two additional decades of study and the integration of the parallel evidence from the comprehensive Latin corpus (through the medium of the *Library of Latin Texts Online* (*LLTO*)), each chapter thus addresses, for the first time in print, a far more complete picture, creating in turn a far more comprehensive understanding of both the frequency and the meanings inherent to textile metaphors among the peoples of early medieval England.[5] This study represents a comprehensive discussion of the body of textile metaphors produced among the early medieval English peoples and the material cultural contexts in which they were generated.

The chapters in this volume are structured similarly. Critical traditions and historical, linguistic contexts for some of the textile metaphors addressed in this work are long, complex, and (often) contentious. Wherever such is true, I include discussion of the relevant critical, historical, and linguistic arguments from the first. In the heart of each chapter, I follow with my own analysis of this context and the known Old English and Anglo-Latin evidence for each textile metaphor studied, with a particular additional emphasis: I examine, in each case, how a given textile metaphor might resonate through the rich cultural and literal lens of the material culture of textiles in early medieval England. Within each chapter, translations for Old English will be mine, unless otherwise noted. Translations for Anglo-Latin and Latin will be scholarly editions as often as my own, as noted, but throughout, I will assess and often highlight the textile words in their pre-translated form, providing insight into the nuances that so often accompany textile terms in their locations in primary text, but which do not always survive standard translations.

After analysis of primary text in each chapter, I then examine a range of representative materials gathered from closely related traditions, with emphasis on the traditions of the classical Greek and Roman world, the patristic and early medieval Latin textual tradition (including biblical materials in Latin), proto-Germanic and Scandinavian traditions, and Celtic traditions. I do so deliberately. Early medieval English people did not

5 I differentiate here between this work and Megan Cavell's *Weaving Words and Binding Bodies: The Poetics of Human Experience in Old English Literature* (University of Toronto Press, 2016). Cavell's focus in her work is a "thematic and stylistic analysis" of the early medieval English "poetic mindset" through the lens of weaving and binding, or the examination of construction and constriction imagery in poetry and some prose (p. 11). Citing my 1998 dissertation, Cavell explains that my approach is situated in a context of material culture; Cavell's close readings of lines focus more specifically on Old English poetics, with an intentionally limited focus on prose and Anglo-Latin text.

INTRODUCTION

live in a linguistic, textual, or general cultural vacuum;[6] textile metaphor appears in all of these traditions. As I do so, I weigh the debts to and echoes of these parallel traditions on the metaphors of the early medieval English. Where a clear genealogy or relationship of metaphors is evident across cultures in occurrences of textile metaphor, I make efforts to trace it. But I also consciously and overtly resist oversimplifying such relationships. The very hybridity that renders necessary an analysis of the cultural relationship among ideas and images from this early period also undercuts simple conflations of texts and traditions.[7] Catherine Karkov defines "hybridity" as the contact of cultures that results in a changed picture for one or both; the resulting created objects produced (metaphors, texts, art of any kind) represent "the product of a process of translation and counter-translation between cultures."[8] This concept seems extraordinarily apt for the cultural context of early medieval England. If we discover, for example, that the early medieval English peoples appear to co-opt Latinate textile metaphors, we are not necessarily looking at direct translation of those meanings, and the resulting metaphor is not simply "derivative." Rather, the metaphor in each iteration is far more likely to be unique and have a life of its own in its "translation" (linguistic and social) to a different culture. Indeed, the modern notion of "originality" implicit in a notion of cultural transfer as "derivative" was not the perception of creativity and borrowing among the early medieval English (or other pre-modern cultures). As Karkov notes:

> It is abundantly clear that the Anglo-Saxons themselves viewed works of art as existing within a continuing process of creation, recreation and changing meanings ... those who added to a work of art were considered to be as much its creator (artist or author)

[6] Rosemary Cramp notes, for example, evidence that Celtic "smiths copied Anglo-Saxon techniques and ornament," and similar evidence in graves that "indicate the range of Anglo-Saxon contact with the traditional arts of the Celtic smiths"; she likewise notes stonework which reflects Celtic designs "combined with Germanic animals and a close meshed type of interlace, which is one of the elements of early Insular art found throughout Britain from Kent to southwest Scotland" ("The Insular Tradition: An Overview," in Catherine Karkov, Michael Ryan, and Robert T. Farrell (eds), *The Insular Tradition* (SUNY Press, 1997), pp. 283–95, at pp. 289–90). Catherine Karkov extends the observation more widely, and justly so, "Anglo-Saxon art never existed in a vacuum, and its emergence and development over the centuries were very much a matter of give and take, a process of Anglo-Saxon artists and patrons working in dialogue with other cultures – the Irish, Scots and Welsh, the Romans, the Normans, the Carolingians and Ottonians, the Scandinavian world, and so forth" (*The Art of Anglo-Saxon England* (Boydell, 2011), pp. 252–63, at p. 247).

[7] As Joyce Hill has long argued in the context of the works of Ælfric of Eynsham, simple conflation with a "source text" runs the risk of grossly oversimplifying or overstating the relationships of borrowing between texts and traditions (cf. "Ælfric's Sources Reconsidered," in M. J. Toswell and E. M. Tyler (eds), *Studies in English Language and Literature: 'Doubt wisely,' Papers in Honour of E. G. Stanley* (Routledge, 1996), pp. 362–86); conflation insists on a strongly reductive point of view when the realities of the early medieval English world were far more syncretic and inclusive of disparate traditions than exclusive, and their results arguably as "original" as those who came (and borrowed) before them.

[8] Karkov, *The Art of Anglo-Saxon England*, p. 3.

as the man or woman who first brought the work into being. To represent, reproduce, restore or reuse was never simply to copy or make do, it was to add new layers of meaning ... [Such art] was not just a reuse of the past, but an active intervention in the material of the past that gave to the history it represented a new meaning and a new life in the present.[9]

Adaptation, like invention, is at its heart creative and transformative, whether it is Jerome who adapts Virgil, or Virgil who adapts Homer, or Aldhelm who adapts Jerome. Thus, although some of the lines on Aldhelm's spindle may well have been inspired by classical and patristic poetic references (or condemnatory remarks) on spinning "Fates," Aldhelm's use of textile metaphor is itself always and essentially creative, as he adapts, adorns, and renders resonant an image and a riddle for the minds of his early medieval English audiences.

It is also wise to consider something that textile researchers know very well: textile metaphor is a worldwide phenomenon without respect for time or place, and strikingly similar metaphors can take place in cultures entirely divergent and apparently unconnected with one another. Such metaphors illustrate both the remarkable power of the daily material culture of textiles across pre-industrialized cultures and the resonance of textile imagery for mythic and poetic purposes for cultures around the world and across time. My discussions of "source or analogue" in each chapter will take these elements into careful consideration.

As this study is based in the analysis of a closely connected range of metaphors, I conclude my introduction with a few pertinent observations about metaphor more generally. In the enormous body of discussion of the theory of metaphor that stretches back at least as far as Aristotle, the insights of Paul Ricoeur are among the most relevant for how I conceive of and use the term "metaphor" in this work. In simplest terms, metaphor is a "semantic innovation through which a previously unnoticed 'promixity' of two ideas is perceived despite their logical distance."[10] A human being creates the metaphor by imposing and then rendering articulate a relationship between those two ideas, be they processes, objects, beings, or institutions. The imposition of relationship is profoundly transformative, but not only in that a new relationship among words or ideas has been perceived and then created. In addition, created metaphor has the ability "to 'redescribe' reality"[11] and take on a life of its own, in hybridity, changing the way both elements and their subsequent joint concept are perceived. Ricoeur argues that, "If metaphor adds nothing to the description of the world, at least it adds to the ways in which we perceive; and this is the poetic function of metaphor,"[12] and George Lakoff and Mark Johnson

[9] *Ibid.*, pp. 9, 19.

[10] *The Rule of Metaphor*, trans. Robert Czerny, Kathleen McLaughlin, and John Costello (University of Toronto Press, 1991), p. 6.

[11] *Ibid.*

[12] *Ibid.*, p. 190.

affirm, "metaphors make sense of our experience."[13] The study of metaphor undertaken here invites readers to observe and perhaps begin to perceive the rich layers of meaning introduced when the daily processes of spinning, weaving, and finishing garments are associated with larger cultural concepts important to early medieval English peoples. Ricoeur observes that "it always takes two ideas to make a metaphor,"[14] and it is true that many prior scholarly examinations of the textile metaphors discussed in this work have focused far more on the non-textile than textile components. An understanding of the dual nature of metaphor, however, underpins this work; I argue throughout that it does and should change the way we interpret "peaceweaving," "wordweaving," or any other weaving metaphor, for example, if "weaving" is examined as closely as "peace" or "word" as a referent.

Metaphors will only persist over time if they are resonant for subsequent authors and readers; even metaphors with an illustrious genealogy are unlikely to be adapted widely unless apt. In other words, textile metaphors are only likely to evolve into related webs of meaning where there exists a rich textile culture to make them meaningful. Such was most definitely true for the early medieval English peoples, who, as I will discuss in Chapter 1, were renowned across Europe for their skilled and abundant production of stunningly colorful and elaborately embroidered and adorned textiles. Indeed, as this study will demonstrate, the attractiveness of such textile metaphors and the creation of webs of related metaphors highlight the cultural importance and centrality of textile production in the daily lives of the early medieval English, a process to which they returned again and again for poetic and symbolic inspiration. Clare Lees and Gillian Overing have stated, "Metaphors are ways of knowing, even as they structure that knowing ... We consider what it means when a metaphor is alive and thriving, and the body it signifies is long dead."[15] The analysis of textiles and textile imagery is thus, in many respects, a social and cultural history of the early medieval English peoples themselves.

[13] *Metaphors We Live By* (Chicago University Press, 1980), p. 139.

[14] *Ibid.*, p. 21.

[15] Lees and Overing, *Double Agents: Women and Clerical Culture in Anglo-Saxon England* (University of Philadelphia Press, 2003), p. 154.

CHAPTER 1

Process and Product: Spinning, Weaving, and Finishing Garments

sona godum towcræftum onfeng, swyðor þonne ænig þara
þe heora bearn wæron wifa and fæmnena[1]

She [Mary] directly undertook good textile work, better than any child
of those who were women and maidens.

Textiles are meaningful signifiers across many cultures and represent far more than simple, fiber coverings. We can safely assume that the people throughout the early Middle Ages, like people today, relied upon clothing and other textiles for their physical needs, but also for their emotional, social, and spiritual ones. All available evidence suggests that, as a non-industrialized people, the early medieval English naturally knew the time-tested (and time-intensive) methods for making textiles and meeting those needs, and they valued their textiles accordingly. The technologies they used were commonly known and practiced throughout Europe and beyond, and such technologies furnished not only material articles, but also images and associations. Thus, textile process and product came to evoke connections between meeting basic human needs and related, abstract social ideals, and textile terms consequently permeated the literary vocabulary and metaphors of Old English and Anglo-Latin texts across centuries. Archaeological, linguistic, and documentary evidence provides us with a sense of what the material culture of textiles looked like among the pre-Conquest English, and that evidence also reveals the extent to which the early medieval people and their literary vocabularies, virtually independent of century or region, were influenced by the symbols of their daily need to dress and find protection and comfort. This chapter will examine the evidence for both the process of textile production and its products, discussing the metaphors that grew out of both among the early medieval English.

[1] Old English Pseudo-Matthew (mid-eleventh century): Bruno Assmann (ed.), *Angelsächsische Homilien und Heiligenleben*, Bibliothek der Angelsächsischen Prosa, 3 (repr. Wissenschaftliche Buchgesellschaft, 1964; 1889), no. 10, lines 338–41. Translations mine, unless otherwise noted.

PROCESS AND METAPHOR: SPINNING

It has often been remarked, and justly so, that there is danger in essentializing the pre-Conquest English, who varied considerably across the centuries and tribal/geographical regions of England. Nevertheless, as inhabitants of a less industrialized age, the early medieval English throughout the centuries and across regional divisions seem to have had remarkably similar methods for producing the textiles they needed for their clothing, blankets, seat covers, cloaks, and other fabrics. More detailed descriptions of these processes can be found elsewhere,[2] but a basic overview suffices for the purpose of understanding the widespread metaphorical seedbed for textile imagery among those we call the early medieval English.

Generally speaking, the pre-Conquest English, like most northern Europeans for thousands of years, used wool and flax for the majority of their textile needs, with luxury goods such as silk being used for decorative purposes among the elite, and other vegetable and animal fibers (nettle, goat, etc.) used on occasion. Silk could arrive already processed as thread, but not usually wool or flax. Processing wool and flax was long a cottage industry, and they both required labor and time to render them useful. Preparation of wool and flax had been relatively standard since prehistory: after preliminary processing, which in the case of wool included sorting and combing (aligning the fibers with combs made of wood or bone), or, in the case of flax, retting (rotting the outer casing of the plant), beating the casing open with a mallet (scutching), and combing out the shorter "tow" (hackling), the fibers could be tied loosely in a bundle (perhaps on a distaff, a tool which can range in size from an arm-length stick with a notch in the top to a pole several feet tall with a rack at the top, particularly for flax).[3] The spinner pulled a few out from the mass of fibers and twirled them between fingers and thumb to create a composite thread. The direction of "spin" between fingers and thumb could create a different look and was probably deliberately chosen. The first section of spun thread was then wound around a foot-long stick tapered at both ends, a spindle. The spindle often had a "whorl" or circular weight near its bottom that assisted the spinner; if she rolled the spindle against her thigh or twirled the spindle with her fingers with the newly-formed thread attached, the spindle

[2] See, for example, Maren Clegg Hyer and Gale R. Owen-Crocker, "Woven Works: Making and Using Textiles," in Maren Clegg Hyer and Gale R. Owen-Crocker (eds), *The Material Culture of Daily Living in the Anglo-Saxon World* (University of Exeter Press, 2011), pp. 157–84; Owen-Crocker, *Dress*, pp. 272–315; Walton Rogers, *Cloth and Clothing*, pp. 9–47; and Elizabeth Coatsworth and Gale R. Owen-Crocker, *Medieval Textiles of the British Isles AD 450–1100: An Annotated Bibliography*, BAR British Series, 445 (Archaeopress, 2007), pp. 23–9. In addition, there are two very useful online resources: "Textiles," a bibliography by Owen-Crocker and Coatsworth in the "Medieval" section of the *Oxford Online Bibliographies* (edited by Paul Szarmach, 2013), and the Lexis of Cloth and Clothing (http://lexisproject.arts.manchester. ac.uk/), a website developed by Owen-Crocker, Louise Sylvester, and Cordelia Warr and their teams at the Universities of Manchester and Westminster that incorporates a searchable database of textile terms, definitions, and associated textual references.

[3] Henry Hodges, *Artifacts: An Introduction to Early Materials and Technology* (John Baker, 1964), pp. 126–7.

Fig. 1. Textile fibers and tools from Anglo-Saxon and Anglo-Viking York. Photograph: York Archaeological Trust; used by permission of the estate of Penelope Walton-Rogers.

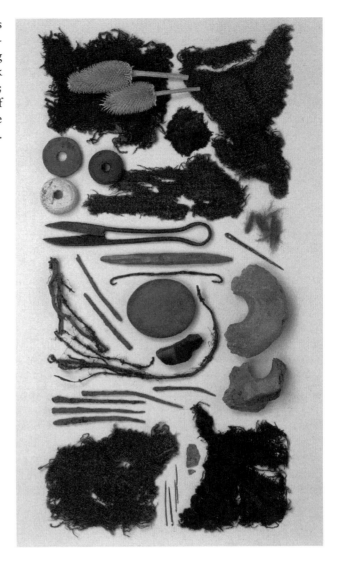

and its weighted whorl would continue to spin the thread for her, while she fed and combined more fibers onto the top of the growing spool of thread. For thicker thread, the spinner might ply thinner threads together in opposite directions.

Abundant linguistic terms and archaeological finds of tools and textiles confirm these fibers and processes among the early medieval English peoples,[4] and spindle whorls are

4 See extensive discussion of related linguistic terms in Hyer and Owen-Crocker, "Woven Works," p. 164, and also the comprehensive, multilingual database of textile terms, including

particularly ubiquitous finds (Figure 1).[5] Their prevalence underscores an important aspect of pre-industrial spinning: hand spinning of thread for textiles is a time-intensive process, as it generally takes ten spinning hours for every one weaving hour to produce a textile. In essence, the spindle whorls found in so many contexts tell us that spinning took place with many hands and in many different environments; most early medieval English people must have seen a lot of spinning done, whether at home on a farm or in a village, in a monastery, or in a busy town.[6]

Spinning would thus have been likely to form part of the daily existence of the average, early medieval English person across the entire early Middle Ages. It is therefore unsurprising to find spinning images used readily in art and literary contexts in both literal and metaphorical ways. When Sarah is depicted chastising Hagar in the Old English Hexateuch (London, British Library, Cotton MS Claudius B. IV, fol. 28r; see Frontispiece), she is envisioned at her daily household work, spinning from distaff to drop spindle.[7] In a twelfth-century image thought to depict the "ages of woman," at least two of the "ages," old and older age, show one woman, *senectus*, making the yarn into skeins, and another, *decrepitas*, spinning (Figure 2).[8]

In the case of Aldhelm, writing at the outset of the period, the spindle and spinning thread provide useful imagery for the riddle with which this volume began, his Anglo-Latin Riddle 45, as the speaker describes itself, *veho per collum teretem vertigine molam*

 terms related to fibers and spinning as discussed here, at http://lexisproject.arts.manchester.ac.uk/.

5 Items pictured in Figure 1 include wool and linen fibers, a slickstone and broken loomweight at center, a wooden spindle, shears, three spindle whorls, a needle, and modern teasels. See the range of finds of spindle whorls from diverse "occupation sites of all periods" listed, for example, in Walton Rogers, *Cloth and Clothing*, p. 23, and David Wilson, "Craft and Industry," in David Wilson (ed.), *The Archaeology of Anglo-Saxon England* (Methuen, 1976), pp. 271, 280.

6 Spindle whorls have been found in all such contexts: lowly settlement huts of fifth- to seventh-century Suffolk (Walton Rogers, *Cloth and Clothing*, p. 23), the seventh- to ninth-century monastic community at Northumbrian Whitby (Rosemary Cramp, "Analysis of the Finds of Whitby Abbey," in Wilson, *Archaeology*, pp. 456–7), and busy business districts in ninth- and tenth-century York (Penelope Walton, *Textiles, Cordage and Raw Fibre from 16–22 Coppergate* (CBA, 1989), p. 412).

7 My sincere thanks to Samantha Zacher (and the British Library) for helping me to secure this image.

8 The image is taken from the Age of Woman, detail from Cambridge, Gonville and Caius College, MS 428/428, fol. 28v, probably mid-twelfth century. Thijs Porck discusses proposed associations of the image with Byrhtferth of Ramsey but concludes that the manuscript shows signs of a German continental hand, with nevertheless an English association (and location) before the fourteenth century. Cf. "The Ages of Man and the Ages of Woman in Early Medieval England: From Bede to Byrhtferth of Ramsey and the *Tactatus de quaternario*," in Thijs Porck and Harriet Soper (eds), *Early Medieval English Life Courses: Cultural-Historical Perspectives* (Brill, 2022), pp. 17–46, at pp. 39–43.

Fig. 2. From the Age of Woman, detail from Cambridge, Gonville and Caius College, MS 428/428, fol. 28v, probably mid-twelfth century. Used by permission of the Master and Fellows of Gonville and Caius College, Cambridge.

"I move my rounded shape twirling through the smooth-spun thread."[9] As indicated in the section above, even if readers or auditors did not see the title of the riddle, *Fusum* "Spindle," listed in their manuscript version of the riddles, it is still quite likely they would have been able to identify the graceful imagery. Spinning appears in other contexts, as well. In a medical text, a leech or physician is instructed to *nim þone hweorfan þe wif mid*

9 Latin text from *Aldhelmi Opera*, Ehwald, pp. 103–17. Translation from Lapidge and Rosier, *Aldhelm: The Poetic Works*, pp. 73–9.

PROCESS AND PRODUCT: SPINNING, WEAVING, AND FINISHING GARMENTS 13

spinnað[10] "take that whorl with which a woman spins" as an aid to cure cheek disease. In this case, what the whorl represents as an image or metaphor in the healing process is unknown, but it had clearly come to represent something beyond itself that might aid in the healing process.[11]

Legal terminology provides another example of spinning as metaphor, indeed, as a metaphor for woman herself. In a will written between 883 and 888, King Alfred indicates his wish that he pass his inheritance along the male line, *on þa wæpnedhealfe* or *on þa sperehealfe næs on þa spinlhealfe* "on the weapon-side [paternal]" or "on the spear-side and not the spindle-side [maternal]," although he retains the right to give *wifhanda* "to the woman-side" as much as *wæpnedhanda*.[12] In this instance, the spindle has become a metaphor for the maternal line, a synonym for *wifhanda* that does not require definition at all. That spindle might equate metaphorically with woman is unsurprising: spinning was invariably women's work across the period, perhaps the province of the very old and very young women and the unmarried "spinster."[13] After the spun thread had been wound in usable lengths or skeins, perhaps using an ancestor of today's "Niddy Noddy," or a yarn ball, it might be dyed (if not already dyed before spinning), or woven and later dyed in fabric form.

PROCESS AND METAPHOR: WEAVING

The next stage in the textile process provided an even richer base for metaphorical borrowing into the literary lexicon: weaving.[14] Weaving seems to have been done on at least two types of looms within and across the early Middle Ages in England: the common warp-weighted loom and a less common, two-beam, fixed horizontal loom (depicted on the back cover as two women chatting while warping a two-beam loom, detail from Cambridge, Trinity College, MS R.17.1, fol. 263, mid-twelfth century). Given its prevalence in archaeological finds (demonstrated by rows of loom weights and also types

[10] T. O. Cockayne (ed.), *Leechdoms, Wortcunning, and Starcraft of Early England*, Rerum Britannicarum Medii Ævi Scriptores, 35 (3 vols, Longman, Green, Longman, Roberts and Green, 1864–66), vol. 2, pp. 310–13.

[11] I will return to this metaphor in Chapter 3 during discussion of medico-magical healing texts.

[12] "King Alfred's Will," ed. F. E. Harmer, *Select English Historical Documents of the Ninth and Tenth Centuries* (Cambridge University Press, 1914), pp. 15–19, lines 115, 117, 122, and 123.

[13] As Christine Fell indicates, "[While it] is obvious that as the grammatical forms of Old English came to be used with less precision these words would also describe men engaged in these occupations … it is equally obvious that a group of words of this kind originally represented a connection between women and the various skills of cloth production" (*Women in Anglo-Saxon England* (British Museum Press, 1984), p. 41).

[14] As with spinning, more detailed descriptions of both the weaving and the finishing process (such as the terms found in the Old English estate management text, the *Gerefa*) can be found in Hyer and Owen-Crocker, "Woven Works," pp. 157–84; Owen-Crocker, *Dress*, pp. 272–315; Walton Rogers, *Cloth and Clothing*, pp. 9–47; Coatsworth and Owen-Crocker, *Medieval Textiles*, pp. 23–9; and, by term, throughout the website for the Lexis of Cloth and Clothing (http://lexisproject.arts.manchester.ac.uk/).

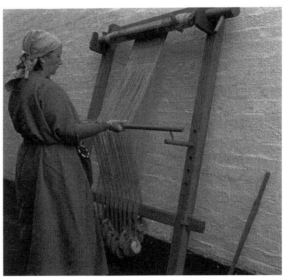

Fig. 3. Warp-weighted loom with beams, heddle, weft, and beater pictured in use by a re-enactor. Photograph: Ian Uzzell.

of woven fabrics recovered), the warp-weighted loom is the type of loom most early medieval English people would have likely seen, whether in early *grubenhäuser* or pit-houses surrounding rural halls, later manorial textile workshops, monastic estates, or personal homes.[15]

The warp-weighted loom consisted of two upright beams and a horizontal beam to which the warp threads were attached at one end (Figure 3). At the other end, the warp threads were gathered in bundles and tied to loom weights made of stone, baked clay, or more rarely, lead, an arrangement for which the loom is named. Once the warp threads were weighted and tied to the loom, the loom could be set upright and leaned against a roof beam or the wall. With a shed rod in place dividing half of the weighted warp threads in front and half behind, leaning the loom provided a natural advantage; the shed rod kept the warp threads separated while gravity and the loom weights kept the warp threads firmly vertical, with a space opened in the warp, the shed, through which a horizontal thread, the weft, was passed. Heddle rods were attached with short thread leashes to specifically chosen warp threads, and when pulled forward, they created different versions of the shed for the weft to pass through. The weft thread might be passed through the shed hand to hand on a thread ball or on a shuttle, a wooden implement which holds

[15] According to C. J. Arnold, weights from warp-weighted looms are among the most common and prolific archaeological finds within the period, suggesting "Such looms may have been present in every household" (*An Archaeology of the Early Anglo-Saxon Kingdoms* (Routledge, 1988), pp. 18, 113). Wilson concurs, "The most important piece of domestic equipment in the Anglo-Saxon house may well have been the loom … the loom would be a normal piece of equipment in practically every household" ("Craft," p. 271).

the thread on a spool or bobbin.[16] After each pass across the warp, the weaver then lowered or changed the position of the heddle rod or rods and passed the weft thread again. Fragments of textiles across the period and at various sites demonstrate that early medieval English weavers understood and used heddle rods in their weaving to create an array of both simple and complex patterns in their fabrics, from "over-under, over-under" tabby fabrics (one heddle rod) to two-by-two twills and complex diamond and lozenge twills (multiple heddle rods).

The woven threads of the weft might be subsequently compacted into tight fabrics within the loom by combs or by hand, with finer work done by shafts of bone or wood called "pin beaters," or "sword beaters" for heavier, lengthier work. Other than loom weights and the occasional beater, most loom parts do not survive in the archaeological record (given their composition was of wood), but lexical terms abound for the loom and for weaving generally: *wearp* "warp," *wefte* "weft," *scytel* "shuttle," *hefeld* "heddle," and *slæ* "slay or beater" are a representative few.[17] Weaving would have been a common task and indeed a common sight across the entirety of the early Middle Ages in England. Use of such a common process for a metaphor is therefore hardly surprising and is found widely across Old English and Anglo-Latin writings, ranging from metaphors for peace and death to metaphors for the magical and the cosmic. Such metaphors will be the subject of subsequent chapters of this work.

PROCESS AND METAPHOR: FINISHING

A few steps remained for the unfinished textile after it was woven and cut from the loom.[18] Linen (woven flax) might be bleached to whiteness in the sun and smoothed with hot stones. It might also have been left a natural cream or brown, and wool might have already been a desired earth tone of natural cream, brown, gray, or black. Alternately, textiles might be dyed with bright natural dyes in a variety of hues, resulting in shades of red and orange, yellow, green, and blue. Even purple from sea molluscs native to England's waters was possible.[19] After dyeing, fabric could be cut and sewn into

[16] To date, no shuttles have been identified archaeologically in an early medieval English context, a somewhat unsurprising fact, given that most would have been made of perishable and relatively unidentifiable sections of wood. However, there is evidence that they did exist at some point in the period, in the form of the word *scytel* in Old English.

[17] For a full discussion of the linguistic evidence, see Hyer and Owen-Crocker, "Woven Works," pp. 168–72; all terms are also defined and discussed in the database of the Lexis of Cloth and Clothing (http://lexisproject.arts.manchester.ac.uk).

[18] Lengthier discussions of the methods of finishing textiles, such as range of dyes and embroidery and tablet-weaving techniques, can be found in Hyer and Owen-Crocker, "Woven Works," pp. 172–9; Owen-Crocker, *Dress*, pp. 302–15; and Walton Rogers, *Cloth and Clothing*, pp. 35–41.

[19] Bede: *Bede's Ecclesiastical History of the English People*, ed. and trans. B. Colgrave and R. A .B. Mynors (Clarendon, 1969), book 1, chapter 1, pp. 14–15.

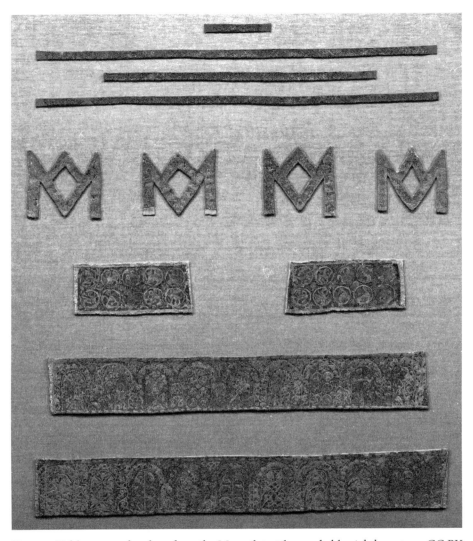

Fig. 4. Tablet-woven borders, from the Maaseik textiles, probably eighth century. CC BY 4.0 KIK-IRPA, Brussels, X085890.

desired articles. As is evident from extant textiles across the period, fabrics might then be adorned with ornamental borders and simple or elaborate embroidery.

If extant pieces are any indication, such finishing techniques reached a high artistic level among the pre-Conquest English. Borders were often "tablet-woven," woven either on the edges of a fabric in the loom, or more frequently, separately, with different, patterned tablets guiding the interlacing of threads into tightly woven, colorful borders or decorative strips. An excellent example of these techniques is evident in the tablet-woven

pieces stitched into the *casula* and *velamen* at Maaseik, Belgium, fragments which, according to Mildred Budny and Dominic Tweddle, "originated in southern England and date from the late eighth century or the early ninth."[20] These fragments and some other sections of embroidery sewn into the same composite textiles are worked in gold and silk and adorned with blue and green glass beads, pearls, copper bosses, and threads of several colors: red, beige, green, yellow, light blue, and dark blue (Figure 4).

Such striking and luxurious pieces could be sewn onto fabrics and garments and reused at need, particularly when woven separately.[21] The vestments of St Cuthbert, another group among the few remaining textile works of early medieval English hands, are good examples of tablet-woven borders and embroidery in their original arrangement, and, according to textual accounts, appear to have been characteristic of much of the elite finish work of the period. The Cuthbert vestments include a stole and two maniple fragments (or more likely, a maniple and a girdle) donated by Athelstan to the shrine of St Cuthbert at Durham in 934. The vestments themselves were worked between 909 and 916 at the behest of Athelstan's stepmother, Ælfflæd (as stitching on the backs of the terminals state) and depict Old Testament prophets (on the stole) and saints, popes, and deacons (on the maniple). Durham E, or the maniple (Figure 5), is constructed of tablet-woven bands and embroidery.

Each of these devotional textiles was "thickly, but delicately, embroidered in silk,"[22] in a variety of colors and gold-wrapped thread. Both side edges of the stole and maniple were adorned with matching tablet-woven braids made from silk and gold and brocaded in "silver-gilt thread."[23] Today, many of the colors have faded, but the gold thread still glows amidst brownish-red threads. A. G. I. Christie describes the visual impact for its viewers in both tenth-century and twentieth-century Durham:

> Draperies were coloured purple-red and green, both tints occurring on the same vestment. Hair, usually worked in fawn striped with purple-red and green, was sometimes executed in blue and white lines. Faces were pale fawn, with the features outlined in a deeper tint. Some of the foliage was in purple-red, pink and sage green, a line of each colour being worked in succession ... The letters ... were in either myrtle green or

[20] "The Early Medieval Textiles at Maaseik, Belgium," *The Antiquaries Journal*, 65 (1985), 353–89, at p. 366.

[21] Ealdorman Byrhtnoth (of Battle of Maldon fame), for example, detached a border from his cloak to donate to the abbey at Ely just prior to his death, as an incentive for the house to pray for his soul, should he fall in battle (as he did). See this and other similar examples of detached borders and embroideries in repurposed contexts in Hyer, "Recycle, Reduce, Reuse: Imagined and Re-Imagined Textiles in Anglo-Saxon England," *Medieval Clothing and Textiles*, 8 (2012), 49–62. Alexandra Lester-Makin's recent close analysis of seventh-century English embroidery reinforces the notion of repurposing embroidery in *The Lost Art of the Anglo-Saxon World: The Sacred and Secular Power of Embroidery* (Oxbow, 2019), p. 73.

[22] Peter Hunter Blair, *An Introduction to Anglo-Saxon England* (Cambridge University Press, 1959), p. 193.

[23] Elisabeth Crowfoot, "The Braids," in C. F. Battiscombe (ed.), *The Relics of Saint Cuthbert* (Oxford University Press, 1956), p. 433.

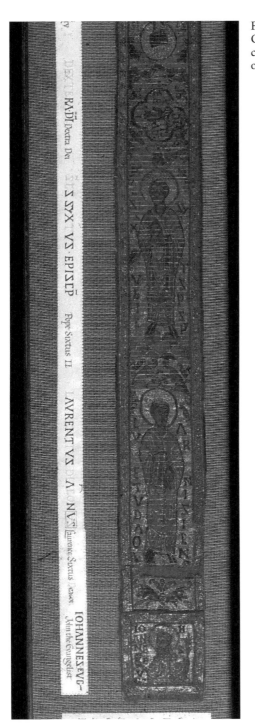

Fig. 5. Maniple from the tomb of St Cuthbert in Durham Cathedral, tenth century. Photo: Used with the permission of the Chapter of Durham Cathedral.

PROCESS AND PRODUCT: SPINNING, WEAVING, AND FINISHING GARMENTS 19

pale purple-red ... These colours have now perished, and the embroidery is of a warm brown tint which varies slightly in depth in different parts of the design.[24]

Without a doubt, the Durham vestments represent some of the most elegant, sumptuous, and skilled products which remain in their original configuration as witness to the abilities of early medieval English embroiderers, and are widely considered "the most beautifully designed and technically sophisticated work of Western European textile art surviving from this period."[25]

One interesting feature about early medieval English embroidery is that the embroidered designs in three of the half dozen larger textile works remaining from the early Middle Ages in England can be associated with regional manuscript design styles. Bird and beast figures embroidered in the late eighth-/early ninth-century embroideries (now located at Maaseik) are Tiberius style,[26] the Cuthbert embroideries are associated with the Winchester style,[27] and the many figures of the eleventh-century Bayeux Tapestry (or more appropriately, embroidered hanging) are demonstrably related to the Canterbury manuscript style (see front cover image).[28] An explanation for the correspondences of embroidered and manuscript design styles may lie in an illustrative late tenth-century Anglo-Latin "Life" of St Dunstan. The author of the life (usually known as author "B") describes Dunstan (tenth-century West Saxon saint and eventual archbishop of Canterbury) on a visit to the home of a matron named Æthelwynn, at her request; she had asked him to draw a pattern on a stole so that she and her young women or *operatricibus* "workers" could embroider it richly in gold.[29] The episode suggests that embroidery might have been done privately, in groups, or even workshops; in those contexts, visual artists might make the designs for both textile and text.[30]

The finishing process, like the other processes of textile production, must have been common knowledge, and likewise invited metaphorical comparison. Dyes, for example, resulted in complaints from ecclesiastical sources, who equated use of bright colors with worldliness.

Aldhelm criticizes the sumptuous clothing of aristocratic ecclesiasts among the West Saxons of his day, near the end of the seventh century:

[24] *English Medieval Embroidery* (Clarendon, 1938), p. 47.

[25] J. P. P. Higgins, *Cloth of Gold: A History of Metallised Textiles* (Buckland, 1993), p. 23.

[26] My thanks to Gale R. Owen-Crocker for this observation.

[27] David M. Wilson argues there are also significant parallels between embroidery designs and a wall-painting in Winchester, as well as the later manuscripts associated with the Winchester school (*Anglo-Saxon Art* (Thames and Hudson, 1984), pp. 154–6).

[28] See Owen-Crocker, *Dress*, p. 331.

[29] In William Stubbs (ed.), *Memorials of Saint Dunstan, Archbishop of Canterbury*, Rerum Britannicarum Medii Aevi Scriptores, 63 (repr. Kraus, 1965; 1874), pp. 20–1.

[30] See Lester-Makin's comprehensive overview of the compelling evidence for textile workshops across the period, including archaeological evidence, charters and wills, religious institutional histories and inventories (the *Liber Eliensis*, in particular), Domesday evidence, and even the evidence of the textiles themselves (*The Lost Art*, pp. 101–40).

20 TEXTILES & TEXTILE IMAGERY IN EARLY MEDIEVAL ENGLISH LITERATURE

Nam cultus gemini sexus huiuscemodi constat subucula bissina, tonica, coccinea sive iacintina, capitium et manicae sericis clavatae; galliculae rubricatis pellibus ambiuntur; antiae frontis et temporum cincinni calamistro crispantur; pulla capitis velamina candidis et coloratis mafortibus cedunt, quae vittarum nexibus assutae talotenus prolixius dependunt.

In both sexes this kind of costume consists of a fine linen undergarment, a red or blue tunic, a headdress and sleeves with silk borders; their shoes are covered with red dyed leather; the locks on their foreheads and temples are crimped by the curling iron; instead of dark head coverings they wear white and coloured veils which hang down luxuriantly to the feet and are held in place by *vittae* sewn on to them.[31]

Similarly, St Boniface (a West Saxon who passed his life first in southern England, and later the Continent) criticizes elaborate and colorful dress among the servants of the church of the eighth century. He lambasts the *odibilem vestimentorum superstitionem* "odious superstition of dress," in particular *Illa ornamenta vestium ... latissimis clavis vermium marginibus clavata* "Those dress ornaments ... embroidered with the widest of borders, decorated with images of worms," which Alexandra Lester-Makin brilliantly observes may be "complaining about knot-like beasts motifs that had been stitched onto bands decorating the monks' clothing."[32] Ultimately, Boniface felt such dress was inspired "by Antichrist to herald his coming."[33] Elaborate and colorful borders and fabrics did not always represent the Antichrist, however; when put to use in beautiful textiles for the church, such as the Cuthbert vestments, such materials won encomia, instead. Thus, Aldhelm describes appreciatively the altar cloth of the church of St Mary at Malmesbury, *Aurea contortis flavescunt pallia filis, / Quae sunt altaris sacri velamina pulchra* "a golden cloth [which] glistens with its twisted threads and forms a beautiful covering for the sacred altar."[34] Such appreciation can be found across the period. Flemish writer Goscelin of St Bertin, for example, describes an early eleventh-century oratory at Wilton, which ecclesiasts, in an effort to recreate a church worthy of the temple of Solomon, decorated with lavish display. Remembering Exodus, he lauds the fine work of one nun in making colorful vestments, *Hic purpura, punico, murice et Sidoniis conchiliis*

[31] Quoted and translated in E. Crowfoot and S. Chadwick Hawkes, "Early Anglo-Saxon Gold Braids," *Medieval Archaeology*, 11 (1967), 42–86, at pp. 63–4. This translation was by Christopher Hawkes (personal information provided to Gale R. Owen-Crocker from the late Sonia Hawkes). For other possible interpretations and a detailed discussion of the passage see Owen-Crocker, *Dress*, pp. 134–7.

[32] Boniface's words come from E. Dümmler (ed.), "S. Bonfatii et Lulli epistolae," MGH, Epistolae, 3, Merovingici et Karolini Aevi, 1 (Weidmann, 1892), pp. 215–433, at p. 355, lines 18 and 19. I am indebted to Alexandra Lester-Makin's work for this quotation and translation by Lester-Makin and Christopher Monk. See Lester-Makin, *The Lost Art*, p. 69.

[33] In C. H. Talbot (ed. and trans.), *The Anglo-Saxon Missionaries in Germany* (Sheed and Ward, 1954), p. 133.

[34] Latin text from *Aldhelmi Opera*, Ehwald, p. 18. Translation from Lapidge and Rosier, "Carmina Ecclesiastica," *Aldhelm: The Poetic Works*, p. 49.

imbuta, coccusque bis tinctus auro intexitur "This [cloth], in purple, bright red, imbued with murex and Sidonian shells, and scarlet twice-dyed, is interwoven with gold."[35] Criticisms and encomia aside, colorful fabrics also told a story, brightened a wall, and taught important lessons, as evident in the Bayeux Tapestry, in its 224-foot long, embroidered narrative in linen. Shirley Ann Brown counts: "626 people, 202 horses or mules, 55 hounds, 505 other animals, 37 buildings, 41 vessels, and 49 trees"[36] in brightly colored wool threads in pinkish or orange red, brownish-violet red, mustard yellow, beige, blue-black, dark blue, mid-blue, dark green, mid-green, and light green.[37]

Like color, embroidery and tablet-weaving likewise invited both positive and negative comment, as well as metaphorical comparison. As with dye, if this finishing step were used for personal ornamentation, it was considered a worldly affectation and might invite ecclesiastical censure. On the other hand, if it adorned vestments designed for the greater glory of God, embroidery invited praise. As Goscelin praised the nun at Wilton, so he praises the elaborate embroideries of St Edith, a West Saxon nun of the late tenth century, for adorning a white alb, *praestantissimam auro, gemmis, margaritis ac perulis Angligenis a summo contextam … circa pedes aureas apostolorum ymagines Dominum circumstantes* "the most excellent, with gold, gems, pearls, and small English pearls embroidered at the top … [and] near the feet, golden images of the apostles standing around the Lord."[38] It is of some note that Goscelin's description of the embroidery mirrors closely both the pearl-adorned, embroidered textiles found at Maaseik (late eighth or early ninth century) and the gold-embroidered images of prophets on the Durham vestments (donated a generation before by Edith's great-uncle Athelstan). The alb he describes is thus clearly part of a larger tradition of luxuriously finished textiles put to godly use. Such beautiful work was a metaphor for the vanity of the world, or the glory of God, depending on the final use to which it was put.

Other metaphors grew out of the tradition of embroidered work, as well. In Aldhelm's late seventh-century prose *De Virginitate*, the beauty of colorful embroidery is adopted as an extended metaphor to teach a visual and spiritual lesson, as Aldhelm instructs abbess

[35] *Le Légende de Sta. Edith en prose et verse par le moine Goscelin*, André Wilmart (ed.), *Analecta Bollandiana*, 56 (1938), 5–101, 265–307, at p. 69. I am indebted to C. R. Dodwell, *Anglo-Saxon Art* (Cornell University Press, 1982), p. 33, n. 90, for this reference.

[36] Shirley Ann Brown, Preface, in Gale R. Owen-Crocker (ed.), *The Bayeux Tapestry: Collected Papers* (Ashgate, 2012), p. xi. For other authoritative studies of the "Tapestry," see Gale R. Owen-Crocker (ed.), *King Harold II and the Bayeux Tapestry* (Boydell, 2005); Michael J. Lewis, Gale R. Owen-Crocker, and Dan Tekla (eds), *The Bayeux Tapestry: New Approaches* (Oxbow, 2011); Shirley Ann Brown, *The Bayeux Tapestry. Bayeux Médiatheque Municipale: MS 1. A Source Book* (Brepols, 2013); and Elizabeth Carson Pastan and Stephen D. White with Kate Gilbert, *The Bayeux Tapestry and Its Contexts* (Boydell, 2014).

[37] Isabelle Bédat and Béatrice Girault-Kurtzeman, "The Technical Study of the Bayeux Tapestry," in Pierre Bouet, Brian Levy, and François Neveux (eds), *The Bayeux Tapestry: Embroidering the Facts of History* (Presses universitaires de Caen, 2004), pp. 83–109, at p. 91.

[38] *Le Légende de Sta. Edith*, p. 79; see Dodwell, *Anglo-Saxon Art*, pp. 261–2, n. 103.

22 TEXTILES & TEXTILE IMAGERY IN EARLY MEDIEVAL ENGLISH LITERATURE

Hildelith and her peers in their duty.[39] This instruction includes praise for virginity, in particular, but also leaves room for the value of chastity in marriage as well as conjugality:

> siquidem curtinarum sive stragularum textura, nisi panuculae purpureis, immo diversis colorum varietatibus fucatae inter densa filorum stamina ultro citroque decurrant et arte plumaria omne textrinum opus diversis imaginum thoracibus perornent, sed uniformi coloris fuco singillatim confecta fuerit, liquet profecto quoniam nec oculorum obtutibus iocunda nec ornamentorum pulcherrimae venustati formosa videbitur. Nam et curtinae veteris delubri non simplici et singulari tincturae genere splenduisse leguntur, sed ex auro, iacintho, purpura, bis tincto cocco sive vermiculo cum bisso retorto dispari murice fulsisse describuntur.[40]

> (in the case of) the weaving of hangings or carpets, if threads dyed with purple and indeed with diverse varieties of colours do not run here and there among the thick cloth-fibres and according to the embroiderer's art ornament the woven fabric with the varying outlines of pictures, but it is made uniformly with a monochrome dye, it is immediately obvious that it will not appear pleasing to the glances of the eye.[41]

Aldhelm (as Goscelin later does) sees in this image a parallel to the brilliant dyes used for fabrics in the ancient Hebrew tabernacle and temple.[42] At the same time, he makes a comparison which would have had some real-life parallels for his auditors or readers: the nuns at Barking, Essex, and perhaps also nuns and leaders of other houses. As they created or viewed the highly valued, multichromatic, embroidered church hangings and vestments, so frequently linked in textual sources with early medieval English religious women across the period, these holy women could remember the colors and threads as metaphorical injunctions, first to virginity or chastity, but second to unity with their sisters. Aldhelm argues that it is the diversity of dyes and threads that creates the beauty of the work; so, likewise, the beauty of virginity co-exists alongside marital chastity and procreative conjugality to create a beautiful, valuable whole. Aldhelm revisits the metaphor in a subsequent chapter, envisioning the distinction thus: *virginitas purpura, castitas rediviva, iugalitas lana*[43] "virginity is the royal purple, chastity the re-dyed fabric, conjugality the (undyed) wool."[44] Even in the simplest fabrics which formed part of their daily

[39] Commonly assumed to be comprised of the nuns of the community at Barking, Essex, but Scott Gwara makes a compelling argument that Aldhelm's intended audience may be Hildelith and her fellow abbesses within Wessex ("Introduction," *Aldhelmi Malmesbiriensis Prosa de Virginitate cum Glosa Latina atque Anglosaxonica*, CCSL, 124 (Brepols, 2001), pp. 51–3).

[40] *Aldhelmi Opera*, Ehwald, p. 244, lines 12–20.

[41] *Aldhelm: The Prose Works*, trans. Michael Lapidge and Michael Herren (Boydell, 1979), pp. 71–2.

[42] See Exodus 35 and 2 Chronicles 2.

[43] *Aldhelmi Opera*, Ehwald, p. 248, lines 19–20.

[44] *Aldhelm: The Prose Works*, Lapidge and Herren, p. 75.

PROCESS AND PRODUCT: SPINNING, WEAVING, AND FINISHING GARMENTS 23

life, Aldhelm's audience of nuns might "see" reminders of the differing paths of devotion through an evocative metaphor reminiscent of the very ways they finished their fabrics.

PRODUCT AND METAPHOR: DRESS AND SOFT FURNISHINGS

Secular and Religious Dress

Two seminal works discuss the wide range of dress prevalent among the early medieval English peoples across time and region: *Cloth and Clothing in Early Anglo-Saxon England AD 450–700* by Penelope Walton Rogers and *Dress in Anglo-Saxon England: Revised and Enlarged Edition*, by Gale R. Owen-Crocker.[45] What may be surmised generally across time and geography is that basic costume seems to have changed very little; ornamentation and variations in style of costume are another story. Basic garments for both men and women would have included linen undergarments and different varieties of sleeved undergown with an overdress for women, and a (long) shirt and trousers under a tunic for men.[46] Additional textile accessories might include a belt or girdle at the waist, a cloak or mantle, and headgear, with women in particular being likely to wear veils or head coverings across the period.[47] Abundant archaeological and textual evidence also exists for shoes, as well as images in manuscripts of leggings or hose.[48] The sheer volume of textile necessary to dress each early medieval English man, woman, and child tells a significant tale: textile production must have been a constant necessity. Textiles themselves, with the possibilities of a variety of colors and finished states, must have made up much of the colorful visible world for them.

The different finished states of textiles would probably have spoken most loudly and metaphorically to dress distinctions by social class, ranging from humble stitches in natural-dye wools to elaborate embroideries in gold-wrapped silk couched in a variety of more exotic hues. Such distinctions lend resonance (and hierarchy) to Aldhelm's metaphors for nuns in their orders. The finishing of secular dress with elaborate, possibly tablet-woven borders seems to have been a fairly common technique and may have even been considered an identifying factor for the "English people" themselves. When describing King Edward's unusually sumptuous costume, for example, Goscelin or an eleventh-century contemporary remarks that the gold was exceptional, but the borders were not, as *sagos auro supra paratos et huiusmodi uestes secundum morem gentis* "cloaks [were] designed with gold on the top and on over-clothing of the same manner,

[45] In addition, all dress terms are searchable, documented, and defined at the website for the Lexis of Cloth and Clothing (http://lexisproject.arts.manchester.ac.uk).

[46] See Owen-Crocker, *Dress*, in which she traces these basic as well as changing styles from the fifth through the eleventh century (pp. 54, 115, 150–1, 156, 183–4, 187–9, and 213–18).

[47] *Ibid.*, pp. 62, 71, 77, 119, 125, 152, 157–9, 195, 212–13, 217, and 219.

[48] *Ibid.*, pp. 82–3, 123, 160–1, and 190–2. See also Esther Cameron and Quita Mould, "Devil's Crafts and Dragon's Skins? Sheaths, Shoes and Other Leatherwork," in Hyer and Owen-Crocker, *Material Culture*, pp. 93–115.

according to the custom of the people."[49] To the Flemish monk's eyes, borders on the tops of clothing were a national norm for the eleventh century in early medieval England.

The monk could have said the same for much of the rest of the period and probably have spoken accurately: fragments of tablet-woven bands, some attested only by thin, gold foil wrapped around a now-absent thread core, are "common Anglo-Saxon finds."[50] Borders on clothing are a pre-Migration phenomenon, and Walton Rogers documents the use of tablet-woven borders across all regions of early medieval England in the sixth and seventh centuries.[51] They are described as characteristic dress among the pre-Conquest English by Paul the Deacon in the eighth,[52] border strips (perhaps once attached to ecclesiastical clothing) are attested abundantly among the eighth- or ninth-century embroideries at Maaseik, and they appear in manuscript and embroidered depictions of dress from both the tenth and eleventh centuries.[53] Both Paul the Deacon and King Edward's biographer suggest that woven borders thus become a metaphor for the early medieval English themselves.

Aside from vestments, religious dress does not appear to have differed dramatically in design from secular, with the exception that those devoted to the religious life would have been expected to adopt more austere and humble fabrics and eschewed fine finishing of textiles in their personal dress.[54] Nuns certainly wore veils, like many of their secular sisters, and had a style of clothing recognizable as *nunscrude* "nun's clothing."[55] Monks were known by their tonsure, and often cowled robes, but not at all times, according to pictorial evidence. Austere standards in dress were likely the most important guideline, deriving from the ascetic, hermitic tradition of Late Antiquity and adopted by the admiring Middle Ages. Thus, according to Bede (Northumbria, *c.*673–735), one external sign of ecclesiastical sanctity, as in the case of St Cuthbert, is an overt rejection of worldly fashion:

> Uestimentis utebatur communibus, ita temperanter agens, ut horum neque mundiciis neque sordibus esset notabilis. Unde usque hodie in eodem monasterio exemplo eius

49 Latin quoted from *The Life of King Edward Who Rests at Westminster*, ed. and trans. Frank Barlow, 2nd edn (Clarendon, 1992), p. 25. Translation is mine.

50 Coatsworth and Owen-Crocker, *Medieval Textiles*, p. 29.

51 *Cloth and Clothing*, pp. 110, 233–4.

52 He states, *Anglisaxones habere solent, hornata instititis latioribus vario colore contextis* "The Anglo-Saxons are accustomed to have [clothing] adorned with wide borders woven with diverse color." Translation is mine. Quoted in Owen-Crocker, *Dress*, p. 171.

53 As evident in the cloak of King Edgar, as depicted in London, British Library MS Cotton Vespasian A viii, fol. 2v, and the borders of the clothing of Harold II, as well as others, in the eleventh-century Bayeux Tapestry.

54 Owen-Crocker includes discussion of lexical terms and contexts for references to "nun's clothing" and ecclesiastical dress for males in *Dress*, pp. 222–4 and 267–8, respectively.

55 "The Will of Wynflæd," ed. and trans. Dorothy Whitelock, *Anglo-Saxon Wills* (AMS, 1973; 1930), p. 14, line 18. Translation is mine.

PROCESS AND PRODUCT: SPINNING, WEAVING, AND FINISHING GARMENTS 25

obseruatur, ne quis uarii aut preciosi coloris habeat indumentum, sed ea maxime ues-
tium specie sint contenti, quam naturalis ouium lana ministrant.

He wore ordinary garments and, keeping the middle path, he was not noteworthy either for their elegance or for their slovenliness. Hence his example is followed in the same monastery even to this day, so that no one has a garment of varied or costly colouring, but they are fully satisfied with that kind of garment which the natural wool of the sheep provides.[56]

Austerity in dress becomes a key metaphor of sanctity traceable throughout the period.[57]

When ignored, the invocation to austerity resulted in critique; like his contemporary Aldhelm and his successor Boniface, who commented on color among the religious in southern England, Bede condemns luxurious fabrics among eighth-century Northumbrian ecclesiasts. In his *Historia ecclesiastica gentis anglorum* (731), Bede recounts the destruction by fire of Coldingham monastery and attributes it directly to the wickedness of its inhabitants, whose sins include lust for glorious apparel:

uirgines quoque Deo dicatae, contemta reuerentia suae professionis, quotiescumque uacant, texendis subtilioribus indumentis operam dant, quibus aut se ipsas ad uicem sponsarum in periculum sui status adornent, aut externorum sibi uirorum amicitiam conparent.

Even the virgins who are dedicated to God put aside all respect for their profession and, whenever they have leisure, spend their time weaving elaborate garments with which to adorn themselves as if they were brides, so imperiling their virginity, or else to make friends with strange men.[58]

The notable exceptions to the rule of austerity, as discussed in the section on dyes and finishing, were adornments for the church and accoutrements of the Mass. Thus, Bede's earlier contemporary Eddius Stephanus speaks reverentially of Bishop Acca's contributions to the beauty of their church at Ripon, with its *magnalia ornamenta huius multiplicis domus de auro et argento lapidibusque pretiosis et quomodo altaria purpura et serico induta decoravit, quis ad explanandum sufficere potest?* "splendid ornaments of gold, silver, and precious stones; but of these and of the way he decorated the altars with purple and silk, who is sufficient to tell?"[59] In an epigram also roughly contemporary to Bede's work, Cuthbert of Canterbury commemorates an altar cloth commissioned by his predecessor at Hereford, Bishop Walhstod (d.736). He writes appreciatively of the beauty of the

[56] Bede, "Life of St Cuthbert," ed. and trans. Bertram Colgrave, *Two Lives of Saint Cuthbert* (Praeger, 1968; 1940), pp. 212–13.

[57] For later examples, see saints' lives written by Ælfric of Eynsham (late tenth to early eleventh century) or Osbern (late eleventh century).

[58] Bede, *Bede's Ecclesiastical History*, Colgrave and Mynors, book 4, chapter 25, pp. 424–7.

[59] Eddius Stephanus, *The Life of Bishop Wilfrid by Eddius Stephanus*, ed. and trans. Bertram Colgrave (Cambridge University Press, 1985), pp. 46–7.

vexilla "cross-cloth" Walhstod had undertaken (or perhaps commissioned) *argenti atque auri fabricare monilibus amplis*"[60] "to fashion from a great many necklaces of silver and also gold."

Vestments worn to celebrate the Mass are clearly another exception to the rule of austerity. A significant proportion of the extant textiles from the period (such as the Maaseik and Cuthbert pieces) are eighth-/ninth- and tenth-century ecclesiastical fragments which attest to the sumptuous richness of color, elaborate nature of design and ornament, and expense of materials in gold, silver, silk, and other precious materials that went into early medieval English ecclesiastical dress for the Mass. Charters and monastic chronicles confirm abundantly and universally the numbers and richness of vestments produced across the eighth to eleventh centuries. Even after the large-scale Norman lootings at Ely at the Conquest, it is telling that its monastery could still account for forty chasubles, fifty-two albs, over fifty amices, five dalmatics, seven tunicles, seventeen stoles, thirty-three copes, eleven palls, forty-three cloaks, fifty hangings, fifty bench-covers, two altar tapestries, and four other tapestries, with an additional six sets of priestly vestments and seven deacons' vestments listed thereafter, many of the textiles worked in gold, silver, and embroidered threads.[61] The production of such elaborate textiles in the great quantities which written sources attest is remarkable. Such textiles must have been intended to represent not only a metaphor for the glory of God and the saints, but also the piety of the makers and donors of such works.[62]

Soft Furnishings

Like dress, soft furnishings are both a comfort and a necessity in human life, and their production and meaning are both attested in documentary sources of the period. In her article, "Cushioning Medieval Life: Domestic Textiles in Anglo-Saxon England," Elizabeth Coatsworth examines the evidence for these soft furnishings in depth, demonstrating that surfaces of many early medieval English dwellings seem to have been replete with textiles, with hangings on the walls, curtains surrounding beds, coverings on beds

[60] Quoted in Michael Lapidge, "Some Remnants of Bede's Lost *Liber Epigrammatum*," *Anglo-Latin Literature 600–899* (Hambledon, 1993), p. 371. The epigram was apparently transcribed by John Leland. Translation is mine.

[61] *Liber Eliensis: The History of the Isle of Ely*, ed. and trans. Janet Fairweather (Boydell, 2005), pp. 234–5, 2.114.

[62] As Christina Lee points out, such work was as desirable for donors as recipients, as the textiles "clothed priests and adorned altars and were a visible reminder of the generosity that endowed these institutions. In return for this largesse the donors could secure intercession for themselves and their kin" ("Embroidered Narratives," in R. Norris, R. Stephenson, and R. R. Trilling (eds), *Feminist Approaches to Early Medieval English Studies* (Amsterdam University Press, 2023), pp. 53–82). For additional discussion of textiles as women's expression of worship in the period, see Maren Clegg Hyer, "Adorning Medieval Life: Domestic and Dress Textiles as Expressions of Worship in Early Medieval England," in Gale R. Owen-Crocker and Maren Clegg Hyer (eds), *Art and Worship in the Insular World: Papers in Honour of Elizabeth Coatsworth* (Brill, 2021), pp. 100–20.

PROCESS AND PRODUCT: SPINNING, WEAVING, AND FINISHING GARMENTS 27

and chests, seat covers on benches and chairs, and occasionally covers on tables and rugs on the floor, all with the primary functions of both warming and brightening a home.[63]

The will of Wulfwaru (written between 984 and 1016) gives some indication of the soft furnishings a well-to-do woman might bequeath to adorn a tenth-century home.[64] To her son Wulfmær, Wulfwaru leaves *anes heallwahriftes. 7 anes beddreafes* "a hall-hanging and a bed hanging," as well as *anes heallreafes. 7 anes burreafes, mid beodreafe. 7 mid eallum hræglum swa ðerto gebyreð*[65] "a hall-hanging and a bedroom-hanging, with a tablecloth, and with all the cloths which belong with it" to her son Ælfwine. Goscelin provides an outsider's impression of the similar customs of home décor in the eleventh century. Although originally assigned what he considered a very poor lodging in the bishop's compound in Wiltshire, he was cheered to see its transformation through soft furnishings:

> Repente omnis illuuies exstirpatur, parietes et laquearia sordentia purgantur, frondibus et iuncis uiridantibus herbisque flagrantibus gratificatur, parietes et superna cortinis et auleis, sedilia tapetiis contexuntur, cunctisque solemniter paratis hospes inducor. Non illam putabam domum quam prius uideram.[66]

> All at once all the filth was rooted out, the walls and filthy beams were cleansed and strewn with foliage and green rushes and sweet-smelling grasses, the walls and ceilings were entwined with curtains and hangings, the seats with covers, and when all things had been prepared in a proper fashion, I was brought in as a guest. I did not believe it was the house I had first seen.[67]

Clearly, to Goscelin, the colorful, soft furnishings are a metaphor for comfort and welcome. They changed his feelings about his dwelling-place among the early medieval English people, so that he wished to remain.

Goscelin's experience is a good reminder that the customs of soft furnishings crossed the boundaries between the dwellings of the seculars and those of ecclesiasts. Indeed, the wills of seculars include donations of soft furnishings once made and/or used by seculars, now ready to be repurposed for ecclesiasts. In Wulfwaru's case, she leaves a grant *anes mæssereafes mid eallum þam ðe ðærto gebyreð. 7 anes hricghrægles þæs selestan þe ic hæbbe. 7 anes beddreafes mid wahryfte 7 mid hoppscytan. 7 mid eallum þam þe þærto gebyreð*[68] "of a mass-vestment with all that belongs with it, and the best mantle that I have, and bed-clothing with a hanging and with a curtain and with all that belongs with it" to St Peter's monastery at Bath.

[63] *Medieval Clothing and Textiles*, 3 (2007), 1–11.

[64] "The Will of Wulfwaru," in Whitelock, *Anglo-Saxon Wills*, pp. 62–5. Translation is mine for all references from this text.

[65] *Ibid.*, p. 64, lines 16, 17.

[66] Goscelin, "Liber Confortatorius of Goscelin of Saint Bertin," ed. C. H. Talbot, *Analecta Monastica*, 3rd ser. (Herder, 1955), p. 102.

[67] Coatsworth, "Cushioning Medieval Life," p. 6. Translation is Coatsworth's.

[68] "The Will of Wulfwaru," Whitelock, p. 62, lines 20–3.

Despite injunctions to ecclesiastical austerity, men and women religious clearly valued the comfort supplied by such donations. Late tenth/early eleventh-century writer Byrhtferth of Ramsey describes reverentially the outfitting of his community by Archbishop Oswald in 974:

> Qualibus illud monasterium ornamentis ditauit et gloriosis muneribus exornauit, quis expediet? Libros sancti euangelii concessit; uestes ad ministrandum Deo optulit; cuncta necessaria ecclesie dedit et, ut paucis concludam uerbis, calices, sciffos, manutergia, sexonica, cornua ad uinum fundendum, stragulas, tapetia, lectisternia, cortinas, cucullas fratrum, pellicia, sicque ut cum honore Domino parere potuerint.

> Who shall say with what adornments he enriched that monastery, and with what bounties he endowed it? He gave gospel books; he gave vestments for performing services to God; he gave all necessary church furniture including, if I may conclude in a few words, chalices, cups, towels, girdles (?), horns for pouring out wine, coverlets, tapestries, beds, curtains, monks' cowls, furs – and all so that they could obey the Lord with dignity.[69]

For Byrhtferth, like Goscelin, the soft textiles that covered, warmed, and comforted the monks become a metaphor for the dignity of ecclesiasts and the ecclesiastical life.

PROCESS, PRODUCT, METAPHOR: GENDER AND TEXTILES

The documentary evidence discussed thus far highlights subtly a telling fact: if the producer of a textile has been mentioned, she has invariably been a woman. Penelope Walton Rogers summarizes what scholars have long assumed about textiles and gender expectations in the period: "Anglo-Saxon women were clearly and demonstrably in charge of textile production."[70] Archaeological and textual evidence support this assumption. Textile implements found in early medieval English graves have a striking feature in common: they are almost universally located within a woman's grave.[71] C. J. Arnold suggests that the range of items "buried as grave-goods may be symbolic of an individual's role in society," and he offers as his paradigmatic example the "pieces of weaving equipment in durable materials … found in richly accompanied women's graves."[72] In recent years, this identification has faced some challenge in that archaeologists' own normative expectations of medieval gender may have prejudiced at least some of these results, particularly when grave goods have been used as a determining factor for the "sexing" of a

[69] Byrhtferth, *Byrhtferth of Ramsey: The Lives of St Oswald and St Ecgwine*, ed. and trans. Michael Lapidge (Clarendon, 2009), pp. 130–3.

[70] *Cloth and Clothing*, p. 2.

[71] *Ibid.*, p. 45.

[72] *Archaeology of the Early Anglo-Saxon Kingdoms*, p. 116.

burial when technology or situation has not allowed bone analysis.[73] On the other hand, experiments continue to demonstrate that the "sexing" model can be proven correct in a significant majority of cases.[74] The outliers, nonetheless, suggest that gender norms may require more evidence than archaeology alone.

Textual references support the archaeological connection across the mid-Saxon and late Saxon periods. Christine Fell suggests a longstanding linguistic connection between women and textile production in light of the attested use of the Old English suffix –*stere* (a grammatically female ending) in words such as spinster, seamster, and webster.[75] The will of King Alfred, as earlier discussed, identifies his male line as *þa wæpnedhealfe* "the weapon-side" or *þa sperehealfe* "the spear-side," and his female line as *þa spinlhealfe* "the spindle-side." Two later references which connect women and textile production include the Old English Hexateuch, produced under the supervision of Ælfric of Eynsham, in which Sarah is depicted as a spinner as she punishes Hagar (as discussed above; see Frontispiece), and Ælfric's Grammar, which translates the Latin term *GENERIS FEMININI* "about women" into Old English and includes phrases such as *illa suit heo*

[73] See arguments, for example, in Irene Barbiera, "Material Culture, Gender and the Life Cycle in Early Medieval Europe," in Enrica Asquer *et al.* (eds), Ving-Cinq Ans après (Rome: Publications de l'École française de Rome, 2019), https://doi.org/10.4000/books.efr.36447 (accessed 19 August 2024), paras 4–5; Susanne Brather-Walter, "Military Equipment in Late Antique and Early Medieval Female Burial Evidence: A Reflection of 'Militarisation'?", in Ellora Bennett *et al.* (eds), *Early Medieval Militarisation* (Manchester University Press, 2021), pp. 266–82; and Neil Price *et al.*, "Viking Warrior Women? Reassessing Birka Chamber Grave Bj.581," *Antiquity*, 93.367 (2019), 181–98.

[74] Eleanore Pape and Nicola Ialongo report, for example, that bone analysis of over 1200 burials from the seven largest, known burial sites from the Early Neolithic and the Late Bronze Age in Europe indicated that the majority (about 90 percent) are sexed in ways that agree with gender-normative grave goods ("Error or Minority? The Identification of Non-Binary Gender in Prehistoric Burials in Central Europe," *Cambridge Archaeological Journal*, 34 (2024), 43–63, at p. 56). Roberta Gilchrist, in her seminal *Gender Archaeology: Contesting the Past* (Routledge, 1999), summarizes the difficulties of typing biological sex by both gender-normative assumptions and by bone and reports similar percentages of accuracy for such methods (a 90 percent range for matching bone to gender-normative grave contents versus 10 percent range not matching) (p. 69). She argues that the most important way to ascertain generally accurate results is to ensure "Material culture is used together with contemporary literature, … manuscript illuminations and documents" (p. 110) and lists as a paradigmatic example the association of textile production and early medieval English women (pp. 50–1). She argues, as I do, that "The most convincing and nuanced readings of gender have been developed from multiple lines of evidence" (p. 53).

[75] *Women in Anglo-Saxon England*, p. 41. Related terms include *wultewestre* or *wulltewestre* (R. L. Venezky and A. diP. Healey, *A Microfiche Concordance to Old English*, Publications of the Dictionary of Old English, 1 (Pontifical Institute of Mediaeval Studies, 1980), hereafter *Concordance*) and *byrdestre*, defined "presumably one who ornaments textiles" (*Dictionary of Old English*, Fascicle B, ed. Ashley Crandell Amos, Antonette diPaolo Healey, Joan Holland *et al.* (Pontifical Institute of Mediaeval Studies, 1991), *s.v. byrdestre*).

siwa "she sews" and *illae nent lanam hig spinna wulle* "they spin wool."[76] Real women of the day were found doing both. In the contemporary life of St Oswald, Byrhtferth describes how the death of the saint occasions calamitous interruption of daily life, with merchants leaving the market and women their *colos et opus textrinum*[77] "distaffs and the work of the weaver's area/workshop."

Other evidence linking women and textile work includes *Maxims* I of the Exeter Book, which states *fæmne æt hyre bordan gerised* "a woman belongs at her embroidery" (63b).[78] The ultimate womanly ideal, the Virgin Mary, is herself praised above the other maidens at the temple in an eleventh-century apocryphal Pseudo-Matthew in Old English, as she *sona godum towcræftum onfeng, swydor þonne ænig þara þe heora bearn wæron wifa and fæmnena*[79] "directly undertook good textile work, better than any woman's child or any maiden." In the case of both the embroiderer of the Exeter Book and the Virgin Mary, as well as Aldhelm's audience of nuns, not only is textile production linked to "woman," but excellent textile product is linked to "virtuous woman." In this, early medieval English social mores mirror similar biblical values that the English might have known well: the counsel of King Lemuel's mother (Proverbs 31) for securing a *mulierem fortem* "strong woman" (verse 10) includes seeking a virtuous woman who works *lanam et linum* "wool and linen" (verse 13) and often has her *fusum* "spindle" (verse 19) in her hands. She is known for creating the finest of clothing, both for her home, and for trade (verses 21–2, 24).[80] In both traditions, the message remains the same: a virtuous woman is renowned for her textile work.

By the twelfth century, and perhaps earlier, men had moved from support roles to the center of the textile trade, with male weavers using new technology in the form of horizontal treadle looms. Interestingly, this technology, which swept across Europe, may have entered along gendered lines; Rashi (1040–1105), who lived in Troyes and briefly in Germany, described two looms in use, "men weave with their feet, while women have a cane which moves up and down."[81] In other words, the men used horizontal looms with treadles (or foot pedals that raise or lower threads to alter the shed and the weave), while women used (or continued to use) looms with heddles (such as the warp-weighted

[76] *Ælfrics Grammatik und Glossar*, ed. Julius Zupitza (Weidmannsche Buchhandlung, 1880), p. 97, lines 6, 9.

[77] *Byrhtferth*, Lapidge, p. 194. Translation in this instance is mine.

[78] *The Exeter Book*, eds G. P. Krapp and E. Van Kirk Dobbie, ASPR 3 (Columbia University Press, 1936), pp. 156–63.

[79] Assmann, *Angelsächsische Homilien*, no. 10, lines 338–41.

[80] Latin drawn from *The Vulgate Bible: Douay-Rheims Translation* (Harvard University Press, 2010).

[81] Quoted in Marta Hoffmann, *The Warp-Weighted Loom* (Universitetsforlaget, 1964), p. 260. Guilds for male weavers appear in the written record for England as early as 1130 (Eleanor Chance *et al.*, "Craft Guilds," in Alan Crossley and C. R. Elrington (eds), *A History of the County of Oxford: Volume 4, The City of Oxford* (Oxford University Press for the University of London, Institute of Historical Research, 1979), *British History Online*, https://www.british-history.ac.uk/vch/oxon/vol4/pp312-327 (accessed 19 July 2024)).

loom) for that function. Eventually, to women remained the process, the product, and the metaphors of spinning and finishing, as "spinsters" and embroiderers *par excellence*.[82]

PROCESS, PRODUCT, METAPHOR: SOCIOECONOMICS AND TEXTILES

The socioeconomics of textiles in the larger trade of early medieval England has been discussed elsewhere,[83] but the final products of the textile process that this chapter will discuss are the metaphors which link textiles and socioeconomics. If early ecclesiastical texts and later tenth-century women's wills are indicative, everyday clothing of wool and linen could vary in color, weave, and finishing. Certainly the silks and fine threads characteristic of vestments and hangings would have been available for clothing, but predominantly according to social class. As in any age, access to the means of production for expensive luxury textiles must have been limited to the upper class; thus, all luxury textiles discussed for which provenance can be established are associated with upper-class donors. Less expensive natural dyes, earth colors, and embroidery in simpler materials, however, must have been available to the lower classes, as they were to ecclesiasts. Documentary references attest to an awareness of the differences of social class (legal texts in particular), but awareness of social class differences associated with dress can also be documented. Thus, Byrhtferth deprecates his own work in writing a *vita* of St Oswald, claiming that he seeks to end a work so lacking in noble wording, a work metaphorically *induta pauperina ueste* "dressed in the clothing of the poor."[84]

A divide may also have occurred between lower-status and upper-status women in terms of who undertook various textile tasks, or at least, who took credit for them. Archaeological evidence shedding light on the relationship between textile implements and status is early, but it exists in consistent patterns. The patterns relate to specific textile implements known as sword beaters or weaving battens, understood to have been used to compact the weft in the loom. Such battens rarely survive if made of wood, but battens of iron have been found at Sarre (Kent), Bifrons (Kent), Buckland/Dover (Kent), Mitcham (Surrey), Holywell Row (Suffolk), Spong Hill (Norfolk), Chessel Down (Isle of Wight), Ozingell (Kent), and Finglesham (Kent), as well as West Stow (Suffolk), Luton (Bedfordshire), Ramsgate (Kent), and Barton (Lincolnshire).[85] Bone versions

[82] Thus, the Wife of Bath of Geoffrey Chaucer's *Canterbury Tales* (late fourteenth century) comments that women have certain gifts from God at birth, "Deceite, wepyng, spynnyng" (Geoffrey Chaucer, *The Riverside Chaucer*, ed. Larry D. Benson, 3rd edn (Houghton Mifflin, 1987), p. 110, line 401).

[83] See Hyer and Owen-Crocker, "Woven Works," pp. 182–4.

[84] *Byrhtferth*, Lapidge, p. 144. Translation is mine.

[85] Genevieve Fisher, "'Her Fitting Place': Women, Weaving, and Power in Early Anglo-Saxon England," Society for American Archaeology, Minneapolis, Minnesota, 7 May 1995 (unpublished conference paper). Susan Harrington's magisterial work on iron weaving swords updates this information with three additional finds in Kent and one in Cambridgeshire and one in Gloucestershire: *Aspects of Gender Identity and Craft Production in the European*

of the tool are also found throughout the period.[86] Where found in grave goods, the iron battens have a unique correspondence: they are usually found in "well-equipped" women's burials in Kent, probably indicating each woman's "seniority in the household, as director of the textile crafts,"[87] and perhaps representing a regional trend.[88] One sword beater found at Finglesham, Kent, indicates why this type of batten is often called a "sword beater"; it is pattern-welded, which suggests that it is either a re-used sword blade or a very luxurious weaving item which represents, like the real swords of the period, "a symbol of the rank and social status of [its] owner."[89] What makes the apparent correspondence with rank more interesting is that "all finds of weaving battens except for the questionable Shudy Camps [Cambridgeshire] example are mutually exclusive with finds of spindle whorls [spinning tools]. This distinction suggests that symbolically those who spun – spinsters – held a different role than women who wove."[90]

The distribution of textile implements at West Stow is a good reminder that spinning "was universally practiced whereas weaving was restricted to only one or two groups of practitioners within the settlement."[91] As earlier stated, many hours of spinning are required to produce enough thread or yarn for weaving, and spinning is a much easier and more mobile task than weaving. Anyone in a household, including young girls and elderly women, could spin to feed the demand for materials for weaving.[92] Weaving, on the other hand, takes more physical strength and much more experience, as well as more complicated equipment and more expensive resources, so such work might logically fall to the higher-status women (most often, women in their prime) among workers within a household or a workshop. However, it is difficult to determine if the finds show a divide

Migration Period: Iron Weaving Beaters and Associated Textile Making Tools from England, Norway and Alamannia, BAR, International Series, 1797 (John and Erica Hedges, 2008), p. 33.

[86] Owen-Crocker, *Dress*, pp. 275–6.

[87] Walton Rogers, *Cloth and Clothing*, p. 47; see also Coatsworth and Owen-Crocker, *Medieval Textiles*, p. 26.

[88] Owen-Crocker, *Dress*, p. 276.

[89] Sonia E. Chadwick, "The Anglo-Saxon Cemetery at Finglesham, Kent," *Medieval Archaeology*, 2 (1958), 1–71, at pp. 34–5. Chadwick points out that three of the finds of weaving swords accompanied other highly symbolic status objects such as solid gold fillets, crystal balls, and spoons.

[90] Fisher, "Her Fitting Place." Harrington's research concurs (*Aspects of Gender Identity*, pp. 27–8).

[91] Stanley West cited in Fisher, "Her Fitting Place."

[92] Reminiscent, again, of Sarah's depiction in the Old English Hexateuch (pictured on this volume's Frontispiece); both Sarah's and Abraham's elderly status is commented upon in biblical texts as a reasonable explanation for their lack of children, prior to Hagar's and later God's involvement in bringing them children in their old age. The mid-twelfth-century image, Cambridge, Gonville and Caius College, MS 428/428, fol. 28v, earlier discussed and also pictured in Figure 2, depicts the "Ages of Woman" as four stages; notably, both *senectus* and *decrepitas* are shown spinning.

PROCESS AND PRODUCT: SPINNING, WEAVING, AND FINISHING GARMENTS 33

between weavers and spinners by role within a household or community, a divide in those tasks by larger social class, or both.

In practical terms, the first is perhaps more likely. Differentiation of tasks of any kind within a household or community is entirely logical. Differentiation of industry by social class is another matter. For a relatively small group of upper-class women to have done all of the weaving for an entire community would have been an awesome feat, indeed. Women in households and communities across differing socioeconomic levels of society (and some lower-status men) must certainly have either taken responsibility for or assisted one another in almost every part of the process of the endless draping of early medieval English society. As Kelley Wickham-Crowley states, "Women's work on cloth must have figured in the economy of any community or family in Anglo-Saxon England."[93]

In Æthelgifu's tenth-century will, she frees a male *fullere*,[94] and in the tenth- or eleventh-century will of Wynflæd, she mentions that *hio becwið Eadgyfe ane crencestran 7 ane sem[estra]n*[95] "she bequeaths to Eadgyfu a female weaver and a seamstress." The will suggests that, although higher-status women seem to have been identified with high-status weaving equipment (such as weaving swords), as well as to have "owned" the elaborate and expensive woven and embroidered vestments they donated, they did not reserve the work of "weaving" solely for themselves and clearly had assistance in the physical labor and many hours required to complete their projects (luxury or not) across all stages of textile production. Richer or higher-status women would naturally have been more likely to adopt luxury textile projects impossible for slaves or lower-class households, but the demand of each community for more basic textiles as well as luxury goods must have required a large labor force, probably comprised of both higher-status and lower-status women (and some men, as fullers, at least) involved in at least some stages of the task.[96] Textile production of all kinds was clearly both a cottage and a workshop industry. In terms of the work produced, for luxury textiles, Fell remarks, "Who took the credit for the work finally produced may be left to conjecture."[97]

To parallel weaving and high-status women, and spinning and lower-status women, is thus very likely to be an oversimplification (with Sarah's depiction as a spinner in the Old English Hexateuch as a good example). One real opposition probably lies in the possession of the means of production for textiles, the most luxurious ones, in particular. At the same time, metaphors often fulfill the function of idealizing social roles and mores, and

[93] "Buried Truths: Shrouds, Cults, and Female Production in Anglo-Saxon England," in Catherine Karkov and Helen Damico (eds), *Aedificia Nova: Studies in Honor of Rosemary Cramp* (Medieval Institute Publications, 2008), p. 301.

[94] *The Will of Æthelgifu*, ed. and trans. Dorothy Whitelock, Neil R. Ker, and Francis James Lord Rennel of Rodd (Roxburghe Club, 1968), p. 16. Translations from this text are mine.

[95] "The Will of Wynflæd," Whitelock, p. 10, line 30. As in earlier citations, translations for this text are mine.

[96] Fell, *Women in Anglo-Saxon England*, pp. 40–1.

[97] *Ibid.*, p. 41.

while spinning is closely and metonymically associated with all women (young, old, high, or low) in the more limited textual evidence that remains, weaving and embroidery are more often referenced in literature and are more often associated with either high-profile or upper-class women, a fact which will be evident throughout subsequent discussion. The women referenced in literature are often those who are of high status within their households and communities, as well as within larger society. Perhaps it is to be expected that they would be associated so frequently with "high-status" women's work such as weaving, as a consequence.[98]

A final product of the socioeconomics of textiles is the metaphor that textiles and their producers became for England itself. England's renown in the later Middle Ages as a textile nation began in early medieval England, which participated in a lucrative trade, as eighth-century correspondence between Offa and Charlemagne indicates.[99] By the ninth century, if not earlier, early medieval English textiles had made their way to Rome, as well; the father of King Alfred, King Æthelwulf, presented St Peter's with gold-embroidered hangings in 855.[100] H. R. Loyn relates that "Even the Moslem world knew of the reputation of the English cloth and from the ninth to the eleventh century many Arabic sources referred to its fame."[101] C. R. Dodwell remarks that as a result of the personal and collective fame early medieval English women acquired through their textiles, their embroidery was so "much respected at home and admired abroad" that even the occasionally skeptical William of Poitiers lauded their ability and skill with "the needle and in weaving with gold."[102] Pre-Conquest English textile work appears to have been quite distinctive; during a visit to the Italian archbishop of Benevento, an early medieval English ecclesiast named Eadmer who lived at the time of the Conquest was able to recognize on sight that an ornate and highly prized cope at least fifty years old was of English origin, an estimate which local ecclesiasts confirmed.[103]

Although women probably continued to produce great works of art after the Conquest, during spinning and embroidering phases in particular, male weavers and tradesmen began to take over more aspects of the industry, benefiting greatly from the reputation of the early medieval English textile tradition, as papal inventories indicate: "By the time

[98] In *Weaving Words and Binding Bodies*, Megan Cavell argues that the high status of weaving is the most important element in its assignment within metaphorical contexts (p. 296), and this discussion might be considered to support that point of view. However, Cavell's argument rests on downplaying gender as a consideration when defining textile metaphor. As I argue throughout this work, however, there is no separating gender from textiles in early medieval English culture. As discussed in this chapter, women are identified archaeologically, linguistically, and culturally with textiles across the period, and even in this instance, the status under discussion is the status of women who wove, versus those who spun.

[99] H. R. Loyn, *Anglo-Saxon England and the Norman Conquest*, 2nd edn (Longman, 1991), p. 85.

[100] Discussed in Dodwell, *Anglo-Saxon Art*, p. 129.

[101] Loyn, *Anglo-Saxon England*, p. 86.

[102] *Anglo-Saxon Art*, p. 45.

[103] *Ibid.*, p. 183.

of the Papal inventory of 1295 *Opus Anglicanum* is mentioned more often than any other form of embroidered decoration in the vestments held in Rome by the Holy See."[104] Until 1350, "when the depredations of the Black Death decimated the embroiderers," the English embroidery which ultimately originated among early medieval English women "was the most admired and most sought after indigenous European textile artwork."[105] Given the central place of textiles and their production within early medieval English society and beyond, the frequency of textile metaphors in Old English and Anglo-Latin literature is hardly surprising. It is this metaphorical richness to which I now turn.

[104] Higgins, *Cloth of Gold*, p. 28.
[105] *Ibid.*, p. 22.

CHAPTER 2

Weaving Peace, Weaving Life

Ne bið swylc cwenlic þeaw
idese to efnanne, þeah ðe hio ænlicu sy,
þætte freoðuwebbe feores onsæce
æfter ligetorne leofne mannan (1940b–43)

Nor is such behavior queenly conduct for a woman to bring about,
although she be gloriously beautiful, that a peaceweaver take the life of a
beloved man because of feigned grief/anger.[1]

Two powerful metaphors found in the literature of the early medieval English peoples are the weaving of peace and the weaving of death. Both metaphors have generated a long history of argument and discussion, a history which this chapter and the next necessarily address. In this chapter, I begin with an overview of critical opinion on the potential definitions to date for "peaceweaver/peaceweaving," and then follow with the definitions considered here. Meanings considered in this work take into account all of the elements of the word "peaceweaving," including the often under-considered second half of the metaphor: "-weaving." Anglo-Latin evidence has also rarely been taken into account in this conversation, and I do so here, documenting previously unaddressed evidence. After assessment of this full range of evidence, the chapter will also examine potential analogical influences in the development of the early medieval English metaphor for weaving peace.

PEACEWEAVING

Conventional Definitions
Of the textile metaphors in Old English, the peaceweaving metaphor is one of the most compelling, and its potential meaning has generated significant discussion among scholars. As Peter S. Baker points out, the term itself was itself romanticized among early Anglo-Saxonists and Germanicists of the nineteenth century. Just as early scholars

[1] This and all lines from *Beowulf* in this work are taken from *Klaeber's Beowulf and the Fight at Finnsburg*, 4th edn, ed. Fr. Klaeber with R. D. Fulk, Robert E. Bjork, and John D. Niles (University of Toronto Press, 2008).

projected a kind of "Germanic super-identity" onto the literature they rediscovered, so some interpreted the "peaceweaver" as the early Germanic "wise woman" of pre-Christian heroic days. Victorian-era Anglo-Saxonists in their turn adopted the peaceweaver metaphor to characterize these "early Germanic women" as prototypical "angels in the house," peace-makers whose domestic roles were comprised of gentle, soothing actions often thwarted by their sturdy masculine counterparts.[2] In more recent years, interpreters have refashioned the metaphor to mirror some of the older ideas, but also to cast the "peaceweaver" as either the oppressed heroine paralyzed and victimized by a patriarchal culture, or a constructive and active participant in her society whose power can be reconstructed by analysis of the metaphor, or both. The metaphor itself has further inspired the central themes of works on women and metaphors around which discussion of the feminine roles of women (both in and outside of the period) is organized[3] and a wide variety of other projects.[4] There are good reasons to accept at least some of these interpretations as culturally and textually appropriate to the people of early medieval England, and evidence to support a few. At the same time, however, assumptions about the metaphor must undoubtedly be weighed more carefully than they often are: as L. John Sklute and more recently Peter Baker point out, one of the handful of actual examples of a "peaceweaver" in an early medieval English text is a male angel, and none of the textual examples comes with an explanation that indisputably connects peaceweaving with any of the definitions thus far assigned to it (including Sklute's and Baker's).[5] This chapter will address the textual evidence for the major definitions for "peaceweaver/peaceweaving" in currency today, but will also depart somewhat from the standard discussion in examining the constituent issues with a focus on understanding the role of the second half of the poetic compound in the metaphor's meaning, as well as the first. In other words, while analyzing definitions and considering available evidence, I will also interrogate why peace-making is conceptualized as "weaving," as well as how weaving is related to those who "weave peace."

[2] *Honour, Exchange and Violence in Beowulf* (D. S. Brewer, 2013), pp. 107–19.

[3] Examples include texts which evoke the metaphor in ways related only distantly to its appearance in the textual corpus, such as *Peaceweavers*, volume 2 of *Medieval Religious Women* (eds Lillian Thomas Shank and John A. Nichols (Cistercian Publications, 1987)), which uses the metaphor as a broad collective idea binding articles on a wide range of predominantly late and/or continental medieval religious women's experiences. Other examples evoke the metaphor in ways much closer to its textual genesis, such as Gillian R. Overing's use of the metaphor as a conceptual frame for her insightful semiotic analysis of *Language, Sign, and Gender in Beowulf* (Southern Illinois University Press, 1990).

[4] As Baker notes, some applications of the metaphor range as widely as popular novels, "organic agriculture," and "feminist Neopaganism" (*Honour*, pp. 125–6). These instances and many others suggest that the metaphor has at times taken an imaginative life of its own inside and outside of academia.

[5] "*Freoðuwebbe* in Old English Poetry," in Helen Damico and Alexandra Hennessey Olsen (eds), *New Readings on Women in Old English Literature* (Indiana University Press, 1990), pp. 204–10, at p. 208, reprinted from *Neuphilologische Mitteilungen*, 71 (1970), 534–41.

The actual word "peaceweaver" appears only three times in the Old English corpus. In *Beowulf*, the feminine form of the word occurs in the description of a young noblewoman who orders the execution of any retainer who offends her. Rather than naming her a faithful "peaceweaver," the text comments, *Ne bið swylc cwenlic þeaw / idese to efnanne, þeah ðe hio ænlicu sy, / þætte freoðuwebbe feores onsæce / æfter ligetorne leofne mannan* "Nor is such behavior queenly conduct for a woman to bring about, although she be gloriously beautiful, that a peaceweaver take the life of a beloved man because of feigned grief/anger" (1940b–43). In contrast, in the Exeter Book poem *Widsið*,[6] the first-person speaker of the same name designates Queen Ealhhild as a *fælre freoþuwebban* (6a), or "faithful [or dear] peaceweaver." In both instances, the term clearly refers to noble women who appear to be evaluated in part for their role in making or keeping peace in their communities. One resulting interpretation of "peaceweaver/peaceweaving" is that espoused, for example, in the translation of *Beowulf* by E. Talbot Donaldson. In his note on the translation of the word, Donaldson explains that the term alludes to the historical practice of making alliances by marriage: "Daughters of kings were frequently given in marriage to the king of a hostile nation in order to bring about peace."[7]

The history of the early medieval English peoples (as well as other European contemporaries) does in fact document that noble women were often exchanged in politically motivated marriages intended to result in peace and alliance.[8] Thus, for example, in eleventh-century England,

> The healing of the breach between Edward himself [the Confessor] and the powerful Earl Godwin was symbolized in the marriage, possibly not consummated it is true, between Edward and Godwin's daughter, Edith. Among the nobility in general a marriage was a common, though dangerous, way of publicly announcing the end of a feud.[9]

Despite the risks of intermarriage as a peace tool between warring factions, "marriages for purposes of allegiance were a political reality."[10] As a result, the definition of "peace-

6 ASPR 3, pp. 149–53.

7 In *Beowulf* (W. W. Norton, 1966), p. 34.

8 Pauline Stafford documents an extensive body of evidence for women in positions of power and influence in early medieval Europe, with that power often cemented through political marriages and communal roles of queenship. She likewise documents the vulnerability of such women, including both Emma and Edith, discussed here (cf. *Queens, Concubines, and Dowagers: The King's Wife in the Early Middle Ages* (repr. Leicester University Press, 1998; 1983); *Queen Emma and Queen Edith: Queenship and Women's Power in Eleventh-Century England* (repr. Blackwell, 2001; 1997)).

9 Loyn, *Anglo-Saxon England*, pp. 274–5.

10 Joyce Hill, "'Þæt Wæs Geomuru Ides!' A Female Stereotype Examined," in *New Readings*, Damico and Olsen, pp. 235–47, at p. 239.

weaver" as a woman who engages in a marriage alliance in the name of peace has often been accepted among scholars.[11]

However, the third character assigned the title of "peaceweaver" is often considered a reason to call the former interpretation into question; in the poem *Elene*, the "peaceweaver" is an angel sent to mediate between Constantine and God. The angel comes to Constantine on the eve of a great battle while he sleeps. The angel appears *on weres hade* "in the form of a man" (72b), but not an average warrior.[12] Rather, the angel *is hwit ond hiwbeorht* "white and shining in hue" (73a), a *wlitig wuldres boda* "radiant messenger of glory" (77a) who instructs Constantine to adopt the standard of the cross to ensure victory the following day. Constantine listens to the angel, the *fæle friðowebba* "faithful or trusty peaceweaver" (88a). As Sklute points out, the angel is male, as the gender of the weak noun *friðowebba* reinforces, and although not a strictly normal human male, he does not "peaceweave" in a marital sense. Sklute argues that the title "peaceweaver," therefore,

> does not necessarily reflect a Germanic custom of giving a woman in marriage to a hostile tribe in order to secure peace. Rather it is a poetic metaphor referring to the person whose function it seems to be to perform openly the action of making peace by weaving to the best of her art a tapestry of friendship and amnesty. The warp of her weaving is treasure and the woof is composed of words of good will. The compound *freoðuwebbe* expresses the duty of the king's wife to construct bonds of allegiance between the outsider and the king and his court. If it reflects anything of the social system of the Anglo-Saxons, it is that of the diplomat.[13]

Sklute argues that the "peaceweaver" would be one who does not necessarily weave peace through marriage, but one who weaves diplomatic ties or peace-creating bonds within society.

In some respects, Sklute's argument for a diplomatic rather than a marital definition of peaceweaving agrees with Jane Chance's seminal discussion of the metaphor's possible meanings in her work published a few years later. Both see the metaphor as applying more generally to diplomacy than (solely) marriage, but Sklute applies the metaphor to diplomats male or female, while Chance suggests that the metaphor belongs predominantly to the expected social role of the noble woman or *ides* as depicted in Old English poetry. She argues that such a role includes a much longer list of expected behaviors and responsibilities than simply marital peaceweaving; "peaceweaving" may be defined as the weaving of peace through *all* of the expected social actions of the "ides [noble woman]"

[11] See, for example, Kathleen Herbert, *Peace-Weavers and Shield Maidens: Women in Early English Society* (Anglo-Saxon Books, 1997), p. 16, or Stacy S. Klein's *Ruling Women: Queenship and Gender in Anglo-Saxon Literature* (University of Notre Dame Press, 2006), p. 19.

[12] This and all subsequent quotations from *Elene* come from *The Vercelli Book*, ed. George Philip Krapp, ASPR 2 (Columbia University Press, 1932), pp. 66–102.

[13] "*Freoðuwebbe* in Old English Poetry," p. 208.

within her community (which may or may not include marital peace-making).[14] An interpretation of peaceweaving as a communal style of peace-making does not limit a woman's peace-making function to marriage, but does not exclude it either.

Instead, Chance suggests that additional, critical social responsibilities of the noble woman go well beyond the marriage act in determining if a noble woman "weaves" or destroys peace. First, the noble woman or queen must pass the mead cup between lord and thanes in a symbolic, unifying act. Second, she must give gifts to ensure the loyalty of the thanes to the lord and her offspring. Third, she must give wise counsel to the lord, and fourth, exact oaths of loyalty from the thanes, all in an effort to preserve peace. Through these interlocking threads of action, the noble woman of heroic poetry plays and is expected to play an important symbolic role in creating the bonds of order, unity, and peace within her society. Chance's definition of *freoðuwebbe* as embodying communal peaceweaving has proven profoundly influential and remains so today, perhaps for good reason: each individual element of the diplomatic, communal style of peace-making or peaceweaving identified is easily documented by reference to Old English and Anglo-Latin poetry and prose.

The passing of the mead cup, the first of the communal peaceweaving elements listed by Chance, is illustrated in early laws which suggest that the server of drink was generally female, although not necessarily always the noble's wife.[15] Bede provides an illustration of what appears to be a similar or the same custom in eighth-century Northumbria, telling a story he heard from Abbot Berhthun about John, Bishop of York. During a visit to a nobleman, John heals the nobleman's wife of a lasting illness, upon which *obtulit poculum episcopo ac nobis, coeptumque ministerium nobis omnibus propinandi usque ad prandium conpletum non omisit* "she brought the cup to the bishop and to the rest of us and continued to serve us all with drink until dinner was finished."[16] Later poetic texts (some of which I will discuss in the next section) demonstrate the lasting nature of this tradition, as passing the cup "is documented in all formal heroic poetry as the duty not merely of the 'woman,' but of the 'lady.'"[17] The frequent and clearly ceremonial nature of the custom suggests that passing the mead cup is a highly symbolic social act: to receive drink from the lord's wife means a retainer or a guest has accepted the duty to demonstrate loyalty to her and the lord in return for their hospitality. Thus, the noble woman who passes the symbolic mead cup between the lord and his retainers ensures both reciprocal loyalty and peaceful internal relationships among all members of her community and their visitors.

[14] *Woman as Hero in Old English Literature* (Syracuse University Press, 1986), p. 1.

[15] Fell, *Women in Anglo-Saxon England*, p. 50. The symbolic nature of sharing the mead finds a parallel in Norse and continental Germanic tradition.

[16] Bede, *Bede's Ecclesiastical History*, Colgrave and Mynors, book 5, chapter 4, pp. 462–3. Translation is by Colgrave and Mynors.

[17] Fell, *Women in Anglo-Saxon England*, p. 50.

When a noble lady gives gifts, she performs the same function: she reinforces the gifts of her lord, which, like drink, cement loyalty and peace within and at times between communities. As Fred Robinson states,

> Gift taking also had social and ceremonial significance, being an overt symbol of the social contract implicit in the heroic world. When a man receives a gift from his lord or queen, for example, he solemnizes his allegiance to the dispenser of the gift. For a man to accept a gift and then fail his benefactor in time of need would not merely be ingratitude; it would be a violation of the heroic code.[18]

A noble woman's generosity thus helps her in her efforts to preserve stability and peace among her people, and may also bring her fame, perhaps as a "good" peace-bringer or "peaceweaver."[19]

According to Chance's paradigm, the communal peace-maker or metaphorical peaceweaver also fulfills her function through wise counsel to her lord. If the somewhat romanticized observations on earlier Germanic relatives of the early medieval English peoples bear weight, Tacitus indicates in his *Germania* that *inesse quin etiam sanctum aliquid et providum putant*" "they conceive that in woman is a certain uncanny and prophetic sense: and so they neither scorn to consult them nor slight their answers."[20] In the ninth century, theorists such as the Irish poet and scholar Sedulius Scottus also "commented on the appropriateness of kings plucking the fruits of their wives' good counsels."[21] Certainly the pre-Conquest English themselves were well aware of the importance of good counsel, and praised those who, as *Maxims* I of the Exeter Book indicates, *hi a sace semaþ, sibbe gelærað / þa ær wonsælge awegen habbað* "wisely ever settle conflict, advise the peace that unhappy men had previously weighed" (20–1). Enjoining a leader to keep the peace, particularly during internal, communal conflicts, would certainly demonstrate a noble woman's right to a title such as "peaceweaver."

The final element of the poetic noble woman's societal role within Chance's paradigm for a communal peaceweaver is as an enjoiner of oaths to fight bravely, a role that seems somewhat paradoxical to the role of a peace-maker. Tacitus records the tradition of earlier Germanic women changing the tides of battles *constantia precum et obiectu pectorum* "by the incessance of their prayers and by opposing their breast."[22] He explains that, through the women's presence near the battlefield and their pleas for protection,

[18] "History, Religion, Culture," in Jess B. Bessinger, Jr., and Robert F. Yeager (eds), *Approaches to Teaching Beowulf* (MLA, 1984), p. 121.

[19] In the German epic *Nibelungenlied* (*c.*1200), a poem which celebrates the martial Germanic society of the past, the narrator comments that when Queen Kriemhild was pleased with the reports of two men, "she lavished rewards on those minstrels and enhanced her good name in doing so" (trans. A. T. Hatto (Penguin, 1969), p. 189).

[20] Tacitus, *Tacitus in Five Volumes: I Agricola, Germania, Dialogus*, ed. and trans. M. Hutton with E. H. Warmington, Loeb Classical Library, 35 (Harvard University Press, 1980), pp. 142–3.

[21] Hill, '*Þæt Wæs*,' p. 238.

[22] *Tacitus*, Hutton and Warmington, pp. 142–3.

the women incite the men to much greater bravery. Alexandra Hennessey Olsen discusses a similar tendency more contemporary to the early medieval English among "the women of Germanic tradition who admonish their male kinsmen to act in accordance with the heroic code," using "both speech and actions" to incite men to battle.[23] In the Old English tradition, a section of the fragmentary poem *Waldere*[24] provides a prototypical example of a woman inciting her lover in just such a way. As Waldere prepares to battle singlehandedly against two warriors who impede their escape, Hildegund, his companion, eagerly urges him,

> Ætlan ordwyga, ne læt ðin ellen nu gy[.]
> gedreosan to dæge, dryhtscipe
> [...] is se dæg cumen
> þæt ðu scealt aninga oðer twega,
> lif forleosan oððe lag[n]e dom
> agan mid eldum, Ælfheres sunu (6–11)

> Great warrior of Attila, do not now allow your courage, your nobility to fail today ... the day is come that you must certainly [do] one of two things: lose your life or obtain a lasting reputation among men, son of Ælfhere.

While some might argue that the woman who incites warriors to battle belongs to the opposite camp, death-bringers, Chance attributes this characteristic to the peace-maker *ides*, and there are reasonable grounds for doing so. While inciting to battle does not promote universal peace, it does promote the general welfare and preservation of a woman's own community, or in other words, the hope for return to peace and stability for her community.

The poetic *Maxims* of the Exeter Book comment rather directly on most of these proposed communal peaceweaving characteristics in a description of the noble woman's expected role:

> Cyning sceal mid ceape cwene gebigcan,
> bunum ond beagum; bu sceolon ærest
> geofum god wesan. Guð sceal in eorle,
> wig geweaxan, ond wif geþeon
> leof mid hyre leodum, leohtmod wesan,
> rune healdan, rumheort beon
> mearum ond maþmum, meodoræddenne

[23] "Cynewulf's Autonomous Women: A Reconsideration of Elene and Juliana," in *New Readings*, Damico and Olsen, p. 225.

[24] *The Anglo-Saxon Minor Poems*, ed. Elliott Van Kirk Dobbie, ASPR 6 (Columbia University Press, 1942), pp. 4–6. My emendation in line 10 is based on *Waldere*, ed. Arne Zettersten, Old and Middle English Texts (Manchester University Press, 1979). Zettersten's reading of the manuscript under ultraviolet light allows additional letters to be seen.

fore gesiðmægen symle æghwær
eodor æþelinga ærest gegretan,
forman fulle to frean hond
ricene geræcan, ond him ræd witan
boldagendum bæm ætsomne. (81–92)

A king must buy a queen with goods, with cups and rings. Both must first be liberal with gifts; valor in battle must flourish in the noble man, and the woman must prosper beloved among her people, be light of heart, keep counsel, be generous with horses and precious things. At the mead-passing, before a band of warriors anywhere, she will always greet the ruler of princes first with the first cup, quickly offer it to the hand of the lord and keep counsel with him in the household, both of them together.

As the gnomic poem suggests, as part of her ceremonial duties, the noble woman is expected to pass the mead cup from lord to thanes, give gifts, and keep counsel with her lord, all elements constituent to the internal peace-keeping process identified by Chance. The identification of the communal peace-making role as a primary responsibility of the noble *ides* is thus compelling and evidence-based.[25]

Chance's work has had its detractors, including a handful of contemporary reviews, and more recently, Peter Baker, who, while he considers her writings "among the most influential works of Old English literary criticism of the last three decades" and accepts some of her arguments,[26] also rejects her definition as lacking any supporting evidence, suggesting that her interpretation and similar readings ever since have had the "pernicious" effect of encouraging simplistic readings of the metaphor.[27] I differ from Baker in a few key respects; most importantly, I accept and have here offered some of the abundant primary evidence I consider as directly supporting Chance's arguments regarding the responsibilities most praised and perhaps expected for noble women, particularly peace-making. At the same time, I consider Baker's challenge a fair one, in the sense that documentation and qualification of interpretive leaps are essential steps for a metaphor used elliptically in Old English literature, with one example out of three masculine. I offer

[25] Her definition is more generally adopted, for example, in Michael Enright, *Lady with a Mead Cup: Ritual, Prophecy and Lordship in the European Warband from La Tene to the Viking Age* (Four Courts, 1996), pp. 21–2; Victoria Wodzak, "Of Weavers and Warriors: Peace and Destruction in the Epic Tradition," *Midwest Quarterly*, 39 (1998), 253–64, at p. 256; Lori Eshleman, "Weavers of Peace, Weavers of War," in Diane Wolfthal (ed.), *Peace and Negotiation: Strategies for Coexistence in the Middle Ages and the Renaissance* (Brepols, 2000), pp. 15–37, at p. 16; and Francis Leneghan, *The Dynastic Drama of* Beowulf (D. S. Brewer, 2020), pp. 178–80, as a few among many that stretch to the present day. For his part, Enright exalts peaceweaving, arguing that the noble woman's role has cultic function (p. 22) and considering it the necessary "mortar" at the heart of the continuation of the warband (p. 35).

[26] *Honour*, pp. 121, 160.

[27] *Ibid.*, p. 125.

TEXTILES & TEXTILE IMAGERY IN EARLY MEDIEVAL ENGLISH LITERATURE

in response a test case for Chance's definition: a close examination of each occurrence of "peaceweaver" in Old English, with particular reference to *Beowulf* and a careful assessment of the behaviors and cultural contexts within each text for each weaver of peace. The Anglo-Latin evidence also follows.

Assessing Evidence for Communal "Peaceweaving"

As Beowulf returns to his people after his exploits at Heorot, he is greeted by his uncle and his aunt, the noble Hygd. In introducing her, the text lauds Hygd's overall behavior, stating that she is *wis welþungen ... / næs hio hnah swa þeah, / ne to gneað gifa Geata leodum, / maþmgestreona* "wise and well-thought of ... she was not niggardly, nor too sparing of gifts or treasures to the people of the Geats" (1927a, 1929b–31a). In other words, it is clear she gives good counsel and is herself generous in gift-giving. Although we are told she is young, her unusual wisdom demonstrates her understanding that by giving treasure and mead she helps to preserve peace and stability within her community. The poet emphasizes her virtuous behavior by then contrasting it with that of another young queen.

The name of the other young queen has, of course, been a matter of some debate. The unamended line *Mod þryðo wæg, / fremu folces cwen, firen ondrysne*, is indeed problematic as emended in Frederick Klaeber's earlier editions, "Modthryth, excellent queen of the people, brought about terrible crime." The abrupt transition between her excellence and her guilt led to the alternate reading suggested by Kemp Malone and reasserted by Fred C. Robinson, in which her name remains unamended as "Thryth," and in which the subject of *fremu folces cwen* is Hygd. According to this second reading, after the poet has introduced the good example of Hygd, he immediately explains her inspiration, "the good folk-queen had weighed the arrogance and terrible wickedness of Thryth."[28]

A more recent interpretation of the lines by Robert Fulk and the other editors of the newest edition of *Klaeber's Beowulf* mirrors Fulk's earlier arguments from "The Name of Offa's Queen,"[29] and reads, *Modþryðo wæg / Fremu, folces cwen, firen ondrysne* (1931b–32). In this third version, the young queen is named Fremu, and she considers terribly wicked ways. Thus, the young queen of these lines may be named Modthryth, Thryth, or Fremu, depending on which editorial interpretation one accepts. I tend to agree with Peter Baker that, while the more recent interpretation takes care of one set of translation issues and is very ingenious (and very possibly correct), it is not without difficulty.[30] While some scholars do not, many do accept the weight of the historical sources that support the first or second interpretation, as these sources name the young queen who marries Offa a form of Thryth, "Cynethryth." The meaning of the passage is quite nearly the same no matter how the queen's name is translated, but in keeping with historical tradition, I use the name "Thryth" to describe the young queen for the purposes of this discussion, following the interpretation suggested by Malone and Robinson.

[28] Malone's translation is included in Fred C. Robinson's article, "*Beowulf* in the Twentieth Century," *Proceedings of the British Academy*, 94 (1997), 45–62, at pp. 53–4.

[29] Robert D. Fulk, "The Name of Offa's Queen: *Beowulf* 1931–2," *Anglia*, 122:4 (2004), 614–39.

[30] *Honour*, p. 104, fn. 2.

Within the text as interpreted, Hygd considers the ways of "Thryth" and chooses to behave differently, electing to bring peace and stability to her community through wise counsel and generous behavior. Perhaps to highlight the contrast between the women more markedly, the poet explains Thryth's evil ways in greater detail, stating emphatically, *Ne bið swylc cwenlic þeaw / idese to efnanne, þeah ðe hio ænlicu sy, / þætte freoðuwebbe feores onsæce / æfter ligetorne leofne mannan* "Nor is such behavior queenly conduct for a noble woman to bring about, although she be gloriously beautiful, that a peaceweaver take the life of a beloved man because of feigned anger" (1940b–43). The poet is clearly offended that the young queen executes any retainer who displeases her by looking upon her in ways she dislikes; he considers her response destructive and irresponsible. Unlike Hygd, whose name means "thought" or "consideration" and whose wisdom and generosity protect the peaceful stability and well-being of her community, Thryth thus defies the expected role of *cwen* and *ides* by taking the lives of beloved retainers lightly, showing in the process that she chooses not to be a *freoðuwebbe*, a "peaceweaver."

The narrator's commentary on the proper behavior expected of a *freoðuwebbe* is particularly important because this instance of the term is the only one of the three extant in the Old English corpus that provides any kind of elaboration of what the metaphor "peaceweaver" means. What the poet does say is that Thryth is a poor "peaceweaver": she hurts, binds, and destroys in anger, rather than "weaving peace." Mirroring conduct literature in tone and voice, the poet also states critically that her choices in doing so are not *cwenlic þeaw* "queenly conduct" for *idese* "a noblewoman." His remarks render apposite *idese* and *freoðuwebbe*, suggesting that queenly conduct for the *ides* includes being a *freoðuwebbe*. The queenly conduct expected of an *ides* and a *freoðuwebbe* is thus the conduct we see in Hygd. She, then, is an example of a "good" *freoðuwebbe*, and her actions do, in fact, mirror many of the peace-making actions described in the *Maxims.* Although young, she is a wise counselor and is generous to the people of her community, her actions throughout the work clearly bent on preserving the internal peace and stability of her husband's and son's people. She will later offer the throne to Beowulf, considering her son too young for the responsibility, and when Beowulf refuses it, her son does indeed get himself killed. Thus, it is a fair interpretive leap to suggest that a "peaceweaver" is indeed a kind of communal peace-maker and a role expected and praised for an *ides* or noble woman.

Examination of Wealhtheow, the other major, highly-praised *ides* within *Beowulf,* offers significant additional support for these contentions. The first mention of Wealhtheow in *Beowulf,* perhaps not coincidentally, occurs as she fulfills the role of mead- and peace-bringer. The visiting hero Beowulf and the resentful retainer Unferth engage in a verbal duel; Unferth loses. As Beowulf then affronts Unferth by vowing to do the work Unferth cannot, Wealhtheow immediately moves forward, *cynna gemyndig* "mindful of her offspring/people":

> ond þa freolic wif ful gesealde
> ærest East-Dena eþelwearde,
> bæd hine bliðne æt þære beorþege,
> leodum leofne …

> Ymbeode þa ides Helminga
> duguþe ond geogoþe dæl æghwylcne,
> sincfato sealde (613b, 615–18a, 620–2a)

> and the beautiful woman offered the cup first to the guardian of the
> native land of the East-Danes, asked him to be happy at the beer-
> drinking, beloved to the people … Then the woman of the Helmings
> went around to each one of the old and young retainers, gave them the
> precious drinking vessel.

Wealhtheow's timing is either planned or providential; as hostilities escalate between Unferth and Beowulf, she arrives with the mead cup, perhaps not only checking ruffled tempers, but also reminding those within of their duties to one another and the lord. Unferth should not insult his lord's guest to the point of violence, nor should Beowulf antagonize the band he has sworn to protect.[31] Her behavior also directly mirrors the ceremony described in the *Maxims*; first she offers drink to her lord, then to his guests.

Wealhtheow continues her efforts by honoring Beowulf with thanks and praise for coming to their rescue. Gratified, Beowulf answers, *guþe gefysed* "impelled to fight" (630b), that he resolved long before to be the champion of the Danes. Beowulf's response suggests that Wealhtheow has incited Beowulf to battle and to an oath which binds him to her lord Hrothgar's service. In doing so, she has protected peace and stability within the mead-hall, directing Beowulf's valor to proper channels. He will focus on fighting Grendel, and not Unferth. Both the actual and potential threat are thus resolved by Wealhtheow's timely peace-making. Wealhtheow's efforts to incite Beowulf to engage in violent combat with the monster Grendel seem paradoxical to a (perhaps contemporary) notion of "peace-making," and indeed, they are. However, the battles to which Wealhtheow enjoins Beowulf are intended to restore peace *within* her troubled realm, a peace which she despairs of seeing otherwise. Thus, inciting oaths of loyalty and oaths for battle would serve the same peace-bringing ends *within* the troop but promise violence and death to outsiders who threaten it.

When the text next mentions her, Wealhtheow continues to function as a powerful peace-keeper as she advises her lord after Grendel's death and Beowulf's victory:

> Onfoh þissum fulle, freodrihten min,
> sinces brytta. Þu on sælum wes,
> goldwine gumena, ond to Geatum spræc
> mildum wordum, swa sceal man don.
> Beo wið Geatas glæd, geofena gemyndig,

[31] A number of scholars have argued that Unferth's hostile speeches are less the acts of a resentful retainer, and more the words of the king's "right-hand-man" in his role as a "tester" of Beowulf (see, for example, Carol J. Clover's "The Germanic Context of the Unferth Episode," *Speculum*, 55 (1980), 444–68). Such an interpretation is certainly feasible. Either way, however, Wealhtheow's entrance suggests the moment has come for calming tempers that must have been raised by such questioning, be it ritualized, or not.

nean ond feorran [þa] þu nu hafast.
Me man sægde, þæt þu ðe for sunu wolde
hereri[n]c habban. Heorot is gefælsod,
beahsele beorhta; bruc þenden þu mote
manigra medo, ond þinum magum læf
folc ond rice þonne ðu forð scyle,
metodsceaft seon. Ic minne can
glædne Hroþulf, þæt he þa geogoðe wile
arum healdan, gyf þu ær þonne he,
wine Scildinga, worold oflætest;
wene ic þæt he mid gode gyldan wille
uncran eaferan, gif he þæt eal gemon,
hwæt wit to willan ond to worðmyndum
umborwesendum ær arna gefremedon.(1169–87)

Take this cup, my great lord and treasure-giver. Be happy, gold-friend
of men, and speak to the Geats with kind words, as a man ought to do.
Be cheerful with the Geats, mindful of the gifts from near and far which
now you have. Someone told me that you might wish to have the warrior
[Beowulf] for a son. Heorot is cleansed, a bright ring-hall; enjoy the
many rewards while you are able, and leave your people and kingdom to
your kinsmen when you must go forth to see the decree of fate. I know
my gracious Hrothulf; he will keep in mind the honor due the young
warriors if you, friend of the Scyldings, leave the world sooner than he.
I believe he will repay our children with good if he remembers all which
we two have done for his delight and honor when he was a child.

In the course of her admonition, Wealhtheow offers wise counsel to her lord, but she also
behaves as a peace-maker in several other senses. First, she offers mead to the company,
as well as reminding Hrothgar to give gifts to his guests. Both actions serve to reinforce
the intertwining links of mutual obligation and loyalty. But she then counsels Hrothgar
not to take this gift-giving so far as to offend his own kin by taking Beowulf as a son and
contender for the leadership of the Danes. Instead, she enjoins Hrothgar, in the name of
keeping peace within his own family, to be mindful of his obligation to his kin and leave
the rulership to his heirs; his young adult nephew Hrothulf is the next in line as lord of
the Danes. Wealhtheow's open remark also reminds Hrothulf (who is present) of the
protective loyalty he should show to his cousins, her children, in return for the rewards
and protection she and Hrothgar have given (and continue to give) him.[32]

[32] Elise Louviot has problematized Wealhtheow's direct addresses to Hrothgar and Beowulf in
these moments (*Direct Speech in Beowulf and Other Old English Narrative Poetry* (D. S. Brewer,
2016), pp. 80–1). Enright goes further, arguing that Wealhtheow is a failed peaceweaver and
a destructive force in this speech, trying to sow dissension between Hrothgar and Beowulf,
and, in essence, "picking the wrong horse" (*Lady with a Mead Cup*, p. 42). However, Enright's
interpretation seems based on his notions of peaceweavers as wise women who should always

It is no coincidence that, immediately following this speech, Wealhtheow turns towards her own sons, whose interests she is ultimately attempting to protect with both Hrothgar and Hrothulf. In part, these sons represent her success as a mother (and perhaps a marital peaceweaver), since they provide safe leadership for the future after Hrothgar's and Hrothulf's deaths, as well as ensure her own personal happiness and longevity through offspring. But Beowulf sits with them, perhaps at Hrothgar's wish. Having spoken to the other two powerful lords (Hrothgar and Hrothulf) who might threaten her peace-making efforts, she turns to ensuring Beowulf's loyalty to her sons: *Him wæs ful boren, ond freondlaþu / wordum bewægned, ond wunden gold / estum geeawed, earmhreade twa, / hrægl ond hringas, healsbeaga mæs* "To him was the cup borne, and a friendly invitation offered with words, and wound gold displayed with kindness, two arm-ornaments, a garment and rings, the greatest of necklaces" (1192–5). Given both mead and great gifts, Beowulf becomes honor-bound to be loyal to both Hrothgar and his offspring, and not to fight to displace them. But Wealhtheow is not yet satisfied; she speaks again to Beowulf, reminding him of his obligations as she reminded Hrothgar and Hrothulf:

> Bruc ðisses beages, Beowulf leofa,
> hyse, mid hæle, ond þisses hrægles neot,
> þeo[d]gestreona, ond geþeoh tela,
> cen þec mid cræfte, ond þyssum cnyhtum wes
> lara liðe. Ic þe þæs lean geman.
> Hafast þu gefered þæt ðe feor ond neah
> ealne wideferhþ weras ehtigað,
> efne swa side swa sæ bebugeð,
> windgeard, weallas. Wes þenden þu lifige,
> æþeling, eadig. Ic þe an tela
> sincgestreona. Beo þu suna minum
> dædum gedefe, dreamhealdende.
> Her is æghwylc eorl oþrum getrywe,

choose the strongest hero rather than their own offspring in order to promote the good of the community. There is no indication in the text, however, that the poet or Beowulf expects Wealhtheow or anyone else to exalt the "sacral" nature of the warband to the exclusion of an equally compelling cultural imperative: kin solidarity. Enright's opinion of Wealhtheow is not borne out in the text, at any rate; both the poet and Beowulf praise Wealhtheow openly. Enright's discussion is part of a larger argument over the tenor of Wealhtheow's speeches. For an excellent overview of the opposing viewpoints, see Helen Damico, *Beowulf and the Grendel-Kin* (West Virginia University Press, 2015), p. 207, fn. 4; Elizabeth Cox, "Ides Gnornode/ Geomrode Giddum: Remembering the Role of a Friðusibb in the Retelling of the Fight at Finnsburh in Beowulf," in Elizabeth Cox, Liz Herbert McAvoy, and Roberta Magnani (eds), *Reconsidering Gender, Time and Memory in Medieval Culture* (D. S. Brewer, 2015), pp. 61–78; Helen Conrad O'Briain, "Listen to the Woman: Reading Wealhtheow as Stateswoman," in Helene Scheck and Christine E. Kozikowski (eds), *New Readings on Women and Early Medieval English Literature and Culture Cross-Disciplinary Studies in Honour of Helen Damico* (Amsterdam University Press, 2020), pp. 191–208; and Alison Vowell, "Grendel's Mother and the Women of the Völsung-Nibelung Tradition," *Neophilologus*, 107 (2022), 239–55.

modes milde, mandrihtne hol[d];
þegnas syndon geþwære, þeod eal gearo;
druncne dryhtguman doð swa ic bidde. (1216–31)

> Enjoy this ring, beloved Beowulf, young man, with prosperity, and use this garment, both treasures of the people, and rightly prosper. Prove yourself with courage, and be gracious with advice to these youths. I will remember to reward you for it. You have behaved such that far and near all men will always praise you, even as widely as the sea, home of the winds, extends its walls. As long as you live, prince, be prosperous! I wish you well with each of these precious treasures. Be kindly and joyful in your deeds with my sons! Here is each brave man true to another, kind of heart, faithful to his lord. The thanes are peaceful/obedient, retainers prepared, warriors furnished with drink do as I bid.

While Wealhtheow wishes Beowulf well-deserved success, she also solicits his respect for and protection of her sons, bringing to mind in the process the gifts he has received, which require loyalty even as they express gratitude. Her description of the good faith and honor prevalent at Heorot reminds Beowulf of the similar behavior expected of him: at Wealhtheow's command, Heorot's retainers are peaceful and obedient. They have drunk from the ceremonial cup from her hand; they are therefore honor-bound to her. So is Beowulf. Wealhtheow's role as a powerful peace-keeper within the troop is clear as she binds several groups of men with conflicting loyalties and desires into a unified community through social obligation and ceremonial gifts and speech. As to the effectiveness of Wealhtheow's words, the text mentions no further attempts to put Beowulf in power among the Danes by anyone, even Hrothgar.[33] Moreover, when Beowulf faces a similar situation in his homeland and Hygd offers him the kingdom over her young son, Beowulf shows he has learned the lesson the wise and honorable Wealhtheow taught; he holds the kingdom in stewardship for his young lord and remains loyal to him until the young king's death. Wealhtheow's words have successfully "woven" peace in more than one social group, at least for the time being.

A significant note in this exchange between Wealhtheow and Beowulf is her wording *swa ic bidde* (1231b). That the retainers owe obedience to Wealhtheow clearly shows her in a position of social and economic power. Since the dispensing of treasure, substantial control in dynastic succession, serving of mead, and a high position as counselor to the lord seem to be part of the functions of the communal peace-making *ides*, and these same things also define the power of the lord, the noble woman appears to

[33] In the Exeter Book, *Widsið* mentions that *Hroþwulf ond Hroðgar heoldon lengest / sibbe ætsomne suhtorfædran* "Hrothulf and Hrothgar held peace together longest, uncle and nephew" (ASPR 3, p. 150, lines 45–6). The line may allude to their success in keeping peace between their nation and others, or it may indicate the fame of their long peace with one another. Eventually this peace would end with the destruction of Heorot.

acquire measurable status through her role.[34] The behavior of the strong male characters in *Beowulf* certainly implies a healthy respect for Wealhtheow and her opinions, and her impact on Beowulf is evident when he returns and reports his adventures to his own lord, Hygelac. Beowulf describes her, *Hwilum mæru cwen, / friðusibb folca flet eall geondhwearf, / bædde byre geonge; oft hio beahwriðan / secge (sealde), ær hie to setle geong* "At times, the glorious queen, peace-friend of the people, passed throughout all the hall, incited a young man; often she gave a warrior an armlet, before she went to her seat" (2016b–19). Beowulf's memory obviously stems from his own experiences with Wealhtheow; she incited him several times to do his duty to Hrothgar and then rewarded or promised reward to him for doing so. Beowulf honors these actions by calling Wealhtheow *friðusibb folca*, or "peace-friend of the people," an epithet strikingly close to *freoðuwebbe*. Just as Hygd is, Wealhtheow is associated both with communal peace-making behaviors and a *frið-* compound.

Beowulf's description of her movement among the people as a "peace-friend" also includes a rather intriguing word choice: during her work, she *geondhwearf* "passed among" or "throughout" the group. The verb *geondhwearf* is related both to the verb *hweorfan* "to turn" or "to spin," and to the noun for an extremely common object in the period and subsequent archaeological finds, the *hweorfa* or "spindle whorl." The imagery thus evoked may associate her efforts as a peace-making woman with words related to or suggestive of women's daily textile labors. The description of her movements certainly seems reminiscent of expressions of both old and recent date: we also "weave in and out" of crowds when we are "net"-working.

The praise accorded Wealhtheow's actions within *Beowulf* itself is supportive of Chance's contention that the noble *ides* achieves positive notoriety through communal peace-making. Hygd is praised as a *freoðuwebbe* for her actions; Wealhtheow is praised as a *friðusibb* for the same kinds of actions as she works among her people. Their actions and epithets are significantly and perhaps deliberately paralleled. In other words, Wealhtheow may be fairly considered a "peaceweaver," as well as Hygd.

A handful of the other female characters in the text may be connected with the same types of praiseworthy characteristics. Hrothgar's daughter Freawaru, for example, follows the patterns of Wealhtheow. Beowulf calls attention to her in the recounting of his adventure:

> Hwilum for (d)uguðe dohtor Hroðgares
> eorlum on ende ealuwæge bær,
> þa ic Freaware fletsittende
> nemnan hyrde, þær hio (næ)gled sinc
> hæleðum sealde. Sio gehaten (is),
> geong goldhroden, gladum suna Frodan;
> (h)afað þæs geworden wine Scyldinga,

[34] Helen Damico makes the same point, arguing a historical resemblance between Wealhtheow and Queen Emma (*Beowulf and the Grendel-Kin*, p. 208).

rices hyrde, ond þæt ræd talað,
þæt he mid ðy wife wælfæhða dæl,
sæcca gesette. (2020–9a)

> Sometimes the daughter of Hrothgar bore the ale-pitcher before the
> troop of old retainers, in the region of warriors; then I heard those
> seated in the hall call her Freawaru, where she gave the precious nailed
> cup to the retinue. She is promised, young gold-adorned one, to the
> gracious son of Froda; the lord of the Scyldings, guardian of the nation,
> has brought this about and considers it gain, that he may settle a portion
> of deadly feuds and strife with this woman.

Like Wealhtheow, Freawaru functions in ways that may be considered a communal kind
of peaceweaving, in particular as she passes the mead cup to the retainers, symbolically
weaving unity among the warriors. At the same time, she is promised to Ingeld of the
Heatho-Bards in a clear attempt by Hrothgar to bring peace to the two peoples through
the interweaving of their peoples in kin relationships through her offspring. If Freawaru
is a peaceweaver by association, such a consideration would strengthen the argument
that marital peaceweaving may be strongly associated with *freoðuwebbe*.

The preponderance of evidence in *Beowulf*, however, suggests that less emphasis is
placed on a solely marital style of peace-making than a communal style of peaceweav-
ing. Hygd and Wealhtheow are communal or diplomatic types of peace-makers, as is
Freawaru, but Freawaru alone of the three is married as part of a peace-bringing initia-
tive, at least as far as can be determined within the text. Thryth, unlike Freawaru, is not
married at all, at least when she engages in her improper "peaceweaving"; her marriage
to Offa, *Hem[m]inges mæg* "kinsman of Hemming" (1961b), seems to bring her "bad"
behavior to an end. It would thus be difficult for Thryth's refusal to peaceweave to be
marital under such circumstances, unless the offending retainers were marriage candi-
dates from other social groups. Diplomatic or communal peace-making seems the most
likely definition for the "peaceweaving" *freoðuwebbe* in *Beowulf*, although marital peace-
weaving might just as easily function as one type of communal peace-making. Either way,
the characteristics of the highly-praised female characters of the text help to elucidate the
meaning of Thryth's role as an anti-*freoðuwebbe* and suggest a gender-normative expecta-
tion of peace-keeping within the text.[35]

[35] Alexandra Henessey Olsen makes a similar argument in "Gender Roles," in Robert E. Bjork
and John D. Niles (eds), *A Beowulf Handbook* (University of Nebraska Press, 1997), pp.
311–24. Erin Sebo and Cassandra Schilling, however, argue that Thryth's improper behavior
is based on a demonstration of poor leadership and character, a flaw that invites criticism in
the poem whether a male character like Heremod or a female character like Thryth is under
discussion. In this case, Thryth's expected behavior as a queen, an *ides*, and a "peaceweaver" is
to lead her community for the good of the whole, even when she feels threatened or targeted
by others ("Modthryth and the Problem of Peace-Weavers: Women and Political Power in
Early Medieval England," *English Studies*, 102 (2021), 637–50). If their argument holds true,
then Thryth is still facing the same expectations, but she faces more "equal opportunity"

Either the marital or the communal interpretation of *freoðuwebbe* may explain the word's meaning in the second of its textual appearances, in *Widsið* of the Exeter Book. The poem itself offers no other examples of noble female characters except Ealhhild by which to gauge or define her title as a *fælre freoþuwebban* (6a), and a further complication in understanding her title is that she is relatively unknown beyond the poem itself. As Ealhhild is introduced in the poem, she is met in the company of a male character described simply as *he* (5b).[36] If that "he" means Widsið, then the poet accompanies Ealhhild, presumably on a journey to the court of Eormanric, her future spouse. This seemingly minor detail would indicate a highly symbolic journey was underway, as Kemp Malone states, "In the Heroic Age such a journey was undertaken by a woman for one purpose only: to be married."[37] In this case, Widsið may be giving Ealhhild her title because of the symbolic journey they share as she goes to cement a peace-bringing alliance through blood ties (of corresponding offspring) between distinct groups, in her case between Anglia and the Ostrogoths.

However, the *he* of 5b may also refer to Eormanric, Ealhhild's eventual husband. In this case, the lines indicate instead that the poet (alone on a journey) visits Ealhhild and Eormanric (already married) at the Ostrogothic court.[38] Then, Ealhhild's behavior at the court, not her journey, must explain her title as a "peaceweaver." Widsið's description of Ealhhild at court shows Ealhhild giving the poet a ring and acting as *dryhtcwen duguþe* "noble queen of the retinue" (98a). Widsið offers Ealhhild as *selast wisse / goldhrodene cwen giefe bryttian* "best example I knew of a gold-adorned queen to dispense gifts" (101b–02a). These actions mirror closely the characteristics of communal peace-making described in other texts already discussed. Ealhhild demonstrates her peaceweaving in this sense when, as a "noble queen of the retinue," she ensures loyalty and renown for Eormanric and herself through her generosity to Widsið and others. Very little can be taken for granted about Ealhhild beyond the few lines which describe her in *Widsið*, so ultimately, either standard interpretation (or both) would account well for Ealhhild's designation as a "peaceweaver."

The definition for communal peaceweaver offered by Chance is clearly targeted to the noble *ides* of the warband.[39] Where does such a definition leave the third "peaceweaver," the "male" angel of *Elene*? Other than his celestial gender, to which I will return, the definition may otherwise explain his appellation quite nicely, as the angel who visits

 critique in failing to meet them. She is a leader who is expected to lead less cruelly in her role as a queen and "peaceweaver," just as Heremod should lead less cruelly in his role as a king and lord.

36 See note 5.

37 *Widsið*, ed. Kemp Malone (Methuen, 1936), p. 136. The Heroic Age referenced by Malone is generally considered to be comprised of the fourth to the sixth centuries, the time of the northern heroes depicted in later legends among Germanic and Scandinavian groups, including the English.

38 *Ibid.*, p. 137.

39 Cf. *Woman as Hero*, p. 1.

WEAVING PEACE, WEAVING LIFE

Constantine in *Elene* is indeed a masculine *freoðuwebba* in communal, diplomatic terms, as Sklute observes.[40] With his visits, the angel unites two kings who have previously been at variance, God and a heathen Constantine. His intervention is necessary to end Constantine's unwitting enmity with his best ally and to provide Constantine the needed strength of his ally as he fights his way to peace, making the angel's role much like that of Hygd or Ealhhild as they establish peace within their respective communities, all three in the face of constant threats of war.

PEACEWEAVING

As is evident from discussion to this point, arguments for the usual definitions of *freoðu-webbe/a* "peaceweaver" generally place emphasis on the peace-making process that must somehow be explained by the metaphor. However, any definition proposed for *freoðu-webbe/a* must pass an equally important test threshold: it must also take into account the *second* half of the compound. Whatever the women and angel are doing, it is envisioned as weaving; therefore, any definition proposed to explain the metaphorical compound must likewise make sense of this comparison. Marital "peaceweaving" and communal "peaceweaving" definitions both pass such a test: either one makes good sense of the imagery of weaving. The image of interwoven threads would be appropriate to the work of a marital peaceweaver who makes peace and creates stability through interwoven ties between groups within the blood and sinews of her offspring, themselves a web or tissue of life.[41] Interweaving is also an apt description of the intermediary function of those who weave in and out within groups of people, making a communal bond on one side, travelling to another and making a linked social bond there, and so forth, creating a stable web of peace among potentially competing parties. Such bonds are physically and metaphorically woven by the actions of the "peaceweaver," be it the idealized, noble woman as described in Old English poetry, or the angel of *Elene*.

A weaving perspective must also be weighed in considering the angel of *Elene* as a "peaceweaver." All of the other characters associated with "peaceweaver" within the Old English poetic tradition are female, and as discussed in Chapter 1, female gender is connected almost exclusively with spinning and weaving in the archaeological, etymological, iconographic, and textual traditions of the early medieval English peoples (and their neighbors and precursors), from prehistory to the end of the early Middle Ages. Weaving metaphors are thus highly likely to have originated as metaphors associated with female roles and functions.[42] The evidence of these cultural associations cannot be overstated

[40] *"Freoðuwebbe* in Old English Poetry," p. 208.

[41] See related images from Latin texts which imagine flesh and blood as a web of life, as discussed in the "Parallels" section below, as well as "creation-weaving" texts in Old English and Latin in Chapter 4.

[42] Here, I disagree with Megan Cavell, who argues that weaving's associations in textile metaphors such as peaceweaving are defined as likely by status and by idealized "heroic" behavior as gender ("Formulaic *Friþuwebban*: Reexamining Peace-Weaving in the Light of Old English Poetics," *The Journal of English and Germanic Philology*, 114.3 (2015), 355–72,

and is a strong indication that the term, as applied to the angel, has been usurped or appropriated from the feminine domain to the angelic. John Sklute points out just such a possibility, positing that the author of *Elene* may be refashioning a secular metaphor for a spiritual context.[43] It may be no coincidence then that, although Elene is herself depicted as a devout peace-bringer for teaching the penitent Jews she converts to keep *lufan dryhtnes / 7 sybbe swa same sylfra betweonum* "the love of the Lord and peace just the same among themselves" (1205b–06), it is the angel who is designated the "peaceweaver" for bringing Constantine to God.

Jill Fitzgerald explores this argument, examining instances of imagery of the *angelus pacis* "the angel of peace," initially a biblical and patristic idea that grew through the Middle Ages to mean a protective, guardian angel that led the soul to God at death. Fitzgerald argues that the idea appears in earlier Old English poetry in references to "faithful" peace-bringing angels (in wording similar to the "faithful" "peaceweaver" Ealhhild), and by the end of the pre-Conquest period in medieval English benedictionals and glosses in the guardian sense.[44] Fitzgerald posits that Cynewulf, in his use of an angelic, male-gendered "peaceweaver," provides an example of an intentional refashioning of a Germanic metaphor to suit a Christian concept, showing Cynewulf "boldly rewriting poetic tradition, first by uniquely incorporating a male peace-weaver into his poem and then by aligning the figure with the Christian-Latin tradition."[45]

Such a transferral of credit for the peace-making (and "peaceweaving") role is consistent with Stacy Klein's findings in her critical examination of Bede's *Historia ecclesiastica*; she demonstrates that Bede appears quite deliberately to minimize the powerful roles of

and *Weaving and Binding Bodies*, pp. 46, 286). While I respect her argument that caution is necessary to avoid over-extrapolation in interpreting weaving metaphors, as indicated in Chapter 1 and the wide array of evidence cited throughout this volume, the larger context of poetry, prose, iconography, and archaeology renders explicit a normative connection between textile production, including weaving, and women and female gender, without respect to class or status. Her argument rests largely on the example of wordweaving, an Old English weaving metaphor which I will discuss in Chapter 5. As I indicate there, wordweaving is more likely a borrowing of a textile metaphor from the early Latin tradition, where it is associated as often with male writers as female subjects. It is not a metaphor, however, which is ever applied directly to female characters of Old English poetry. "Peaceweaver" is, as are the majority of the metaphors discussed in this work. I consider "wordweaving" a separate but related tradition to the rest of the weaving metaphors of the Old English corpus. In contexts in which women or female characters are present, as Roberta Gilchrist attests, "The association between women and textiles may have originated with the female contribution in domestic production, but extended to construct femininity and convey social and religious roles" (*Gender Archaeology*, pp. 51–2).

43 "*Freoðuwebbe*," pp. 205–6.

44 Peter Baker similarly identifies three other instances of *friðu* compounds aside from *freoðuwebbe/a* and *friðusibb* which are applied to angels, namely, *freoðuscealc/as* "angel" in *Genesis A*, lines 2303, 2498, and *freoðuweard* in *Guthlac A*, line 173 (*Honour*, p. 106).

45 Jill Fitzgerald, "*Angelus Pacis*: A Liturgical Model for the 'fæle friðowebba' in Cynewulf's *Elene*," *Medium Ævum*, 83 (2014), 189–209, at pp. 191, 194–9, and 202.

early queens in promoting Christian conversion (and thus acting as "spiritual peaceweavers") and to refashion the history of the early church by giving credit to the evangelizing power of the bishops who attended the brides, instead.[46] Such a literary transference is undoubtedly a distortion; could we really suppose those first ecclesiastical figures held more sway in the acceptance of Christianity than the influential, royal Frankish brides, who in some cases, came with agreements that churches be built, that they be allowed to remain Christian, and that they be able to offer welcome to those very ecclesiastical leaders? In his discussion of political peace-making subsequent to that time, Ryan Lavelle argues that "in the post-Conversion 'heptarchy' of the seventh and eighth centuries, the most obvious intermediary and peace-maker was the Church,"[47] a role it had obviously not played in the earlier history and the heroic cultures which Hygd and Wealhtheow represent. Perhaps, then, as the church and its authorities took to themselves the role (or the credit) of peace-maker, they may also have borrowed and refashioned metaphors to fit that shift to male influence. Ultimately, it is not possible to determine definitively the implications of the male "peaceweaving" angel in *Elene*, but it is undeniable that the cultural connections between women and weaving and other textile tasks were indeed very strong and cannot be discounted.

Although it has never been noted in any discussion of which I am aware, there is a fourth instance of the metaphor "peaceweaving" by an early medieval English author, Alcuin of York (*c.*732–804), and I propose that it be taken into account here. The instance comes not in Old English, but in an Anglo-Latin letter Alcuin sent to his former student and fellow servant at Charlemagne's court, the Irish scholar Joseph Scottus. In the letter, Alcuin attempts to comfort Joseph, who has been struggling with his health, and then adds that he himself is in need of comfort and prayers:

> Nostri quoque memor sedulas pro nobis fundere preces non cessa, quatenus divina nobis provideat clementia perpetuae conversationem prosperitatis. Adhuc dubio stamine pacis sub tegmine causa texitur, et dum plenum perficitur vestimentum, mox ad induendum vestraedirigetur fraternitati.[48]

> Mindful of us also, do not delay to pour out earnest prayers for us, until divine mercy provides conversation of uninterrupted success to us. As yet, with a wavering thread in the web, the cause of peace is woven, and as the full vestment is completed, it will soon be arranged for clothing your brotherhood.[49]

[46] *Ruling Women*, pp. 17–52.

[47] "Towards a Political Contextualization of Peacemaking and Peace Agreements in Anglo-Saxon England," in *Peace and Negotiation*, p. 45.

[48] Alcuin (Latin), *Epistolae Karolini Aevi, Tomus II*, ed. Ernest Dummler, MGH, *Epistolae*, 4 (Weidmann, 1925), letter 14, p. 40, lines 19–21.

[49] Translation mine, although I offer sincere thanks to Dr. Thomas Henderson for his assistance in discussing and weighing the intricacies of the Latin in this passage.

The metaphorical imagery of "weaving the cause of peace" with a "wavering thread in the web" may well relate to a specific situation that was causing Alcuin significant distress. The letter is dated between 790 and 793, a time when Alcuin had returned to visit his homeland, and Joseph was filling Alcuin's position for the court of Charlemagne. A dispute had arisen between Offa of Mercia and Charlemagne, two very powerful kings, over a set of proposed inter-dynastic marriages. Matters had escalated to the point that trade had been disrupted between their peoples. Douglas Dales cites a letter from Alcuin to another Irish friend (and possibly, fellow student at York), Colcu, which indicates that Alcuin was

> apprehensive that he and some others of his English friends might be drawn in as peace-makers. Perhaps they were, for in another letter written later in that year ... Alcuin wrote to his friend, Adalhard ... explaining his delay, reporting a settlement between Charlemagne and Offa, and encouraging the abbot to act as a peace-maker if necessary, too.[50]

In other words, Alcuin was anxious about what he perceived as his expected responsibility to foster peace between two parties attempting to bring about inter-dynastic marriages, and he wrote about this anxiety to Joseph and others.

It is only in his letter to Joseph that Alcuin uses "weaving peace" to describe the way he envisions the process moving forward, resulting in a "full vestment" which will ultimately "clothe" the "brotherhood." What might have inspired such a "peaceweaving" metaphor for Alcuin in his correspondence with Joseph? Alcuin's imagery of the wavering thread in the loom and its eventual connection to a vestment certainly suggests a firsthand awareness of the textile process; like Aldhelm, Alcuin "gets it right" in what he calls the constituent elements and how he describes the process of weaving, something he very likely saw with his own eyes in early medieval English Mercia or Northumbria, from the warp-weighted looms present in religious and lay environments, to the beautiful and glowing vestments of the church that represented the end of that process.[51] He found the imagery of the metaphor resonant for the circumstances. His imagery also seems rather reflective of how peaceweaving metaphors, as herein discussed, function in the Old English corpus. First, the larger peace-making efforts he had reluctantly joined were increasingly rocky attempts ("a wavering thread"?) at diplomatic interconnections of two kingdoms through dynastic marriages and trade ("weaving of peace"?). His own efforts were unattended by angelic visitants, but like the angel in *Elene*, he felt himself

[50] *Alcuin: His Life and Legacy* (James Clarke, 2012), p. 64.

[51] It is easy to imagine what these vestments might have looked like, given the roughly contemporary textiles still extant which were fashioned (or in some cases, re-purposed) for ecclesiastical use; a lustrous example is the vestments deposited with St Cuthbert at Durham (see discussion and an image in Chapter 1). Vestments appear to have been sent with some frequency as gifts from female, early medieval English ecclesiasts to their male counterparts on the Continent in the eighth and ninth centuries, as letters of thanks on the subject from Boniface to abbess Eadburg and his friend Bugga indicate.

to be an agent of God being asked to help with preserving a fragile ("wavering"?) peace between disputing kings. The correlations of both marriage and type of intermediary role are striking. Whatever connections he might have been envisioning metaphorically, he thought of a "wavering thread in the warp" as descriptive of the attempts at making peace; he used "peaceweaving" as the way to describe the fraught situation. He hopes for a happy conclusion for the metaphorical weaving of any of the parties he might mean: the royal families trying to create interrelated peace through dynastic and diplomatic relationships of kinship and trade or the diplomatic efforts of himself and others trying to help those efforts avoid failure. The hoped-for consequence is a harmonious vestment of peace for the "brotherhood." This brotherhood might represent any number of groups: Alcuin's brethren of the cloth, one or both courts, or the larger brotherhood of Christ; Alcuin had a deep personal stake in all of these groups.

Alcuin's use of such a metaphor is the earliest attestation we can firmly identify on a textual basis of a metaphor of "peaceweaving" among early medieval English writers. Could his Anglo-Latin metaphor have inspired all of the later Old English attestations already discussed? I will state categorically that I believe the answer to be "no." Scholars of the early medieval English period all know that textual survival is a fluke that problematizes the genealogy of ideas in early medieval England in ways that should prove a cautionary tale for us all. Alcuin also does not describe himself or anyone else as a "peace-weaver" in his Anglo-Latin text, but the Old English texts all do; Alcuin does, however, describe efforts at peace-making as "peaceweaving." The Old English "peaceweaving" texts in discussion may arguably have roots as early as Alcuin's, as well. *Widsið*, though currently found solely in late tenth-century form in the Exeter Book, has been posited as being (or descending from) one of the earliest poems in Old English, with its focus, allusions, and reader assumptions placed squarely in the Heroic Age. It has also been argued to be a later text.[52] Similarly, to date, *Beowulf* is found solely in a manuscript context that spans the late tenth and early eleventh centuries, but contains archaic linguistic forms from earlier dialects which speak of earlier iterations and a worldview only slightly less removed from the Heroic Age than *Widsið*. As a consequence, scholars argue extensively over even the smallest details in the current form of the poem but cannot achieve

[52] For most of the history of scholarship on the poem, it has been considered very early; scholarship in the late twentieth century has questioned those claims. More recent discussion follows the same trend, with some scholars placing the poem earlier on the timeline based on linguistic and historical grounds, and others problematizing that evidence and suggesting a later date. Cf. Leonard Neidorf, "The Dating of *Widsith* and the Study of Germanic Antiquity," *Neophilologus*, 97 (2013), 165–83, but Erik Weiskott, "The Meter of *Widsith* and the Distant Past," *Neophilologus*, 99 (2015), 143–50. John D. Niles examines their arguments alongside his own, ultimately positing that, whatever its date of origin, *Widsið* is "set in the voice of an imagined bard of the Heroic Age of the Germanic peoples" (*God's Exiles and English Verse: On the Exeter Anthology of Old English Poetry* (Exeter University Press, 2019), p. 119). My own thought in weighing the evidence is that the poem has its ethos in the Heroic Age (early), but its (current) textual and rhetorical being in a later age.

consensus on the earliest date of its parent text.[53] The poet behind the "peaceweaver" of *Elene*, Cynewulf, writes removed from the Heroic Age in a clearly post-conversion era, but his work is dated anywhere from Alcuin's own lifetime to the early tenth century.[54] Source study is not safe ground for Alcuin's version of the metaphor.

What may prove more interesting (and perhaps safer) ground is the possibility of a nexus of ideas. Three of the four texts in which "peaceweaver" or "peaceweaving" occurs as a metaphor are associated with the northern regions of early medieval England. Alcuin is thought to have been from either Northumbria or Mercia. *Beowulf*, as already indicated, contains a range of dialectal variants, some of which include archaic Mercian word forms that may represent survivals from a source text. Cynewulf is thought to have been either Northumbrian or Mercian. All of the four texts have possible dates of origin in the eighth century or shortly thereafter (though these datings are forever embattled). These potential overlaps are worth contemplating. Peaceweaver/peaceweaving as a metaphor also occurs in slightly differing clusters, depending on how Alcuin's Anglo-Latin version of the metaphor is interpreted. Powerful dynastic and diplomatic efforts at peace-making involving women and marriage describe the "peaceweavers" of *Widsið* and *Beowulf*, and possibly Alcuin's world. Divinely inspired diplomatic efforts at peace-making involving holy agents describe the peaceweaving of the angel in *Elene*, and possibly Alcuin himself.

As we attempt to understand what "weaving peace" and "peaceweavers" evoked in the minds of early medieval English audiences, we might consider that, although Alcuin spoke of this peace-making with Adalhard, Colcu, and Joseph, he reserved his peaceweaving imagery for a letter to Joseph, his Irish friend and former student at York. He must have assumed that Joseph would have known what he meant, as he provides no further explanation for the metaphor. That such a metaphor was eventually well-known among the early medieval English peoples (and perhaps their students) is clear. As already noted, "peaceweaver" appears in three of the four major surviving volumes of Old English poetry, and in each case, the metaphor may have early roots, with two of those texts situating their characters squarely in the Heroic Age. Alcuin is very likely to have been aware of the literary traditions of his own people, and I would suggest that it

[53] The dating of the poem has led to spectacular fireworks among scholars for decades, with relatively recent scholarly opinion and evidence arguing for dates for the "original" poem ranging anywhere from the eighth to the eleventh century. As with other poems under discussion, given the lack of scholarly consensus, an earlier date of original composition cannot be ruled out any more than a later one. Research on early word forms in Anglian, probably from the area of Mercia, comes from a variety of sources, including Joseph F. Tuso, "Beowulf's Dialectal Vocabulary and the Kiernan Theory," *South Central Review*, 2.2 (1985), 1–9; Sam Newton, *Origins of Beowulf and the Pre-Viking Kingdom of East Anglia* (D. S. Brewer, 1993); Leonard Neidorf (ed.), *The Dating of* Beowulf: *A Reassessment* (D. S. Brewer, 2014); and many others.

[54] See an overview of the discussion on the dating of Cynewulf's work in Niles, *God's Exiles* (p. 83). Throughout this volume, I refer to the poet of *Elene* as "Cynewulf" in keeping with long-standing scholarly tradition. I would note, however, that not all scholars accept Cynewulf's authorship of the entire work. For an overview of the controversy, see Jason R. Puskar, "*Hwa þas fitte fegde?* Questioning Cynewulf's Claim of Authorship," *English Studies*, 92 (2011), 1–19.

is possible that he could have been inspired by metaphors of peaceweavers and peace-weaving in the only other corpus outside of his Anglo-Latin letter where such a metaphor appears in the literary cultures he knew: Old English literature. I will discuss the unique nature of "peaceweaver/peaceweaving" as an early medieval English metaphor in later sections, but I will remark here that it does seem far too much of a coincidence that the only direct example of "peaceweaving" to be found outside of Old English in the early medieval Latin corpus occurs in the work of an early medieval English author. Alcuin's metaphor in Anglo-Latin (like the instances in Old English) may well belong to a tradition of "peaceweavers" in a metaphor unique to his home culture.

PEACEWEAVING? PEACE-MAKING WEAVERS
IN BIBLICAL AND HISTORICAL TRADITIONS

Jane Chance has argued that a broader group of biblical and historical women within the literary tradition of the pre-Conquest English should be considered peaceweavers, or at the very least, viewed as part of the peaceweaving tradition. For example, she nominates Eve as an example of a (failed) peaceweaver in the Fall in the poetic *Genesis B*.[55] According to this interpretation, Eve's reason for convincing Adam to partake of the forbidden fruit is that Eve wishes to act as a communal peaceweaver; in the *Genesis B* account of the Fall, the Tempter tells Eve that God will be angry with Adam because he refused to partake of the fruit at his lord's command.[56] The Tempter then cajoles, *Gehyge on þinum breostum þæt þu inc bam twam meaht / wite bewarigan, swa ic þe wisie* "Consider in your heart that you might be able to ward off punishment from you both, as I will show you" (562–3). Because Eve considers the Tempter a loyal retainer to God and fears the "enmity" arising between Adam and God by Adam's refusal to eat the apple at the Tempter's command, the *idesa scenost* "the most radiant of noble women" (626a) persuades Adam to abandon the *laðlic strið* "hateful strife" (663b). The poet adds, *Heo dyde hit þeah þurh holdne hyge, nyste þæt þær hearma swa fela, / fyrenearfeða, fylgean sceolde / monna cynne* "She did it, however, because of a loyal heart; she did not know that from there so many harms, sinful torments, must follow for mankind" (708–10a). The Eve of *Genesis B* seems rather unconventional (certainly surprisingly sympathetic) for the medieval literary tradition of the Fall, but perhaps the difference arises because the early medieval English poet designs an Eve with motives and behavior conventional to his own society in her role as *ides*, a noble woman interested in bringing about stability, peace, and reconciliation between her household and that of their lord. While her actions in *Genesis B* can be described as communal or diplomatic peaceweaving, however, Eve is given no literal connection to weaving in extant Old English literature. Chance cites a patristic source which comments on Eve's role as a textile producer, the Greek text of Saint Epiphanius, who "glosses the ancient Greek rendering of Job 38:36

55 *Woman as Hero*, pp. 65–79.

56 *Genesis B*, from *The Junius Manuscript*, ed. George Philip Krapp, ASPR 1 (Columbia University Press, 1931), pp. 9–28, at lines 551b–56a.

… Who hath given to woman wisdom, or knowledge of weaving, by contrasting the clothing woven by Eve with the garment of immortality created out of the Lamb by the Virgin Mary."[57] However, we are unable to determine if this source was known to the pre-Conquest English.

Another work which links the attempts of a biblical woman and the bringing of peace to a community is a translation of the book of Esther by Ælfric. The text is found solely in a transcription by William L'Isle (late sixteenth/early seventeenth century).[58] In Ælfric's version of the book, Esther is praised overtly for a number of actions, not least of which is the saving of her people. Ælfric states, *hi on friþe wunedon / þurh þære cwene þingunge* "they dwelt in peace through the intercession of the queen." Esther's actions as one who brings peace between her people and Ahasuerus through both her marriage and her subsequent dealings with the king (involving wise counsel and feasting, etc.) fit the model of either marital or communal peaceweaving, a potentially significant coincidence given how often Esther is evoked as a medieval model "for queens," one "deeply embedded in early medieval thinking about queenship."[59] If she did indeed serve as a model, this Esther would fit in nicely with the other "good" queens of *Beowulf* and other Old English and Anglo-Latin texts, both in her mediation and diplomatic creation of peace among and between her people and their lord, and perhaps not coincidentally, in her role in inciting the slaughter of her enemies in order to achieve that peace and stability. Like Eve, however, she is also not identified as a weaver in either the Old English or the Anglo-Latin literary corpus.

Chance argues that Mary, the embodiment to medieval Christians of all positive roles available to women, could be another example of a peaceweaver in the early medieval English corpus. Mary's role as a *mediatrix* and *conciliatrix* who reconciles sinning humanity with their lord is well-attested in the period, and certainly must have suggested a connection between Mary and peace-making and reconciliation to the early medieval English people.[60] Unlike the other biblical examples cited in Chance's argument, Mary is also linked closely with literal textile production. In "Cloth-Making and the Virgin Mary in Anglo-Saxon Literature and Art," Elizabeth Coatsworth examines the artistic and textual depiction of Mary as idealized textile producer, and she identifies at least two Northumbrian images of the Virgin spinning.[61] As discussed in the previous chapter, a pseudo-Matthew text in Old English similarly depicts Mary as the finest of textile

57 *Woman as Hero*, p. 78.

58 I am indebted for this reference and the subsequent quotations of Ælfric's original to Klein, *Ruling Women*, pp. 166–8; the transcription itself can be found in Oxford, Bodleian Library, MS Laud Misc. 381, fols 140v–48r. With Klein, Timothy Graham, and other scholars, I assume the text to be accurate in its copy of Ælfric's original.

59 Baker, *Honour*, p. 135.

60 See, for example, Assmann, *Angelsächsische Homilien*, no. 10, lines 699–705.

61 "Cloth-Making and the Virgin Mary in Anglo-Saxon Literature and Art," in Gale R. Owen-Crocker and Timothy Graham (eds), *Medieval Art: Recent Perspectives: A Memorial Tribute to C.R. Dodwell* (Manchester University Press, 1998), pp. 15–16.

workers during her sojourn at the temple. Chance cites one late classical Greek text by St Proclus of Constantinople and its later Latin translation that connect Mary with metaphorical weaving, as well, likening the Incarnation to a metaphorical weaving of the flesh of the Word in the loom of her womb:

> The loom-worker was the Holy Spirit; the wool-worker the overshadowing power from on high. The wool was the ancient fleece of Adam; the interlocking thread the spotless flesh of the Virgin. The weaver's shuttle was propelled by the immeasurable grace of him who wore the robe; the artisan was the Word who entered in through her sense of hearing.[62]

The Greek text is unlikely to have been available to the pre-Conquest English as an inspiration, but it is possible that the later Latin homily may have been; the image is thus an interesting parallel, though not identifiable as a potential source. In the final analysis, the evidence for an early medieval English connection between biblical women and peace-*making* or redemptive reconciliation is thus quite convincing; the connection between them and "peaceweaver/peaceweaving" as a metaphor is likewise possible, but not currently attested.

Similarly, the evidence for an early medieval English connection between contemporary, historical queens and peace-*making* is very strong, and in this case, some are described as weavers. In their careful studies of early medieval English queens across the period, Stephanie Wragg and Matthew Firth identify consistent patterns. Wragg observes that from the seventh century onward, "By their very nature, queens were mediatory figures" who were "regularly called upon to give advice, settle disputes, promote family interests or proteges, or safeguard dynastic interests."[63] Her study includes an extensive list of examples of early medieval English queens (AD 650–850) who bound together rival groups or mediated conversion to Christianity,[64] confirming Klein's arguments discussed above. In analyzing the power available to these early queens, Wragg states,

> Either by using her influence to persuade the king, whether to donate to a particular monastic foundation or to confirm a gift to a loyal thane, or by giving her own gifts to cultivate loyalty, the queen commanded considerable social and political power, a key role in keeping the balance in kingdoms ... Her role as an almsgiver reflects her access to monetary resources, and reinforces the view of the queen as a major financial power in this era.[65]

[62] In *Proclus of Constantinople and the Cult of Virginity in Late Antiquity: Homilies 1–5, Texts and Translations*, trans. Nicholas Constans (Brill, 2003). I am indebted to Chance for the allusion (*Woman as Hero*, pp. 78–9) and to Baker for an updated translation of the passage and for awareness of its relationship to the later Latin material (*Honour*, p. 137, fn. 72).

[63] *Early English Queens, 650–850* (Routledge, 2022), pp. 4, 6.

[64] Ibid., pp. 4–5, 47–8, 164–5, and 172–205.

[65] Ibid., pp. 11, 14.

Focusing on queens from AD 850–1000, Matthew Firth observes similar patterns and likewise argues that the considerable sources of a queen's intercessory power came through relationships of influence with the royal family, religious leaders, and houses, and through the lands and goods given her.[66] Indeed, he indicates that "The potential to mediate between the royal court and those who were unable to access it was a defining element of pre-Norman queenship and central to its development as an office over the years 850–1000."[67] In ways that look very consistent with the earlier English queens (and Old English poetry),

> an astute queen could benefit from her proximity to the king. She would have been courted by secular and ecclesiastical elites alike, beseeching her to mediate with the king or to intercede on their behalf. Thus, in establishing a network of political support at court, a queen did not seek out allies; rather, potential allies sought her out. The decision the queen faced was whose voice to amplify in the king's ear. Her advocacy would create alliances with, and deepen connections to, the beneficiaries; any decision to deny such mediation had the potential to create political opposition. Meanwhile, the king's assessment of the outcomes of the queen's activities would decide whether she continued to be empowered to exercise royal authority. As such, a queen's ability to effectively balance the competing demands of the personalities at court was central to the success, or at least the prominence, of her queenship.[68]

Historical queens were also linked explicitly to textiles, particularly through donation records, but also in some cases, through histories. For example, Edith, wife of King Edward, appears in the eleventh-century *Vita Ædwardi Regis*. Although the *Vita* is ostensibly written about Edward, the narrator dedicates space to praise of Edith, who commissioned the work, depicting her as an *exemplo uirtutis* "example of virtue" and characterizing her in ways strikingly like Wealhtheow and other similar female characters.[69] As discussed previously, this Edith is often cited as a prototypical example of marriage bringing peace to a divided realm, or marital peaceweaving, and indeed, in the *Vita Ædwardi*, she is characterized as a societal peace-maker. She is also characterized as a consummate textile producer. The *Vita* lauds Edith in particular for acting as a wise counselor to her husband, urging him to be generous, while she herself gives bountiful gifts with similar purpose: *honestate hanc intendebat largitionem, ut ad regis quoque plurimum spectaret honorem*[70] "for reputation she extended this generosity, and she bore in mind, too, the great honor of the king." The narrator highlights the effect of her good counsel as well as the cheer she imparts to her lord and his troop, stating that *Irruentibus*

[66] *Early English Queens, 850–1000: Potestas Reginae* (Routledge, 2024), p. 177.

[67] *Ibid.*, p. 184.

[68] *Ibid.*, p. 185.

[69] *Life of King Edward*, Barlow, p. 64. Barlow draws some of the material about Edith from the work of Richard of Cirencester, believing it is the missing part of the *Vita Ædwardi*. Translations for all quotations from the *Vita* are mine.

[70] *Ibid.*

enim ante id aliquibus aduersis, ipsa presidio adesse solebat, que et aduersa cuncta efficaci con-
silio depelleret, et regem eiusque frequentelam serenaret[71] "before this, when calamities were
rushing in, she was accustomed to be at hand for defense, and both drove out all adver-
saries with powerful counsel, and cheered up (lit. 'made serene') the king and his reti-
nue." The narrator praises her for both her peace-making and -keeping abilities, claiming
that *Cuius consilio pax continet undique regnum, / atque cauet populis, uiolent ne federa*
pacis[72] "Through her counsel, peace binds the royalty on all sides and guards the people
(so that) they do not dishonor agreements of peace." Within the *Vita*, he also alludes
to Edith's well-known proficiency as a textile producer, stating that thanks to her own
excellence in producing embroidered work and her selection of tasteful work by others,
the king was arrayed so that *uix ipse Salomon in omni gloria sua ita indutus putari posset*[73]
"scarcely could Solomon himself in all his glory be considered so dressed." It is fitting
that an embroidered image of Edith from the Bayeux Tapestry (mourning her husband's
death), the only extant embroidered image of an early medieval English woman we know
as an embroiderer, graces the front cover of this volume.

The narrator attributes metaphorical weaving to Edith as he describes Edith's haste in
completing buildings for the church, stating *Nulla enim mora huic perficiendo innectitur*[74]
"For no delay is devised (interwoven) [by her] in completing this [work]." This state-
ment is high praise, considering it links her behavior to the epic wording of the *Aeneid*.
The phrase is copied from Virgil's work in a variety of contexts, classical, late classical,
and medieval, from Statius to the *Vita*, but originates in a scene in the *Aeneid* in which,
in order to detain Aeneas and his men, Dido's sister advises that she *causasque innecte*
morandi (4.51) "devise (interweave) reasons for delay."[75] Edith is thus unlike Dido in
allowing no delay for a good cause. What is equally striking about this classical allusion
is that the author of the life, most likely Goscelin or another Flemish monk, may have
thought it *à propos* to associate such metaphorical "interweaving" or "contriving" of a
female character with Edith.

While no statement by the narrator of Edward's life explicitly connects Edith's weav-
ing and what seems like both marital and societal peaceweaving, it is clear that Edith's
portrait includes and links certain elements of the character of an idealized early medieval

71 *Ibid.*, p. 80.

72 *Ibid.*, p. 26.

73 *Ibid.*, p. 24. The allusion, of course, is to Matthew 6:29 or Luke 12:27. Later chroniclers such as
Osbert of Clare and Richard of Cirencester commented that Edith was reputed to have been
altera Minerua "another Minerva" (both cited at note 51 in *Life of King Edward*, Barlow, p. 23).

74 *Ibid.*, p. 72.

75 All references to the *Aeneid* are cited from Virgil, *The Aeneid of Virgil, Books I–VI* and *The Aeneid*
of Virgil, Books VII–XII, both edited by T. E. Page (Macmillan, 1964). Each citation follows
the format "book, line." Translations are mine. In this instance and a few others, *nectere* is the
verb form that may mean "to weave/to interweave" rather than *texere*, an interesting choice
because *nectere* in its primary sense means "to join" or "to bind." The layers of meaning in such
an instance must have been evocative. Dido would thus "bind" as she devises or "interweaves"
a cause for delay.

English *ides*: a fine counselor, a bounteous gift-giver, a bringer of cheer, a peace-maker, and an exceptional textile producer on both literal and metaphorical levels. Edith's case likewise suggests one way a peaceweaving metaphor might be born into poetic text, resulting quite naturally from the association between the high-profile, high-status textiles and the high-profile, socially binding activities expected of the idealized noble woman of early medieval English literature. It is only logical that such roles would be metaphorically linked in text, when beyond being resonant and apt comparisons, they were also linked in person.[76]

"FAILED" PEACE-MAKING

As many have noted and argued, a social role grounded in peace-making also has limitations. In a warrior culture, peace-making, whether communal (internal) or marital (external), faces strong, counter-opposing social forces. As Tacitus points out in his observations on larger Germanic culture centuries before,

> magnumque comitatum non nisi vi belloque tueare: exigunt enim principis sui liberalitate illum bellatorem equum, illam cruentam victricemque frameam; nam epulae et quamquam incompti, largi tamen apparatus pro stipendio cedunt. materia munificentiae per bella et raptus.

> you cannot keep up a great retinue except by war and violence, for it is from their leader's bounty that they demand that glorious war-horse, and that murderous and masterful spear: banquetings and a certain rude but lavish outfit are equivalent to salary. The material for this freehandedness comes through war and foray.[77]

[76] What makes this potential connection of Edith and her elegant literary forebears even more interesting is the idea that Edith was also inspired by her mother-in-law Emma and the *Encomium Reginae* (Damico, *Beowulf and the Grendel-Kin*, p. 297; Karkov, *The Art of Anglo-Saxon England*, p. 271). In her monograph analyzing *Beowulf* as social commentary on the eleventh century, Helen Damico makes a compelling case that Emma meets many of the same criteria here discussed. Pauline Stafford identifies Emma as a peace-pledge between the Normans and the English in the face of Viking depredations (*Queen Emma and Queen Edith*, p. 23), and Damico considers her so close a parallel to Wealhtheow in class and behaviors (including those often argued as characteristic of peaceweaving) to be considered an inspiration for the character (*Beowulf and the Grenkel-Kin*, pp. 208, 236–57). The argument is plausible, although I would observe that many a virtuous early medieval English noble woman, queen or abbess, as encountered in hagiographical or historiographical narratives, demonstrates similar characteristics, because we are looking at a literary type emulated by such women and their biographers, a type connected to the characteristics identified by Chance with the "peaceweaver" metaphor. For an insightful set of readings of a number of historical interchanges that included early medieval English women in this light, see Laura Michele Diener, "Sealed with a Stitch: Embroidery and Gift-Giving among Anglo-Saxon Women," *Medieval Prosopography*, 29 (2014), 1–22, at pp. 8–15.

[77] Tacitus, *Tacitus*, Hutton and Warmington, pp. 152–3.

In discussing the more closely-related milieu out of which *Beowulf* grows, Gillian Overing observes, "Peace-weavers are assigned the role of creating peace, in fact, embodying peace, in a culture where war and death are privileged values."[78]

Beowulf himself introduces what he perceives as the limitations to marital peace-making when he discusses Freawaru's marriage to the son of Froda: *Oft seldan hwær / æfter leodhryre lytle hwile / bongar bugeð, þeah seo bryd duge* "Very rarely does the hateful spear bow down anywhere, a little while after the death of a ruler, though the bride be worthy!" (2029–31). Beowulf reminds his audience that when Freawaru brings her Danish retainers to the marriage feast, the Heatho-Bard retainers (their former enemies) will remember fighting them, or even see some battle-prize her retainers' ancestors had taken from one of their dead kinsmen. Violence under the code of vengeance will be the likely result. Or, perhaps after a time, when the lord's *wiflufan / æfter cearwælmum colran weorðað* "wife-love becomes colder after welling sorrows" (2065b–66), then the alliance bought may lose value to the lord, and hostilities may begin anew. Beowulf proves prophetic concerning the ultimate failure of Freawaru's peace-making attempts.

A parallel episode, one which many have argued is a similar failure of marital peace-weaving, comes in the story of Hildeburh, the Danish king's daughter married to the king of the Jutes, Finn, in an attempt to create ties of peace between their two peoples. The *Beowulf* poet's *scop* highlights how, after she enters Jutland to begin her role as mother, cup-bearer, and gift-giver, Hildeburh sees old enmities arise and her husband's kinsmen (including her son) and her own kinsmen slaughter each other. The Hildeburh episode emphasizes her role in the conflict as a relatively helpless bystander,

> ... unsynnum wearð
> beloren leofum æt þam lindplegan
> bearnum ond broðrum; ...
> ... þæt wæs geomuru ides!
> Nalles holinga Hoces dohtor
> meotodsceaft bemearn, syþðan morgen com,
> ða heo under swegle geseon meahte
> morþorbealo maga, þær he[o] ær mæste heold
> worolde wynne. (1072b–80a)

> Guiltlessly she was deprived of beloved ones at that shield-play, of son and brother ... That was a mournful woman! Not without reason did the daughter of Hoc bemoan the decree of fate after morning came, when she was able to see under the heavens the hateful murder of kinsmen, where she before had the greatest joy in the world.

Hildeburh hardly seems to have been present or aware of the dramatic destruction of her community until it was too late. In the end, she is able only to mourn and to command that her brother's and son's corpses be burned side by side. Even the word

[78] *Language, Sign, and Gender*, p. 82.

choice and passive syntax *unsynnum wearð / beloren* emphasize her innocence and help-lessness. Later, when the feud breaks out again, the text only mentions Hildeburh as an afterthought to her husband's murder; she is seized after the second battle and led to her people. Hildeburh's experience echoes what Beowulf observes when discussing peace-making brides more generally: a woman may have the intention to create bonds of peace within and among communities, but in the heat of the battle, her voice and her blood ties are ignored. In a bitter irony, because Hildeburh is the common element that brings them together, she is also the cause of the renewed hostilities. A marital style of peaceweaving, then, can arguably house the seeds of its own dissolution or unraveling.[79]

As a result of the *geomuru ides* role played by Hildeburh, scholars have long debated whether "peaceweaving" as commonly conceived, and marital peaceweaving in particu-lar, represents a passive role for female characters and real women (though curiously, not for angels or men). Jane Chance argues that it does:

> Unfortunately, women who fulfill this ideal role in Anglo-Saxon literature are usually depicted as doomed and tragic figures, frequently seen as weeping or suffering ... It appears that the very passivity of the bride and peace pledge leads inexorably to disas-ter, both in Anglo-Saxon and in Germanic literature.[80]

Christine Fell agrees, "a woman whose role was designed as that of 'peace-weaver' may find that her mere and innocent presence is a spur to the renewal of hostilities. In such hostilities her situation is normally both passive and pitiable,"[81] and Joyce Hill suggests likewise that "the highlighting and stereotyping of an idealized male hero-ism has as its counterpart the highlighting and stereotyping of female helplessness."[82] Some historical evidence parallels the political and personal helplessness of women who could be considered marital peaceweavers. The same Edith, wife to King Edward, lauded for her ability to be a peace-bringer, watched her fortunes rise and fall with the political usefulness of her marriage to the king. Her husband married her to secure the influence of her (then) powerful father Godwine; as Godwine's influence at court waned, so did the place of Edith. When Godwine displeased the king, the alliance was no longer desirable, and Edith was sent from court to live at Wherwell Abbey.[83] When political realities changed, Edith was recalled, without much reference to her desires or her choice in the matter.

[79] Leonard Neidorf argues that Hildeburh is not necessarily a passive victim in these scenes, suggesting her choice to lay brother and son side by side and her mourning song act to inspire vengeance later against her husband. If so, then she is all the more like other potential peaceweavers considered passive failures (see discussion below) ("Hildeburh's Mourning and the Wife's Lament," *English Studies*, 89 (2017), 197–204).

[80] *Woman as Hero*, p. 10.

[81] *Women in Anglo-Saxon England*, p. 37.

[82] "*Þæt wæs geomuru ides,*" p. 240.

[83] F. M. Stenton, *Anglo-Saxon England* (Clarendon, 1988), p. 565.

However, some have objected to the "active and aggressive warrior/passive and victimized *ides*" opposition suggested by such a model for the feminine, arguing that it renders those involved into simplistic "cartoon figures,"[84] and I would agree that the traditional divide seems overly reductive. But I would suggest that, in the case of those designated overtly as "peaceweavers," peaceweaving is an active role for one significant additional reason: the perspective given through the second half of the compound. For anyone with any familiarity with it at all, weaving is impossible to imagine as passive in nature. As Agnes Day states:

> Weaving is not a quiet, gentle occupation like sewing. It takes strength to set up the loom and pull the warp threads to the proper tension, and the weaving itself is very active. Hand weaving has been compared to organ playing, for although the artist is seated, her hands and feet fly, and her body sways back and forth rhythmically in a great output of energy. Her mind is not idle either, for she has an intricate pattern to follow. It is really an occupation that requires total involvement if it is to produce the desired wholeness and beauty in the union of the disparate.[85]

The pre-Conquest English knew what weaving was from firsthand experience or observation, an intellectually and physically active and time-intensive task. If passivity had been intended, I would contend that early medieval English authors would have chosen a different metaphor. It is probably not a coincidence that the early medieval English version of the Virgin Mary is distinguished for her superior spiritual diligence and her excellence as a woman weaver, with both elements linked to her virtue in working actively for long hours at the tasks considered appropriate to a good woman: *And heo ʒesette hyre sylfre haliʒne reʒol, swa þæt heo wolde beon fram þære ærestan tide þæs dæʒes on hyre halʒum ʒebedum wuniende oð þæt ða þriddan tid and fram þære þriddan tide oð ða niʒoþan tid ymbe hyre webbʒeweorc*[86] "She set herself a holy rule, so that she would from the first hour of the day be continuing in her holy prayers until the third hour [probably *terce*] and from the third hour until the ninth [probably *none*] about her weaving." She would pray thereafter until retiring at night. Assuming the homilist meant the canonical hours, Mary would thus spend the morning praying until 9 am or so, followed by weaving until afternoon, followed by continued prayers through the evening. Even if prayer of such length is somehow considered a passive task, the early English version of the Virgin is far from a passive ideal in virtuously weaving for five or six hours a day.

Metaphorical weaving would be similarly active. Highly lauded, Wealhtheow is as busy intervening and managing the peace and social stability of her community as any literal weaver, as are Hygd, Freawaru, Hildeburh, Ealhhild, and the angel of *Elene* (and in the "real world," Alcuin and his peers). They work in opposition to the destructive forces

[84] Baker, *Honour*, p. 123.

[85] Agnes Day, "Afterword," in *Peaceweavers*, Shank and Nichols, pp. 373–4.

[86] Assmann, *Angelsächsische Homilien*, no. 10, lines 341–8.

around them.[87] They do not always succeed: all four female characters who may arguably be considered peaceweavers in *Beowulf* watch their work unravel due to the destructive actions of other characters (and the same could be said for Ealhhild and Queen Edith's peace-making efforts). To be thwarted does not render their choices or actions passive.[88]

PEACEWEAVING PARALLELS

In marked contrast to later metaphors discussed in this work, there are no texts (biblical, classical, patristic, late classical, Germanic, Scandinavian, or Celtic) that can be definitively argued to be sources or direct analogues for the metaphor of "peaceweaver/ peaceweaving" in the literature of the early medieval English. Nonetheless, a handful of classical references do appear to be potential parallels, if indirect ones.

In his work, "Politikós" or "The Statesman," Plato uses weaving as a metaphor in ways reminiscent of communal peaceweaving. After carefully and minutely differentiating what weaving is *not* (combing, fulling, dyeing, etc.) as well as discussing the tools involved in weaving, his characters young Socrates and a philosopher from out of town simply titled, "Stranger," describe what weaving *is*: "when that part of the art of composition which is included in the art of weaving forms a web by the right intertwining of woof and warp, we call the entire web a woollen garment, and the art which directs this process we call weaving" (96–7).[89] The two philosophers determine that the weaving process, although not something a "man of sense would wish to pursue" in and of itself,[90] has "sensible resemblances which are easily perceived" and which provide an "image" by which humans can understand the state (106–7). In other words, weaving is a good metaphor to describe the process of unifying a state.

They designate weavers as the top level of the hierarchy in textile production, the kings and the statesmen, in contrast to "spinners" and other workers who prepared and finished textiles, meaning, slaves and servants (118–19). To this top level belongs the art of metaphorical "weaving" of state: "the art which holds sway over them all and watches over the laws and all things in the state, weaving them all most perfectly together, we may ... with full propriety call 'statecraft'" (174–5). The statesman who manages this "kingly process

[87] Stacy Klein has traced arguments that suggest *frið* can imply a militant form of peace (*Ruling Women*, p. 100), and J. M. Wallace-Hadrill asserts that in Roman and Germanic cultures, war and peace were "two poles of a single concept" ("War and Peace in the Earlier Middle Ages," *Transactions of the Royal Historical Society*, 5th ser., 25 (1975), 157–74, at p. 157).

[88] My argument is one among many that may differ in rationale but agree in rejecting a wholesale passivity for the metaphor of peaceweaving. See O'Briain, "Listen to the Woman," pp. 193, 205, 207, and Vowell, "Grendel's Mother," pp. 242 and 251–2.

[89] All quotations from Plato's "Statesman" are drawn from Plato: *Plato in Twelve Volumes: The Statesman. Philebus. Ion*, ed. and trans. Harold N. Fowler and W. R. M. Lamb, Loeb Classical Library, 164 (Harvard University Press, 1975). The discussion of weaving stretches from pp. 82–195.

[90] This distaste no doubt arises from the strong association of weaving with women's roles among the ancient Greeks.

of weaving" manages likewise the modes of production that feed it, such as spinning and preparing fibers (184–5), all creating the fabric of society. The statesman has certain types of materials to work with, and, according to Plato's speakers, he is wise to discard that which is destructive, enslave that which is ignorant, and use the rest carefully:

> As for the rest of the people, those whose natures are capable, if they get education, of being made into something fine and noble and of uniting with each other as art requires, the kingly art takes those natures which tend more towards courage, considering that their character is sturdier, like the warp in weaving, and those which incline towards decorum, for these, to continue the simile, are spun thick and soft like the threads of the woof, and tries to combine these natures of opposite tendencies and weave them together. (186–7)

The bonds in this case are those of religion and "intermarriages and the sharing of children by adoption" (190–1), ties and tugs that would encourage the "self-restrained characters" never "to be separated from the courageous, but weaving them together by common beliefs and honours and dishonours and opinions and interchanges of pledges, thus making them a smooth and, we say, well-woven fabric" (192–5). The Stranger concludes the metaphor and the dialogue with a description of the result:

> This, then, is the end, let us declare, of the web of the statesman's activity, the direct interweaving of the characters of restrained and courageous men, when the kingly science has drawn them together by friendship and community of sentiment into a common life, and having perfected the most glorious and the best of all textures, clothes with it all the inhabitants of the state, both slaves and freemen, holds them together by this fabric, and omitting nothing which ought to belong to a happy state, rules and watches over them.

Thus, the intertwining of the elements of a society into a peaceful, productive whole is linked metaphorically with weaving.

In his play *Lysistrata*, Aristophanes may well be drawing on these ideas of his earlier contemporary Plato for comic effect. Within the play, the irate (and frustrated) women of Athens begin an anti-war movement involving withholding sex from their husbands and holding the treasury of Athens hostage until, with their allies in Sparta and across Greece, they bring the fighting men of the rival city-states to agree to peace. During the conflict, the male characters cannot understand why or what the women are planning; Lysistrata, the leader of the women, explains their aims and how she thinks peace within and between states can be achieved, all through metaphors of textile production:

> It's rather like yarn. When a hank's in a tangle, we lift it – so – and work out the snarls by winding it up on spindles, now this way, now that way. That's how we'll wind up the War, if allowed: We'll work out the snarls by sending Special Commissions – back and forth, now this way, now that way – to ravel these tense international kinks. (60)[91]

[91] All quotations are taken from Aristophanes, *Lysistrata: Aristophanes*, trans. Douglass Parker (Signet, 2001), and are listed by page.

When the male characters object, Lysistrata tries again, recommending that the male characters "Consider the City as a fleece, recently shorn": it must be cleansed of dirt, burrs, and vermin; combed to align all citizens in parallel threads; and blended with the fibers of trusted allies and colonial descendants of Athens (61). The result, she explains, is that "drawing this blend of stable fibers into one fine staple, you spin a mighty bobbin of yarn – and weave, without bias or seam, a cloak to clothe the City of Athens!" (61). In other words, the women plan to bring the peoples of Athens and Sparta and their allies together in peace, a marvel of statecraft they imagine as spinning and weaving. For their part, the male characters are skeptical, arguing that in asking Athenians to trust the Spartans, the women may have "woven the City a seamless shroud" (64). The women thus see their efforts at peace-making as metaphorically spinning and weaving peace; the men see the same efforts as the weaving of death. These competing perspectives mirror in some ways the juxtapositions between the intent of marital or communal peaceweaving and unintentional but consequent renewals of hostility, as Beowulf notes.

While it is hypothetically possible that these texts could have inspired the creation of the term and related metaphor of peaceweaving, there is no indication that the early medieval English peoples had access to the works of Plato or the classical Greek dramatists at any point in the early Middle Ages, and the metaphors themselves are rather differently drawn. Latin influence is naturally far more likely, but in fact, there is even less evidence for sources or analogues for "peaceweaving" in the Latin corpus. There are no direct examples, for instance, of the "weaving of peace" in Latin texts, meaning the metaphor as *pax* + *texere*, aside from the early medieval Latin example of Alcuin's letter.[92] The only additional, indirect example from Latin that seems even close occurs in Augustine, as he argues that, from the root of charity *contexuntur* "are connected/woven" the fruits of the Holy Spirit, including a lengthy list of attributes that includes *pax*.[93] To take this list as the source of peaceweaving as a poetic metaphor would be a sizeable interpretive leap, however, to say the least. There are also a few instances of *concordia* + *texere*, *concordia* + *nectere*, and *pax* + *nectere*. Each is rendered problematic by its primary sense: *concordia* is agreement or harmony more often than peace, but can be used as a synonym for peace; *nectere* means binding or joining in most cases, but at times, interweaving. In the case of *concordia* + *texere*, the only two instances in extant Latin texts are either too late, or clearly not related to weaving.[94] The pairing of *concordia* + *nectere* is the most promising, with the phrase occurring in Augustine, Arator, Smaragdus, and liturgical texts, but

92 Based on extensive searches of related word forms (including variants such as *contexere*, *detexere*, and *attexere*) within three lines of one another and on analysis of resulting examples in the comprehensive *Library of Latin Texts Online*, databases A and B (Brepols, http://clt.brepolis.net/cds/pages/Search.aspx), hereafter *LLTO*. For *LLTO*, translations are mine unless otherwise noted.

93 Information for this reference in *LLTO* lists its source as line 609 of Sermon 37, from *Sermones*, CCSL, 41.

94 The first, which seems a reference to the weaving of harmonious melodies, occurs in the late twelfth-century *Commentaria in Cantica canticorum* of Philippus Haruengius; the second is an obscure line in Manilius's *Astronomica* in which the two word forms are not complementary, and "text" instead of weaving is implied (*LLTO*, *concordia* + *texere*).

most often it appears to mean "bound in agreement" or "bound in harmony" rather than "woven in peace,"[95] even though it is clear that at times, *nectere* carries the sense "bind, interweave," as in poem 10 from Claudius Claudianus, when he asks *Concordia, necte coronas*[96] "Concordia [Roman goddess of peace and harmony], interweave crowns [of flowers or vines]." The collocation of *pax* + *nectere* is also promising as a source or analogue for Old English "peaceweaving," but in its appearances within the Latin corpus, it generally means "joined/bound in peace," as in a commentary on Pauline epistles said to date from tenth- or eleventh-century England: commenting on a concept from scripture, the author explains that, *ut pacis se concordia necterent*[97] "as they joined themselves in harmony of peace," laws were less needful. More resonant possibilities occur in texts too late for comparison with Old English poetic metaphors, but one example of an early Latin text which could have a double meaning that might connect peace and weaving comes from the elegies of Maximianus Etruscus, as the poem's narrator describes himself at the start of the day, *Missus ad Eoas legati munere partes,/ Tranquillum cunctis nectere pacis opus*[98] "I was sent to eastern parts with legate's duty to bind together the tranquil peace for all." The sense is possible that he might "weave the work of peace," but his gender and a lack of related imagery make the possibility rather dubious. Although the absence of evidence is rarely positive proof, it is true nonetheless, that despite the survival of thousands of Latin lines of prose and verse, there is simply no close equivalent found for the Old English metaphor of peaceweaving in the extant Latin corpus, outside of the work of Alcuin. What makes such an absence the more astounding is that no parallels exist, as far as I am aware, after three decades of searching, for *freoðuwebbe* in the related literary traditions of the medieval North, as well. "Peaceweaver" seems a textual metaphor unique to the early medieval English.

CONCLUSION

What can be determined about "peaceweaving" as a metaphor among the early medieval English is straightforward. The metaphor *freoðuwebba/e* or "peaceweaver" is found three times in Old English poetry, with a potential fourth instance in an Anglo-Latin letter of

95 *LLTO, concordia + nectere* (with "hits" from Augustine's "De Musica," book 6; Arator's *Historia apostolica*, book 1, page 240, verse 241; Smaragdus's *Versus ad unum de filiis Ludovici Pii*, in *Poetae latini aevi Carolini*, MGH, 4, poem 15, verse 4; and others). As a representative example, in line 230 of his Homily 15, Heiricus Autissiodorensis (a ninth-century Carolingian) laments how the wicked may choose to be *concordia necti* "bound in agreement," but suggests that such agreements rarely prosper. An alternate example similar to Augustine's occurs in Petrus Damiani's *Epistulae* 149, line 12, where he explains, *Nam dum fratribus per concordiam nectitur, Deo suaviter concinit* "For, when he is bound through harmony with the brothers, he sings sweetly to God." Neither example seems an equivalent to "peaceweaving."

96 *LLTO.*

97 *Ibid.* The text quoted is listed as "*Ad Galatas*, cap. (s. s.):5, linea:1269," in *Exp. Pauli epist. ad Romanos, Galathas et Ephesios e cod. S. Michaelis in periculo Maris*, and is found in *LLTO* A. Commentary by the database editors suggests the text's dating and provenance as a potentially English manuscript.

98 *Ibid.* The text in question is Elegy 5, verses 1–2.

Alcuin, as he evokes a "wavering thread" weaving a shaky fabric of peace. Two of the three Old English instances, both in poems describing Heroic Age relationships, show the metaphor lauding a noble woman who acts, in keeping with wisdom literature, as a connecting force for good in her husband and lord's tribal group through generous and cheerful conduct, wise counsel to the lord, and perhaps generative relationships of interwoven kin and friendship. The third Old English instance shows an angel fulfilling what appears to be a similar role of diplomatically reconciling warring lords in the bonds of peace. Scholars have long argued whether the role of "peaceweaver" is traditionally linked to women and then appropriated later to men, and that shift is certainly possible. A significant body of evidence, linguistic, archaeological, and textual, identifies textile production, including weaving, as strongly marked by female gender for millennia prior to and during the early medieval English period. The gendered associations of the metaphor have in turn caused some to question whether or not the role of a "peaceweaver" is one doomed to passivity and failure in a contemporary societal ethos dominated by war. I would contend, rather, that all generative action attempted, whether by an *ides* or an angel, deserves recognition as a task as active and constructive as the second half of the compound, "peaceweaving."

Fred Robinson once argued that interwoven objects, including textiles, would have appealed to the pre-Conquest English on a metaphorical level; in a world of cold and frighteningly powerful nature, "Each artifact ... is reassurance that mankind can control the natural world, can constrain its brute substance into pattern and order."[99] Patterns of order promote peace and stability as "The conduct of human beings is formalized into banqueting rituals, social forms, traditions, and patterns of allegiance, thus bringing human nature as well as external nature into reassuring patterns."[100] As this chapter has demonstrated, Robinson's argument holds true; it is clear that the pre-Conquest English found "peaceweaver/peaceweaving" an attractive and resonant metaphor for the making of peace, with appearances within both of the literary traditions of the time (Old English and Anglo-Latin) and across three of the four major poetic codices of the period. Weaving was something most people in the early Middle Ages recognized and understood as a part of the daily patterns of life, protection, and warmth. The reassuring role of the "peaceweaver" most likely began in the realm of the idealized *ides* of Old English heroic poetry, and in that world, as in the real one, as a powerful woman, she would have woven the physical as well as metaphorical threads of warmth and life to protect her family and her community. As far as can reasonably be determined, "peaceweaver/peaceweaving" is a metaphor unique to early medieval English culture, a testament to the imaginative and generative ways the early medieval English saw the work of both weaving and peace.

99 Robinson, "History," p. 121.
100 *Ibid.*

CHAPTER 3

Spinning, Binding, and Weaving: Magic and Death

webbu swa wilc swa wyfð 7 blisse oððe unrotnysse gesihð god ærende

Tela quicumque texerit & letitiam siue tristitiam uiderit bonum nuntium significat

If someone weaves on a loom and sees joy or sadness that signifies good news.[1]

Today's modern preconceptions of "magic" and "medicine" place them at opposite poles, but these oppositions do not appear to have operated so simply among the early medieval English peoples. In instances that might approximate either term, or both, the pre-Conquest English identified the use and invocation among them of supernatural and other healing and cursing aids, some of which include material and metaphorical textile tools and processes. This chapter addresses important questions based on this evidence: do patterns exist for those who appear to have used these aids? How were textile objects and processes used in such contexts? Why might textile production, material or metaphorical, have proven resonant for magic? Are magical women related to a pattern easily attested in poetic and historical texts of seeing some women as deathweavers and binders, in contrast to the "peaceweavers" of the previous chapter? Finally, do similar patterns exist among the cultures of related people? The answers form the core of this chapter.

MAGIC IN CONTEXT IN EARLY MEDIEVAL ENGLAND

In a discussion of magic, some definition of the term is, of course, indispensable. It is nonetheless a difficult task, as one must define "magic" in a way that would be as accurate across the early Middle Ages in England, as it is comprehensible today. The dividing lines between science, magic, and medicine are far more distinct for us today than they likely would have been for medieval peoples more generally, rendering the task additionally complex. The simplest definition for "magic" is the belief in or attempt to harness supernatural forces for the aid of a living creature, whether to curse or bless, heal or kill.

[1] Roy M. Liuzza (ed.), *Anglo-Saxon Prognostics* (D. S. Brewer, 2010), no. 6, pp. 112–13. Translations of the Latin and the Old English gloss are both Liuzza's.

73

Such a definition does not, however, differentiate, as medieval peoples did, what kind of supernatural force is involved. Faith in God, for example, is belief in a supernatural force and the invocation of that force (through prayer or blessing, for example) for the benefit of a living creature. But faith and magic were viewed as different poles within the Judeo-Christian tradition from the beginning, and the early medieval English peoples, to varying degrees, adhered to that tradition. Thus, to invoke holy supernatural forces such as God or the saints and angels would be less likely to count as "magic" or "magical practice" for the early medieval English. Invoking the help of devils and demons, on the other hand, would count as some form of dark magic – what we would call witchcraft or sorcery today, arguably as the early medieval English did themselves, since we have terminology for both ideas, and both associate witches and sorcerers with demonic power. Moving away from these clear points of distinction, however, we enter a world of murky dividing lines.

Other potentially supernatural forces for the early medieval English peoples might include dwarves or elves, perpetrators of night terrors and "elfshot." To invoke their power would be more likely to be "magic" than faith. But there were additional magico-medical forces that were human, "wise" women and men who were healers. These healers must have engaged in a wide range of practice and belief, as surviving medical (or magico-medical) texts include prescriptions for healing that invoke nature and mother earth, use names of pagan gods alongside Christian ones, use the Creed and the Paternoster alongside herbal remedies, and generally, invoke the powers of nature to assist in the healing of the individual. Where one draws lines within such a charm between magic and faith, is difficult and open to question. Even prognostic texts that "read" the stars, a person's dreams, or other unusual natural phenomena, though not necessarily always identified as "magic" by the early medieval English, do seek the aid of the extra-natural or supernatural forces to help an individual "see" the future. Amuletic objects, objects designed to protect their owners, likewise indirectly invoke a supernatural, protective power, and could be considered as connected to "magic."

In scholars' efforts to grapple with this body of evidence, many tomes have been written on the subject of medieval magic, and many of their pages argue eloquently for differentiations and gradations between and among the diverse varieties of "magic" and "non-magic."[2] Such works have a different focus and purpose from the present study, and while many will inform the arguments within this chapter, for this discussion, I will be keeping the definition of "magic" fairly simple by comparison. I do so for two reasons. First, as will be clear in the following discussions of Old English penitential and homiletic injunctions and charms, for writers such as Alfred and Ælfric and the health practitioners who compiled the medical remedies, the category of non-faith "magic" was

[2] See, for example, helpful discussions in Richard Kieckhefer's *Magic in the Middle Ages* (Cambridge University Press, 2000; 1989), pp. 8–17; Karen Jolly, Catharina Raudvere, and Edward Peters's *Witchcraft and Magic in Europe: The Middle Ages* (Athlone, 2002), pp. 3–5; and Jeffrey Burton Russell's *Witchcraft in the Middle Ages* (Cornell University Press, 1984), pp. 4–7.

an amorphous one that represented a wide range of practices and beliefs, rather than a discrete term or set of terms with well-defined boundaries. A wide-ranging and inclusive definition of "magic," in other words, seems more true to the diversities inherent to the early Middle Ages in England. Second, this study's intent is to examine metaphor and metaphorical connections, in this case, the metaphorical connections among magic (including medical magic), women, and textiles as categories of meaning. The creation of metaphor relies on identifying relational similarities perceived across those very categories of meaning, generally categories with more connotative than denotative boundaries. "Magic" will therefore be used as a connotative category rather than a restrictive set of categories within this discussion.

In short, "magic" for this chapter will mean all practices that involve an individual appeal to supernatural forces outside of the conventional Christian religious framework so dominant across the period, from syncretic blending of religious, herbal, and animistic or stellar appeals on the one hand, to alarming appeals to demons and pagan supernatural creatures on the other. "Magic" includes the use of amulets or amuletic objects, and likewise, can mean both healing charms and cursing spells (which are, after all, two sides of the same coin). "Magic" means both the witch's/prophetess's prediction and the classical prognostics of dreams. All represent the range of (potentially dangerous) ways to seek blessing or cursing from supernatural forces that may be read as "un-godly." All were the sorts of appeals to "superstition" or the supernatural that might have been and often were condemned specifically and directly by Augustine, Caesarius of Arles, Isidore, and other influential Christian thinkers as deceits of the devil: the early medieval English would have been informed by such beliefs.[3]

However it is defined, some sort of belief in magic seems to have existed, both pre- and post-conversion, in early medieval England. Evidence from archaeology is difficult to interpret, but the grave goods from early in the period include assortments of objects often identified as amuletic in nature, from beads and shells to crystal balls.[4] Such items may be related to much later textual references to amuletic objects in Old English charms, objects used in the healing process; Audrey Meaney estimates that one-quarter of those charms which survive refer to amulets, so perhaps so.[5] At the same time, it is difficult to assess connections between early archaeology and later textual evidence. The textual evidence for practices of "magic" in the following centuries fills in the picture considerably, particularly the medical collections and the penitentials. The collections tell us there was a wide range of approaches to healing and solving problems that required supernatural intervention. Interventions might include use of natural agents

[3] See lists of forbidden practices, for example, in Augustine, *De Doctrina Christiana*, ed. and trans. R. P. H. Green (Clarendon, 1995), pp. 91–5, 97–101, and in Isidore, as collected in *Witchcraft in Europe, 400–1700: A Documentary History*, eds Alan Charles Kors and Edward Peters, 2nd edn (University of Pennsylvania Press, 2001), p. 54.

[4] For work on the subject and lists of a wide variety of examples, see Audrey L. Meaney, *Anglo-Saxon Amulets and Curing Stones* (BAR, 1981).

[5] *Ibid.*, p. 20.

76 TEXTILES & TEXTILE IMAGERY IN EARLY MEDIEVAL ENGLISH LITERATURE

such as herbal remedies or practical objects, but also the use of the same with invocations to those herbs or objects, or to supernatural agents of both help and harm. An illustrative example comprised of elements of all of these interventions is the "Nine Herbs Charm" in London, British Library, MS Harley 585.[6]

The charm opens with an enumeration of nine healing herbs and the essential properties of each, from mugwort to crabapple. For example, *Stiðe heo hatte, wiðstunað heo attre, / wreceð heo wraðan, weorpeð ut attor* "'Stith' she (it) is called, she withstands poison, / she expels evil, casts out poison" (16–17). The charm also specifies the use of certain objects for administration to the troubled person, as the healer is instructed at the end of the charm's poetic lines, *Gewyrc ða wyrta to duste, mængc wiþ þa / sapan and wiþ þæs æpples gor* "Work those herbs to dust, mix these with salve and with the dirt/leavings of a fruit" (66–7). But the charm's enumeration of the herbs is also an invocation to them as natural agents:

> Gemyne ðu, mucgwyrt, hwæt þu ameldodest,
> hwæt þu renadest æt Regenmelde.
> Una þu hattest, yldost wyrta.
> ðu miht wið III and wið XXX,
> þu miht wiþ attre and wið onflyge,
> þu miht wiþ þam laþan ðe geond lond færð.
> Ond þu, wegbrade, wyrta modor ... (1–7)

> You remember, mugwort, what you made known, what you arranged at Regenmelde [or, if lower case, "at the time of announcing"]. *Una*/One you are called, oldest of herbs. You, mighty against three and against thirty, you, mighty against poison and against infectious disease, you mighty against that hateful one who fares around the land. And you, waybroad, mother of herbs ...

The enumeration of herbs is thus a conversation in which the healer rallies the herb, asking that it invoke its power on behalf of the afflicted, as promised. The "Nine Herbs Charm" also invokes other powerful agents thereafter, presumably agents of help against hurt, including *Crist*, who *stod ofer adle ængan cundes* "opposed sickness of any kind" (58), but also *Woden*, who reacts, in the poem, to the *wyrm* that would harm man, *ða genam Woden VIIII wuldortanas, / sloh ða þa næddran, þæt heo on VIIII tofleah* "then Woden seized nine glory-twigs, then slew the snake, that it (she) flew apart into nine parts" (32–3). The inclusion of the northern pagan god Woden is surprising in what is usually read as a distinctly post-conversion text. So is the potential double meaning as the poem continues:

6 The text is drawn from *The Anglo-Saxon Minor Poems*, ASPR 6, pp. 119–21. The manuscript, generally known as the *Lacnunga*, is thought to date from the late tenth to early eleventh century. For a thorough overview of the manuscript and its features, see Emily Kesling, *Medical Texts in Anglo-Saxon Literary Culture* (D. S. Brewer, 2020), pp. 95–129.

SPINNING, BINDING, AND WEAVING: MAGIC AND DEATH

þa wyrte gesceop witig drihten,
halig on heofonum, þa he hongode;
sette and sænde on VII worulde
earmum and eadigum eallum to bote. (37–40)

The wise lord, holy in the heavens, shaped/made the herb, when he hung; he placed and sent into the seven worlds, for the miserable and the happy, for all a remedy.

Since *Crist* follows, the imagery explaining the origin of healing herbs and extolling the lord who "hung" to save others may ostensibly be connected to him; however, the lines about Christ begin at 58; this imagery comes twenty lines before, immediately following mention of Woden, a supernatural figure whose story also includes hanging on a tree, in his case, to gain wisdom and knowledge of the runes and other magical secrets (such as healing). The charm concludes with the instruction that the healer is to sing *þæt galdor* "that song/spell" (70) over the herbs and the afflicted person, and then to apply the herbs.

What reaction the "Nine Herbs Charm" might have garnered in ecclesiastical circles is a good question. Penitentials make it clear that the gathering and using of herbs themselves are acceptable, but only when the process is removed from the realm of medico-magic and sanctified instead: *ne wýrta gade runga mid nanum galdre butan mid pater noster 7 mid credo. oððe mid sumon gebede þe gode belimpe* "No gathering of herbs with any song (or spell), except with the *Pater Noster* and with the Creed, or with some prayer that belongs to God."[7] The opening and closing of the charm fit such a pattern, and even the invocation of the herbs and the application of objects might not have raised questions or eyebrows. The possible invocation of and credit given to Woden, however, would have been another matter entirely, likely to have evoked the other side of the medico-magical remedies, the side always called into question and censured in councils, penitentials, and homilies as magic, an appeal to supernatural forces eventually linked to demons. The boundaries of acceptable and unacceptable "magic" thus become, from very early on, a social problem.

It becomes clear from the earliest textual records that practices associated with "magic" were perceived as problematic by the early medieval English Christian church. The summary from the ecclesiastical council at Clofesho (747) prohibits *paganas observationes, id est, divinos, sortilegos, auguria, auspicia, fylacteria, incantationes, sive omnes spurcitias impiorum* "pagan observations, that is, soothsayers, fortune tellers/diviners

7 *Old English Penitential*, Oxford, Bodleian Library, Laud Misc. MS 482, fols 3a and 9b (Y41.08.02 and Y42.23.01), respectively. The Old English texts for all four penitentials cited here and below are based on editions taken from Allen Frantzen's now-defunct "The Anglo-Saxon Penitentials: A Cultural Database," http://www.anglo-saxon.net/penance/. All were accessed on or by 8 March 2023.

by lot, auguries, divination by watching birds, amulets, incantations, or all filthinesses of the ungodly."[8]

In penitential collections, both clergymen and the penitent are warned against practicing magic of any kind. The oldest of these texts, the *Old English Introduction*, which may be as old as the records about Clofesho or older, teaches the religious to guard against *lýblacas· 7 attorcræftas* "wizard's medicines and poison-crafts."[9] Likewise, in the *Canons of Theodore*, purportedly the compilation of the archbishop and early missionary Theodore of Tarsus, the author teaches that other superstitious practices are also forbidden for parishioners, such as burning grain for the dead and *galdorcreaftas* "spell-crafts" of any kind.[10] The prohibition is repeated, and a canon further warns that anyone who leads another *on ðam drýcræft* "into sorcery" is also subject to penance and judgment.[11] Later penitentials similarly prohibit *lýblac*, condemning and considering un-Christian the seeking of signs through the celestial bodies (sun, moon, and stars) and other "useless" heathen practices.[12] In what may be the latest of the penitentials, more serious invocations of magic are addressed, as the *Old English Handbook* recommends the most demanding penance for those who *operne mid wiccecræfte fordó* "harm another through witchcraft,"[13] including such actions as putting iron stakes through another (perhaps a doll, or else a real person),[14] or trying to use *wiccige ýmbe oðres lufe* "witchcraft for the love of another," *oðð̄e on drence. oþþe on galdorcræftum* "either through drink or through spellcraft."[15]

Some caution is necessary in interpreting the penitentials as evidence of problematic magical beliefs, since most penitential material draws on earlier Latin sources describing the practices of other areas. Nonetheless, a vocabulary for "magic" existed in Old English to translate the Latin words, and the cultural context is likely to have existed

8 In *Councils and Ecclesiastical Documents Relating to Great Britain and Ireland*, ed. Arthur West Haddan and William Stubbs (3 vols, Clarendon, 1869), vol. 3, p. 364. It is interesting that many of the Latin terms used mirror wording in similar prohibitions in the works of Augustine, Isidore, and other earlier Latin writers. The correlation seems less likely to be rote or formulaic borrowing, however, and more likely to be an appropriation of Latin terminology to describe social conditions that concerned the ecclesiastical council and to record those concerns in the language of the church.

9 According to Frantzen, this text is the oldest of all of the penitentials, with source texts likely constructed in the eighth century, though extant, as with all of the penitentials, in eleventh-century manuscripts. This reference comes from Cambridge, Corpus Christi College, MS 190, fol. 368 (S31.06.04).

10 Brussels, Bibliothéque royale, MS 8558-63, fol. 152r (B78.01.03). The text is generally considered as deriving from an eighth-century source with tenth-century revisions; its manuscript context is dated as closer to the twelfth century in most versions.

11 *Ibid.*, fol. 152v.

12 *Old English Penitential*, Oxford, Bodleian Library, Laud Misc. MS 482, fols 3a and 9b (Y41.08.02 and Y42.23.01), respectively.

13 Cambridge, Corpus Christi College, MS 265, fol. 78 (CS54.35.01).

14 *Ibid.*

15 *Ibid.*

SPINNING, BINDING, AND WEAVING: MAGIC AND DEATH

to render useful a translation of the problem into local terms, as well. Harsh punishments for practitioners of magic are part of the laws of the early medieval English kings, and similar (indeed often identical) cautions against practices of witchcraft make their way into later homiletic literature. Ælfric's sermon "On Auguries" is a case in point. In the homily, Ælfric virtually quotes passages from the penitentials about forbidden magical practices: divination by animal behavior; consultation of witches; offering to stones, trees, and wells at the instruction of witches; and engaging in superstitions such as dragging children across crossroads and making love potions.[16] As Audrey Meaney points out, while Ælfric's sources may be Latin, and perhaps pseudo-Augustinian texts transmitted through Hrabanus or Cesarius de Arles before finally being translated into Old English terms,

> it seems to me that we can accept what he has to say about idolatrous practices as referring to things current in the society that he knew. There would have been little point in his trying to combat superstitions which posed no danger to the souls of the "foolish men" and "witless women" whom he was addressing.[17]

Support for Meaney's contention comes in the words of his contemporary Wulfstan, Bishop of Worcester and Archbishop of York. Wulfstan decries the wickedness of his day that allows for the curse of the Vikings upon them all, and among the malefactors responsible for society's decline are *wiccan 7 wælcyrian* "witches and valkyries [presumably sorcerers]."[18] What is also interesting is how many of the penitentials' and Ælfric's examples of problematic behaviors include magic attempted by women, a connection to which I now turn.

WOMEN AND MAGIC IN EARLY MEDIEVAL ENGLAND

Whatever the idea of "magic" meant in early medieval England, it was linked to women in a significant number of cases, perhaps from early in the period. The archaeology of amuletic crystal balls, possibly related to magic, has close correlation with women's graves, both in England and on the Continent.[19] Christine Fell likewise notes that while objects interpreted as charms can be found in both men's and women's graves, most are found in the graves of women.[20] She argues some logical possibilities for the meaning of such findings:

[16] Ælfric, "XVII. On Auguries," in *Ælfric's Lives of Saints*, ed. and trans. Walter W. Skeat, EETS os, 76, 82, 94, 114 (Oxford University Press for EETS, 1881; 1966), vol. 1, pp. 364–83.

[17] Audrey L. Meaney, "Ælfric's Use of Sources in His Homily on Auguries," *English Studies*, 6 (1985), 477–95, at p. 495.

[18] Wulfstan, *Sermo Lupi ad Anglos*, ed. Dorothy Whitelock, 3rd edn (Appleton Century Crofts, 1966), p. 64, line 171.

[19] See Meaney, *Anglo-Saxon Amulets*, pp. 82–6, 93–6.

[20] *Women in Anglo-Saxon England*, p. 34; see related discussion in Helene Scheck, *Reform and Resistance: Formations of Female Subjectivity in Early Medieval Ecclesiastical Culture* (SUNY Press, 2008), p. 75.

Some wealthy women's graves contain a considerable number of objects of this kind, and it is not impossible that these represent the graves of women who were thought to have, or claimed to have, healing and prophetic powers, and might properly be considered as *burgrunan*, "wise women" of the community.[21]

Women are also linked with magical practices in texts compiled by later generations. The connection appears repeatedly in penitential and homiletic literature, for example, in collections both early and late. In the *Canons of Theodore*, we are told *Gýf hwýlc wif wiccunga begá. 7 þa deofollican galdorsangas blinne 7 fæste an gear* "If any woman practices witchcraft and devilish song-spells, she is to cease and fast for a year,"[22] a comment repeated in the *Scriftboc*.[23] As referenced above, women are also mentioned in connection with the correction of "heathen," magical traditions: *Wif beo þæs ýlcan wýrðe gif heo tilað hire cilde mid ænigum wiccecræfte. oððe æt wega gelætan þurh eorðan týhð. forþam hit is mýcel hæðenscipe* "A woman gets the same [punishment] if she tries out any witchcraft on her child or lets it be drawn through the earth at a crossroads, for this is a great heathen practice."[24] Ælfric's condemnation of magical practices in "On Auguries" includes the latter example from the penitentials, as he condemns female witches who drag their children through crossroads, alongside the wicked women who use love potions to secure their lovers.[25] Interestingly, where the penitential source for his second example leaves the gender of the wicked maker of love potions non-specific, Ælfric identifies the maker as female.[26]

Similar connections between women and magic occur in legal texts, such as the preface to King Alfred's late ninth-century laws. As Meaney points out, where Alfred's source text in Exodus reads, "'Do not allow magicians to live,' the preface states, 'Do not allow the women who are accustomed to receive enchanters and magicians and witches to live.'"[27] Perhaps in light of these texts, we should not be surprised to see Old English charms that guard specifically against the power of women's speech, such as the charm

[21] Fell, *Women in Anglo-Saxon England*, p. 34.

[22] Brussels, Bibliothéque royale, MS 8558-63, fol. 148v (B66.05.01).

[23] The text has the same meaning, but reads slightly differently in the *Scriftboc*: *G/ýf wif drýcræft· 7 galdorgræft· 7 unlib / ban wýrce· 7 swýlc bega fæste .xii· monað* "If a woman undertakes magic and spell-making and sorcery, etc., she must fast 12 months" (Oxford, Bodleian Library, Junius MS 121, fol. 93b, X14.05.01).

[24] *Old English Penitential*, Oxford, Bodleian Library, Laud Misc. MS 482, fol. 16a (Y44.16.01).

[25] Ælfric, *Ælfric's Lives of Saints*, vol. 1, pp. 374–5. The latter example is also from the penitentials (see note 16).

[26] As Emily Kesling observes, what is evident in both the penitentials and later texts is the "pronounced tendency to link women with the practice of *drycræft*" sometimes described "as a feminine art" (*Medical Texts*, p. 176). Indeed, "when Ælfric considered healing magic as something actually being practised in his own time, he envisioned a female practitioner" (p. 177).

[27] *Anglo-Saxon Amulets*, p. 256; the passage she discusses from the preface to Alfred's laws can be found in F. Liebermann (ed.), *Die Gesetze der Angelsachsen* (M. Niemeyer, 1903–16), vol. 1,

Wiþ wif gemædlan "Against the speech of women."[28] The apparent fear of the power of women's magical agency, particularly their verbal power, seems, in some respects, a formulaic expression in penitential and homiletic texts, perhaps drawn from a long tradition of patristic antagonism towards women in general. This attitude might play out in interesting ways in the early medieval English world, however, as there is also evidence that a cultural awareness of and respect for women's power of speech pre-dated and outlasted Christian conversion, to some extent, among the Germanic tribes, and that in some cases, it carried the weight of magic as well as power. In the oft-quoted passage from Julius Caesar, for example, we are told that, *apud Germanos ea consuetudo esset, ut matres familiae eorum sortibus et vaticinationibus declararent, utrum proelium committi ex usu esset necne; eas ita dicere: non esse fas Germanos superare, si ante novam lunam proelio contendissent* "It was a custom among the Germans that their matrons should declare by lots and divinations whether it was expedient or not to engage, and the matrons declared that heaven forbade the Germans to win a victory, if they fought an action before the new moon."[29] As indicated in Chapter 2, in his *Germania*, Tacitus similarly notes the prophetic abilities attributed to women among the Germanic tribes he observed, and adds, as evidence, discussion of a number of important past prophetesses known among them.[30] Tacitus's work is well-known to have had its own purposes as a cultural call to reform for wealthy Romans, but his references to magic, power, and women among the Germanic tribes are not unique. In "The Prescient Woman in Old English Literature," Fred Robinson summarizes the work of Reinhold Bruder, who "cites nineteen passages in classical authors alluding to Germanic women as seeresses."[31] It is a fair question to ask to what extent the observations of these early Latin authors reflect the realities of early medieval England centuries later. There is some corroborating evidence that respect for women's speech was at least initially characteristic of the society of the latter in ecclesiastical and royal circles.

Evidence of respect for women's speech (magical or not) can be found among the pre-Conquest English from very early in the period, as in the description of Hild, the powerful abbess of a double monastery at Whitby. Bede reports that

> Tantae autem erat ipsa prudentiae, ut non solum mediocres quique in necessitatibus suis sed etiam reges ac principes nonnumquam ab ea consilium quaererent et inuenirent.

pp. 38–9. The laws of Edward the Elder and Athelstan were similarly harsh, ranging from exile to execution for conviction for witchcraft (Russell, *Witchcraft in the Middle Ages*, p. 73).

[28] Cockayne, *Leechdoms*, vol. 3, p. 342 (LVII).

[29] Caesar, *Caesar: The Gallic War*, ed. and trans. H. J. Edwards, Loeb Classical Library, 72 (Harvard University Press, 1979; 1917), book 1, section 50, pp. 82–3.

[30] Tacitus, *Tacitus: Agricola, Germania, Dialogus*, Hutton and Warmington, pp. 142–3.

[31] See Robinson's work, *The Tomb of Beowulf and Other Essays on Old English* (Blackwell, 1993), pp. 155–63, at p. 155.

So great was her prudence that not only ordinary people but also kings and princes sometimes sought and received her counsel when in difficulties.[32]

What makes Bede's statement more striking is that within the same few pages of his work, he likewise remembers Hild's mother for her prophetic statements about her daughter, based on a dream, and reports that an older nun who served with Hild had a vivid vision that led her to prophesy or pronounce the news of Hild's death, before news came.[33] Bede accorded similar prestige to St Æthelthryth of Ely, and Mary Dockray-Miller identifies additional convincing evidence for and even entire genealogies of powerful women whose words and deeds in ecclesiastical and political circles were acknowledged by and respected among their peers.[34] Stacy Klein argues that far more could be said about the social power of queenly women's speech in the conversion process in the early medieval English kingdoms, a role often elided in monastic histories, including Bede's.[35] In each of these cases, it is noteworthy that the women whose voices were so well-respected and honored were speaking as spiritual leaders or prophetic women, or, in other words, as agents of a supernatural force, the Christian God. For these examples, then, we are not necessarily looking at respect for "magical wise women," but rather spiritual wise women whose roles may have mirrored a long-standing tradition, one transferred to a new arena.

Textual evidence for respect for women's speech continues through the period, in literary texts in particular. As discussed in Chapter 2, the *Maxims* of the Exeter Book describe the ideal *ides* and *wif* as one who gives and keeps counsel with her lord, the two of them ruling together. The *Maxims* mirror closely the role of Wealhtheow as influential speaker and counselor within *Beowulf*, a woman who states openly and publicly that the "troops do as I bid" in her implicit warning to *Beowulf* (1231). Indeed, her husband the king, the troops, and Beowulf himself respect her counsel, and Beowulf returns to his people, with no further word from any party about his hopeful "adoption" by Hrothgar. There are a number of authors, including Fred Robinson, who see in these actions a connection between Wealhtheow and divination. It is true that Wealhtheow predicts a number of potential consequences for different choices in the story, most of them quite accurately. Robinson argues that

It is significant that this prediction is assigned by the poet to a woman, for in Germanic society … women were credited with special powers of prophecy, a belief exemplified by the *Beowulf* poet himself when he has Wealhtheow express such accurate forebodings about future trouble from Hrothulf.[36]

[32] Bede, *Bede's Ecclesiastical History*, Colgrave and Mynors, book 4, chapter 23, pp. 408–9.

[33] *Ibid.*, pp. 410–13.

[34] *Motherhood and Mothering in Anglo-Saxon England* (St Martin's, 2000).

[35] *Ruling Women*, pp. 17–52. See related discussion in Chapter 2.

[36] "History," p. 111.

That the words and pronouncements of these particular historical and literary women of the early medieval English world were considered with great respect is undeniable. That their words were overtly identified as prophetic is sometimes suggested, but far less certain. That their words were considered magical is improbable, but the sacral impact of women's speech is implied in many of these texts, and that implication is interesting, given the earlier historical connections between women and powerful and supernaturally connected speech.

MAGIC AND TEXTILES

The Medicine and Magic of Spinning, Weaving, Thread, and Cloth
Given the pervasive links between women and magic, and women and textiles, it is perhaps unsurprising that textile tools, processes, and related imagery have potential associations with magic, as well. Such a development of symbolic meanings might be natural enough. The spindle whorls and weaving swords that made up part of daily life and its tasks found their way into early graves, perhaps because they identified the role of the dead in their community while alive and represent that role ritually in the grave. The same tools seem to have developed symbolic, medico-magical function among the living. Thus, for someone with a sore cheek, a part of the remedy is to be found in a spindle whorl: *Við ceocadle nim þone hweorfan þe wif mid spinnað, bind on his sweoran mid wyllenan þræde 7 swile innan mid hate gate meolce; him bið sel* "Against pain in the cheek, take that whorl with which a woman spins, bind it onto his neck with a wool thread and rinse inside the cheek with hot goat's milk; it will be well with him."[37] Parts of the remedy may be practical, but there is no practical reason for the spindle whorl. As M. L. Cameron states, "The spindle [whorl] tied to the neck is an amulet; the hot goat's milk is a rational medicine."[38] Spinning and weaving tools can thus become "objects which are in themselves (or in origin) useful, but which appear to typify or symbolise some activity, so that they acquire magic qualities, and may thereby come to be regarded as amulets by their wearers. This category includes spindle-whorls and perhaps sword-beads."[39] The spindle whorl is well-understood as a gendered object associated exclusively and often metonymically with the women of its culture. If it is the "magical" or amuletic element of the process, the spinning tool attests, yet again, a direct association between women and magico-medical practice.

Another textile tool, the loom, also has associations with magic and prediction as well as women in the Old English prognostic tradition. Prognostics, prediction of events by dreams or signs of nature, held an important place for the early medieval English and medieval peoples more generally, if the number of prognostic texts which remain are any indication. In his collection and study of early medieval English prognostic texts, Roy M. Liuzza documents that tradition, including one prognostic in an eleventh-century text

[37] Cockayne, *Leechdoms,* vol. 2, pp. 310–12.

[38] *Anglo-Saxon Medicine* (Cambridge University Press, 1993), p. 132.

[39] Meaney, *Anglo-Saxon Amulets,* p. 78.

which connects the loom to the prediction of future events: *Tela quicumque texerit & letitiam siue tristitiam uiderit bonum nuntium significat* "If someone weaves on a loom and sees joy or sadness that signifies good news" (Old English gloss: *webbu swa wilc swa wyfð 7 blisse oðða unrotnysse gesihð god ærende*).[40] According to Liuzza, this prognostic text is associated with continental Latin traditions more than native traditions. Whatever the source of the idea, however, its link between the loom, the weaver, and a vision of the future is clear, and an early medieval English audience would likely have assumed the hands of the weaver at the loom were those of a woman. Other than the prognostic text, no additional references appear in extant Old English sources for weaving itself in association with magic, but references for threads and woven textiles do.

Scholars have long wondered if small, seventh-century "work-boxes" found in early graves are related to these later images of spinning and weaving in ritual contexts, or at the least, have a similar history – personal textile tool or object functions as a status or gender identifier which then develops a ritualized role. Certainly, the threads and the seeds in the small boxes, such as the Kempston box, which measures only 2.75 inches (68 mm) high and 2.25 inches (55 mm) in diameter, must have served some function.[41] The Kempston box, like the handful of similar boxes excavated to date, was found buried with an early medieval English woman, and like most of the other finds, was reported to be situated at the waist.[42] Like the other boxes found to date, the Kempston box held threads and fragments of fabric; according to Lester-Makin, however, the woollen Kempston fragments have the distinction of being the earliest examples of embroidery known from the early medieval English period, all part of a fine, woollen, purple backing fabric embroidered with colorful wool threads in "knot-like beast motifs."[43] Lester-Makin posits that the fabric was most likely a border piece, exceptionally good work that was intentionally saved.[44]

In all other respects, the Kempston fragments are like those found in other women's "work-boxes": each contains very small scraps of fabric and thread, and they must have had some symbolic function, as the fragments and threads are too small to be of extensive practical use, as "woollen threads and fragments of braid."[45] Citing Elisabeth Crowfoot's findings, Audrey Meaney suggests that the inclusion of odd threads and weaves may be emblematic, their insertion "among the grave goods deliberate, perhaps for sentimental reasons, or as a record of the weaving skill of the woman."[46] While it is very likely the boxes were thus representative of status or gender, as well as being personal items, it is

[40] *Anglo-Saxon Prognostics*, no. 6, pp. 112–13.

[41] The measurements are drawn from the revolutionary analysis of Alexandra Lester-Makin of the Kempston fabric fragments: *The Lost Art*, chapter 3, pp. 57–76, at p. 60.

[42] *Ibid.*, p. 61.

[43] *Ibid.*, p. 69.

[44] *Ibid.*, pp. 71–2.

[45] Meaney, *Anglo-Saxon Amulets*, pp. 61–2.

[46] *Ibid.*, p. 184.

not completely certain that such boxes were ritualized or amuletic. At the same time, they could very well have been. Meaney reasons,

> even if we assume that some of the threads found in the boxes were there for tying on amulets; that the pieces of cloth were there because of the religious or magic power woven into them; and even if we deduce from this that these boxes were, in a sense, first aid boxes, we still run into the problem of size. The Anglo-Saxon woman may have wished to show by wearing such a box that she prided herself on her skill in the feminine tasks of healing and textile-work: but nothing can alter the fact that she would have needed other, very much larger boxes, to have held her stock of herbs, and her cloth. Once again, it seems necessary to have recourse to the word symbolic. These boxes were symbolic of the woman's role in Anglo-Saxon society: therefore, they probably partook of something of the nature of amulets, but probably without actually being such.[47]

Lester-Makin agrees, suggesting that rather than "work-boxes," these containers should really be considered "amulet boxes."[48] Similarly unusual pendants in the shape of miniature buckets with threads inside have been found in a mixed cemetery burial in Bidford-on-Avon, Warwickshire (interpreted as a 'cunning woman' burial), as well as four other sites. Whatever the threads or their containers mean, they are clearly symbolic, perhaps in ways that overlap with the amulet-boxes.[49]

Like textile tools, textiles themselves also seem to have evolved from practical necessities to symbolic objects in medicine. Christina Lee documents a wide array of evidence for the use of textile materials in the magico-medical texts of early medieval England: cloth to clean and bind wounds and broken bones and cloth for bandaging.[50] At some point, thread and cloth, and even specific colors of thread and cloth, may have been considered to have had healing powers of their own. Thus, one charm specifies that the healer take *hefelþræd* "heddle thread," a specific type of thread attached to the heddle of a loom, to tie a herb to a patient.[51] This selection seems simple enough, but begs a question: why, of all choices, is heddle thread chosen, as opposed to just thread? The answer is not clear, but Meaney suggests, "The 'weaving thread' to be used with *milotis* [the herb] was also probably credited with powers of its own."[52] If looms are often associated with life and the power of creation (perhaps through their connection to women), as I will

[47] *Ibid.*, p. 188.

[48] *The Lost Art*, p. 69.

[49] T. Dickinson, "An Anglo-Saxon 'cunning woman' from Bidford-on-Avon," in M. Carver (ed.), *In Search of Cult: Archaeological Investigations in Honour of Philip Rahtz* (Boydell, 1993), pp. 45–54.

[50] "Threads and Needles: The Use of Textiles for Medical Purposes," in Maren Clegg Hyer and Jill Frederick (eds), *Textiles, Text, Intertext: Essays in Honour of Gale R. Owen-Crocker* (Boydell, 2016), pp. 103–17.

[51] Meaney, *Anglo-Saxon Amulets*, p. 56.

[52] Cockayne, *Leechdoms*, vol. 1, p. 320.

address in Chapter 4, perhaps the loom's heddle threads carry that generative power with them for the creator of the charm.

In other instances, the color is specified, rather than the thread type. Thus, one charm requires that the healer bind *readne þræd* "red thread" on a patient,[53] while other charms identify and require specific types and even colors of cloth. In a charm that makes use of fruit as part of its remedy, the audience is instructed to take an apple (or fruit) and *bewind on weolc readum godwebbe. 7 seoð þonna eft mid sceate oþres godwebbes* "wind [it] in whelk-red silk/fine cloth, and boil it again with another cloth of silk."[54] A similar remedy occurs in a charm for sick cattle: the healer is instructed to burn *godeweb*, which is most likely a type of expensive silk, to include in the recipe.[55] We can only guess at what these threads and scraps of cloth symbolize, but one thing the latter two examples have in common is that a high-status textile product is demanded, silk that, in one instance, is finished in the most expensive dye possible (whelk-red). Would such silk be akin to a sacrifice? Audrey Meaney observes that, "To burn *godwebbe* would be virtually like burning money ... This is at the other end of the scale from using scraps of *godwebbe* to wrap a medicinal amulet; but the same sort of reasoning may underlie the two practices."[56]

Nonetheless, more homely fabrics might also have magico-medical function. In another remedy, a woman who cannot *afedan* "nurture/nourish" her child (perhaps through miscarriage, through a lack of sufficient breast milk, or through a failure of her infant to thrive) is to gather dirt from the grave *hyre agenes cilde* "of her own child" and *wry æfter þone on blace wulle 7 bebicge to cepemannum 7 cweþe þonne: "ic hit bebicge, ge hit bebicgan þas swearten wulle 7 þysse sorge corn"* "conceal it afterwards in black wool and sell [it] to a merchant and say this: 'I sell it, you buy it, the dark wool and the seeds of this sorrow.'"[57] The black wool itself holds no power, except in the mind of the grieving mother, who longs to give away her sadness in hopes for a brighter future. The cloth's purpose, then, is both medical and magical, as it covers, removes, and embodies the physical and spiritual tragedy to be given away.

These uses of textile tools and textiles in magico-medical charms and recipes may be explained in a variety of ways. In practical terms, thread and cloth are used extensively in medical situations today to aid in cleansing and healing wounds; they were used so then. But other uses documented in this section are likely symbolic – employing spindle whorls, loom threads, burnt silk, black wool. What they each symbolize is a good question, but what they have in common is a connection to women, the users of spindles and looms and the makers of the thread and fabric. Women are thus linked to both magic and textiles, and magic and textiles are linked to one another, as well. The grieving

53 *Ibid.*, vol. 2, p. 304.

54 *Ibid.*, vol. 1, p. 332.

55 In Stephen Pollington (ed. and trans.), *Leechcraft: Early English Charms, Plantlore, and Healing* (Anglo-Saxon Books, 2000), p. 230 (no. 141). For all quotations from the *Lacnunga*, translations are mine.

56 Meaney, *Anglo-Saxon Amulets*, p. 188.

57 In Pollington, *Leechcraft*, p. 236 (no. 170).

mother with her black wool and the women condemned in the penitentials for making love potions also share in common a manifest anxiety over procreative issues. Many of these magico-medical uses of textiles were clearly under concerned scrutiny by ecclesiastical leaders, as were the women who used them. If the penitentials are an indicator, perhaps if accompanied by a paternoster or a creed, the practices could have passed muster.

Textiles invested with approved, holy supernatural healing powers were clearly a related, but different matter and had some precedent in biblical and later hagiographical sources. The book of Matthew, chapter 9, includes one story of Jesus healing a woman with an issue of blood by her simply touching his garment, and this was a story known and translated into Old English. In hagiographical tradition, similar miracles provide evidence for the legitimacy of early medieval English saints such as St Cuthbert or St Æthelthryth of Ely. Thus, when a holy woman suffering from debilitating illness wraps herself in a *zonam lineam* "linen girdle" that had come from St Cuthbert, she is healed of her affliction; days later, another nun uses the girdle to heal pain in her head.[58] In these cases, however, the supernatural agent is divine, making these remedies less likely to involve penance for those healed for resorting to non-canonical sources for healing.

The Magic of Binding Threads

One kind of working in thread or fiber, which by itself may or may not be considered textile work, is the binding of knots, a simple enough act, but one that has been seen by a wide variety of cultures around the world as potentially magical and very often treacherous. Binding imagery is textile imagery when knots are bound as necessary steps in securing or finishing thread or cloth. But most binding images relate, instead, to the securing of an enemy.[59] However, I discuss binding in this context for good reason: many of the same associations between threads, magic, death, and at times, women, occur with binding images that do with textile images in the early medieval English corpus, and that intersection is worth examining both here and in a later section on deathweaving.

A fair number of references to magical bindings appear in early medieval English literature. In some of these instances, the binding of knots for magical purposes is described as a pagan tradition. In his *vita* of Wilfrid (erstwhile bishop of seventh-century Northumbria), Eddius Stephanus describes events that transpire when Wilfrid and his companions are shipwrecked near Sussex. While trying to make good their escape, they engage in a fight with pagan South Saxons. During the battle, the *princeps sacerdotum idolatriae* "chief priest of their idolatrous worship" stood on a high mound to curse them and *suis magicis artibus manus eorum alligare* "to bind their hands by means of his magical

[58] According to Bede, in his life of St Cuthbert, in *Two Lives of Saint Cuthbert*, ed. and trans. Colgrave, pp. 232–3.

[59] Because it is only somewhat textile-related, I will address a representative sampling of binding imagery briefly here and refer the reader to other studies that discuss such imagery at greater length. See in particular Megan Cavell's *Weaving Words and Binding Bodies*.

88 TEXTILES & TEXTILE IMAGERY IN EARLY MEDIEVAL ENGLISH LITERATURE

arts."[60] The would-be magician is killed before he is successful. However, God could also bind his enemies at the behest of Wilfrid. In a later dispute with the Northumbrian king, the king fell ill, as apostolic power *sedis vinculis alligatum infirmitatis districte regem compressit* "laid hold upon the king binding him fast by the chains of sickness."[61]

More generally, however, God is not represented as a "binder," but instead a releaser of (evil) magical bindings, as in a story told by Bede:

> ... a young Englishman taken prisoner in 679 could not be chained ... His captors enquired whether he possessed any "written charms" (HE, IV, 22, p. 239). Bede used the Latin words *litteras solutorias*. The ninth-century scholar who translated Bede's *History* into English paraphrased the passage into an enquiry *hwæþer he þa alysendlican rune cuþe, and þa stafas mid hine awritene hæfde* (Schipper, p. 457, ll. 2857–9), "whether he knew releasing runes and had the written letters with him."[62]

What freed the young man, however, was the power of God. In a similar moment in the poem *Judgment Day II*, God is praised for his ability *ræplingas recene onbindan* "to unbind the prisoners quickly."[63] Such powers clearly mirror biblical tradition with which the early medieval English would have been familiar, including, for example, references in Isaiah (61:1) and the second epistle to Timothy (2:26) to God's ability to destroy all snares and bonds initiated by Satan, as well as the healing of a woman who had been "bound" by Satan in affliction for eighteen years, but whose bonds were removed as she was healed by Jesus by touching his clothing (Luke 13:16). Scripture reminds readers that binding and loosing are ultimately under God's sway, as it is Jesus who gives his disciples the power to bind and loose in heaven and on earth (Matthew 16:19, 18:18) in spiritual ways, but perhaps also in physical ones.[64]

Such godly binding is not the focus of medical or homiletic materials, however, which address a far more sinister kind of binding, one that they took very seriously, considered real, and placed more squarely in the category of the magical and the demonic. The Leechbook's summary of contents promises help and medical remedy *gif mon forboren sie ealles* "if a man be completely restrained," which Cockayne interprets as "tied with a magic knot."[65] A similar reference occurs in the Old English Herbarium. Lionsfoot is the remedy, and we are told that *Gyf hwa on þære untrumnysse sy þæt he sy cis, þonne meaht ðu*

60 Eddius Stephanus, *The Life of Bishop Wilfrid*, Colgrave, pp. 28–9. Translation is Colgrave's.

61 *Ibid.*, pp. 126–7.

62 As narrated by Gale R. Owen, *Rites and Religions of the Anglo-Saxons* (David and Charles, 1981), p. 59.

63 *The Anglo-Saxon Minor Poems*, ASPR 6, pp. 58–63, at line 48.

64 For a thoughtful exploration of the theme of binding and the paradoxical dynamic of God's power to bind, to loose, and to be bound, in the context of Old English poetry, see Thomas Rendall's "Bondage and Freeing from Bondage in Old English Religious Poetry," *Journal of English and Germanic Philology*, 73 (1974), 497–512.

65 Cockayne, *Leechdoms*, vol. 2, pp. 10–11. See Kesling, *Medical Texts*, for background on the Leechbooks, generally dated to the tenth century (pp. 23–94).

hine unbindan "If one be nauseated/unwell in that illness, then you can unbind him."[66] Stephen Pollington translates the passage as, "If someone be in the affliction that he be 'bewitched' you can unbind him then."[67] Whatever the ailment, the remedy is unbinding, which implies someone has been bound and tells us much about how the pre-Conquest English envisioned illness and disease. A more extreme example of binding and bewitching comes from Ælfric's homily "Natale Sancti Stephani," which describes a mother so enraged with one of her children that she determines to avenge herself on him by cursing him: *wolde ðone sunu þe hi getirgde mid wyriungum gebindan* "she wished that she might afflict that son to bind him with curses."[68] We are told that she succeeds in her death-binding by witchcraft with aid from the devil, and she hangs herself thereafter. Such behavior is depicted in ways consistent with demonic action; the notion of being "bound" by sin speaks to the nature of Satan himself within Old English texts, as well as biblical ones. As Ælfric warns, *Se syrwienda deofol swicað æfre embe us, / and on þæs mannes forðsiðe fela cnottan him bryt* "The sorrowing devil works ever about us, and in the going-forth of that man destroys him with many knots."[69] The only release in this case is prayer to one who holds ultimate power over binding and loosing.

As is evident from even this handful of examples, most binding in early medieval English texts is characterized negatively, a power associated with dark magic and the devil, as well as death. Like textile imagery, binding imagery is resonant; when the narrator describes the hoard of ancient gold in *Beowulf* as *galdre bewunden* "bound or woven with a spell" (3052b), the audience can sense the danger.[70] From cursed gold to a mother cursing her child by binding him to death, binding is a second type of interwoven imagery, interrelated with the weaving of death and destruction, the metaphor to which I now turn.

THE WEAVING OF DESTRUCTION

Both Riddles 35 and 56 of the Exeter Book link violence and the textile arts in ways that prefigure the imagery of weaving and death. Riddle 35,[71] as I argue in "Textiles and Textile Imagery in the Exeter Book," uses the tools and processes of textile production to

[66] In Pollington, *Leechcraft*, p. 290 (no. 8). See Kesling, *Medical Texts*, for background on the Old English Herbarium, generally dated to the late tenth century (pp. 130–52).

[67] Pollington, *Leechcraft*, p. 291.

[68] Ælfric, *Ælfric's Catholic Homilies: The Second Series*, ed. Malcolm Godden, EETS ss, 5 (Oxford University Press for EETS, 1979), vol. 2, p. 2, section 15, line 102.

[69] Ælfric, "XI. Sermo ad Populum in Octavis Pentecosten Dicendus," in *Homilies of Ælfric*, ed. John C. Pope, EETS os, 259, 260 (2 vols, Oxford University Press for EETS, 1967), vol. 1, p. 423, lines 163–4.

[70] Cavell suggests that here, the sense of *bewunden* is that of enclosing, "apt in the sense of wrapping and covering used to describe bandaging wounds, swaddling clothes, and death shrouds" (*Weaving Words and Binding Bodies*, p. 259). Such a sense would make the wording more than sufficiently ominous.

[71] *The Exeter Book*, ASPR 3, p. 198. Numbering of the Exeter riddles follows that of the ASPR edition cited.

describe what it is: a battle byrnie.[72] In what may be an image with double meaning, the byrnie states, *ne mec ohwonan sceal am cnyssan* "no beater strikes me anywhere" (8). The byrnie is a mailcoat, but not a coat of textile itself. No sword or pin beater strikes through it; however, a sword might. The subtext of sword in both loom and war is alluded to in similar ways in Riddle 56.[73] The riddle uses martial imagery to represent the process of textile production,[74] describing a *winnende wiht* (2a) "struggling creature" who receives *heaþoglemma* "battle-scars" (3b) from an unknown foe. The creature is subject to this torture because *Daroþas wæron / weo þære wihte, ond se wudu searwum / fæste gebunden* "Spears were woeful to the creature, and the wood bound fast with skill" (4b–6a). In other words, the web bound fast to the loom receives "scars," perhaps temporary holes, from weaving "spears," very likely the sword or pin beaters inserted into the loom to "beat up the weft" or tighten the weft threads into a pattern. The violence offered to "textiles" of fiber and metal mirrors that offered to the "web" of flesh.

Most industrialized peoples today have little sense of what the weaving task might have been like for pre-industrialized peoples, but weaponry and weaving tools might not have functioned so very differently, as the riddles suggest, a fact worth considering carefully:

> Weaving was a heavy task. The warp threads had to be beaten violently in an upward direction, with sword-shaped beaters made of wood or metal. There are cases of real swords and spears having been used for the task. The Anglo-Saxons themselves seem to have made the connection between weaving and warfare, as weaving is used figuratively in an Anglo-Saxon riddle about a mail-coat and battle imagery is used in a riddle which may be about a loom.[75]

Thus, weaving might well have been seen as violent in the interaction of tools and web, as well as constructive.

Perhaps it is unsurprising, then, that just as generative weaving metaphors can be found in the early medieval English literary corpus, so images of interwoven destruction can also be found in the same. *Andreas*[76] of the Vercelli Book provides one such example of connection between destructive behavior and what may be textile metaphor. The poet narrates the fate of Matthew the Apostle at the hands of the Mermedonians, whose land was *morðre bewunden* "entwined/enveloped with murder" (19b). He describes the tortures and persecutions Matthew undergoes, such as having his eyes put out, with the heathen hordes involved represented as *deofles þegnas* "the thanes of the devil" (43b). Their *dryas þurh dwolcræft* "sorcerers through magic" (34a) do all within their power to

72 *Medieval Clothing and Textiles*, 1 (2005), 29–39, at p. 30.

73 *The Exeter Book*, ASPR 3, pp. 208–9. See also Jill Frederick's "The Weft of War in the Exeter Book Riddles," in Hyer and Frederick, *Textiles, Text, Intertext*, pp. 139–52.

74 An interpretation in keeping with most scholarly opinion on the riddle. See Hyer, "Textiles and Textile Imagery in the Exeter Book," p. 31.

75 Owen, *Rites and Religions*, p. 15.

76 ASPR 2, pp. 3–51.

destroy Matthew. Despite their success in binding and imprisoning Matthew, however, *Him wæs Cristes lof / on fyrhðlocan fæste bewunden* "Christ's love was wound fast within him in his soul" (57a–58). Nonetheless, Matthew complains to God: *Hu me elþeodige inwitwrasne / searonet seowað!* "How the hostile strangers weave/sew an ensnaring net for me!" (63–64a). By contrast, God sends Matthew *sybbe under swegle* "peace under the heavens" (98a), promising, *Nis seo þrah micel / þæt þe wærlogan witebendum, / synnige ðurh searocræft, swencan motan* "Nor is the time great that the deceivers [modern English *warlocks*] will be able to torment you sinfully with bonds of affliction through treachery" (107a–09). The contrasts of binding and winding throughout the passage, evil and good working their way through the hearts of men, may (or may not) be textile imagery, since *windan* does carry the sense of "to twist, plait, weave,"[77] and in glosses *bewindan* may refer "to the interweaving of materials."[78] The sewing together of a net is more clearly related to textile imagery, although the sewing seems to involve a trapping net, rather than cloth. What we clearly see, in either case, is how the destructive purposes of the war-like Mermedonians find an outlet through interwoven nets of destruction, both magical and metaphorical.

A similar image occurs in *Beowulf* as Beowulf returns to the court of his lord and uncle Hygelac. As Beowulf recounts his experiences at Heorot, he gives the sumptuous gifts to Hygelac and Hygd which Hrothgar and Wealhtheow had initially given to him. This exchange seems to be a sign of his loyalty and his intent to continue as a faithful retainer to Hygelac, despite Beowulf's own recent personal successes. The narrator strongly approves Beowulf's actions, commenting: *Swa sceal mæg don, / nealles inwitnet oðrum bregdon / dyrnum cræfte, deað ren(ian) / hondgesteallan* "So must a kinsman do, not ever weave a malice-net for another with secret [magical?] skill, to arrange death for a companion" (2166b–69a). The verb *bregdan*, like *bewindan*, is capable of several meanings, but one which is often applied in this context is "to weave," under which definition the *Dictionary of Old English* includes this example.[79] According to the *Dictionary*, in the form of the past participle, *bregdan* also refers "to battle garments: woven, meshed, interlocked" in poetry, reminiscent of the parallel of byrnie and woven fabric in Riddle 35.[80] What is striking about the example is the repeating elements seen in *Andreas*: sinister, magical, interwoven nets or webs fashioned by a treacherous foe. Ælfric's homily "Sermo ad Populum in Octavis Pentecosten Dicendus" contains a comparable image, but one closer to binding, *Se syrwienda deofol swicað æfre embe us, and on þæs mannes forðsiðe fela cnottan him bryt*[81] "The plotting devil forever deceives us, and on the death of

77 Joseph Bosworth and T. Northcote Toller, *An Anglo-Saxon Dictionary: With revised and enlarged addenda by Alistair Campbell* (2 vols, Oxford University Press, 1983; 1898), *s.v.* (hereafter Bosworth and Toller).

78 *Dictionary of Old English*, Fascicle B, *s.v.*

79 *Ibid., s.v.* At the same time, an image of braiding and knotting a net for trapping purposes is also feasible.

80 *Ibid., s.v.*

81 Ælfric, *Homilies of Ælfric*, Pope, vol. 1, homily 11, lines 163–4.

that man binds him with many knots." The devil is conceived of as a weaver and binder of malice and death from his biblical beginning. In *Genesis A*, for example, when Satan begins to seduce angels to his rebellious cause in the heavens, *þone unræd ongan ærest fremman / wefan and weccean* "that first unwise counsel he began to advance, to weave and to set in motion."[82]

As suggested above, images and metaphors of binding and weaving often intersect in the context of death, and in some cases, those who bind and weave destruction for others act in opposition to those typically identified as "peaceweavers," particularly so in *Beowulf*. Thryth is a characteristic example. As discussed in the previous chapter, the narrator places her in direct contrast to the constructive *freoðuwebbe* of the text (Hygd) as Thryth sends retainers to their destruction. The description of her behavior in *Beowulf* provides linguistic evidence that she is not only visualized as a faulty peaceweaver, but also as one who weaves or binds the bonds of death. Whenever a retainer has offended, then *him wælbende weotode tealde / handgewriþene* "she truly arranged slaughter-bonds twisted/woven by hand for him" (1936–37a). The image, with its interwoven and destructive bonds, is inversely parallel to the image of the *freoðuwebbe*.[83]

The other major example in *Beowulf* of a female character whose behavior is painted in stark contrast to the communal peaceweaving characters of the text is, of course, Grendel's Mother. Yet, one significant point of similarity between Grendel's Mother and the noble women of the poem is a shared designation: like them, Grendel's Mother is titled an *ides* (1259a) "noble woman." The word may be used ironically in this case, or it may indicate that *ides* does not describe the moral character of those it names. It may indicate that the female in question is "extraordinary. There is, further, more than a hint in its usage that the power to be exercised may have a supernatural dimension."[84] Grendel's Mother is the key female villain of the text because, in her vengeance for Grendel's death, she engages in destructive behavior outside the accepted codes of Danish society,[85] including actions directly opposite that of a constructive character like Hygd or Wealhtheow, both associated with peaceweaving.[86] She comes in the night after the feasting at Heorot with the heart of a *wrecend* "avenger" (1256b) to *sunu deoð wrecan* "avenge her son's death" (1278b). Once there, she seizes a respected elder, Æschere, and kills him. But *Wæs se gryre læssa / efne swa micle, swa bið mægþa cræft, / wiggryre wifes be wæpnedmen* "Her violence

82 *Genesis A*, from *The Junius Manuscript*, Krapp, ASPR 1, p. 3, at lines 30–31a.

83 Dockray-Miller elaborates on this possibility and related binding images in *Beowulf* in *Motherhood and Mothering*, pp. 81–2.

84 Henrietta Leyser, *Medieval Women: A Social History of Women in England 450–1500* (Weidenfeld and Nicolson, 1995), p. 57.

85 Assuming, of course, that since Grendel was a murderer, his family was allowed neither compensation nor revenge for his death, a point others have interpreted differently. See for example Wendy Hennequin, "We've Created a Monster: The Strange Case of Grendel's Mother," *English Studies*, 89.5 (2008), 503–23.

86 Chance, *Woman as Hero*, p. 97. As Leneghan puts it, she is "an anti-type of the poem's ideal royal women" who evokes both "sympathy" and "revulsion" (*Dynastic Drama*, pp. 155 and 177, respectively).

SPINNING, BINDING, AND WEAVING: MAGIC AND DEATH 93

was less just so much as a woman's fierceness, the war-rage of a woman in comparison with a warrior's" (1282b–84), and so when the men arise, she flees. When Beowulf tracks her down, this warlike *ides* drags him through the water to her *niðsele* "evil hall" (1513a) where Beowulf and the *merewif mihtig* "mighty lake-woman" (1519a) begin fighting in earnest. When Beowulf fails to kill her with his sword and handgrip, she *andlean forgeald / grimman grapum ond him togeanes feng* "retaliated, with grim grasp seized him in return" (1541b–42). After seizing the sword, she tries to pierce his protective mail-coat, but fails, and Beowulf succeeds in killing her by means of a convenient magic sword (1554b–56).

Though brief, Grendel's Mother's episode is, in many ways, an inversion of the model of communal peaceweaving examined in the previous chapter. Chance sees the episode, in fact, as parodic.[87] First, Grendel's Mother, acting as "a kind of feminine antitype,"[88] visits the hall in darkness, unlike Wealhtheow, whose entry is characterized by light. Next, instead of carrying the cup and gifts to the retainers to unite them, she takes away, kills, and despoils Æschere. This pattern continues as she draws Beowulf into her hall. Instead of being bright like Heorot, the hall is a liminal space as hostile as its host.[89] She greets Beowulf with violence and "repays his gift" with battle. The poet also identifies Grendel's Mother with masculine pronouns as well as feminine ones.[90] Chance postulates that this gender confusion, along with both the warrior-epithets used to describe Grendel's Mother and the naming of her den as a battle hall, are evidence of the poet's wish "to stress this specific inversion of the Anglo-Saxon ideal of woman as both monstrous and masculine."[91] Such an inversion would be fitting only if the poet viewed her aggressive behavior as inappropriate and non-gender-normative because she is a female, an *ides* (although it may also be because she is an enemy from his point of view).[92] It is also probably not a coincidence, in the end, that the episode takes place in the center of the poem surrounded spatially by most of the references to the women associated with peaceweaving in *Beowulf*. To all appearances, the poet defines the monstrous in opposition to the socially acceptable; Grendel's Mother is monstrous in part because she stands in contrast to the highly praised women, those associated with communal peaceweaving characteristics, in the text. She represents their opposite in bringing death and destruction to heroic society (or at least to the Danish house) instead of stability and life.

[87] Jane Chance, "The Structural Unity of *Beowulf*: The Problem of Grendel's Mother," in *New Readings*, Damico and Olsen, pp. 248–61, at p. 253.

[88] Paul Acker, "Horror and the Maternal in *Beowulf*," *PMLA*, 121.3 (2006), 702–16.

[89] See an interesting discussion of this liminality in Alfred K. Siewers's "Landscapes of Conversion: Guthlac's Mound and Grendel's Mere as Expressions of Anglo-Saxon Nation Building," *Viator*, 34 (2003), 1–39, at pp. 33–7.

[90] Chance, "Structural Unity," p. 249.

[91] *Ibid.*

[92] See Chance, *Woman as Hero*, p. 99. Klein, *Ruling Women*, describes the inversion in lovely, metaphorical textile terms, "both invert the role of peaceweaver: Grendel's mother seeks to destroy bonds between men in Heorot, as well as the woven nets of Beowulf's mailcoat, while Thryth weaves" deadly bonds (p. 105).

One further argument that has bearing on the characterization of Grendel's Mother, according to Chance, is the claim that Grendel's Mother's crime in killing Æschere is not, in fact, that she has avenged her son unlawfully, but rather that the two feuds are separate, at least in Beowulf's eyes:

> Beowulf later implies that the two feuds must remain separate, as she desires her own 'revenge for injury' (*gyrnwræcu*, 2118) ... she is legally justified in pursuing her own feud given the tribal duty of the retainer to avenge the death of his lord, regardless of the acts he has committed.[93]

The battles and resulting slaughters initiated by Hygelac and other lords do not exempt their retainers from seeking vengeance for them; Grendel is the closest equivalent his mother has for a "lord," and murder is clearly relative in battle. So, if Grendel's Mother's vengeance has the possibility of justification, then what would count as her crime? Chance argues that it is her gender: she transgresses societal gender norms when, as a female, she commits violence, in what might be called "deathweaving" instead of peace-weaving.[94] The commentary of the *Beowulf* poet in condemning Thryth for bringing death rather than weaving peace is rather too similar an attitude to be coincidence and may derive from the same set of social mores: it is not a woman's place to make war or kill. Chance asserts that the very definition of the failed woman is one who inverts her peaceweaving role "through an arrogation of the heroic role of the retainer."[95] Norse epics cite examples of women wreaking vengeance for their slain kinsmen in a poten-tially positive way, but the matter may or may not be the same in the eyes of the *Beowulf* poet or early medieval English society more generally.

Helen Damico points to historical counterparts for figures such as Grendel's Mother, and their characterization in subsequent literary and historiographical narrative paints a similar picture. Ælfgifu/Alfifa, one of the wives of Cnut and mother to Harold Harefoot, for example, is associated at length in both northern and early medieval English texts with cruelty, murder, paganism, and sorcery for violence on behalf of her son; she her-self is characterized as a woman endowed with "a sharp, manipulative intelligence."[96] Damico assesses those descriptions of Ælfgifu against similar passages that describe Grendel's Mother, and the overlaps are considerable.[97] A similar point could be made with Ælfthryth, mother of Æthelred, whose historiographical image deteriorates after the murder of her stepson Edward the Martyr; eventually she is implicated as the architect

93 Chance, "Structural Unity," p. 252.

94 *Ibid.* Paul Acker makes a similar argument, suggesting that much of what the poet's audience finds horrifying in the conduct of Grendel's Mother derives from her identity as an implacable and avenging mother ("Horror and the Maternal," p. 705).

95 Chance, *Woman as Hero*, p. 65.

96 *Beowulf and the Grendel-Kin*, p. 169; the full chapter is particularly instructive: pp. 152–203.

97 *Ibid.*, pp. 176–80.

of Edward's murder and, by the composition of the *Liber Eliensis*, cast as a heartless killer and cruel sorcerer.[98]

At the same time, it may be somewhat problematic to assume that Grendel's Mother's crime in bringing death to others is solely a case of gender. Beowulf, although a male, is praised for *not* weaving death for others, in particular family. Moreover, the Mermedonians, whose leaders are probably male, are implicitly criticized and condemned in *Andreas* because they "weave" spiteful bonds for Matthew. Anything that might be considered "deathweaving" or the construction of interwoven bonds to destroy another is depicted as negative behavior regardless of gender, and therefore does not seem to be the same thing as making war, something for which the heroes of Old English literature are not generally criticized.[99] Further support for a difference between death-weaving and war-making is the characterization of the extremely martial heroines Elene, Judith, and Juliana, who are portrayed as warlike *and* righteous women, even when perpetuating torture (Judas) or killing someone (Holofernes); like Æthelflæd of Mercia in the ninth century, their violent acts are lauded as a positive benefit to the community. An alternative or an additional explanation may be the means or mode through which such destruction is accomplished. When Beowulf attacks Grendel, he attacks in retribution and indicates his hostile intent openly. He carries his notion of a fair fight so far that he refuses to use a sword against the monster when he learns Grendel does not use one. But both Grendel and Grendel's Mother attack in secret, in Grendel's case, without violent provocation. Grendel and his mother are liminal characters who also utilize cunning arts to give themselves an unfair advantage, as Beowulf's companions discover when they try to intervene to aid Beowulf in his fight against Grendel:

> Hie þæt ne wiston, þa hie gewin drugon,
> heardhicgende hildemecgas,
> ond on healfa gehwone heawan þohton,

[98] Damico, *Beowulf and the Grendel-Kin*, p. 169; *Liber Eliensis*, book 2, section 56, pp. 153–4. As Peter Baker notes, the trajectory of public opinion implicates Ælfthryth in a widening circle of crimes, as she is "accused of witchcraft, promiscuity, bestiality and at least one more murder" (*Honour*, p. 145). Matthew Firth details what is actually known about her in her own day as a powerful woman, as well as her reputation's later deterioration (*Early English Queens*, pp. 124–75).

[99] In its criticism of secret weaving of wiles by men, early medieval English culture may be different, for example, from ancient Greek. In Homer's work, Odysseus and others are depicted as weaving snares for enemies (John Scheid and Jesper Svenbro, *The Craft of Zeus: Myths of Weaving and Fabric*, trans. Carol Volk (Harvard University Press, 1996), p. 112). While Homer's characterization of Odysseus is somewhat ambivalent, Odysseus is certainly not villainized for his tricks, perhaps because he is the hero of the epic, as opposed to his characterization in Roman sources. Immortals such as Eros, Aphrodite, Hephaestus, Hermes, and Athena are also connected to wile-weaving and considered clever for their subtlety (Marcel Detienne and Jean-Pierre Vernant, *Cunning Intelligence in Greek Culture and Society*, trans. Janet Lloyd (Chicago University Press, 1978; 1974), pp. 45, 180, 284–6). The same does not always seem to hold true for mortal Greek women, however, as will be discussed in a later section.

> sawle secan: þone synscaðan
> ænig ofer eorþan irenna cyst,
> guðbilla nan, gretan nolde;
> ac he sigewæpnum forsworen hæfde,
> ecga gehwylcre (798–805a)

> They did not know, when they undertook the trouble, the brave shield-warriors, and on each side thought to hew him, to seek his soul: not one of the choicest of iron battle-swords over the earth would be able to have an effect upon that wicked criminal; but he had made battle-weapons, any kind of edge, useless by a spell.[100]

Whatever can be said of Grendel can usually be said of his mother, and Grendel's Mother can hardly be considered anything *but* magical, in the sense of an agent drawing upon supernatural power. She is the ruler of a fiery and gloomy underwater hall in which she and Beowulf can nevertheless breathe. She is also charmed; even with a direct strike from a sword, Beowulf cannot harm or kill her. Most likely, she is under a protective weapon-spell, as was her son Grendel (804–05a). Only use of an *ealdsweord eotenisc* "old sword made by giants" (1558a) found in the magical hall allows Beowulf to defeat her. Grendel may be called a *feond on helle* "a fiend in hell" (101b) and a *deorc deaþscua* "a dark death-shade" (160a), and so likewise may Grendel's Mother. The text asserts that Grendel is a descendant of Cain; from Cain *woc fela / geosceaftgasta* "originated many of the fate-spirits [those sent by fate?]" (1265b–66a). Grendel's Mother would likely share this origin with her son. Grendel's glowing eyes and the unearthly fire in their magical cave suggest both son and mother are not simply mortal man and woman going about everyday feuds. These liminal deathweavers are deceitful sorcerers, death-spirits, and even emissaries of fate.[101]

As such, they are remarkably like the Mermedonians of *Andreas*, who capture and torment Matthew, their *dryas* "sorcerers" using *dwolcræft* "magic" (34a) to snare him in their literal and figurative nets and bonds. The *wærlogan* "warlocks" (108) are not ultimately allowed to keep him, as a follower of God. The Mermedonians, like Grendel and his mother, are thus considered offspring or at least servants of evil who work in secret. It is perhaps unsurprising that Ælfthryth, like the literary characters, evolves from shadowy bystander to an evil sorcerer and murderer in the historical annals of early England, given that the death of her stepson Edward took place in secret circumstances and was the result of trickery and her household's betrayal of him as a family member. Discussing such types of murder, *Maxims I* indicates, *ne biþ þæt gedefe deaþ, þonne hit gedyrned*

[100] Lines 987b–90 later elaborate that no weapons of iron are able to hurt Grendel, and by extension his mother.

[101] They differ, in this respect, from Beowulf in yet another way; while they use magical arts to harm others, the *inwitnet* "malice-net" with which Beowulf might entrap his kinsmen, metaphorical or otherwise, is associated with *dyrnum cræfte*, "secret" and possibly "magical skill" (2167a, 2168a); he firmly rejects it.

weorþeð "that death is not proper, when it is kept secret" (116). Ultimately, Grendel's Mother's crime is worse in that she does not attack openly, but in darkness and deceit, and also in that she makes use of evil magic to do so. Of course, the crime of Grendel, Grendel's Mother, the Mermedonians, Ælfgifu of Northampton, and Ælfthryth may simply be that they are on the wrong side of the argument from the perspective of their respective authors; if such is the case, then each author's decision to characterize his or her work's villains as duplicitous, underhanded deathweavers and binders associated with evil magic, sorcery, and bonds demonstrates the honor and dishonor culturally associated with different methods of violence.[102]

The specific characteristics and liminal spaces associated with these potential death-weavers and binders have long invited a comparison between them and the shadowy characters of myth and legend well-known among the early medieval English peoples, the death-bringers of their pagan ancestors, the northern European valkyries, women or female agents of the supernatural world. Across all of the northern European cultures, the valkyries are themselves closely associated with magic, sorcery, and magical medicine; as such, they appear within the textual record of the pre-Conquest English. The most basic evidence for awareness of their existence among the early medieval English is the recurring appearance of the Old English word *wælcyrige* or "chooser of the slain" in the Old English corpus. Christine Fell states, "The existence of the English form must mean that the Anglo-Saxons had once had a similar tradition [to the Norse valkyries], and the word itself must have remained readily comprehensible throughout the Anglo-Saxon period since both its elements were in common use."[103] Within the corpus, they are always depicted as women, and the range of meanings associated with *wælcyrige* demonstrates a universal connection between the valkyries and magic.

Most extant instances of *wælcyrige* in Old English texts are glosses for Latin words for the avenging furies or battle goddesses of the Romans and Greeks, suggesting the elements glossators must have associated with the word *wælcyrige*: supernatural females who might destroy or save a warrior in their power.[104] In one instance, *wælcyrie* is paired with *gydene* "goddess." This pairing may be related to the Latin lemma, *ueneris* "of Venus,"[105] but one might wonder why *wælcyrie* would be considered an appropriate translation for Venus. Is the *wælcyrige* a seductive *ides*, or simply a pagan female figure of danger? The "Wonders of the East" explains the term differently: *Gorgoneus, þæt is*

[102] Francis Leneghan argues that Beowulf is an agent of the wrath of God against both Grendel and his mother because they represent demonic forces of evil in each of their actions ("Beowulf, the Wrath of God and the Fall of the Angels," *English Studies: Special Edition on Morality, Exemplarity, and Emotion in Old English Literature*, 105.3 (2024), 383–403), an explanation that may overlap with those argued thus far, or stand alone as an explanation for the vilification and destruction of Grendel and his mother.

[103] *Women in Anglo-Saxon England*, pp. 29–30.

[104] *Concordance*, see also *s.vv. wælcyrge, wælcyrie*.

[105] *Concordance, s.v.*

Wælcyrginc "Gorgoneus, that is 'valkyrie-like.'"[106] This particular conflation of valkyries and the Gorgons may arise from the baleful eyes associated with valkyries,[107] since the "Wonders" also describes a creature of horror and gives it *wælkyrian eagan* "valkyrie eyes."[108] The remaining references to *wælcyrige* occur in homiletic texts. In these contexts, as earlier discussed, the word is linked to other terms for witches and other reprobates, a logical association for someone considered a demonic figure or one who invokes demonic, magical forces, by post-conversion standards.[109]

Images powerfully reminiscent of valkyries also occur in the well-known Old English charm "For a Sudden Stitch," in which the narrator chants:

> Hlude wæran hy, la, hlude, ða hy ofer þone hlæw ridan
>
> ...
>
> Stod under linde under leohtum scylde,
> þær ða mihtigan wif hyra mægen beræddon
> and hy gyllende garas sændan. (3, 7–9)[110]
>
> Loud they were, lo, loud, when they rode over the barrow ... I stood under the shield, under the light shield, where the mighty women concentrated their might, and yelling, they cast spears.

The narrator repeatedly promises protection from such spears, the *hægtessan geweorc* "work of the witches" (19a), the *esa gescot* "shot of the demons/pagan gods [the Æsir]" (23a, 25a), the *ylfa gescot* "shot of elves" (23b, 25b), or the *hægtessan gescot* "shot of witches" (24a, 26a). Like most of the remaining early medieval English charms, the interpretation of this charm, as Audrey Meaney states, "has exercised the minds of a heap of learned men; fortunately, we have only to note here that the agent of inflicting harm is certainly supernatural."[111] The word *hægtessan* (related to modern "hag") appears in the Old English corpus few times outside this charm, but where it does, it glosses terms for the Roman furies, as the word *wælcyrige* does in half of its glossarial appearances.[112] It is thus fairly likely that the two words overlap in meaning for the glossators. The mean-

[106] In Andy Orchard (ed.), *Pride and Prodigies: Studies in the Monsters of the Beowulf-Manuscript* (D. S. Brewer, 1995), p. 190, §9.

[107] In the *Poetic Edda*, for example, the nobleman Hagal explains away the revealing eyes of disguised Helgi Hundingsbana by claiming Helgi is not simply a captured serving maid (which is his disguise), but a valkyrie who "sped above the clouds and dared to fight like a Viking ... that's why the Ylfing girl has terrifying eyes" (*The Poetic Edda*, ed. and trans. Carolyne Larrington (Oxford University Press, 1996), p. 133, stanza 4, lines 3–4, 7). One thinks of Grendel's glowing eyes, and by extension, those of his mother.

[108] In Orchard, *Pride and Prodigies*, p. 186, §4.

[109] *Concordance, s.v. wælcyrian.*

[110] *Anglo-Saxon Minor Poems*, ASPR 6, pp. 122–3.

[111] *Anglo-Saxon Amulets*, p. 110.

[112] *Concordance, s.vv.*, see also *s.vv. hægtes, hægtessa, hægtesse.*

SPINNING, BINDING, AND WEAVING: MAGIC AND DEATH 99

ing and imagery involved are thus rather remarkable: aggressive, death-bringing "hag/witches," women either of inhuman origin or dark magical association, ride armed from a grave mound, screaming all the while and attempting to destroy a human being. The "witches" look rather like the images of death-bringing valkyries of other Germano-Scandinavian traditions. The appearance of these females from the vicinity of the *hlæw* "burial mound/grave" is a striking connection to the typical entrance space of valkyries, who come from the realms of the slain.[113] A demonic, death-bringing spirit such as Grendel's Mother would likewise fit well into such a tradition.[114]

What may be a similar image occurs in one other charm, "For a Swarm of Bees."[115] The narrator chants to keep bees from dissipating during a swarm, calling the bees *sigewif* (9) "victorious woman" and attempting to harness their cooperation. The epithet *sigewif* seems an allusion to a martial female, one who happens to be armed with spear-like barbs and who threatens to run out of control. Some scholars list the charm as an indication of early medieval English belief in valkyries, but the context of this particular charm does not seem clear enough evidence to make quite so definitive a statement, even if it is likely.[116] The epithet may also be related to a number of other factors, including the ancient respect for bees as unusually intelligent creatures who might be flattered by what seems a term of respect.[117]

There have been many scholars that have linked the valkyries themselves to the death-bringers already discussed, Grendel's Mother in particular. Helen Damico, for example, argues that, as a death-bringing *ides*, Grendel's Mother may have some connection, or at least share characteristics, with the valkyries of Germano-Scandinavian mythology. Damico's ideas have had their detractors, but there are a number of factors

[113] In Norse tradition, for example, Helgi Hiorvardsson meets his *femme fatale*, Svava the valkyrie, as she and other valkyries ride near the burial-mound on which he is sitting (*Poetic Edda*, Larrington, p. 125). Larrington comments, "burial-mounds are places where supernatural incursions often occur" (p. 280, n. 125). Likewise, in multiple appearances in the *Poetic Edda*, Norse valkyries come riding wildly into battle on horseback (cf. p. 135).

[114] A point argued at length by Nora Chadwick in examining the striking similarities between the triads of warriors and monster characters and their interactions in *Beowulf* and a range of Norse works. In describing the remarkably similar types of heroes fighting similar troll-like characters and their mothers (all of whom inhabit liminal spaces), Chadwick asserts that most of the mothers of troll-characters have evil, supernatural associations, in one case with the valkyries and in all cases with the world of the undead ("The Monsters and Beowulf," in Peter Clemoes (ed.), *The Anglo-Saxons: Studies in Some Aspects of Their History and Culture Presented to Bruce Dickins* (Bowes and Bowes, 1959), pp. 171–203, at pp. 175–7, 180–7, and 192).

[115] *Anglo-Saxon Minor Poems*, ASPR 6, p. 125.

[116] John Mitchell Kemble, for example, supports Grimm's assertion that *sigewif* is reminiscent of and linked to the names of a number of the valkyries of Germanic mythology, including Sigrdrifa, Sigrun, and Sigrlinn (*The Saxons in England: A History of the English Commonwealth till the Period of Norman Conquest*, ed. Walter de Gray Birch (2 vols, AMS, 1971; 1876), p. 404). The visual similarity is undeniable, but *sige* is a very common epithet in Old English; the argument cannot be accepted uncritically.

[117] G. Storms, *Anglo-Saxon Magic* (Martinus Nijhoff, 1948), p. 138.

that suggest the plausibility of many of her arguments. In brief, Damico first argues that Grendel is a demon sent by fate; if so, then his mother is probably one as well. This role makes Grendel's Mother a death-bringer sent by fate, like the valkyries, who are typically death-bringers sent by fate and the old gods (demons in the new tradition) to collect the slain. Damico also argues that, particularly in a post-conversion context, "*Wælcyrge* 'chooser of the slain' ... consistently refers to creatures who are malevolent, destructive, corrupt, and associated with slaughter,"[118] a contention borne out in the glossarial and homiletic materials discussed. Grendel's Mother also fits such a description closely. She likewise has a paralytic effect upon the warriors in the hall when she attacks and fills them with terror, an effect characteristic of a valkyrie.[119] When she strikes, Grendel's Mother "seizes" the men she wishes to kill, as valkyries do in battle. Nora K. Chadwick suggests that Grendel's Mother's epithets such as *wælgæst wæfre* or "roaming slaughter-spirit" identify her with valkyries, as well.[120] The structure of the poem itself provides support for the possibility of an intentional characterization of Grendel's Mother as a valkyrie-like figure. When the poet chooses to give Grendel's Mother the title of *ides*, for example:

> Without disrupting the metrical pattern or breaking semantic congruity, he could, for example, have substituted for *ides* the more appropriate *atol* "horrid," "dire," "terrible" ... He chose instead to evoke a dialectical image encompassing two extremes of female identity – the splendid noblewoman on the one hand and the monstrous creature on the other.[121]

Damico extends her argument to include Thryth, "A similar hybrid is found elsewhere in *Beowulf* in Modthrytho, whose blend of evil spirit and beautiful form is also reminiscent of the image of the *dísir* of Old Norse literature – at once dire, vengeful war-spirits and resplendent women."[122] Thryth does seem a reasonable candidate for a valkyrie in her murderous behavior as she "weaves bonds" for the men she has selected to be killed. Further connection between Thryth and the valkyries comes from mythology, in which her name (itself not entirely unproblematic, as discussed) is linked to stories of a valkyrie married to Offa.[123] If Thryth as well as Grendel's Mother is indeed linked to valkyries and deathweaving, the *Beowulf* poet(s) may have set monstrous deathweavers in structural

[118] Helen Damico, "The Valkyrie Reflex in Old English Literature," in *New Readings*, Damico and Olsen, pp. 176–90, at p. 177.

[119] *Ibid.*, pp. 178–9.

[120] "The Monsters and *Beowulf*," pp. 176–7. She also observes that Grendel's Mother is identified as *helrunan* within the text, a word linked to a variety of "sinister spirits of the underworld" in glosses, with similar glosses for valkyries (p. 175).

[121] Helen Damico, *Beowulf's Wealhtheow and the Valkyrie Tradition* (University of Wisconsin Press, 1984), p. 69. The *dísir* of Norse mythology are often conflated with both valkyries and fates because they "concern themselves with the fates of fighting men" (*Poetic Edda*, Larrington, p. 283, n. 156).

[122] Damico, *Beowulf's Wealhtheow*, p. 69.

[123] *Ibid.*, p. 28.

opposition to the *freoðuwebbe*-associated characters in the text. The poet's direct and intentional opposition of Thryth and Hygd supports this contention, and an opposition of interest is clear in Grendel's Mother's case as she seeks to destroy the community preserved by Wealhtheow's peace-keeping through her own death-bringing.

Among contemporary scholars, however, there are those who scoff at the notion of overt valkyrie imagery in *Beowulf* and other Old English texts. To an extent, such skepticism is appropriate; even in *Beowulf*, neither Grendel's Mother nor Thryth could possibly be valkyries in a clear or direct way, given the narrator's post-conversion, Christian worldview as well as the fact that neither character seems to fulfill either of the classic functions of valkyries: serving Woden in Valhalla or allotting death in battle. At the same time, both female characters share enough characteristics with death-bringing valkyries to suggest a similar set of nuances is at play within their characterizations in *Beowulf*. It is, after all, quite clear from a variety of evidence in the Old English and Anglo-Latin corpus that the early medieval English people had some belief in the existence of sinister, magical, death-bringing women like the valkyries and an awareness of their characteristics, whether they thought of them as religious figures or demonic spirits by the time references enter the written tradition. Northern European valkyries with such characteristics are closely associated with both textile and binding imagery in the analogical traditions of the early medieval English peoples' closest neighbors. I will discuss this evidence in the next section.

PARALLELS AND ANALOGUES: MAGIC, DEATHWEAVING, AND TEXTILE IMAGERY

The matters discussed to this point in the chapter – magic, secretive death-bringing, and textile and binding imagery – have interesting parallels in the respective textual and oral traditions of the neighbors and cultural ancestors of the early English peoples. The many Latin and northern European analogues, early and late, that link textile and binding imagery to magic (usually centering in references to women) may well illuminate a common heritage that helps explain why we see such images and metaphors in Old English texts. At the same time, there are a number of instances across the world that make similar connections, particularly between magic and binding. An early Babylonian incantation against an evil sorceress, for example, asks that her "knot be cut in twain, her work destroyed,"[124] and this is one example of the many that could be drawn from cultures across millennia in Central America, India, Japan, and Africa.[125]

Among the textual traditions most likely to have influenced early medieval English writers, the earliest extant Greek texts include associations between binding and magic,

[124] Quoted in Lynn Thordike, *A History of Magic and Experiential Science during the First Thirteen Centuries of Our Era* (Columbia University Press, 1964; 1923), vol. 1, p. 19.

[125] See enumeration of multiple examples from around the globe in *The Encyclopedia of Religion*, ed. Mircea Eliade and Charles J. Adams (Macmillan, 1987), vol. 8, pp. 340–2. See also Russell, *Witchcraft in the Middle Ages*, p. 15.

as Medea is linked to "spell-binding magic,"[126] and more images and references appear in a wide array of contexts in Roman literature, early and late. Derek Collins states that, "binding magic" happens to be "Among the most widely employed kinds of magic" in Greek and Roman magical texts.[127] According to Collins's research, among the most frequent are references to the binding of amuletic curse charms, and this contention finds support at a linguistic level for the Latin examples. In Pliny's remedy sections of *Naturalis Historia*, although Pliny uses the term *amuletum* for "amulet," he very frequently prefers *adalligatus* (*ad* + *al* + *ligo*), a word based on *ligare* "to bind," for the same.[128] A link between amulets and *ligare* would be logical, given that amulets seem often to have been tied to the afflicted (or targeted) person, something representative of them, or a location associated with the supernatural force being invoked for assistance in the cursing or blessing. The linguistic connection is persistent in Augustine's and Isidore's respective interdicts against magical practices: they both use the word *ligaturae* to mean amulets, and both equate it to objects being suspended (Augustine: *suspendis*) or tied (Isidore: *ligandis*) to someone or something.[129] Knots in thread or cord were not only magical when used to suspend an amulet; according to Pliny, the famous knot of Hercules was medico-magical in its own right.[130] Virgil's shepherd-poet Alphesiboeus has his poem's female narrator resort to love knots as part of her magical charm, one that will either bring back her beloved, or destroy him.[131]

Outside of knots and related binding imagery, however, it is surprising how very few connections appear in the Latin corpus between magic-makers and other "threaded" actions, including spinning and weaving. Database searches using *nere*, *texere* (and variants), and *nectere* paired with Latin words for magic-makers such as *magicus, magus, saga, striga, malefico/a,* and *venefica* result in no instances at all. Searches for *nere* or *texere* + *ligatura* or *nodus* (both of the latter words can mean "bond, knot") also provide no examples

[126] Scheid and Svensbro, *Craft of Zeus*, p. 58; Detienne and Vernant, *Cunning Intelligence*, p. 189.

[127] Cf. "Binding Magic and Erotic Figurines," in particular, in *Magic in the Ancient Greek World* (Blackwell, 2008), pp. 64–103. The quotation comes from p. 64.

[128] See book 29, chapter 38, section 132, in *Pliny: Natural History*, ed. and trans. W. H. S. Jones, Loeb Classical Library, 418 (10 vols, Harvard University Press, 1975; 1963), vol. 8, p. 266. Quotations from Pliny throughout this section are drawn from Jones's edition. This word form is related to the verb used in the story of Wilfrid by Eddius Stephanus, although the verb does not seem related to amulets there.

[129] *LLTO: De doctrina christiana*, book 2, chapter 20, line 10 (Augustine) and *Etymologiarum siue Originium*, book 8, chapter 9, part 30 (Isidore). In this sense of the word, we find even Boniface condemning binding. See a fascinating overview and citations in Sir William Smith and Samuel Cheetham's *A Dictionary of Christian Antiquities: Being a Continuation of the "Dictionary of the Bible"* (2 vols, J. B. Burr, 1880), vol. 2, pp. 990–2.

[130] Book 28, chapter 17, section 64 (8.46).

[131] Eclogue 8, in Virgil, *The Eclogues and Georgics of Virgil*, trans. C. Day Lewis (Anchor/ Doubleday, 1964), lines 76–9.

SPINNING, BINDING, AND WEAVING: MAGIC AND DEATH

linked to magic, and none occur for *nectere* + *nodus*.[132] That there is at least a connection between *nectere* and *ligare* "to bind" is indisputable, as Pompeius Festus states, *Nectere ligare significat* "*Nectere* means *ligare*."[133] If anything, however, the equation undercuts the notion that we are looking at a spinning or weaving metaphor when *nectere* is involved, particularly in the context of "fetters"; instead, in such a context, *nectere* would imply its primary sense "to join, connect" or "to intertwine."

Some indirect imagery suggests a classical correlation between spinning and superstitious belief, at least. Pliny describes a custom of rural farmlands that *cavetur ne mulieres per itinera ambulantes torqueant fusos aut omnino detectos ferant* "forbids women to twirl their spindles while walking along the road, or even to carry them uncovered," all to keep the spindles from touching the ground and purportedly blighting the harvest.[134] There is also an instance in the Latin corpus that connects *texere* and *ligare*, albeit rather indirectly, in the context of the description of magic in Seneca's play *Medea*. Medea invokes Hecate, and among other offerings, presents an interwoven object, *Tibi haec cruenta serta texuntur manu, / novena quae serpens ligat* "For you these bloody wreaths are woven by hand, which nine, a serpent binds."[135] The wreath is more likely to be constructed of plant material than plant or animal fibers or threads, although the interweaving is clear, and the image is certainly evocative of amulets and curse charms. One line from Pliny's *Naturalis Historia* reports a remedy which calls for a thread taken from a woven web, *liceum telae*, a thread which will be tied in knots to help afflictions of the groin.[136] The thread, like the "woven" or "interwoven" wreath, appears amuletic, at the least. Most other instances of potential textile imagery for magic involve *nectere* (or variants such as *subnectere*) in the context of amulets and thread, meaning, they can only be considered textile metaphors in the sense of knotting thread or cords; binding, however, naturally includes working with cords not made of textile fibers.[137] One beautiful example of *nectere* in the sense of "binding" is the love charm from Virgil's Eclogue 8:

> terna tibi haec primum triplici diversa colore
> licia circumdo, terque haec altaria circum

[132] *LLTO, s.vv.* There are also no examples that link *obligamentum* with any of the other search terms in the Latin corpus.

[133] *LLTO: Epitoma operis de uerborum significatu Uerrii Flacci*, p. 160, line 14 (second century AD). Paul the Deacon lists the same equation in the eighth century, and both authors were known to the pre-Conquest English, although we are not certain they had access to either of these particular texts (see Helmet Gneuss, "The Study of Language in Anglo-Saxon England," in Donald G. Scragg (ed.), *Textual and Material Culture in Anglo-Saxon England: Thomas Northcote Toller and the Toller Memorial Lectures* (D. S. Brewer, 2003), p. 90).

[134] Book 28, chapter 5, section 28 (8.20).

[135] *LLTO:* verses 771–2.

[136] Book 28, chapter 11, section 48 (8.36). Jones is reading *liceum* as *licium*, a logical inference given the presence of *telae*. This thread is roughly equivalent to the heddle thread used in an English remedy discussed in an earlier section.

[137] See, for instance, *Pliny: Natural History*, book 28, chapter 5, section 29 (8.22).

effigiem duco; numero deus impare gaudet.

…

necte tribus nodis ternos, Amarylli, colores;
necte, Amarylli, modo, et "Veneris," dic, "vincula necto."

I have fashioned an image of Daphnis. Three threads
Of three different colours about it I lace.
Then bearing this mommet I've fashioned, three times –
Odd numbers bring luck – round the altar I pace.

…

Amaryllis, now plait you and fasten the threads –
These tricoloured threads in a triplicate knot:
And while, Amaryllis, you're twining them, chant
This cantrip – "It's Venus's chains that I plait."[138]

The thread used is *licia*, meaning it may be associated with weaving, and a similar image opens the poet-shepherd's song, as his female narrator calls for *Molli cinge haec altaria vita* "wool-wreaths to garland the shrine" (63). The latter images are also reminiscent of Seneca's and Pliny's respective connections between weaving and a magical context. It is not likely a coincidence that three of these four instances are spoken through the voice of female narrators (Medea and the lovesick woman of the Eclogue). Nonetheless, the connections between magic and binding are strong in early Latin texts, while connections between spinning, weaving, and magic are surprisingly few and far between in the Latin literary corpus.

When examining the connection between the commission of deceitful or violent death (potentially magical) and cloth and loom, however, there are more classical parallels. As Marcel Detienne and Jean-Pierre Vernant point out, in Aeschylus's *Agamemnon*, Clytemnestra is portrayed as the evil and deceitful genius responsible for her husband's death as she traps Agamemnon (who has ritually slaughtered their daughter) in a woven cloth from which he cannot escape during a fatal attack.[139] They comment, "Wherever cunning plotting or fraudulent manoeuvring is concerned the Greek likes to believe that it is a matter for a woman."[140] Other potential examples related to "the weaving of death" as a metaphor occur in the early Latin corpus, with one example of the metaphor as *letum + texere* and a handful of possible examples of *letum + nectere*.[141] The earliest example of *letum + texere* which appears to mean "deathweaving" unequivocally is a passage in an elegy from Propertius (first century BC). Lamenting the death of a drowned friend, he sorrowfully instructs others to go ahead and build more ships, *leti texite causas* "weave

[138] *The Eclogues and Georgics of Virgil*, trans. Lewis, lines 72–4, 76–7.

[139] *Cunning Intelligence*, p. 296.

[140] *Ibid.*, p. 321, n. 78.

[141] *LLTO*: Elegy 7 (book 3) of Sextus Propertius; Virgil (book 12, verse 603), discussed above; later authors who borrow his line (Donatus, Jerome, Lactantius, and Sedulius Scottus); and Statius.

engines of death."[142] The most well-known example of *letum* + *texere*, however, occurs in a passage in Virgil which describes the suicide of Queen Amata when she assumes Turnus has fallen in battle. Distraught, *nodum informis leti trabe nectit ab alta* "she fastens/connects/interweaves a knot of shapeless death on a high beam" (book 12, line 603) and hangs herself. The latter example is not a very sure example of "deathweaving," as other senses are equally possible and perhaps more probable, as the product of her actions is a knot, suggesting a binding, rather than a weaving image, but the image itself is influential and is used among a number of later authors (each known to the early medieval English). Potentially similar patterns include *mors* + *texere* and *mors* + *nectere*; however, there are no examples of the first, and a handful of possible examples in Statius of the second.[143] Interestingly, both of the suggestive examples from Statius refer to thwarted actions of the "Fates" as bringers of death, and will be addressed in Chapter 4.

Patricia Joplin discusses a similarly bloody set of incidents in Ovid's *Metamorphoses*, which she argues pits peace-making and cunning death-making against each other in the story of Procne and Philomela: "There are, after all, two women, and peace (making) and violence (unmaking) are divided between them."[144] Procne may be considered a peace-maker in that her father wed her to Tereus to form an alliance between Thrace and Athens (mirroring, in fact, the definition for marital peaceweaving) (426–8).[145] For her part, Philomela may be considered a violence-maker because she "tells" Procne that Tereus has raped and mutilated her. What makes this "telling" especially compelling is that she does not communicate with spoken words (as Tereus has silenced her by cutting out her tongue), but with woven images; she weaves her story into a cloth and sends the cloth to her sister (576–80). Philomela's woven cloth is an instigator to vengeful thoughts: an enraged Procne *legit* "reads" the textile (582), frees her sister, and, with Philomela's help, slaughters her child to feed to his father Tereus (641–9). In some ways, it is problematic to divide the peace- and death-making between the sisters, however, as only Procne makes peace and both sisters engage in violence; if anything, the opposition between Procne's original role as peace-maker and later role as death-bringer is stark, demonstrating that the same female character can act for either end, as does Thryth in *Beowulf*. It is equally interesting that Philomela's call for vengeance comes through her weaving, although the weaving is not equated to an instrument or method of death, making the story a very indirect possible source of any images linking weaving to violence in Old English texts.

[142] *Propertius*, ed. and trans. H. E. Butler, Loeb Classical Library, 18 (W. Heinemann, 1976; 1912), book 3, elegy 7, line 9.

[143] *LLTO, s.vv.* Surprisingly, searches revealed no contemporary examples of *obitus* + *texere* or *obitus* + *nectere*.

[144] "The Voice of the Shuttle Is Ours," *Stanford Literature Review*, 1 (1984), 25–53, at p. 47.

[145] All citations from the *Metamorphoses* are taken from Ovid, *Ovid in Six Volumes: III. Metamorphoses*, ed. and trans. Frank Justus Miller, Loeb Classical Library, 42 (Harvard University Press, 1977). Where the work is quoted, translations are mine.

Of these sources, ancient Greek texts are by far the least likely to have influenced the pre-Conquest English, as there is no indication that at any time in the period they had access to the works of Plato or the classical Greek dramatists. Virgil and Ovid, however, were most certainly known to the early medieval English, through their own works and commentary by others, and also probably Pliny; on the other hand, Lapidge states that there is no evidence to attest to the works of Propertius in any early medieval English library.[146] There is much more evidence, however, that biblical and early medieval texts in Latin could have influenced appearances of weaving and binding metaphors for magic and violence.

Two very likely sources of influence in general include Latin biblical texts and later Latin verse. In the Vulgate, a passage from Hezekiah's psalm (Isaiah 38:9) envisions the bringing of death as the act of a weaver cutting down the warp. The phrase appears, for example, in the Lambeth Psalter (London, Lambeth Palace, MS 427): *Praecisa est velut a texente vita mea dum adhuc ordirer succidit me*[147] "My life is cut off, just as by a weaver; while yet I was beginning (or being laid as a warp), he/she cut me off from below." The influence of this text is more than usually demonstrable because the line appears in a manuscript known to have been created by an early medieval English scribe. What makes the example from the Lambeth Psalter more intriguing, however, is the Old English inter-linear gloss which accompanies the Vulgate: *Forcorfen is swylce fram wefendum wife lif min þa gyt þe ic wæs gehefaldad heo forcearf me*. In most respects, the Old English lines follow the original closely, even mirroring the word order of the Latin. Unsurprisingly, *wefan* is equated to *texere* (both "to weave") and *gehefeldian* to *ordior* (both "to begin" or "to lay a warp"), but the latter is a revealing choice. The Latin *ordior* can mean both "begin" and "lay the warp," and the Old English glossator's choice *gehefeldian* over another word for "begin" demonstrates that he or she saw the wordplay available in the linkage of *texente* and *ordirer*. In other words, the glossator saw the inherent possibilities of textile meta-phor in the Latin and rendered them explicit in Old English.

The verb *gehefeldian* is a clear reference to "heddling" or tying the heddles to the warp as the web is laid on the loom, as discussed in Chapter 1. The image is evocative from a textile perspective: Hezekiah would hardly expect, as a metaphorical web of life, to be cut from the loom, when his threads are just being laid and bound, or his life has just begun. What may be equally significant about the gloss, however, is the assignment of gender to the Vulgate's unidentified weaver: the Old English glossator identifies the weaver as a *wefendum wife* "a weaving woman," a *heo* "she." In other words, the early medieval English writer who glossed the Lambeth Psalter strengthened the textile imagery within Hezekiah's psalm and explicitly made the death-bringing weaver a woman. The Lambeth

[146] *The Anglo-Saxon Library* (Oxford University Press, 2006), pp. 67 and 323, respectively.

[147] *Der Lambeth-Psalter: eine altenglische Interlinearversion des Psalters in der Hs. 427 der erzbischöflichen Lambeth Palace Library*, ed. U. Lindelöf, Acta Societatis scientiarum fennicae, 35.1 (Helsingfors: Druckerei der Finnischen Litteraturgesellschaft, 1909–14), vol. 1, p. 236. Found at https://archive.org/stream/derlambethpsalte01lind#page/236/mode/2up/search/texente.

glossator's *wefendum wife* is a clear example of a deathweaving metaphor from one culture being translated into the cultural idiom of another: a weaver of peace or death, through an early medieval English lens at any point in the period, would most likely be a woman.

While there are no extant Old English translations of the book of Job, we know the pre-Conquest English knew the book, and a similar image appears there. In the Vulgate version, Job 7:6 reads, *dies mei velocius transierunt quam a texente tela succiditur*[148] "My days have passed by more quickly than a web is cut down by a weaver." Both images are evocative of deathweaving images in Old English literature, and both are likewise similar to some of the fatal and creationary weaving images to be discussed in Chapter 4.

A fourth-century Latin poet known to be an influence on the early medieval English[149] also uses an image reminiscent of deathweaving. In his *Liber Cathemerinon*, a collection of daily hymns, Prudentius includes one hymn about death, which sorrows,

> quia cuncta creata necesse est
> labefacta senescere tandem,
> conpactaque dissociari,
> et dissona texta retexi.[150]

> For all that is created must in the end grow weak, grow old, and all things grown together must separate and discordant tissues/webs must be uncovered/unwoven.

As is evident from this translation, Prudentius is clearly playing on layers of meaning within the hymn, as does the Old English glossator of the Lambeth Psalter. The word *textum* most often means "web" or "text," but, as will be discussed in Chapter 4, it can also be used metaphorically and poetically for a "web of life" or "living tissue." The passive verb form *retexi* usually means "to be uncovered, revealed" but is clearly intended to mirror *texta*, in which case *retexi* would have the subtle additional meaning, "to be unwoven." The sense can thus read that with inevitable aging and death, all bonds, including those within the tissues of the human body, must be uncovered and broken and must decay. It can also read that with inevitable aging and death, all bonds, including those that are woven, must be unwoven by or within death itself. In a figurative sense that mirrors both biblical texts, as well, death is imagined as an un-weaver of the bonds made in life. Could the deathweaving he discusses so poetically have informed the Old English metaphors related to the weaving of death or the weaving of peace? In the case of peace-weaving, such an influence would have been by virtue of oppositional imagery, a rather indirect possibility. In the case of weaving webs of destruction, such an influence is far more possible.

[148] *LLTO.*

[149] Lapidge, *Anglo-Saxon Library*, p. 140, etc.

[150] *Prudentius*, ed. and trans. H. J. Thomson, Loeb Classical Library, 387 (Harvard University Press, 1949), vol. 1, pp. 84 and 86, hymn 10, lines 13–16. Translations for this work are mine.

A final instance of early Latin evidence, although it does not qualify as "deathweaving," does relate to the woven treacheries, avoided or expressed, in *Beowulf* and *Andreas*. In his work *The Golden Ass*, Apuleius (second century AD) relates the tragic story of Psyche, her family, and Cupid. As he describes the machinations against her by Psyche's jealous sisters, one says to the other, *exordio sermonis huius quam concolores fallacias attexamus* "with such forged lies as this let us colour the matter,"[151] or alternately, "with the warp of this discourse, let us weave how you may color such artifices." It is fascinating, of course, that the women are depicted as thinking through their strategies from the perspective of destructive weavers.

Extant magico-medical texts compiled among the pre-Conquest English indicate their debt to and awareness of Latin (and perhaps by translation, Greek) medical texts and associated imagery of binding thread and cloth. The Lambeth Psalter gloss suggests the early medieval English were likewise well aware of biblical imagery for death as the cutting of the web of life from a loom, and also indicates they visualized this figure as a weaving woman. Are associations of magic, violence, and weaving and binding in Old English texts and early medieval English culture then evocative solely of a treasured metaphorical inheritance from Latin text? While the Latin texts referenced may very well have influenced the development of deathweaving metaphors, the other cultural traditions available to the early medieval English in the northern European sphere also contain a rather striking abundance of references to weaving and binding images linked to magic, violence, and women, and should likewise be taken into consideration.

For example, the much-debated First Merseburg Charm, considered a very early and surprising survival of an Old High German pagan charm and dated in its manuscript context between 750 and 925, depicts women often identified as valkyries binding and unbinding the shackles of prisoners:

> Eiris sazun idisi sazun hera duoder
> suma hapt heptidun suma heri lezidun
> suma clubodun umbi cuoniouuidi
> insprinc haptbandun inuar uigandun. H.

> Once the women [*i.e.*, Valkyries] were settling down here and there. / Some were fastening fetters, others were hindering the host, / Others were picking apart the fetters: / Escape the bonds of captivity, flee from the foe.[152]

As are the parallel Old English sources, this text is a charm, a collection of words intended to either bind or unbind, to bring healing and protection, or to bring destruction, all through metaphorical (or literal) invocation of supernatural forces. Unsurprisingly,

[151] *Apuleius: The Golden Ass*, ed. G. P. Goold, trans. W. Adlington, rev. S. Gaselee, Loeb Classical Library, 44 (Harvard University Press, 1977), book 5, part 16, pp. 224–5.

[152] Susan D. Fuller, "Pagan Charms in Tenth-Century Saxony? The Function of the Merseberg Charms," *Monatshefte*, 72 (1980), 162–70, at p. 162. Translation by Fuller.

SPINNING, BINDING, AND WEAVING: MAGIC AND DEATH 109

the forces imagined as freeing the warriors are magical and female, *idisi*, the Old High Germanic linguistic parallel to Old English *ides*.

The most striking imagery connecting valkyries and textile imagery occurs in the Old Norse poem *Darraðarljóð*, which appears in *Njal's Saga* (c.1280). The poem rather graphically describes valkyries in a hut in Scotland weaving a slaughter web which predicts as well as determines the course of the Battle of Clontarf, fought in Ireland in 1014 between two Viking armies.[153] A man named Dorrud witnesses the unfolding action. First, he sees twelve riders go into a woman's room, and as he looks in to find out what is happening, he sees strange women working before a grisly loom, chanting a horrific song as they work:

> Blood rains
> From the cloudy web
> On the broad loom
> Of slaughter.
> The web of man,
> Grey as armour,
> Is now being woven;
> The Valkyries
> Will cross it
> With a crimson weft.
> The warp is made
> Of human entrails;
> Human heads
> Are used as weights;
> The heddle-rods
> Are blood-wet spears;
> The shafts are iron-bound,
> And arrows are the shuttles.
> With swords we will weave
> This web of battle.[154]

The song rather explicitly equates the process of textile production with the metaphorical process of choosing who is to be slain, thus deciding the fates of human beings on "the broad loom of slaughter." The bloody "parts" of the loom indicate that the poet imagines the valkyries using a warp-weighted loom, with heads as loom weights and heddle rods made from bloody spears. The "shuttle" passes back and forth in the form of arrows as the death-bringers weave "With swords ... This web of battle." The envisioning of textile tools as weapons is strongly reminiscent of the web-stabbing sword of Riddle 56 and related images.

[153] Nanna Damsholt, "Role of Icelandic Women in the Sagas and in the Production of Homespun Cloth," *Scandinavian Journal of History*, 9 (1984), 75–90, at p. 87.

[154] *Njal's Saga*, trans. Magnus Magnusson and Hermann Pálsson (Penguin, 1960), p. 349.

In conjunction with these dire and bloody descriptions, the valkyries sing or chant lines which seem reminiscent of the rhythmic weaving and spinning songs of textile workspaces, repeating "Let us now wind / The web of war" as the precursor to each fatal decision concerning the battle, as in this instance:

> Let us now wind
> The web of war,
> Where the warrior banners
> Are forging forward.
> Let his life
> Not be taken;
> Only the Valkyries
> Can choose the slain.
> Lands will be ruled
> By new peoples
> Who once inhabited
> Outlying headlands.
> We pronounce a great king
> Destined to die;
> Now an earl
> Is felled by spears.[155]

The weaving song proves prophetic to the outcome of the battle, as the bloody passing of weapons back and forth in the fatal loom preserves some men and dispatches others. The valkyries then depart with a fierce energy reminiscent of the Old English charm "For a Sudden Stitch": "Let us ride our horses / Hard on bare backs, / With swords unsheathed, / Away from here."[156] Upon the completion of their chant, the women tear "the woven cloth from the loom and rip it to pieces, each keeping the shred she held in her hands."[157] The valkyries of the poem are obviously magical women. They weave destruction in secret for others, much like Grendel's Mother or the Mermedonians. In an area normally "the sphere of peace, the home and women,"[158] this is destructive weaving that rips the "web of man" or life itself.

Interestingly, around the same time as the battle (depicted much later) in *Njal's Saga*, a second such connection is made, but among the continental Saxons. In the *Corrector* (compiled *c*.1010), a penitential that, "following the Frankish penitentials, combines Irish and Anglo-Saxon penitential canons with Roman,"[159] Burchard of Worms discusses penalties for behaviors of women that involve both weaving and magic:

[155] *Ibid.*, p. 350.

[156] *Ibid.*, p. 351.

[157] *Ibid.*

[158] Damsholt, "Role of Icelandic Women," p. 88.

[159] John T. McNeill and Helena M. Gamer, *Medieval Handbooks of Penance: A Translation of the Principal* libri poenitentiales *and Selections from Related Documents* (Columbia University Press, 1938), p. 331.

Hast thou been present at or consented to the vanities which women practice in their woolen work [*lanificiis*], in their webs [*telis*], who when they begin their webs [*ordiuntur telas suas*] hope to be able to bring it about that with incantations and with the beginning of these the threads of the warp and of the woof [*fila staminis, et subtegminis*] become so mingled together that unless they supplement these in turn by other counter-incantations of the devil, the whole will perish? If thou hast been present or consented, thou shalt do penance for thirty days on bread and water.[160]

Weaving is not the sole textile process condemned, however. In another section, he warns:

Hast thou done what some do on the first of January ... who on that holy night wind magic skeins, spin, sew [*filant, nent, consuunt*]: all at the prompting of the devil beginning whatever task they can begin to account of the new year? If thou hast, thou shalt do penance for forty days on bread and water.[161]

What makes Burchard's pronouncement against these kinds of actions of particular interest is that it is not a unique example. Other continental penitential and homiletic collections of even earlier date are replete with references to similar superstitions. Eligius (seventh-century, northern France), who spent much of his life combating paganism among the Germanic tribes in his area, condemned naming others to harm them during dyeing of cloth or working at the loom; the *Homilia de Sacrilegiis*, an eighth-century homily from the same region, condemns the working of wool in the context of magic. The perhaps related early ninth-century Penitential of Silos (northern Spain) also condemns the working of wool in the context of magic, and Hincmar of Rheims (ninth-century Carolingian archbishop) forbids the naming of enemies while weaving. In the same context, Hincmar likewise forbids measuring with threads (a curious detail perhaps related to the discussion of measuring in Chapter 4).[162] Burchard is thus not alone in naming weaving and magic, but he is unique among these sources for his level of detail in describing the 'magical' weaving and its purported methods and intent. Of particular interest are the well-known cultural connections between the pre-Conquest English and the majority of the peoples represented by these references.

Runic magic in much later Norse texts also involves weaving; in the saga of the Volsungs (late thirteenth century), Brynhild explains what she knows about runes: "You shall learn speech-runes, if you want no man to pay back harm with spite. These wind, these weave, these bring all together at the Þing." She likewise explains that there are "birth-runes" that will allow their users to "ask the guardian women for help" during

[160] In McNeill and Gamer, *Medieval Handbooks of Penance*, p. 330. Latin from Burchard, *Burchardi Wormaciensis Ecclesiæ Episcopi: Decretorum*, ed. J.-P. Migne, *PL*, 140 (Migne, 1853), p. 961, accessed at http://www.documentacatholicaomnia.eu/02m/1000-1025,_Burchardus_Wortatiensis_Episcopus,_Decretorum_Libri_Viginti,_MLT.pdf.

[161] *Ibid.*, p. 335; Burchard, *Burchardi Wormaciensis*, Migne, p. 965.

[162] For summary and citation for each of these latter four sources, see Valerie I. J. Flint, *The Rise of Magic in Early Medieval Europe* (Princeton University Press, 1991), pp. 226–7.

birth.[163] Compiled at around the same time (but often thought to be based on much earlier tradition), the poems of the *Poetic Edda* show valkyrie swan-maidens surprised by Weland and his brother while they are "spinning linen."[164] Elsewhere within the *Poetic Edda* in "The Lament of Oddrún," the legendary Brynhildr is named a valkyrie and then described as weaving.[165] The other neighbors of the early medieval English, the Celts, likewise have at least some images that connect magic, women, and weaving. An Old Irish recension of "The Cattle-Raid of Cooley" (eleventh century) includes a prophetess who arrives and warns troops of approaching destruction. She carries what has been interpreted to be a weaver's beam or a distaff and seven strips, "threads woven together, then interpreted to read the future."[166]

While some of these northern European poetic texts are too late to have affected (or reflected) early medieval English imagery, others are not, and all are of an age to showcase what may be a northern European tradition that connects magic not only to binding, but also to spinning and weaving, particularly when women are the sources of the magical acts. Historical evidence from northern Europe reinforces this idea. Just as aggressive women in the pre-Conquest English historical tradition, like their literary counterparts in the Old English corpus, are linked to violent death-bringing, are often associated with weaving or binding, and are villainized, so the same trends appear in the later historical traditions of other northern European authors.[167] The *Gesta Danorum* of Saxo Grammaticus, written in late twelfth- or early thirteenth-century Denmark about Heroic Age Denmark, describes Skuld, sister to Rolf (Hrothulf of *Beowulf*), king of the Danes, as a woman who, growing tired of her noble husband's duty to pay Rolf tribute,

[163] In Daniel G. Calder, Robert E. Bjork, Patrick K. Ford, and Daniel F. Melia (eds and trans), *Sources and Analogues of Old English Poetry: The Major Germanic and Celtic Texts in Translation* (2 vols, D. S. Brewer, 1983), vol. 2, p. 90. I will return to the association between mortal women, supernatural female forces (who appear to spin and weave), and childbirth in the subsequent chapter.

[164] *Poetic Edda*, Larrington, p. 102.

[165] In Calder *et al.*, *Sources and Analogues*, vol. 2, p. 33.

[166] William Sayers, "Old Irish *Fert* 'Tiepole', *Fertas* 'Swingletree' and the Seeress Fedelm," *Études Celtiques*, 21 (1984), 171–83, at p. 178. Sayers is commenting on the translation of the story by Cecile O'Rahilly.

[167] Drawing from some of this later material, in her article, "Weavers of Peace, Weavers of War," Lori Eshleman argues that eighth- and ninth-century, early Viking memorial stelae from Gotland provide archaeological and art-historical evidence for Scandinavian parallels to tensions between peaceweaving in Old English texts and deathweaving in Norse and Old English texts. Examining the iconography of the stelae, she identifies two symbolic roles of Viking women, with some stelae showing women offering the mead cup to warriors (which she identifies as peaceweaving) and others showing women standing between two groups of armed men (which she identifies as deathweaving, although I would argue it could just as easily show peaceweaving) ("Weavers of Peace, Weavers of War," p. 16). Interestingly, she identifies the iconography for both with the tradition of the valkyries and with magic, particularly with Hild (pp. 23, 26, 28). The identifications of the Viking Age drawings with these roles are compelling suggestions, but also obviously rather speculative ones.

SPINNING, BINDING, AND WEAVING: MAGIC AND DEATH

"bent her mind to evil contrivances" by inciting her husband to *insidias Roluoni nectendas* "weave snares for Rolf" that ultimately prove Rolf's destruction.[168] The narrator evinces clear contempt for both Skuld and her husband for their use of deceit, stating elsewhere that even when necessary, to attack in secret *latrocinium* "like a thief," *nocturna fallacia* "with nocturnal subterfuge" and *clandestinas insidias* "concealed ambush" instead of showing strength openly has the added result *maculare* "to sully" a man's fame.[169] In other Icelandic sources roughly contemporary with the work of Saxo Grammaticus, Skuld is depicted as a sorceress of "elfin stock" with "elves and norns and other creatures" in league with her to bring about Rolf's destruction.[170] Like Grendel's Mother, the Mermedonians, and the deathweaving Anglo-Danish and early medieval English women of later English history, Skuld is depicted as engaging in secretive deceit and sorcery in the weaving of wiles, and for such behavior, she is roundly criticized and demonized.

In many ways, Skuld is also reminiscent of Queen Kriemhild of the *Nibelungenlied* (thirteenth-century, Middle High German). Kriemhild, like Skuld, is demonized, a *vâlandinne* or "she-devil" who plots revenge against her brothers and practices "many foul wiles."[171] In her case, there is no reference to wile-*weaving*, but her vilification appears to derive from the same impulse as Skuld's: although Kreimhild is originally a heroine as the bride of Siegfried, she becomes a villain as she plots against kinsmen in secret, and perhaps as she plots revenge as a woman. In some ways, female characters make a natural target for such vilification; open warfare such as Beowulf engages in is generally based on male strength, while secretive and subtle vengeance, the way available to Kriemhild to avenge her lord, is condemned. Interestingly, Kriemhild's parallel in Norse tradition, Gudrun, is not vilified for her role as avenger, perhaps because she does not murder her brothers, although she still contrives to murder her sons and feed them to Attila, as well as to arrange his demise.[172]

Another Gudrun, an Icelandic noble woman in the *Laxdæla Saga* (*c.*1245), differs from both Skuld and Kreimhild in that she is not necessarily demonized for her role in bringing death to others. Gudrun incites her husband Bolli to kill her former lover Kjartan, but while the narrator depicts Gudrun as proud, vengeful, and rather cruel, she

[168] Saxo Grammaticus (Latin): *Saxonis Grammatici: Gesta Danorum*, ed. Alfred Holder (Karl J. Trübner, 1886), vol. 2, p. 57, lines 38–9). The full Latin phrase reads, *ad insidias Roluoni nectendas perductum atrocissimis nouarum rerum consiliis imbuit.* Saxo Grammaticus (translation): *Saxo Grammaticus: The History of the Danes*, ed. Hilda Ellis Davidson and trans. Peter Fisher (2 vols, D. S. Brewer, Rowman, and Littlefield, 1979), vol. 1, p. 56.

[169] Latin: *Saxonis Grammatici*, Holder, vol. 9, p. 309, lines 27–31. Translation: *Saxo Grammaticus*, Davidson and Fisher, vol. 1, p. 287.

[170] See "Saga of Times Past," in Gwyn Jones (ed. and trans.), *Eirik the Red and Other Icelandic Sagas* (Oxford University Press, 1980; 1961), p. 308.

[171] *The Nibelungenlied*, Hatto, pp. 218 and 317, respectively.

[172] See, for example, the summary of her role in the tales of the Volsungs (*The Poetic Edda*, Larrington, pp. xx–xxi). For more extensive exploration of suggestive similarities between the Volsungs and the *Nibelungenlied* and Grendel's Mother, in particular, see Vowell, "Grendel's Mother," pp. 239–55.

is neither a sorceress nor a deceitful weaver of wiles. Interestingly, though, Gudrun parallels her textile work to Bolli's death-work in killing Kjartan. As Bolli returns to report the deed, Gudrun answers, "Morning tasks are often mixed: I have spun yarn for twelve ells of cloth and you have killed Kjartan."[173] Beyond this subtle parallel syntax lies a stronger parallel in etymology. Nanna Damsholt translates the statement, "Great *vaðaverk* have taken place today: I have spun 12 ells of yarn and you have killed *Kjartan*."[174] Gudrun thus implicitly connects her work with death. It may be that Gudrun, unlike the other female characters, is not demonized because she relies on Bolli to do her fighting and states her purposes openly and directly, and because Bolli fights openly with Kjartan rather than deceitfully (though the odds were still five to one). Her role as "inciter to oaths," a role which some associate with the "peaceweaver," here works to similar effect to Wealhtheow's: she incites violence that engenders further violence throughout the work. Gudrun seems closely related to the tradition of the Norse *Hetzerin*, female characters who provoke vengeance and violence in the sagas.[175]

The thirteenth-century *Poetic Edda* does not show deathweaving, but it does include a similar image of wile-weaving. As Sigurd discusses his impossible situation in acting for Gunnar to gain Brynhild's hand while deceiving her, he asks his companion Gripir, "What compensation will that bride [Brynhild] accept, when we've woven for her such deceit?"[176] Curiously, the textile reference is associated with male characters, but as they discuss a female character. Such wile-weaving, while not deathweaving, is still associated with the same, clearly negative characteristic of deceitful dealing.

Another group closely connected to the early medieval English peoples, the Celtic Irish, have in their tradition an interesting parallel to the deathweaving of Old English texts, one early enough to be a potential analogue. The *Metrical Dindshenchas* (eleventh/twelfth century) of medieval Ireland state that a young woman named "Durgen found suffering on every side / by the hand of Indech, who traversed the battle-field, / she was

[173] *Laxdæla Saga*, trans. Magnus Magnusson and Hermann Pálsson (Penguin, 1969), p. 176. This is a tremendous amount of spinning and an enormous undertaking to have accomplished in one morning. My thanks to Gale R. Owen-Crocker for this observation.

[174] "The Role of Icelandic Women," p. 84. See also Jonna Louis-Jensen's "A Good Day's Work: *Laxdæla saga*, Ch. 49," in Sarah M. Anderson and Karen Swenson (eds), *Cold Counsel: Women in Old Norse Literature and Mythology* (Routledge, 2002), pp. 189–99.

[175] For an extensive discussion of the role of these women as inciters to vengeance and violence, see William I. Miller, "Choosing the Avenger: Some Aspects of the Bloodfeud in Medieval Iceland and England," *Law and History Review*, 1.2 (1983), 159–204. See also the related discussion in Enright, *Lady with a Mead Cup*, pp. 38–96. Enright traces the same role outside of the sagas in other Germano-Scandinavian literatures. Michele Hayeur Smith connects the rather reasonable fear manifested in literature by Norse men towards the weaving of death by both Norse women and valkyries, and she argues that the Norse sagas demonstrate an unease, by extension, with textile work more generally, "Textiles and textile work appear to have generated considerable trepidation on the part of the men in this society" (*The Valkyries' Loom: The Archaeology of Cloth Production and Female Power across the North Atlantic* (University of Florida Press, 2020), p. 13).

[176] *Poetic Edda*, Larrington, p. 149, no. 46, lines 1–2.

daughter of Luath, bloody in combat, / overcomer of a hundred warriors, one that knit strife."[177] The text's appositional expressions seem to indicate that the one who "knit strife" was her father, Luath. The sons of Smucaille mac Bacduib are similarly described as "good at weaving strife ... the men of martial arts."[178] The imagery of "weaving strife" does not seem particularly secretive or deceitful, however; the "strife-weaving" of the warriors of the Celtic text seems a positive characteristic and is associated with males. It may represent a different metaphor or carry different associations than the deathweaving or wile-weaving discussed.

CONCLUSIONS

Textiles and textile images and metaphors are clearly part of the larger web of meaning associated with what we might call "magic" among the early medieval English peoples. Textiles or their production techniques might be used in helpful (if ecclesiastically ambivalent) ways, as they are with "peaceweaving," with spindle whorls, spun thread, and scraps of woven cloth and garments used as magico-medical tools for healing the afflicted and with looms prognosticating the future. In a fair number of cases, such magical "cures" specifically reference the involvement of women, the prototypical users and makers of the textiles and tools themselves. In other cases, images of intertwined threads and the making of cloth take on a malevolent hue, with interwoven and sewn nets and binding knots secretly destroying others, often with magical and/or womanly involvement.

The culturally ancestral and roughly contemporary traditions of the pre-Conquest English share many of the same images, with magical binding with rope or thread a universal tradition through classical Greek and Latin and northern European texts, perhaps positive in amuletic contexts, but also profoundly destructive when applied by deceit and force, typically but not always by women. There are most clearly regional trends. The latter tradition appears particularly common in the poetic and historical traditions of the North. The types of textile processes invoked also differ by tradition. Classical sources, perhaps surprisingly, include very few even potential connections between spinning or weaving and the magical bringing of death. The most compelling references to the same are found rather in biblical source material, in the Psalms and Job, alluding to death as a metaphorical weaver, although not likely a magical one. A gendered connection is introduced in the Psalmic passage by an early medieval English translator, who intensifies the weaving imagery involved and identifies the deathweaver as a woman.

Spinning and weaving, as well as binding, however, take on rather more direct and powerful roles in death-bringing in the context of northern European written tradition.

[177] *The Metrical Dindshenchas*, ed. and trans. Edward Gwynn, Todd Lecture Series, 8–12 (5 vols, Academy House, 1903–35), vol. 3, p. 85, lines 1–4. The expression "one that knit strife" translates *fer figed feirg* (vol. 3, p. 84, line 4).

[178] *Ibid.*, vol. 3, p. 273, lines 3–4. The phrase "good at weaving strife" or *fri ferga fige* (line 3) is very similar to the previous expression.

There, from the eighth to the thirteenth century, without intermission, we find instances of women envisioned and condemned for using metaphorical spinning and weaving: spinning in magical ways to affect their futures (both ninth- and tenth-century Carolingian and Saxon contexts), but far more frequently, binding and weaving death for their enemies, whether as imagined valkyries working a gory loom of death and destruction, or as earthly women upbraided for weaving wiles of destruction and death in penitentials, histories, and sagas. Such images square with early medieval English tradition.

For the early medieval English (and their counterparts among contemporary Saxon peoples), thread working appears to have had potentially magical nuance, including spinning, but weaving and binding in particular. In all cases, the textile task, tools, and products correlate with either female characters, women as producers, or both, including even the anonymous deathweaver rendered female in an interlinear biblical gloss. It may indeed be textile-working women whose daily activity inspired or rendered resonant such associations. The associations between magic, women, and textile processes (spinning, weaving, and sometimes binding), tools (spindle whorls, heddle rods, and looms), and products (thread and cloth) are in many respects a natural extension of patterns seen in the previous chapter: women who attempt valiantly to weave or create societal peace are very close parallels (and perhaps often mirror images) to women who work determinedly to access supernatural power for generative or destructive spinning, weaving, and binding force in the same environments. They have unique counterparts in the natural and supernatural forces of creation and fatal destruction: like the mortal or semi-mortal women of Chapters 1, 2, and 3, the cosmic creationary and fatal forces of Chapter 4 are also envisioned as female, and they also spin, weave, and at times bind in what they do. It is to these cosmic, natural, and supernatural forces that I now turn.

CHAPTER 4

Spinning, Weaving, and Forces of Nature

Me þæt wyrd gewæf, ond gewyrht forgeaf
þæt ic grofe græf, ond þæt grimme græf,
flean flæsce ne mæg (70–72a)[1]

Wyrd wove that for me, and gave me the work
that I dig a grave, and that cruel grave,
flesh cannot flee.

The connection of spinning, weaving, and binding with both generative and destructive agency in peaceweaving, healing, and deathweaving is paralleled in particular in the Old English corpus by both generative and destructive weaving of a more cosmic sort: the weaving of creation and the forces of nature and the spinning, weaving, and binding of fate. I will discuss each in its turn with an eye to the textual, linguistic, material, and analogical environment in which it is situated. The discussion, in particular, of *wyrd* and related terms is complicated by many years of scholarly attention and a large array of evidence, and I will take a fresh and relatively unique look at this evidence and the novel patterns that emerge in the abundant fatal textile imagery in Old English and Anglo-Latin literature, often mirroring patterns in associated classical and medieval cultures.

WEAVING FORCES OF NATURE: CREATION AND WATER-WEAVING

Among the many riddles of the Exeter Book are found references to metaphorical, cosmic weaving by forces of nature. The first appears in Riddle 40. The narrator, personified "creation," describes its influence and mode of generative action: *ic uttor eaþe eal ymbwinde, / wrætlice gewefen wundorcræfte* "I easily wind around outside all things, wondrously woven with marvellous power" (84–5). "Creation" acts in concert with God, whose power alone it respects, as it winds and is woven throughout the world.

[1] *The Riming Poem, The Exeter Book*, ASPR 3, pp. 166–9.

117

Incomplete at 108 lines, Riddle 40 is an elaboration of an Anglo-Latin riddle by Aldhelm (complete at 83 lines), which is usually glossed *De Creatura*. The Anglo-Latin riddle does not reference the weaving and winding of creation through the world; Riddle 40, however, does.[2] This creationary weaving is similar to that found in Exeter Riddle 84, which mentions a *moddor* (21a) or mother-figure of great beneficence, *þæt wuldor wifeð, worldbearna mægen* "that weaves glory, the might of the children of the world" (33). The figure, generally identified as "water," is personified as female, like *Creatura*, and she likewise accomplishes her role through weaving.

Both riddles are part of a larger, interrelated group of riddles which make clear that "the Old English and the Anglo-Latin riddle traditions, despite their different poetic styles, are intertwining branches of the same vine."[3] Both share themes with related Old English and Anglo-Latin riddles, with "creation" or "nature" a proposed solution for two of Aldhelm's Anglo-Latin riddles and four of the Exeter riddles, and "water" for two of Aldhelm's and two of the Exeter riddles.[4] These riddles more generally draw upon similar Latin riddle cycles of Late Antiquity, in particular, the riddles of Symphosius. However, none of Aldhelm's or Symphosius's extant riddles mirror the weaving imagery found for creation and water in the Exeter riddles discussed. In other words, these personified, Old English creation weavers are unique additions to the related riddle tradition in Anglo-Latin and broader medieval Latin literature. Just as an early medieval English interlinear glossator added a "weaving wife" to explain a biblical gloss with deathweaving imagery, as discussed in the previous chapter, so early medieval English riddlers twice add weaving imagery for natural forces personified as female.

WEAVING FORCES OF NATURE IN OTHER TRADITIONS

Might these unique instances in Old English literature have been inspired by or be reflective of related literary or cultural traditions? There are scattered uses of similar metaphors for weaving forces of creation in classical texts, early Germanic art, and late Scandinavian texts. Detienne and Vernant argue that ancient Greek texts include linguistic metaphors for creation-weaving: "with its qualities of *mêtis* and omniscient cunning, the primordial Power weaves, plaits, links and knots together the threads whose inter-

[2] This is an interesting coincidence: only upon translation to Old English does Aldhelm's Latin Riddle 45 involve a weaving *wyrd* instead of silkworms or spinning *Parcae*. Likewise, Aldhelm's Latin Riddle 100 only involves "creation weaving" when translated and transformed into an Old English riddle.

[3] Maren Clegg Hyer, "Riddles of Anglo-Saxon England," in Gale R. Owen-Crocker, Elizabeth Coatsworth, and Maria Hayward (eds), *Encyclopedia of Medieval Dress and Textiles of the British Isles c. 450–1450* (Brill, 2011).

[4] Aldhelm's riddle solutions surveyed based on Lapidge and Rosier, *Aldhelm: Poetic Works*, pp. 70–94; the Exeter riddle solutions surveyed based on overview of differing scholarly arguments by Craig Williamson, *A Feast of Creatures: Anglo-Saxon Riddle Songs* (University of Pennsylvania Press, 1982), pp. 228–30.

SPINNING, WEAVING, AND FORCES OF NATURE

lacing composes the tissue of Becoming."[5] More clear reference to creation-weaving is found among the Romans. Statius, for example, describes a day when, *superae seu conditor aulae / sic dedit effusum chaos in nova semina texens* "the creator of the high royal court so yielded, weaving unrestrained chaos into new elements" (3.484–5).[6] Generations later, in his "Reply to Symmachus," Prudentius uses a similar metaphor when describing cycles of bountiful and scarce harvests, explaining poetically that *polus variis proventibus annos / texuit* (997–8) "with changeable harvests the sky has woven the years."[7] In his poem, "Crowns of Martyrdom," Prudentius also argues that the body is a fit offering for martyrdom, a *texta venis languidis* (26) "a fabric of weak nature," a metaphor that evokes the image of mortal bodies as "woven" creations. These images are mirrored in the sixth-century *Moralia in Job* of Pope Gregory I. Commenting on the comparison of the weaver cutting the web down to death in Job 7:6, referenced as a possible example of deathweaving in Chapter 3, Gregory explains the fitness of a web as a biblical metaphor for a living being, in a passage worthy of quoting in full:

> Congrua ualde similitudine tempus carnis telae comparatur, quia sicut tela filis, sic uita mortalis diebus singulis proficit; sed quo augmentum percipit, eo ad incisionem tendit, quia, sicut et superius diximus, cum tempora percepta praetereunt, uentura breuiantur, et de uniuerso uitae spatio eo fiunt pauciora quae ueniunt, quo multa sunt quae transierunt. Tela quippe infra supra que ligata duobus lignis innectitur, ut texatur; sed quo inferius texta inuoluitur, eo superius texenda deplicatur; et unde se ad augmentum multiplicat, inde fit minus quod restat. Sic nimirum uitae nostrae tempora et transacta quasi inferius inuoluimus et uentura a superiori deplicamus, quia quo plus fiunt praeterita, minus esse incipiunt futura. Sed quia nec tela ad expressionem nostri temporis sufficit, nam eius quoque festinationem uitae nostrae uelocitas transit, recte nunc dicitur: dies mei uelocius transierunt quam a texente tela succiditur. Tela quippe tarditatem prouectus habet, uita autem praesens moram defectus non habet.[8]

> By a very suitable image the time of the flesh is compared to a web. For as the web advances by threads, so this mortal life by individual days; but in proportion as it grows to its bigness, it is advancing to its cutting off. For as we have also said above, whilst the time in our hands passes, the time before us is shortened. And of the whole space of our lives those portions are rendered fewer that are to come, in proportion as those are many in number that have gone by. For a web, being fastened above and below, is bound to two pieces of wood that it may be woven; but in proportion as below the

5 *Cunning Intelligence*, pp. 137–8.

6 All references to the Latin text of the *Thebaid* are cited from Statius, *Thebaid, Books 1–7* and *Thebaid, Books 8–12, Achilleid*, both edited and translated by D. R. Shackleton Bailey, Loeb Classical Library, 207, 498 (2 vols, Harvard University Press, 2003). Translations are mine. References include book and line numbers.

7 References to Prudentius in this chapter come from *Prudentius*, ed. and trans. H. J. Thomson, Loeb Classical Library, 398 (Harvard University Press, 1979; 1949), vol. 2. Translations are mine.

8 *LLTO*: book 8, paragraph 10.

part woven is rolled up, so above the part that remains to be woven is being unwound, and by the same act, by which it augments itself in growth, that is rendered less which remains.[9] Just so with the periods of our life, we as it were roll up below those that are past, and unwind at top those that are to come, in that in the same proportion that the past become more, the future have begun to diminish. But because not even does a web suffice for the setting forth of our span of time, for the rapid course of our life surpasses the speed and quickness even of that too, it is well said in this place, "My days are passed away more swiftly than a web is cut off by the weaver." For to the web there is a delay of growth, but to the present life there is no delay of coming to an end.[10]

Gregory's commentary was widely available and was cited by early medieval English writers;[11] his elaboration of woven web of life as metaphor is thus very likely to have been an influence on creationary weaving metaphors and images in Anglo-Latin and possibly the creation-weaving and water-weaving found in the Exeter riddles. It may also have had an influence on the resonance of the deathweaving metaphors of the previous chapter.

There is likewise evidence that creationary nature goddesses were known among the other cultures of significance associated with England in the early Middle Ages, Germanic and Scandinavian peoples, and some of the earliest evidence connects these goddesses with textile tools. Finds include continental Germanic, sixth-century gold bracteates, generally found as ornamental grave goods, some of which are thought to depict pagan deities with tools associated with spinning and/or weaving.[12] One group has excited particular interest; four were discovered in Germany and one in Denmark, and the variant of the group (one of the German bracteates) shows a goddess with either a spindle or a weaving sword, while the other four show a goddess with specific tools either in her hand or near her, tools which resemble a staff with cross bars at top and bottom and a small double cross, which may be on a stand.[13] Michael J. Enright suggests that the small double cross is a swift, a standing tool designed to wind thread off the spindle after it is

[9] The loom he describes here is a two-beam loom.

[10] *Morals on the Book of Job*, trans. James Bliss and Charles Marriott, Library of the Fathers of the Holy Catholic Church, 18 (3 vols, J. H. Parker, 1844), vol. 1, pp. 433–4.

[11] Robert Stanton, *The Culture of Translation in Anglo-Saxon England* (Boydell, 2002), p. 65.

[12] Bracteates are a type of flat, die-cast jewelry with significant distribution in the northern European Migration Period (fifth and sixth centuries). According to Nancy L. Wicker, "burials with bracteates are almost always associated with women and are found in the peripheral areas of the distribution of this artifact type in western Norway, on the Swedish island of Gotland, on the Continent, and in Anglo-Saxon England" ("Mapping Gold in Motion: Women and Jewelry from Early Medieval Scandinavia," in Tracy Chapman Hamilton and Mariah Proctor-Tiffany (eds), *Moving Women, Moving Objects, 400–1500* (Brill, 2019), pp. 13–32, at p. 28). Wicker indicates that bracteates are often found with other jewelry, needles, and objects such as glass drinking vessels; in Kent, all of these items were associated with bracteate finds, and in one case, weaving tools were also present (pp. 29–30).

[13] Michael J. Enright, "The Goddess Who Weaves," *Frühmittelalterliche Studien*, 24 (1990), 54–79, at pp. 55–7.

full, a suggestion which would explain the puzzling tool's appearance at all the different angles of presentation in each of the bracteates.[14] Enright considers the longer object, the pole with cross bars, a weaver's beam, with the cross bars representing either cranks on each end with which the weaver wound the top of the web, or else pegs which hold the loom beam within the two uprights.[15] However, in my estimate, the longer tool may be more likely to represent a tall distaff such as the flax distaff, on which a bottom cross bar could represent the base and a top cross bar a peg or platform on which the unspun flax is dressed. Both common tools would be useful, visually identifiable to contemporaries, and likely present if a woman or a goddess were spinning thread at any significant length. Whichever tools are intended, textile tools in association with a clearly female nature deity argue the possibility of early worship of nature or creationary goddesses who spin or weave among early northern European groups.[16]

Enright addresses the possibility of classical or Mediterranean influence on the most striking bracteates, arguing that they are syncretic,[17] with a focus on the Christian iconographic tradition blending with the Germanic pagan; as he notes, however, classical or late Roman spinning deities are also a distinct potential influence. Either way, out of the five bracteates, two are associated with known pagan cult sites in Germany, a high percentage in so small a group, meaning, Christian influence for such cults is not very likely. Whether or not Roman influence might have inspired or reinforced creationary deities on the northern borders of empire, the bracteates at least suggest that there were local Germanic tribes who worshipped a creationary textile goddess.[18] Among the grave goods associated with the find at Oberwerschen (one of the two cultic sites) are also a spindle whorl, a silver needle, "a goddess-with-spindle bracteate under her chin," scissors,

[14] *Ibid.*, pp. 61–2.

[15] *Ibid.*, pp. 63–4.

[16] *Ibid.* Enright, in fact, argues that the bracteates and related evidence demonstrate a belief in weaving fates (p. 65) and that the weaving implements involved (and also found in what appear to be graves with cultic objects) have magical associations (p. 66). Such conclusions are tempting and possibly accurate, but speculative, just the same; I list such matters here as "possibilities" only.

[17] *Ibid.*, pp. 58–9. Enright indicates that a Byzantine brooch of the same age depicts Mary, mother of Jesus, with a spindle in her hand during a visit with an angel. The scene was apparently not rare in Byzantine art. On this basis, some have suggested that the Germanic bracteates are derivative. Such an argument is possible, although Enright notes important differences of representation. Over time, the image becomes highly characteristic of the Annunciation, with one Carolingian ivory depicting the Virgin with a cross-scepter in one hand and the textile tools in the other, with no angel. The image appears in early medieval English contexts, as well. See Chapter 2, note 61 in this volume and figure 1 in Coatsworth, "Cloth-Making and the Virgin Mary."

[18] Enright, "The Goddess," p. 64.

and a knife.[19] Other finds associated with the bracteates include weaving swords.[20] Additional archaeological evidence for Germanic textile goddesses includes, "the name *Vabusoa* 'weaveress' for a Germanic goddess, on a Roman inscription."[21]

The spinning or weaving of creation by cosmic female forces may seem a far stretch from sixth-century Germany or Denmark to early medieval England, but as I will discuss in greater depth later in the chapter, there is also textual evidence from seventh- and eighth-century sources that the earliest peoples we might consider English (probably late sixth- and early seventh-century) did believe in nature goddesses of some kind. The (arguably) syncretic Old English Metrical Charms also include advice for those suffering from poor harvests and enjoin the sufferers to sing psalms, pray, and then to invoke *Erce, Erce, Erce eorðan modor* "Erce, erce, erce, earth mother" (51) and to ask God to bless her. A later line enjoins this *folde fira modor* "earth, mother of men" (69) for their needs.[22] Echoes of cosmic, personified "earth mothers" thus clearly survived into the post-conversion context, echoes blasted as "folk superstitions" in penitentials. It is possible that they survived in creationary textile metaphors, as well.

As stated earlier in this work, source study is always a fraught endeavor in the study of early medieval England (or any other ancient or contemporary culture). I will not posit Latin sources for cosmic creation-weaving without direct evidence of borrowing, nor will I casually identify these metaphors with ancient, fossilized Germanic beliefs embedded in poetic formulae without sufficient evidence. In my estimate, the late Latin material from Pope Gregory I is the most likely to be a textual influence as a culturally privileged and available text, but folk beliefs inherited through origin northern European traditions are also plausible and demonstrable influences. Neither is mutually exclusive, and either or both could inspire or reinforce the resonance of images of creation or water-weaving for an early medieval English writer. I would note, however, that material resonance is just as important and likely an inspiration for weaving metaphors in early medieval English literature or the literature of any textile-rich culture. Creation weaving is a common metaphor used to describe the generation of life and the world in unrelated cultures around the world, cultures which share nothing, except the daily

[19] *Ibid.*, p. 65. These finds are obviously reminiscent of early medieval English grave goods.

[20] *Ibid.*, p. 65. Enright's claim is in keeping with the finds of weaving swords mentioned in Chapter 1.

[21] G. V. Smithers, "Destiny and the Heroic Warrior in *Beowulf*," in James L. Rosier (ed.), *Philological Essays: Studies in Old and Middle English Language and Literature* (Mouton, 1970), pp. 65–81, at p. 68. Miranda Green also states that early sculpture discovered in the Rhineland contains depictions of motherly divinities whose imagery is in "marked contrast" to other Celtic and Celto-Germanic groups, including one altar on which two of the three goddesses have what is possibly a work-box for textiles and a distaff, respectively. Unfortunately, she does not list the century to which the finds date (*Celtic Goddesses: Warriors, Virgins and Mothers* (George Braziller, 1996; 1995), pp. 108–9). Another find which has been associated with the same Rhineland tradition was from an early grave in Cambridgeshire (p. 110).

[22] Metrical Charm 1, *Anglo-Saxon Minor Poems*, ASPR 6, pp. 116–18.

tasks of spinning and weaving themselves.[23] The metaphor itself was clearly an attractive image on its own material and creative merits within the Riddles, as it has been across a wide range of cultures.

The patterns of ideas that emerge from this close examination of the handful of cosmic, creationary weaving metaphors in the Old English corpus in light of their textual and material context are worthy of thoughtful consideration. In ways unique to the much broader early medieval Latin riddle tradition, the forces of water and creation are characterized by early medieval English authors as grammatically and naturally active female agents. These cosmic "female" forces perform according to the same gender expectations as the mortal women with whom textile work is metonymically and normatively associated in early medieval English culture. But the generative action being described seems to go beyond a simple case of gender identification: the creation of a tissue of life and the weaving of a tissue of cloth resonate from the perspective of potentially influential intellectual and biological ancestral cultures, but also in very distinct ways, from the perspective of the material culture of textiles that formed part of the daily life of early medieval English authors. In each instance in the Riddles, interconnected order is constructed out of chaos or disordered and random threads by creative hands. The creation and water-weaving females of the Riddles mirror female-gendered, personified cosmic forces in cultures across the globe and across millennia, all of whom are similarly envisioned doing what mortal women of those same cultures do: textile work.[24] These patterns and complexities are identical to those found in another type of cosmic weaving found in Old English texts: the weaving of *wyrd*.

WYRD: SOURCE OF MODERN CONTROVERSY

The weaving of fate is part of an important and long-standing controversy in the study of early medieval England, a controversy in which this discussion must necessarily be situated. Scholars have debated the appropriate denotative and connotative translations of the Old English word linked with fate and weaving imagery, *wyrd*, for over two hundred years. *Wyrd* may mean a great many things: an event, the approach of death,

[23] An example comes from Vedic texts, "Who wove in Man his breathing-in, who his breathing-out," from the Atharva Veda, in Dominic Goodall (ed. and trans.), *Hindu Scriptures* (University of California Berkeley Press with J. M. Dent, 1996), p. 22. Additional creationary metaphors involving weaving are scattered throughout the Vedas and the Upanishads; see pp. 23, 29, 34, 72–3, 77–8. See similar examples in *Rigveda Brahmanas*, ed. and trans. Arthur B. Keith (Harvard University Press, 1920), pp. 170–2. The extensive work of Mircea Eliade in documenting and examining the metaphor of creation-weaving in multiple instances all around the world is another case in point; for a summary of these results, see Eliade and Adams, *The Encyclopedia of Religion*, vol. 8, pp. 340–2.

[24] E. J. W. Barber, *Women's Work: The First 20,000 Years: Women, Cloth, and Society in Early Times* (W. W. Norton, 1994), p. 243; Erich Neumann likewise argues that the great goddesses of Egypt, Greece, Germania, and the Maya all spin or weave (*The Great Mother: An Analysis of the Archetype*, trans. Ralph Manheim, 2nd edn (Princeton University Press, 1991; 1955), p. 227).

fate (lower case), Fate (upper case), Providence (upper and lower case), and one's lot in life. The word generally means "what happens" in most of Old English literature, but it is clear that *wyrd* meant some kind of supernatural, perhaps personified, cosmic force of "f/Fate" in its earlier, pre-Christian environment. In a relative handful of instances, even in a post-conversion textual environment, *wyrd* may still carry the echoes of such a cosmic personification. It is over this handful of references that scholars have contended most warmly.

The discussion has been marked by extreme, often mutually exclusive interpretations. On the one hand, there have been those who have interpreted *wyrd* in elegiac and gnomic texts such as *Beowulf* and *The Wanderer* as strictly pagan references to an early medieval English version of a fatal goddess (or set of goddesses). This group of scholars, comprised generally of early Anglo-Saxonists who decried the loss of "native Germanic" culture in subsequent Christian dogma, saw in *wyrd* and other similar words instances of the "true" literary genealogy of the early medieval English past, one easily and readily equated to earlier and later Germanic/Norse parallels. In their earnest desire to prove these theories as fact, the "paganists" (as I will call them) tended to extend their conclusions beyond the strictly reasonable. E. G. Stanley's *The Search for Anglo-Saxon Paganism*, first published as a series of nine articles in 1964–65 and reprinted as a book in 1975,[25] documents some of the most extreme conclusions reached by scholars associated with this group. Stanley discusses, for example, assertions that Old English *mearcweardas* "marsh guardians" should be considered a pagan allusion to Woden, on the basis that marshes were important in the worship of Woden.[26] Similarly, *sigorcynn* "victorious people" was a term said to be a reminder of the joys of Valhalla.[27] Such assertions may be (or more likely, may once have been) true, but as Stanley justly observes, much too little evidence exists to prove them. Biblical references in poems such as *Beowulf*, according to the same group of scholars, were simply interpolations on the part of later Christian poets, in some cases to be excised to preserve the "purely" pagan flavor of the "original" poems. Such assertions about *Beowulf* may or may not be true, but they cannot be accepted lightly in the face of contrary evidence, let alone cited as a reason to consider sanitizing or deleting "christianized" passages or elements of a literary text.

The list of those who approached *wyrd* from this kind of "paganist" perspective is an august "who's who" of early Germanicists and Anglo-Saxonists.[28] Very likely in response,

[25] E. G. Stanley, *The Search for Anglo-Saxon Paganism* (D. S. Brewer, 1975).

[26] *Ibid.*, p. 75.

[27] *Ibid.*, p. 83.

[28] See Jakob Grimm, *Teutonic Mythology*, 4th edn, trans. James Stallybrass (4 vols, Dover, 1966; 1844), pp. 405–6; Kemble, *The Saxons in England*; W. P. Ker, *Epic and Romance: Essays on Medieval Literature* (Dover, 1957; 1897), p. 158; F. A. Blackburn, "The Christian Coloring in *Beowulf*," in Lewis E. Nicholson (ed.), *An Anthology of Beowulf Criticism* (Books for Libraries, 1972; 1897), pp. 1–21; Albert Keiser, *The Influence of Christianity on the Vocabulary of Old English Poetry, Pt. 1* (University of Illinois, 1919); and H. M. Chadwick, *The Heroic Age* (Cambridge University Press, 1912), pp. 47–56. See Tetsuji Oda for the relevant bibliography for Gustav Ehrismann, A. Brandl, Richard Jente, Ernst Alfred Philippson, and Walther Baetke (*Semantic*

SPINNING, WEAVING, AND FORCES OF NATURE

another group of scholars emerged by the 1940s who argued that because Old English poetry is the work of a thoroughly christianized people, all written instances of *wyrd* must have had a thoroughly post-conversion meaning, whether that be Divine Providence or "lot" in life, including elegiac and gnomic instances discussed by the earlier group.[29] In 1988, Jerold C. Frakes nominated his work as the "final step in the development of the scholarly interpretation of *wyrd*" from this point of view, arguing that anything written in a monastic environment would be exclusively Christian in nature, meaning *wyrd* can mean nothing pre-Christian.[30]

The argument over interpretations of *wyrd*, however, has not been so easily decided. Since the mid-twentieth century, a number of scholars have returned to the argument that some instances of *wyrd* (generally, the contested ones) do appear to carry a pre-Christian sense, and in most cases, these scholars have argued without the exaggerations of earlier "paganists." In the 1960s and the 1970s, for example, Charles Moorman and G. V. Smithers stated that Christian meanings are an overlay in the case of *wyrd* and other similar elements in *Beowulf*.[31] Translators across many editions of Old English poems appear to have silently agreed; one need only see a standard Modern English translation of Old English poetry to see how frequently contested instances of *wyrd* continue to be translated as "Fate/fate." In addition, the strict, christianized interpretations of the second group have themselves not remained uncontested. Stanley, for example,

Borrowing of Wyrd with Special Reference to King Alfred's Boethius (PhD diss., University of Tokyo, 2000; published by Nodus Publikationen, 2004), p. 23.

[29] See B. J. Timmer, "Wyrd in Anglo-Saxon Poetry and Prose," *Neophilologus*, 26 (1941), 24–33, 213–28; Marie Padgett Hamilton, "The Religious Principle in *Beowulf*," *PMLA*, 61 (1946), 309–31; Kemp Malone, "Beowulf," in Nicholson, *An Anthology of Beowulf Criticism*; D. W. Robertson, "The Doctrine of Charity in Mediaeval Literary Gardens: A Topical Approach through Symbolism and Allegory," *Speculum*, 27 (1951), 29–49; Arthur Gilchrist Brodeur, *The Art of Beowulf* (University of California Press, 1959); works of Allen Cabaniss (1955) and M. B. McNamee (1960) listed in Michael D. Cherniss, *Ingeld and Christ: Heroic Concepts and Values in Old English Christian Poetry* (Mouton, 1972), p. 129; James H. Wilson, *Christian Theology and Old English Poetry* (Mouton, 1974); Margaret Goldsmith, "Allegorical, Typological, or Neither? Three Short Papers on the Allegorical Approach to *Beowulf* and a Discussion," *ASE*, 2 (1973), 285–302, and *Mode and Meaning of "Beowulf"* (Athlone Press of the University of London, 1970); Jerold C. Frakes, *The Fate of Fortune in the Early Middle Ages: The Boethian Tradition* (Brill, 1988). Oda lists critics with similar arguments: Enrico Pizzi and Adolf Wolf, contemporaries of the early paganist critics; Eric Stanley (whom I consider a conservative syncretist below); and Gerhard Wolfgang Weber (writing in 1969) (*Semantic Borrowing*, pp. 23–4). Along such lines, as an exclusively Christian work, a text such as *Beowulf* would have its inspiration in patristic sources (Hamilton) and would solely be a Christian allegory (Robertson) descending from the Latin epic tradition (Wilson), with *Beowulf* patterned after Job (Goldsmith); there is no room for a Germanic fate in such a work.

[30] *Fate of Fortune*, p. 86.

[31] "The Essential Paganism of *Beowulf*," *Modern Language Quarterly*, 28 (1967), 3–18, and "Destiny and the Heroic Warrior," pp. 65–81, respectively.

amended his own position when he saw Christianist interpretations as exaggerated as those propounded by the early paganists.[32]

B. J. Timmer's 1941 article on *wyrd* is a good example of the kind of interpretation that later gave Stanley pause. At its outset, Timmer writes what seems a supportive statement for pagan undertones for the term:

> There can hardly be any doubt that the outlook on life of the Germanic peoples was fatalistic. In all the old-Germanic dialects words and expressions occur representing an original belief in Fate, still visible even after the actual words had lost much of their original meaning. Such a word, common to all the Germanic languages, is the Anglo-Saxon *wyrd*.[33]

He describes how

> *wyrd*, originally the name for the power that ruled men's lives, the blind and hostile Fate, and at one time a proper name for the goddess of Fate, came to be used for the events as they happened according to fate, followed by a transitional period in which *wyrd* took on a Christianized meaning.[34]

His second statement thus precludes the possibility of overtly paganist readings, but does suggest openness to multiple meanings, including "echoes" of earlier beliefs.

Such interpretive openness is not borne out in his interpretation of the term in context, however. There, he argues that, since all Old English texts as we have them come from a later period than the conversion, even an "association" between a Germanic fate figure and *wyrd* is not possible in Old English poetry.[35] Such a stance seems somewhat extreme, but it is certainly ironic; like earlier "paganist" scholars (to whom he is clearly responding), Timmer insists that one reading (his) of the religious values and consequent connotations of Old English words of early medieval English authors precludes any other semantic possibility. More troubling is that Timmer resembles paganists as he resorts to interpolation as the only explanation of an instance of *wyrd* which upsets

[32] In the revised preface to his work on the subject (1975), Stanley indicates that in his initial series of articles (1964–65) he was writing in response to extreme positions of an earlier time. He adds that although the problem of romanticized paganist readings is still alive and well in his day, now that the predominantly Christian nature of Old English literature has been properly emphasized, he must "protest the secularity" of some non-religious poems in the Old English corpus, including *Beowulf* (*Search*, pp. ix–x). In his subsequent work, *In the Foreground: Beowulf* (D. S. Brewer, 1994), Stanley reaffirms this position. While he indicates that his own leanings are Christianist on the meaning of *wyrd* (except in glosses) (p. 206), he also suggests support for at least one secular, fatalistic reading of *Beowulf* 2526–27b (pp. 237–8, n. 43).

[33] "Wyrd in Anglo-Saxon Poetry and Prose," p. 24.

[34] *Ibid.*, p. 226.

[35] *Ibid.*, p. 216. Timmer's approach is not the most extreme: A. P. Wolf denies that *wyrd* retains any meaning of *fatum* or anything else except "event" anywhere in Old English poetry (quoted and translated in Stanley, *Search*, p. 117).

SPINNING, WEAVING, AND FORCES OF NATURE

his paradigm. This gesture is particularly interesting because Timmer generally insists in his writing that scholars take the text "as it is," without assuming, as the paganists often did, that contrary evidence is the result of a (Christian) redactor. An illustrative passage occurs in Timmer's discussion of *The Seafarer*, lines 115a–16: *Wyrd bið swiþre / meotud meahtigra þonne ænges monnes gehygd*[36] "Wyrd is the stronger / the ruler mightier than the mind/forethought of any man." The appearance of *wyrd* in an emphatic "b" position and in apposition to *metod* as a strong, seemingly personified cosmic force is a daunting counterexample to Timmer's general arguments, as it would be very difficult indeed to translate *wyrd* as "events" in this case.

Timmer's response to the potential crux is simple: "these lines almost certainly do not belong to *The Seafarer*."[37] His assertion is necessary to support his argument; the juxtaposition in the lines undermines the near universality suggested by Timmer's paradigmatic translation of *wyrd* as post-conversion "lot" or "event." The passage "as it is" suggests an equation of *wyrd* "Fate" with a "measurer" or "ruler," which in turn suggests that other interpretations of the meaning of *wyrd* may be valid in some instances in the Old English corpus. Timmer's equivocal response to the multiplicity possible in *wyrd* translation is certainly suspect and reveals, as Susan Pollack points out, Timmer is no more immune to having his ideologies prejudice his interpretations than earlier paganists, or indeed, anyone else:

> [Timmer's] piece is still the most often cited article on *wyrd*, and one that indicates the genuine need for a reassessment of the evidence, as it seems Timmer's sole purpose is to limit the semantic field of all occurrences of *wyrd*. Timmer's analysis is inherently problematic not only for its apparent ideological investment in Patristic readings, but also in that it is still cited unproblematically in recent times.[38]

As Pollack observes, many since Timmer have followed his lead in translating *wyrd*. T. A. Shippey, for example, suggests that translators of *Beowulf* translate *wyrd* as "the course of events" in every instance, claiming "the more impersonal translation saves one from strange conflicts between Fate and Doom, or God and Fate."[39]

However, there is the possibility that such a conflict may have been intentional or meaningful, particularly within *Beowulf*. The possibility of meaningful juxtaposition

[36] Text cited from *The Exeter Book*, ASPR 3, pp. 143–7.

[37] B. J. Timmer, "A Note on *Beowulf*, ll. 2526b–2527a and l. 2295," *English Studies*, 40 (1959), 49–52.

[38] "Engendering *Wyrd*: Notional Gender Encoded in the Old English Poetic and Philosophical Vocabulary," *Neophilologus*, 90 (2006), 643–61, at p. 657, n. 12. Pollack's latest citation example for Timmer is Frakes (1988), but there are more recent examples: in criticizing standard interpretations of fatalistic lines in *The Wanderer*, Mark S. Griffith accepts as unproblematic the opposing interpretations of the "main authorities on the subject" (p. 137, n. 13), listing only Timmer and Weber ("Does '*Wyrd Bið Ful Aræd*' Mean 'Fate is Wholly Inexorable'?", in Toswell and Tyler, "*Doubt wisely*," pp. 133–56).

[39] *Old English Verse* (Hutchinson University Library, 1972), p. 40.

(intentional or not) correlates to what appears to be the third scholarly position on *wyrd* and related terms, arguably the one most consistently adopted today.[40] This position is that the contested, unusual instances of *wyrd* may represent the ideas of *both* pre- and Christian cultures, embodying moments of syncretism when older beliefs and etymologies for words co-existed with newer ones in conscious or subconscious ways. This third position is itself quite old, and it has persisted alongside both paganist and Christianist arguments. Thus, Frederick Klaeber argues that *Beowulf* is a Christian poem with many pre-Christian associations; Dame Bertha Phillpotts argues that a word like *wyrd* changes gradually to a vague meaning but retains some of the earlier associations; J. R. R. Tolkien argues *Beowulf* represents the blending of old and new by a sensitive poet; and Fred C. Robinson argues that the *Beowulf* poet consciously makes old and new apposite in thoughtful and meaningful ways.[41]

The arguments for cultural syncretism among the early medieval English more generally are compelling and quite widely accepted. As Andy Orchard points out in discussion of *Caedmon's Hymn*, "blending of traditions, both native and imported," is "the hallmark of Anglo-Saxon culture."[42] Robinson argues that blending or syncretism

40 According to the extensive surveys of both Edward B. Irving, Jr., and Tetsuji Oda. Irving: "Christian and Pagan Elements," in Bjork and Niles, *A Beowulf Handbook*, pp. 175–92. Oda: see note 41 below. As Irving states in regard to *Beowulf*, "The 'mixed' or 'blended' nature of the poem is now agreed on by almost everyone, but scholars differ in how to describe it or account for it – and will always continue to do so, in the absence of more knowledge" (p. 186). Irving's study on the larger pagan/Christian debate in the context of *Beowulf* surveys the history of this conflict from its beginnings to the late 1990s, Oda's larger context through 2004. My own overview to date confirms their assessment of the critical debate.

41 In *Beowulf and the Fight at Finnsberg*, 3rd edn, ed. Fr. Klaeber (Heath, 1950; 1922), pp. xl–li; Dame Bertha Phillpotts, "Wyrd and Providence in Anglo-Saxon Thought," *Essays and Studies*, 13 (1928), 7–27; J. R. R. Tolkien, "*Beowulf*: The Monsters and the Critics," in Nicholson, *An Anthology of Beowulf Criticism*, pp. 51–103; and Fred C. Robinson, *Beowulf and the Appositive Style* (University of Tennessee Press, 1985), pp. 31–7, respectively. Additional scholars who argue for syncretism in Old English literature and early medieval English culture include William Whallon, "The Idea of God in *Beowulf*," *PMLA*, 80 (1965), 19–23; Cherniss, *Ingeld and Christ*; Mary C. Wilson Tietjen, "God, Fate, and the Hero of *Beowulf*," *Journal of English and Germanic Philology*, 74 (1975), 155–71; and John D. Niles, "Pagan Survivals and Popular Belief," in Malcolm Godden and Michael Lapidge (eds), *The Cambridge Companion to Old English Literature* (Cambridge University Press, 1991), pp. 126–41, among a great many others. Oda lists further members of this group: Hans Galinsky and Ladislaus Mittner (*Semantic Borrowing*, p. 24), both contemporaries of Klaeber; Cherniss mentions additional concurring scholars Peter F. Fisher, Arthur G. Brodeur (whom I consider a Christianist in argument), Charles Donahue, and Larry D. Benson (*Ingeld and Christ*, pp. 128–9). More recently, David Pedersen, writing through the lens of close study of *Solomon and Saturn* in "*Wyrd ðe Warnung* ... or God: The Question of Absolute Sovereignty in *Solomon and Saturn II*," calls for wider reassessment of translation practices based in the old debate on syncretist grounds, given evidence of Timmer's own skewing of the poetic evidence (*Studies in Philology*, 113.4 (2016), 713–38).

42 "Poetic Inspiration and Prosaic Translation: The Making of 'Caedmon's Hymn,'" in Toswell and Tyler, "*Doubt wisely*," pp. 402–22, at p. 402.

of the pre-Christian and heroic tradition and the Christian tradition is evident in contested spaces, such as *Beowulf*, which is clearly composed by a Christian poet/narrator, but in which characters themselves never "allude to Christian lore" and "indulge in known pagan practices, such as cremation of the dead, the reading of omens, and the burial of lavish grave goods with their dead – all practices sternly and often forbidden by Christian Anglo-Saxon writers."[43] C. Tidmarsh Taylor agrees and further suggests that the pre-Conquest English themselves would have considered argument over many Christian and pagan "oppositions" somewhat irrelevant, as they did not see the same oppositions, given Gregorian-inspired assimilations long-evident thereafter in cultural and textual practices.[44] As Pollack also observes, "Both romantic mythological criticism and Christian exegesis ignore the syncretism inherent in much of Old English literature; it is a mixture of not only traditional Anglo-Saxon culture, but Latin Patristics, classical culture, Norse and Celtic themes," and a binary argument between rival groups is therefore, not "productive."[45]

W. P. Ker pointed out long ago that the Franks Casket is a good metaphor for Old English literature and early medieval English culture more generally: it is a blend of Latin and Old English words, Roman and runic scripts, and three literary/historical traditions that include Weland, the Adoration of the Magi, and Romulus and Remus.[46] In her more recent assessment of the Franks Casket, Catherine Karkov reaches similar conclusions, calling the work "a postcolonial space in which a series of appropriated narratives tell a story about the coming into being of Anglo-Saxon England."[47] Karkov argues that the casket's hybridity represents the inherent hybridity of the culture that produced it:

> The scenes on the casket are divided equally between the Anglo-Saxons' imagined homelands so that three are devoted to stories from "Germanic" legend, and three to stories from the history of Rome and the Roman Church. They are all accompanied by inscriptions: some in Latin, some in Old English, some in the Roman alphabet, and some in runes ... These stories from separate and very different peoples and traditions are appropriated and retold by this polyglot Anglo-Saxon object, and in that retelling they are translated into Anglo-Saxon stories.[48]

[43] "*Beowulf*," in *The Cambridge Companion to Old English Literature*, Godden and Lapidge, p. 150. Leonard Neidorf makes a similar argument more recently in *The Art and Thought of the Beowulf Poet* (Cornell, 2022), chapter 3.

[44] "A Christian *Wyrd*: Syncretism in *Beowulf*," *English Language Notes*, 32.3 (1995), 1–10. See also Niles, *God's Exiles*, p. 94, n. 59.

[45] "Engendering *Wyrd*," pp. 645–6.

[46] In 1897 in *Epic and Romance*, pp. 48–9.

[47] "The Franks Casket Speaks Back: The Bones of the Past, the Becoming of England," in Eva Frojmovic and Catherine E. Karkov (eds), *Postcolonising the Medieval Image* (Routledge, 2017), pp. 37–61, at p. 37. Karkov expands this discussion in *Imagining Anglo-Saxon England: Utopia, Heterotopia, Dystopia* (Boydell, 2020), addressing multiple possibilities of translation and meaning for the wording on the casket (pp. 87–8).

[48] Karkov, *Imagining Anglo-Saxon England*, p. 43.

I agree with these assessments of early medieval English culture across the period, and my position in respect to the translation and interpretation of *wyrd* and related terms is based on the same grounds: literary and historical evidence for hybridity and syncretism, as well as additional, historical-linguistic grounds.

Much of the historical-linguistic evidence is weighed in Tetsuji Oda's PhD dissertation, "Semantic Borrowing of *Wyrd* with Special Reference in King Alfred's Boethius: A Reconsideration from an Etymological Point of View,"[49] an often undercited study which examines in detail all instances of *wyrd* in the Old English translation of Boethius and most instances of the same in elegiac poetry, and which makes a thorough and material contribution to the ongoing discussion. Oda points out that *wyrd*, like many other Old English words, is a "semantic loan" word, one used before and after Christian conversion with an older meaning eventually supplanted by a new one assigned to the same form.[50] This linguistic fact is quite obvious, of course, but it has implications worthy of careful consideration. The early medieval English people appear to have been a deeply conservative group of speakers, borrowing as few as 3 percent of non-native words into Old English to express a dramatic range of changing conditions over 600 years.[51] Direct use of Anglo-Latin itself in more than half of the texts probably written in early medieval England must have made so small a borrowing into Old English more feasible, but the authors of Old English homilaries and the Old English poetic corpus alike still expressed the concepts of the learned classical and early medieval Christian traditions with predominantly native, Old English words. To do so, Old English speakers clearly extended the possible meanings assigned to specific Old English words, "loaning" word-forms to newer concepts and meanings that must have seemed related to old ones. It is universally agreed that words such as *dryhten*, *metod*, and *wyrd* all referred to something before Christian conversion, probably native, supernatural beings and pre-Christian concepts.

The point of contention lies, then, not in the multiple meanings (including pre-Christian ones) for these words over time, but whether the loaned word-forms retain any of their original meaning in a denotative or connotative sense in post-conversion texts. In other words, after the early medieval English conversion(s) to Christian teachings, were any non-Christian meanings still operative when *wyrd* appeared in text? How quickly did the term lose "fatal echoes," if ever, in moving from a christianized Providence to a simple "lot" or "event"? Such possible semantic "nuances" are particularly important to the context of metaphors, which draw on imagery and connotative meaning as well as denotative. By extension, such nuances matter in explaining the references to spinning or weaving in relation to words like *wyrd* in works written by Christian, early medieval English writers.

49 Later published by Nodus Publikationen in 2004. His work is cited in the notes of this volume in keeping with the 2004 publication.

50 *Semantic Borrowing*, pp. 21–2.

51 *Ibid.*, p. 27. Wilson points out the same low number of loan words from Latin to Old English, with "practically no direct association with [abstract] religious concepts" (*Christian Theology*, p. 12).

SPINNING, WEAVING, AND FORCES OF NATURE

Most uses of *wyrd* across the range of Old English texts are what Oda terms *nomen actionis* or "the name of an action" and make most sense when translated, in fact, as "one's lot in life," or "events/how life works out," a weakened sense of the original word that aligns nicely within Christian theology. There are, however, a handful of references in the Old English corpus where *wyrd* acts, like a weaving creation, as a *nomen agentis* or "active agent." Of these occurrences, some are clearly references to *wyrd* acting as Christian Providence, but others are less clear. Whether attributable to classical pagan or continental Germanic pagan roots, what is most interesting is that these examples of *wyrd*, a grammatically female *nomen agentis*, correlate closely to textile metaphor.

WYRD AS SPINNER AND WEAVER

Wyrd itself is cognate with similar words in Old Saxon, Old High German, and Old Norse, and all carry an early meaning of "F/fate."[52] All seem to be related to variants of what in Old English is the verb *weorðan* "to become," with a related meaning of "turning." Oda argues the explanation for the association of "fate" and "turning" lies in turning of dice;[53] however, an equally plausible association lies in the "turning" of an early kind of "wheel of fate," the spinning whorl. After all, as will be discussed in subsequent sections, most fates of Greek, Roman, Celtic, and Germanic origin are all visualized as spinners.

As previously discussed, *wyrd* can be used as both *nomen agentis* (agent) and *nomen actionis* (event) and is used in both senses from the earliest extant Old English glosses, c.725.[54] Instances where *wyrd* appears to be *nomen agentis* occur most frequently in glossaries, heroic elegies such as *Beowulf*, and works related to problematic, un-Christian beliefs. Most of these same texts also seem to associate fatal *wyrd* and its fellows with textile imagery. In the glossaries, *wyrd* renders a variety of Latin words, the most common of which include *Fortuna* ("fortune" or "Fortuna" goddess of fortune, eleven times), *fatum/ fata* ("fate(s)" or "destiny"/"Fates," ten times), *Parcae* ("the Fates," eight times), *sors/ condicio* ("lot" or "destiny"/"circumstances," five times), *fors* ("chance," four times), *eventus* ("event," three times), and *casus* ("event" or "chance," three times).[55] While glossaries often reflect the source text more than the Old English context, the glossarial evidence suggests the linguistic range of *wyrd* and implies the apparent correspondence in

[52] Oda, *Semantic Borrowing*, p. 44.

[53] *Ibid.*, pp. 46–8.

[54] *The Oxford English Dictionary*, 2nd edn, *OED Online* (Oxford University Press, 1989), *s.v.* "weird, n.," definitions 2a and 3a, respectively. The entry cites both examples from the *Corpus Glossary* as edited by J. H. Hessels.

[55] *Concordance*, *s.vv.* wyrd, wyrde, wyrdum, gewyrd, gewyrda, gewyrde, gewyrdes, gewyrdum, uurd, uuyrdae. The Latin words are in the oblique case. Latin translations from Charlton T. Lewis and Charles Short, *A Latin Dictionary* (Oxford University Press, 1879), *s.vv.* online at http:// www.perseus.tufts.edu/hopper/text?doc=Perseus:text:1999.04.0059 (accessed 6 March 2024). Lewis and Short comment that *fatum* is often synonymous with *fortuna, fors, sors,* and *casus* and that *fatum* is also synonymous with Greek *moira* (*s.v. fatum*).

the minds of its Old English translators between the personified, female, classical fates, themselves *nomen agentis*, and *wyrd*, in a 2:1 ratio, or 29 instances, compared to 15 equating *wyrd* to an impersonal event.

Old English heroic, elegiac poetry also contains a fair number of instances where *wyrd* appears to act as *nomen agentis*, some of them including references to a weaving fatal force. The most prolific and contested locations are in *Beowulf*. *Wyrd* as perceived by the characters of *Beowulf* is particularly complex. Beowulf says of *wyrd*, *Gæð a wyrd swa hio scel!* "*Wyrd* ever proceeds as it/she must" (455b).[56] *Wyrd* is a feminine noun, leaving a suggestive "she" for choice of pronoun, but the gender may be grammatical or not. Beowulf's acceptance of *wyrd* as absolute is a hallmark of his consistent fatalism; when he recounts his swim with Breca he likewise states, *Wyrd oft nereð / unfægne eorl, þonne his ellen deah!* "*Wyrd* often protects the undoomed warrior, when his courage is good!" (572b–73).

More often, however, when *wyrd* is an agent, it brings death rather than life. As Hrothgar says of his kinsmen, *hie wyrd forsweop / on Grendles gryre* "*Wyrd* swept them away during Grendel's violence" (477b–78a). Similar phrasing appears several more times in the poem. The narrator describes the death of Hygelac by saying *hyne wyrd fornam* "*Wyrd* seized him" (1205b), and Beowulf states, *ealle wyrd forsweop / mine magas to metodsceafte* "*Wyrd* swept all my men away at the decree of the measurer" (2814b–15). Beowulf recognizes that his life is also subject to the decree of fate as he approaches his final battle, and he says, *ac unc [feohte] sceal / weorðan æt wealle, swa unc wyrd geteoð, / metod manna gehwæs* "but for us two, the fight must be at the wall, as *wyrd*, the ruler of each man, rules for us" (2525b–27a). The figure of *wyrd* seems to Hrothgar and, more particularly, to Beowulf, an active force in the universe, one that Beowulf considers the "ruler" or "measurer" of men, or at least of their deaths. Thus, when the narrator states, *him wyrd ne gescraf / hreð æt hilde* "*Wyrd* did not ordain victory in battle for him" (2574b–75a), we know that Beowulf is about to die. Indeed, during Beowulf's fatal battle with the dragon, the narrator informs us that:

> Him wæs geomor sefa,
> wæfre ond wælfus, wyrd ungemete neah,
> se ðone gomelan gretan sceolde,
> secean sawle hord, sundur gedælan
> lif wið lice; no þon lange wæs
> feorh æþelinges flæsce bewunden. (2419b–24)

> He was mournful at heart, wavering and death-ready, *wyrd* must approach the aged man very near, seek the treasure of his soul, divide asunder life from the body; not for long was the life of the prince wound in flesh.

[56] Here and throughout the text, I leave *wyrd* untranslated for a purpose: generally, I believe that the contested instances of *nomen agentis* should be translated as "Fate" or "fate," but leave the possibilities for my reader to consider and determine.

SPINNING, WEAVING, AND FORCES OF NATURE

Wyrd is thus an eerie figure in *Beowulf* who sometimes seems a personification much like the grim reaper.[57] Alan H. Roper points out that the line, *wyrd ungemete neah*, has a close parallel in the poem at line 2728: *deað ungemete neah* "death extremely near," certainly no coincidence.[58] While it does not follow that *wyrd* is necessarily a personified figure of death-bringing "Fate" (proto-English, classical, or Germanic) in *Beowulf*, it is a definite inference, particularly since the narrator also alludes to the paganism of his characters and their culture. In a parallel to such usage in *Beowulf*, it is the pagan characters who are associated with the demonic in *Daniel* and *Andreas* who invoke *wyrda* or *wyrd* (feminine plural and feminine singular, respectively) and die by the same. Thus, when the magicians or wise men of King Nebuchanezzer express consternation at his demand that they interpret his dream, they do not know *hu ðe swefnede, / oððe wyrda gesceaft wisdom bude* "how you dreamed, or how the decree of the *wyrda* granted knowledge" (131b–32).[59] They ultimately fail because they cannot read the *wyrda gerynu* "mystery of the *wyrda*" (149a). Likewise, the Mermedonians holding Andrew begin to realize they are doomed for holding him, *Us seo wyrd scyðeð, / heard on hetegrim* "That *wyrd* crushes us, stern in cruelty" (1561b–62a).[60] The "good" characters evoke God and are saved by him, in contrast to the pagan ones, who wander benightedly into destruction at the behest of *wyrda* or *wyrd*.

Some references in *Beowulf* place *wyrd* in hostile subjection to the Christian God. The opposition is mentioned by the narrator, who reminds the audience that whatever Hrothgar and Beowulf might think rules over them, the Christian God truly reigns. Thus, the narrator remarks that Beowulf was able to stop the *geosceaftgast* "demon sent by fate" (1266a), meaning Grendel, from killing more men because of God's intervention and in spite of fate: *swa he hyra ma wolde, / nefne him witig God wyrd forstode / ond ðæs mannes mod. Metod eallum weold / gumena cynnes, swa he nu git deð* "so he wished [to kill] more of them, except wise God and the power of that man had opposed *wyrd* for them. The Lord ruled all of humankind, as he still does now" (1055b–58). In this instance, the narrator aligns the grim *wyrd* with Grendel, rather an odd connection if this "fate" is linked with Christian Providence. The narrator is the only voice in *Beowulf* to use *wyrd* as a common noun "event," in lines 734b and 3030a, and also in apposition to *geosceaft* or "decree of old" (1233b). The context of *Beowulf* alone indicates that the range of meanings associated with *wyrd* is complex, including personifications of a fatal kind.

In spite of all of the references to *wyrd* as agent in *Beowulf*, here *wyrd* is not the cosmic weaver in the text; the only textile metaphor for the weaving of fate in the Old English corpus which does not mention *wyrd* occurs at lines 696b–97a, as the narrator informs

[57] In the words of Phillpotts, "a mere body-snatcher" ("Wyrd and Providence," p. 21). One need only consider that the adjectival pair for "fate" is "fatal." As I tell my students when studying Old English literature, "If you see a reference to *wyrd*, you'd better call the morgue."

[58] Alan H. Roper, "Boethius and the Three Fates of *Beowulf*," *Philological Quarterly*, 41 (1962), 386–400, at p. 400.

[59] *The Junius Manuscript*, ASPR 1, pp. 111–32.

[60] *The Vercelli Book*, ASPR 2, pp. 3–51.

his audience of the Geats' eventual success at Heorot: *Ac him Dryhten forgeaf / wigspeda gewiofu* "But the Lord granted them webs of good fortune in war." The term *gewiofu* or *gewif* "web" or "web of destiny" is etymologically connected to *gewefan* "to weave"[61] and is elsewhere used alongside *wyrd* as a gloss to *Fortuna*.[62] God grants the happy fate in battle to the Geats, and significantly, that fate is disposed in some way through weaving.

Several works within the Exeter Book connect fate and weaving, as well, but in these instances, directly through a weaving *wyrd*. The first direct reference to fate-weaving occurs as Guðlac's servant mourns the time when, *wefen wyrd-stafum*, his lord must depart from life (1351a),[63] the servant implicitly linking the "woven *wyrd*-staves" or "woven decrees of fate" with the death of Guðlac. Thus *wyrd* is imagined in some way connected to the decreeing of fate through weaving, and that decree means dying. A similar image appears in the *Riming Poem*, in which the narrator states, *Me þæt wyrd gewæf, ond gewyrht forgeaf / þæt ic grofe græf, ond þæt grimme græf, / flean flæsce ne mæg*[64] "*Wyrd* wove that for me, and gave me the work / that I dig a grave, and that cruel grave, / flesh cannot flee" (70–72a). In this cheerful image, yet again, *wyrd* as "F/fate" assigns or allots death to others in the guise of a weaver, evidently not a very constructive one. As the fragmentary poem *The Ruin* mourns, everything in their ruined community was beautiful and their world filled with prosperity *oþþæt þæt onwende wyrd seo swiþe*[65] "until *wyrd* the mighty overturned that" (24b). *Wyrd* in all of these instances is envisioned as a deathweaver in administering "fate."

Another instance of *wyrd* weaving comes in Riddle 35 of the Exeter Book, as the "mail-coat" speaker indicates, *Wyrmas mec ne awæfan wyrda cræftum, / þa þe geolo godwebb geat-wum frætwað*[66] "Worms did not weave me with the skill of the *wyrda* [pl.], / those that adorn the yellow silk so skillfully" (9–10). The riddle, found in the Exeter Book as well as a Northumbrian manuscript, is, for the most part, a translation of Aldhelm's Anglo-Latin Riddle 33. However, as with the Old English creation riddles, the Old English versions of this riddle do not mirror Aldhelm's Anglo-Latin version as they attribute weaving skills to the *wyrda*, or singular *wyrdi* in the Northumbrian version, the "Leiden Riddle."[67] Aldhelm's Anglo-Latin version of these lines reads: *Nec crocea Seres texunt lanugine vermes* "Nor do Chinese silk-worms weave (me) from their yellow floss."[68] The

[61] F. Holthausen, *Altenglisches Etymologisches Wörterbuch*, 2nd edn (Carl Winter, 1963; 1934), *s.v. wæf*.

[62] Bosworth and Toller, *s.v. gewef*; *Concordance*, *s.vv.*, also *s.v. gewefe*.

[63] *The Exeter Book*, ASPR 3, pp. 49–88.

[64] *Ibid.*, pp. 166–9.

[65] *Ibid.*, pp. 227–9.

[66] *Ibid.*, p. 198.

[67] "The Leiden Riddle," *The Anglo-Saxon Minor Poems*, ASPR 6, p. 109.

[68] Latin text from *Aldhelmi Opera*, Ehwald, pp. 111; translation from Lapidge and Rosier, *Aldhelm: The Poetic Works*, p. 76.

allusions to weaving fate(s) in the Old English versions are instead consistent with the imagery of woven or weaving fate in the other poems of the Exeter Book.

The textile associations within this particular riddle (in both languages), among other reasons, may be related to Aldhelm's or his translator's awareness of traditional Old English phraseology in calling the byrnie or mailshirt a garment "woven" with skill.[69] Such phraseology is easily understood through consideration of the material construction and design features of the mailshirt itself: first, the mailshirt functioned as a garment, even if not a garment made from textiles,[70] and second, both manuscript and artefactual evidence for chain mail in the period shows that mailshirts were constructed in interwoven rows of links (some welded, some riveted) that closely resemble interwoven or knitted fibers.[71]

What may be another textile association with *wyrd* occurs in *Solomon and Saturn*.[72] During their "knowledge" contest, Saturn asks Solomon: *hwæt beoð ða feowere fæges rapas?* "What are the four cords of the fated/doomed?" (333). In return, Solomon replies, *Gewurdene wyrda, / ðæt beoð ða feowere fæges rapas* (334–35). Solomon's answer is difficult to translate. It may mean, "The workings of Providence, those are the four cords of the fated/doomed," "Events that have happened, those are the four cords of the fated/ doomed," or "The turnings of *wyrda*, those are the four cords of the fated/doomed." What the "cords" in question are in relation to the *wyrda* is also unclear, but the image of threads/cords/ropes of fate turning in the hands of *wyrda* may well be a textile or a binding image, and the sense of impending doom and destruction that almost universally attends *wyrd* is also apparent.[73] If this *wyrd* is considered agent, the subsequent exchange, in which Jesus Christ is named as the ultimate judge on judgment day, suggests Solomon's *wyrda* more likely represent either Providence or the cruel punishers of the wicked. On the other hand, David Pedersen, in his close examination of *Solomon and Saturn*, sees Solomon as aligning *wyrd* with the forces of Satan as a "misanthropic" and

[69] See, for example, *Beowulf*, lines 552, 1443, 1548, and 2755.

[70] See, for example, the lengthy list of garment names connected to the mailcoat or byrnie in Owen-Crocker, "'Seldom … does the deadly spear rest for long': Weapons and Armour in Anglo-Saxon England," in Hyer and Owen-Crocker, *Material Culture*, pp. 201–30, at p. 227.

[71] *Ibid.*, pp. 226–7. An excellent visual example can be seen in radiographic images of the fragmentary chain mail found at Sutton Hoo (Rupert Bruce-Mitford, *The Sutton Hoo Ship-Burial, Volume 2: Arms, Armour, and Regalia* (Published for the Trustees of the British Museum by British Museum Publications Limited, 1978), p. 235, fig. 180). The image in question shows chain mail that looks very much like the reverse side of a knitted fabric.

[72] *The Anglo-Saxon Minor Poems*, ASPR 6, pp. 31–48.

[73] Cavell observes that the passage "seems to recall a Germanic tradition of fettering and loosing charms" (*Weaving Words and Binding Bodies*, p. 265). Such an association would extend the connection discussed in Chapter 3 between magic and deathweaving to include fatal forces, an idea that is entirely plausible in drawing together sinister supernatural forces that lead to death.

"vague" agent of chaos from the legendary past.[74] Whichever version of *wyrd* is meant, in an interesting way, Solomon's answer is potentially polysemous, and if intentional, cleverly reflects the identities and understanding of those involved in the imagined speech act. For Solomon and a Christian audience, Providence is the agent for how things work out; for Saturn, the spinning and weaving fates would be.

If a syncretic view is correct in terms of these scattered *nomen agentis* or agent occurrences of *wyrd* in early medieval English literature, and uses of *wyrd* such as those discussed trailed any echoes of a dark, powerful, sinister "fate," then there could be a real danger of misunderstanding the re-purposed word in religious texts, as well as poetic ones, with readers "seeing" or thinking of an "old-style *Wyrd*" instead of appreciating the new Providence and its place in the cosmic order. To avoid such a danger, particularly if the old belief were a powerful one, early medieval English texts where these cosmic forces are discussed would likely clarify word usage or comment on "old" and "incorrect" understanding of fatal forces to avoid any misunderstanding. There are such texts, in fact, and textile associations attend some of them.

WYRD: SOURCE OF EARLY MEDIEVAL ENGLISH CONTROVERSY

Dame Bertha Phillpotts argued that the *De Consolatione* of Boethius may not have ever been translated if not for a persistent struggle against a culturally dominant sense of fatalism that King Alfred wished to address and correct, an observation worth considering.[75] In his assessment of all instances of *wyrd* in Alfred's translation of Boethius's work, Oda highlights one passage of the Old English *De Consolatione* which, like many, discusses at length whether God or fate dominates the universe. A plaintive Boethius asks, *Hwy þu la Drihten æfre woldest þ seo wyrd swa hwyrfan sceolde?* "Why, o Lord, do you ever grant that *wyrd* must so turn?" (10.17).[76] He points out how often the wicked prosper while the faithful suffer, suggesting, *Forþa went nu fulneah eall moncyn on tweonunga, gif seo wyrd swa hweorfan mot on yfelra manna gewill, 7 þu heore nelt stiran* "Thus now nearly all mankind turns to doubt, if *wyrd* so may turn on the wish of evil men, and you will not rule her" (10.23–25). The corresponding Latin states, *Nam cur tantas lubrica versat /*

74 "*Wyrd ðe Warnung*," pp. 718, 723, and 727. Pedersen argues that the very clear instances of *wyrd* as a character with agency in the Old English poetic corpus demonstrate that syncretic echoes with *wyrd* deserve more exploration and discussion than is often given them (p. 736). I agree.

75 "Wyrd and Providence," p. 25. Phillpotts assumes, as I do, that the attributions of the translation to Alfred were accurate, a point still well-accepted, but also increasingly debated in recent scholarship (see, for instance, the discussion in Susan Irvine and Malcolm R. Godden, "Introduction," *The Old English Boethius* (Harvard University Press, 2012), p. xi, and Amy Faulkner's overview in *Wealth and the Material World in the Old English Alfredian Corpus* (Boydell, 2023), pp. 90–2). For the purposes of this discussion, I will follow the traditional assumption that Alfred was translator.

76 All passages of Alfred's translation are drawn from *King Alfred's Old English Version of Boethius: De Consolatione Philosophiae*, ed. Walter John Sedgefield (Wissenschaftliche Buchgesellschaft, 1968). All citations are listed as page and line numbers. Translations are mine.

Fortuna vices? "For why should slippery chance / Rule all things?" (1.5.28–30), but does not repeat the lament a second time, as Alfred does emphatically.[77]

Wisdom's reply to the lament of Boethius is a second instance of Alfred's additions in his translation. Wisdom tells Boethius that he suffers because *þu wære ut afared of þines fæder eðele, þ is for minum larum ... þine fæstrædnesse forlete, 7 wendest þ seo weord þas woruld wende heore agenes ðonces buton Godes geþeahte 7 his þafunge* "you had departed out of your father's homeland, that is far from my teaching ... you left your steadfastness, and thought that *weord* might turn this world according to her own purpose without the thought and consent of God" (11.3–7). Wisdom thereafter interrogates Boethius the narrator, *Gelefst ðu þ sio wyrd wealde þisse worulde, oððe auht godes swa geweorðan mæge butan þæm wyrhtan?* "Do you believe that *wyrd* rules this world, or that aught of good may come to pass without the creator?" (12.16–17).

As Oda observes in his analysis of these lines, Alfred inserts more references to both God and *wyrd*,[78] with Boethius as his narrator lamenting that *wyrd* is a sinister rival to the plans of God and that people are getting the wrong idea about who is in charge when they see the wicked prosper. Compared to the initial, rather short complaint of Boethius, Alfred's Boethius argues the problem passionately and repeatedly. However, the misunderstanding is clearly Alfred's narrator's. In subsequent passages, Alfred's Boethius is taught, *Sio wyrd þonne dælð eallum gesceaftum anwlitan 7 stowa 7 tida 7 gemetunga; ac sio wyrd cyð of ðæm gewitte 7 of ðæm foreþonce þæs ælmehtigan Godes* "Wyrd so allots to all creation appearances and places and seasons and measures; but *wyrd* proclaims from the understanding and from the forethought of the almighty God" (128.22–4). This personification of *wyrd* as agent (consistent with many other examples in Alfred's *De Consolatione*) undercuts the likelihood of simple equation of *wyrd* in the passage with "events" or "that which happens." Alfred remains consistent throughout his translation; wherever Boethius lists either *Fortuna* or *Fata* in a subject, "agent" form, she is consistently *wyrd* in Alfred's version.[79]

Oda documents multiple examples of differences introduced in Alfred's translation that similarly render *wyrd* a personified fate where the Latin does not.[80] He concludes that personified instances of *wyrd* far outnumber those in Alfred's source, perhaps because, "The preference for personification in the Old English translation may indicate

[77] All passages of Boethius's text are taken from *Boethius: Tractates, The Consolation of Philosophy,* ed. and trans. H. F. Stewart, E. K. Rand, and S. J. Tester, Loeb Classical Library, 74 (Harvard University Press, 1962; 1918). All citations are volume, book, and line number. Translations are from Stewart *et al.*

[78] Oda, *Semantic Borrowing*, p. 109.

[79] David Pedersen makes this same observation (2016), based on his analysis of *Solomon and Saturn II* and the Old English Boethius (*Wyrd ðe Warnung*, p. 721). He credits F. Anne Payne, *King Alfred and Boethius: An Analysis of the Old English Version of the "Consolation of Philosophy"* (University of Wisconsin Press, 1968), pp. 80–3, for additional support for this position. Amy Faulkner argues persuasively along similar lines in *Wealth and the Material World* (2023), pp. 92–4, 101, and 107.

[80] Oda, *Semantic Borrowing*, pp. 115, 117, 118, and 120–1.

that *wyrd* incorporates a feeling of agentry character."[81] His explanation for the difference is not necessarily that the early medieval English people of Alfred's day were worshipping a pagan goddess, the ultimate *femme fatale*, however; instead, he argues, "The preference for *wyrd* as *nomen agentis* relates to a linguistic tradition."[82] In other words, a sense of agency may attend the use of the word *wyrd*, with both pre- and post-conversion meanings that persisted and co-existed in some instances, meanings which might be translated into and related to folk superstitions of a "fearsome fate." That "fearsome fate" may be the one who appears in Alfred's imagination as he translates and transforms Boethius's text to combat its influence. Such connotations of "superhuman power" associated with *wyrd* from its past uses may not only have allowed it to translate related Latin words and concepts found in the text of Boethius, but may also have allowed *wyrd* to transform into a related, powerful Christian Providence, a dark agent under God's supervision, both within Alfred's version of Boethius's *De Consolatione*, and the early medieval English period more generally.

At the same time, two fair questions arise from these arguments about Alfred's translation: why would Alfred gravitate to a text like the *De Consolatione*, with its extended discussions of classical deities and "Fate," and why would he apparently change it to emphasize even more directly the narrator's confusion about the role of fate/Fate versus God's power in the lives of men? The first question may be answered by the second; perhaps persistent folk belief in the power of some kind of "fearsome fate" remained a problem that needed to be addressed squarely in Alfred's day, as well as Boethius's. Alfred tells his audience (in another statement interpolated into his translation), *þios wandriende wyrd þe we wyrd hatað* "this wandering *wyrd* **which we call** *wyrd*" (128.29, emphasis mine) is actually *Godes foreþanc 7 his foretiohhung* "the forethought of God and his foreordaining" (129.2–3). Alfred's statement suggests that some in his day still call "Fate/fate/the things that happen" *wyrd* and not the will of God or Providence. In another interpolation, he similarly states, *Sume uðwiotan ... secgað þ sio wyrd wealde ægþer ge gesælða ge ungesælða ælces monnes. Ic þonne secge, swa swa ealle cristene men secgað, þ sio godcunde foretiohhung his walde, næs sio wyrd* "Some sages ... say that *wyrd* rules both the good and evil fortune of each man. I say then, just as all Christian men say, that godly foreordination rules, not *wyrd* at all" (131.8–12). Critics have squabbled over precisely what Alfred means by his emphatic remarks, with some seeing a "heathen implication" and others such as Timmer seeing a reference to "chance" versus Providence.[83] Ultimately, however, whether Alfred refers to *Wyrd* or *wyrd* in this instance, he appears to be addressing folk beliefs he feels have persisted tenaciously among his people, beliefs to which he strongly objects. His translation of Boethius, then, is very probably his answer, and likewise explains why there are more references to the word *wyrd* and objections to *wyrd* as an independent agent contrary to God in Alfred's version of the *De Consolatione* than in any other work of the early medieval English corpus, early or late. That is not to

[81] *Ibid.*, p. 150.

[82] *Ibid.*, p. 152.

[83] *Ibid.*, p. 137; and Timmer, "Wyrd in Anglo-Saxon Poetry and Prose," p. 32.

say, of course, that Alfred is decrying belief in a "fate" goddess with a temple in her honor. Such a possibility seems quite unlikely in the face of an utter lack of supporting evidence. Clearly, however, there was still a vague force of the universe feared, credited, and named *wyrd* (the death-bringer!) that Alfred felt was being given more credence than it should. The force, perhaps not coincidentally, was one personified in the feminine and considered a death- and destruction-bringer more often than a life-giver.

Pollack argues that the feminine nature of *wyrd*, whether as a gendered noun or a vaguely remembered female figure, explains one of Alfred's most striking changes to his source, one related to textile imagery: Alfred's Wisdom is male, while Boethius's Philosophy is characterized as female. For the Old English translation, the feminine trappings of Philosophy are removed, with Wisdom enacting the feminine solely to comfort the narrator briefly after his outburst, but the rest of the time connecting "the narrator to the wisdom of the Father" through the masculine figure of Wisdom, who draws the narrator away from the (grammatically) female-gendered figure of *wyrd*.[84] Wandering exiles are very common and the most unhappy, elegiac creatures in Old English poetry; they tend to dwell in liminal spaces such as caves, barrows, and fens. In Alfred's version of the *De Consolatione*, at this most unhappy moment of plaintive lament, the narrator dwells in the liminal wilderness with *seo weord*, an exile from the homeland. In this context, Pollack points out related lines of *The Wanderer*, who, journeying as a solitary exile, exclaims bitterly, *Wyrd bið ful aræd!* "*Wyrd* is wholly inexorable" (5b), *wyrd seo mære* "wyrd the mighty" or "notorious" (100b), who has swept all the exiled warrior's kinsmen to death.[85] The only homecoming for the Wanderer is in heaven, as on earth, *onwended wyrda gesceaft weoruld under heofonum* "the decree of *wyrda* changes the world under the heavens" (107). It is perhaps fitting that *wyrd*, fierce fate or grim event, inhabits the liminal world in both Alfred's text and *The Wanderer*, a space that has become a "living death" for the solitary sufferer who now seeks for life in the heavenly kingdom. Thus, when Wisdom replies to the narrator's cry, he tells Boethius he had noticed the man wandering *afaren of þines fæder eðele* "far from the homeland of the father." In drawing the narrator back to the "right way," there are certainly reasons why Alfred might have wished to alter Philosophy and make male Wisdom the narrator's leader. First, the change allows a starker, (alliteratively) parallel, gendered contrast between Wisdom as male and *wyrd* as female. Wisdom is also more clearly paralleled to a masculine Lord that the narrator must follow. Both possibilities could have related to an authorial effort to find a "particular native vocabulary and set of images and personifications that would resonate with his audience: vernacular speakers and auditors in the Anglo-Saxon aristocracy."[86]

What we may assume is that Alfred's changes, in this and other instances in his text, are quite likely to have been thoughtful as well as intentional. Susan Irvine argues that

[84] "Engendering *Wyrd*," p. 650.

[85] *The Exeter Book*, ASPR 3, pp. 134–7. For additional, more recent discussion of the hostile and rebellious force played by *wyrd* in *The Wanderer*, see Faulkner, *Wealth and the Material World*, p. 186.

[86] Pollack, "Engendering *Wyrd*," pp. 648–9.

Alfred often reworks "the classical material" of Boethius intelligently and "quite drastically in order to enhance his own themes and purposes."[87] In a parallel example, Alfred, unlike his source, eliminates all reference to Mercury assisting Ulysses.[88] Why? Perhaps because some of the early medieval English, some of their contemporaries, and all of their forebears seem to have identified Mercury with Woden.[89] If Alfred's goal is to emphasize the power and supremacy of the Christian God, would he wish to translate a Latin reference as "Woden," or even leave it in a form of "Mercury," long-associated with Woden? Even if he somehow remained unaware of the historical associations of Mercury (which is somewhat unlikely), would Alfred wish to allude to the existence of a pagan god of any stripe without good cause, if doing so undercut his theme? Alfred's changes to his classical source thus clearly emphasize and de-emphasize what messages he may wish to transmit to his audience, and what ones he may not.

Such intelligent shaping of his sources may also explain a final, hotly contested set of Alfred's translation choices for the *De Consolatione*, one closely related to textile imagery: if Alfred meant to translate *wyrd* as "Fate" (as he does consistently for personified *fortuna* and *fatum*), then why not translate the Latin original's use of the most direct names of the Roman fate goddesses the *Parcae* as *Wyrda*? The relevant passage occurs in the twenty-fifth chapter of the *De Consolatione* during a description of the journey of Orpheus: *Ða eode he furður, oð he gamete ða graman metena ðe folcisce men hatað Parcas, ða hi secgað ðæt on nanum men nyton nane are, ac ælcu men wrecen be his gewyrhtu; þa hi secgað ðæt walden aelces mannes wyrde* "Then he went further, until he met the grim measurers ['goddesses' in one MS] which common men call the *Parcas*, those which they say have no reverence for any man, but punish every man according to his deeds; they say that these rule the *wyrde* of each man" (102.21–5). Alfred's explanation of their identity is his own and does not appear in Boethius's Latin text. Timmer argues that this failure to translate *Parcas* into *Wyrda* is a sign that "Fate/Fates" is no longer a possible connotative option for *wyrd* for Alfred.[90] While this is a possible interpretation, it is not a particularly plausible one. In glossaries, nine of the twenty-four times that *Parcae* is glossed in Old English, it is glossed as a form of *wyrda*.[91] The dating of these glosses is uncertain, but they suggest that some form of *wyrd* would have been a semantically acceptable gloss for *Parcae* within the post-conversion period. It seems rather more likely that Alfred might have

[87] "Ulysses and Circe in King Alfred's *Boethius*: A Classical Myth Transformed," in Toswell and Tyler, "*Doubt wisely,*" pp. 387–401, at p. 387. See also Faulkner, *Wealth and the Material World*, pp. 92–4.

[88] Irvine, "Ulysses and Circe," p. 392.

[89] Including writers from Julius Caesar and Tacitus to Ælfric and Wulfstan.

[90] "*Wyrd,*" p. 28.

[91] *Concordance, s.vv. wyrde, uuyrdae, gewyrda, gwyrda*. The other words which gloss *parca, parcae,* or related forms include *burgrunae, burgrunæ, burgrunan, burgrune, hægtesse, wiccena, wiccyna, wincena, wyccena,* and *wylfenne. Burh-rune* or *burh-runan* is defined by *Dictionary of Old English*, Fascicle B as "glossing Parcae 'the Fates,' Furiae 'The Furies'" (*s.v.*). Bosworth and Toller define *hægtesse* "witch, hag, fury" (*s.v.*, also see Chapter 3 of this work), *wicce* "witch, sorceress" (*s.v.*), and *wylfen* "she-wolf" or a gloss of "Bellona" (*s.v.*).

deliberately wished to leave the divine reference untranslated, as he did Mercury. If he is indeed addressing inappropriate folk fatalism with a Christian (and perhaps also Danish) audience in mind, would Alfred wish to reinforce a sense of the *Parcae* as *Wyrda*, if it did indeed exist?[92] Alfred's selective avoidance and equally selective emphasis of concepts related to the varied traditions of paganism seems deliberate, and Alfred should be credited for it where his translation choices and interpolations suggest wise rhetorical design. Oda argues, in fact, that "Alfred's purpose in translating *De Consolatione* is to provide for his people in their own language a rational discussion and to answer the problem arising from an older world view of the Anglo-Saxons, which is, in essence, how they might make the Christian idea of Omnipotence consistent with the accidental force of *wyrd*."[93]

Rhetorical design may also explain why *more* supernatural and fatal textile associations do *not* appear in Alfred's version of Boethius's text. Alfred appears to excise selectively some textile associations with both Lady Philosophy and the classical fates. Lady Philosophy of Boethius's Latin text is consistently feminine, and unsurprisingly (given the Roman world's similar gender norms regarding women and textile production), one of her characteristics is her ability to produce impressive textiles, *Vestes erant tenuissimis filis subtili artificio, indissolubili materia perfectae quas, uti post eadem prodente cognoui, suis manibus ipsa texuerat* "Her dress was made of very fine, imperishable thread, of delicate workmanship she herself wove it, as I learned later, for she told me" (1.1.13–16). As already discussed, Alfred exchanges Boethius's Lady Philosophy for his male-gendered Wisdom, and reference to textile production remains behind with Lady Philosophy.[94] For Alfred, such a deletion would make sense; high-status males of his culture (on whom Wisdom is surely patterned) would never weave. As discussed in Chapter 1, weaving was traditionally the province of women and metonymically and normatively identified with female gender. There is also a possibility, though perhaps less likely, that Lady Philosophy's very status as a supernatural weaver, alongside Alfred's preference for a wise male authority figure, might have encouraged him to reject her in favor of Wisdom. Supernatural female spinning or weaving figures seem to have played some role in all types of paganism from the Mediterranean to Germania, Celtica, and beyond, as I will later discuss. It is always possible that folk superstitions or awareness of the beliefs of his pagan forebears or his contemporary enemies and/or continental relatives may well have called to Alfred's mind such associations. If he were aware or even suspected such pagan traditions might be called to mind for others, he would very likely have shied away from a supernatural, weaving Lady Philosophy as an actor for the Divine, preferring a safer, lordly, male Wisdom, instead.

[92] Oda argues similarly, "Conceivably Alfred would not adapt the pagan idea of goddesses into the native word *Wyrda* since it is one of his tasks in this work to implant a Christian idea of fate into the word *wyrd*" (*Semantic Borrowing*, p. 127).

[93] *Ibid.*, p. 159.

[94] As Pollack ("Engendering *Wyrd*," p. 649) and Faulkner (*Wealth and the Material World*, p. 107) also note.

Alfred excises a second textile reference in his translation, one that links weaving to fate in *De Consolatione*. In the Latin original, weaving is associated with the ways that Boethius imagines "Fate" might play its role as divine Providence:

> Siue igitur famulantibus quibusdam prouidentiae diuinis spiritibus fatum exercetur seu anima seu tota inseruiente natura seu caelestibus siderum motibus seu angelica uirtute seu daemonum uaria sollertia seu aliquibus horum seu omnibus fatalis series texitur, illud certe manifestum est immobile simplicemque gerendarum formam rerum esse prouidentiam, fatum uero eorum quae diuina simplicitas gerenda disposuit mobilem nexum atque ordinem temporalem (4.6.51–60)

> Wherefore, whether Fate be exercised by the subordination of certain Divine spirits to Providence, or this fatal web be woven by a soul or by the service of all nature, or by the heavenly motions of the stars, by angelical virtue, or by diabolical industry, or by some or all of these, that certainly is manifest that Providence is an immoveable and simple form of those things which are to be done, and Fate a moveable connexion and temporal order of those things which the Divine simplicity hath disposed to be done.

Although Boethius's "Fate" thus seems connected in some way to a fatal web, or more closely translated, a "course" or "sequence" of that which is "fated" and which "is woven," Alfred's corresponding passage includes nothing about weaving in association with fate; he substitutes a different set of possible forces at work: angels, souls, creatures, stars, and/or deceits of demons (129.3–7). Such a substitution may well be by design, and the resulting imagery is much more orthodox. But the consistent deletion makes one wonder if Alfred really was aware of *wyrd* as a weaving, cosmic force; even when acting as Providence, his *wyrd* is not allowed to weave.

The potential fatal textile associations that do remain in Alfred's translation are very subtle and are perhaps poetic echoes, ones he may or may not have even recognized. Oda points out the consistent use of the words *hwyrfan/hweorfan* "to turn," for example, in conjunction with *wyrd* in the text, and he suggests such turning implies the turning of cosmic dice.[95] On the other hand, I would argue, as suggested above, that "turning" evokes a different image when linked with *wyrd*, that of spinning. All of the possible classical, Germanic, and Celtic influences for *wyrd* and related terms are associated with spinning and cutting threads of life. For a spinner, threads turn (vb. *hweorfan*) onto a spindle and whorl (n. *hweorfa*). It is interesting and significant, likewise, that *hwyrfan* can carry the implication of "destruction" as well as spinning, both characteristics of fatal figures more broadly. Oda notes that the imagery of turning is carried through in corresponding metrical passages with an alternate verb *wendan* "to turn, to alter" alliteratively accompanying *wyrd*, though with the same meaning.[96] This usage mirrors imagery of *wyrd* in *The Ruin*, which as discussed, links *wyrd* with a related form *onwendan*. Such correspondences imply we are looking at formulaic expressions, ones that incorporate

95 *Semantic Borrowing*, p. 45.

96 *Ibid.*, p. 107.

SPINNING, WEAVING, AND FORCES OF NATURE

the idea of a "turning" and perhaps "spinning" *wyrd*.[97] A final instance of potential textile imagery occurs in a passage already discussed; in his interpolation in which Alfred explains the *Parcae*, he calls them grim *metena*. I will reserve this example, however, for discussion under the related term, *metod*.

Unfortunately, Alfred's efforts do not seem to have solved the issue entirely. Some kind of folk belief in fatal forces persisted. We can tell because almost a hundred years later, Ælfric of Eynsham, like Alfred, discusses similar folk beliefs that he considers completely inappropriate as prevalent among his fellow countrymen. It is in his homily "VIII. Idvs Ianvarii Epiphania Domini" that *wyrd* or *gewyrd* does not seem to mean an "event," as it so often does in homiletic settings. The homily in question is a discourse on the signs of the birth of Jesus, in particular, the great star which shone in the heavens as a sign of creation's recognition of the birth of its creator. In the midst of this discourse, Ælfric debates an unorthodox interpretation of the star: that stars determine the fate of each man, including Jesus, and that *þurh heora ymbrynum him wyrd gelimpe* "by their course [the stars], *wyrd* befalls him," i.e. "one's destiny is determined by the course of the stars."[98] Ælfric's answer to such an idea (like Alfred's) is that good Christians must cast such a belief from their hearts, since the only *gewyrd* that might be real, beyond God's foreordination, is according to the *geearnungum* "merits" of each man (lines 120–2). The problem with the unorthodox belief is that some *stunte menn* "foolish men" say that *hi be gewyrde lybban sceolon: swilce god hi neadige to yfeldædum* (lines 137–8) "they must live according to *gewyrde*, as if God compels them to evil deeds." Thus, they justify their own actions by appealing to the inexorability of *gewyrde*.

Ælfric's interpretation of *gewyrd* itself is that *gewyrd nis nan þing buton leas wena: ne nan þing soðlice be gewyrde ne gewyrð* "*gewyrd* is nothing but a false hope: nothing truly comes about through *gewyrd*" (lines 182–3). With this heresy addressed, Ælfric can turn from the *leasan wenan þe ydele menn gewyrd hatað* "the false hope which worthless men call *gewyrd*" (lines 199–200) back to the gospel story. I have left *gewyrd* untranslated as well as *wyrd* to illustrate a point. To insert "event" or even "course of events" in every instance makes very little sense. Ælfric is probably not alluding to "Fate," nor is he discussing "Divine Providence" (which would not be a "false hope"). Even this late in the period and at a point at which we know the early medieval English people to be long christianized, the word *gewyrd* is related to some kind of popular belief in "fate" or "destiny," in this case, related to the courses of the stars. Thus, the word which most often means "event" in homiletic contexts must still retain a sense of "fate" understandable to Ælfric's audience. The use of *wyrd* or *gewyrd* in the homily suggests that multiple

[97] At the same time, it is also possible that the proverbial "wheel of Fortune" known among the Romans inspires the image.

[98] *Ælfric's Catholic Homilies: The First Series*, ed. Peter Clemoes, EETS ss, 17 (Oxford University Press for EETS, 1997), no. 7, lines 117–18. For this section of text, see pp. 235–7.

connotations of the word (including "destiny" or "fate") cannot be attributed to an early date of composition, since Ælfric is writing to a tenth-century audience.[99]

The genealogy of the homily in question makes Ælfric's comments even more interesting. As Joyce Hill has demonstrated, in much of the homily, Ælfric is borrowing and intelligently reworking content from writings of Paul the Deacon, Smaragdus, and Haymo of Auxerre. However, his comments on *wyrd* and *gewyrd* appear in neither the patristic sources on which these writers draw in their turn, nor in the commentary of the writers themselves. Hill observes that we are looking at a unique, "extensive passage on free will, for which, as far as I am aware, no direct source has yet been identified."[100] In ways thus strikingly similar to Alfred, Ælfric reworks his Latin exemplars and interpolates material to address matters pertinent to his time and his people. The evidence suggests that the same tenacious folk beliefs in a powerful fatal force (as opposed to an acceptable Christian Providence) disturbed Ælfric almost as much as it did Alfred a century before.[101] Manifest concern over the continuing influence of folk superstition in a fatal cosmic force thus continues for some time, and textile imagery associated with such a force exists alongside that evidence in the textual record.[102]

MEASURING: GOD AND FATE

Other words and images occur in Old English literature which may (or may not) be related to *wyrd* and to textile imagery. As previously indicated, the term *metod* almost universally means "God" in Old English. However, in a few scattered instances, the word is quite clearly rendered apposite to *wyrd*, typically at moments when *wyrd* plays a contested role as agent. Like *wyrd* and other terms, *metod* had a pre-Christian meaning, but this meaning has been difficult to identify. In Old English, *metod* is related etymo-

[99] Pedersen, in making similar observations about both Alfred and Ælfric's objections to *wyrd*, argues, "The fact that Ælfric felt the need to make this assertion suggests that he recognized a persistent heretical belief in some authority other than God among his flock – an authority to which he assigned the name gewyrd" (*Wyrd ðe Warnung*, p. 725). He cites similar arguments in Aaron J. Kleist's *Striving with Grace: Views of Free Will in Anglo-Saxon England* (University of Toronto Press, 2008), pp. 109–12.

[100] "Ælfric's Sources Reconsidered," in Toswell and Tyler, "*Doubt wisely*," p. 369.

[101] Ælfric mirrors Alfred in another interesting and related way. In his *De falsiis deis*, Ælfric shows a "tendency to avoid West Saxon cognates of Danish forms," meaning that, like Alfred, Ælfric avoids using words like Woden that smacked of early medieval English paganism of any age, even when paganism was under discussion (Richard North, *Heathen Gods in Old English Literature* (Cambridge University Press, 1997), p. 256).

[102] Elizabeth O'Brien documents a similar example of troubling, recurring "throwbacks" of folk tradition in the guise of burnt grain being offered during burial ceremonies, a tradition forbidden in the early penitentials, such as the Penitential of Theodore, but similarly prohibited in vehement tones in far later texts, including texts contemporary to Ælfric, such as the Confessional of Egbert (950–1000) ("Literary Insights into the Basis of Some Burial Practices in Ireland and Anglo-Saxon England in the Seventh and Eighth Centuries," in Karkov and Damico, *Aedificia Nova*, pp. 283–99, at pp. 294–5).

logically to *metan* "to measure" and "to allot."[103] It has cognates in similar words in Old Saxon, Old Norse, and Gothic, all of which mean "measurer," as well.[104] Additional meanings include "fate, creator, God" in Old Saxon and "fate, death" in Old Norse.[105] The Old English word's association with "allotment" and with *wyrd* has been used to argue its association with "F/fate," and perhaps by extension, with textile imagery.

In *Beowulf*, the first connection of *metod* and *wyrd* occurs in Beowulf's final speech to his men before his fatal battle with the dragon. He tells them his destiny is to be *swa unc wyrd geteoð, / metod manna gehwæs* "as *wyrd* ordains for us, the *metod* [measurer/ruler?] of every man" (2526b–27a).[106] After the battle, as Beowulf lies dying, he speaks of *metod* and *wyrd* again to Wiglaf, reminding him of his leadership responsibilities now that *wyrd* has taken all of their kinsmen to *metodsceafte*, to "death" or "the decree of fate" (2814b–15). Timmer argues that the apposition of 2526b–27a can only mean that *wyrd* has become a vague kind of "lot" that is equated to God because it is subsumed to his will.[107] In contrast, Fred C. Robinson asserts, "In the compound *metodsceaft*, used once by Wealhtheow and once by the dying Beowulf, *metod* can only mean 'fate,' and the simplex *metod* in 2527 is forced to have a predominantly pagan meaning because it is placed in apposition to *wyrd*."[108]

It is notable that all such instances come from the mouths of pagan characters in the work. But elsewhere in *Beowulf*, the same pagan characters refer repeatedly to *metod* in ways that seem to mean "God." The characters may be inconsistent; alternately, it is also possible that when Beowulf and Hrothgar invoke *metod*, whom they trust, they are invoking their "god" and that both meanings are operative in the minds of the audience, who know that their pagan heroes are hardly likely to be speaking of the Christian God, but wish to think of these ancestral figures as noble and godly pagans worshipping their contemporary understanding of a ruling "god," just the same.[109] For his part, the narrator distinguishes between *metod* and *wyrd* and identifies the true *metod* (presumably as opposed to the false one). The distinction between the two occurs at lines 1055b–57a, which (as previously cited) state *wyrd* would have brought about the death of more

[103] See also *Dictionary of Old English*, Fascicle A, ed. Antonette diPaolo Healey, Joan Holland, David McDougall *et al.* (Pontifical Institute of Mediaeval Studies, 1994), *s.v. ametan.*

[104] Oda, *Semantic Borrowing*, p. 51.

[105] Winfred P. Lehmann, *A Gothic Etymological Dictionary*, based on the 3rd edition of *Vergleichendes Wörterbuch der Gotischen Sprache* by Sigmund Feist (Brill, 1986), *s.v. *mitan.* See also Julius Pokorny, *Indogermanisches Etymologisches Wörterbuch* (2 vols, A. Francke, 1969), *s.v. med- 1.*

[106] Some have read *wyrd* as an accusative in this instance, which suggests the alternate reading that *metod* ordains the *wyrd* of each man. See Klaeber's citation of C. W. M. Grein, *Beowulf*, 3rd edn, p. 215, n. 2526. Elsewhere, Grein *et al.* suggest the opposite, that *wyrd* is substantive in these lines. See C. W. M. Grein and F. Holthausen, *Sprachschatz der Angelsächsischen Dichter*, edition revised by J. J. Köhler (Carl Winter, 1912; 1861–64), *s.v. wyrd, wird, wurd.*

[107] Timmer, "Wyrd," p. 226.

[108] Robinson, *Beowulf and the Appositive Style*, p. 49.

[109] See lines 670, 967, 979, 1778, and 2527.

warriors through Grendel if God (*Metod*) had not prevented it. The narrator adds, *Metod eallum weold / gumena cynnes, swa he nu git deð* "The Lord ruled all of the races of men, as he yet does now" (1057b–58). In later lines, the narrator again indicates that the fateful spirits (Grendel and Grendel's Mother) were not allowed to kill Beowulf, but were circumvented by the God of all creation, *þæt is soð Metod* "that is the true God" (1611b). The line may also mean "that is a righteous God," but it may be significant that the narrator's voice seems to be distinguishing twice between his pagan characters' understanding of *wyrd* and *metod* and a Christian understanding.[110]

The Seafarer, another of the heroic elegies, equates *wyrd* and *metod* at line 115, as earlier cited: *Wyrd bið swiþre / meotud meahtigra þonne ænges monnes gehygd* "*Wyrd* is the stronger / the ruler mightier than any man." The context of *metod* in the heroic poetic fragment *Waldere* also suggests the strong possibility that *metod* was once a cognate word for "fate," as the heroine tells Waltharius that because of his courage, *ic ðe metod ondred* "I have dreaded *metod* for you" (19b).[111] Why would she dread God because of the hero's courage in battle, something she praises him for? The related word *metodsceaft*, as has already been indicated, is linked to *wyrd* in *Beowulf*, as "death" or "decree of fate," and it carries the same meaning in its several other occurrences where it is not directly linked to *wyrd*.[112] If *metod* and *metodsceaft* are equivalent in these instances to the Christian God and his decrees, why would he so often be linked with the approach of grim death?

Alfred's translation of Boethius's *De Consolatione* provides further evidence of a possible relationship of *wyrd* and the word family for *metod*. As previously discussed, during Orpheus's journey to Hades, he meets several mythological figures, including the *Parcae*, who, according to Alfred, are grim *metena* who are said to have power over man's *wyrde*. The Old English word *metena* belongs to the same word family as *metod* and can be translated similarly as "measurers."[113] Moreover, *metena* or "metten" (as most etymologists designate the nominative singular form of feminine accusative plural *metena*) may be a feminine form of *metod*. Friedrich Kluge indicates that *metod* itself is formed from *mët* + the nominative agent suffix *-uþ*.[114] The feminine form, according to the paradigm for *god/*

[110] The phrase *soð metod* occurs ten other times in the Old English corpus, including five times in *Genesis* and *Exodus*, where such emphasis would be logical. *Concordance*, s.vv. metod, meotod, meotud.

[111] *The Anglo-Saxon Minor Poems*, ASPR 6, pp. 4–6.

[112] Including two other references in *Beowulf* (lines 1076, 1176) and one each in *Genesis* (*The Junius Manuscript*, ASPR 1, line 1738), *Menelogium* (*Anglo-Saxon Minor Poems*, ASPR 6, line 169), and *Fortunes of Men* (line 17) and *Christ* (line 887) (*The Exeter Book*, ASPR 3); *Concordance*, s.vv. meotodsceaft, metodsceaft, metodsceafte, meotudgesceaft, meotudgesceafte. Another related word, *meotudwange*, is also associated with death, the context indicating a "battlefield" is meant by "the measurer's field," in *Andreas*, line 8.

[113] Holthausen, *s.v.* metten. Julius Pokorny lists the root of the common "measurer" family, which includes *metan*, *metod*, *met*, as well as other Germanic, Latin, and Greek cognates, as Indo-European *med-* (*Indogermanisches Etymologisches*, s.v. med-1).

[114] Friedrich Kluge, *Nominale Stammbildungslehre der Altgermanischen Dialekte*, 3rd edn, with editing by Ludwig Sütterlin and Ernst Ochs, in *Sammlung Kurzer Grammatiken Germanischer Dialekte, Ergänzungsreihe*, ed. Wilhelm Braune (Max Niemeyer, 1926), p. 17, §29.

SPINNING, WEAVING, AND FORCES OF NATURE

gyden ("god/goddess") or *þeow/þeowen* ("male slave/female slave"),[115] would be *met-up-injô-* or syncopated *met-t-en* or *meten*.[116] The word, which does not occur elsewhere, may be Alfred's attempt to coin a feminine word form to distinguish *metod* from *metena* such as the dissolute *wyrda* or *Parcae*. Perhaps because of such associations, Bosworth and Toller define *metena* in this instance as "the Fates."[117]

As explanation, Oda suggests an association between *metod* and birth imagery in Hrothgar's words describing the good fortune of the woman who bore Beowulf, *hyre ealdmetod este wære / bearngebyrdo* "to her the Old Measurer was kind in childbearing" (945–46a).[118] He explains the reference as a textile metaphor, arguing that "the metaphor of a web" differentiates *metod* from *wyrd*; he envisions the warp as "measured" threads given by a life-giving version of fate (*metod*), and the weft thread the indeterminate length woven quickly by *wyrd*. Thus, as in the "image of the shuttle ... since the shuttle weaves the woof into the warp in very quick movement" so *wyrd* ends the weft thread unexpectedly that *metod* first granted.[119]

While I would agree that textile imagery may be used to explain fate imagery and may (or may not) have a connection to *metod*, Oda's conception of an opposition between such fates (*metod* fate versus *wyrd* fate) is difficult from a material and a textual perspective. Oda's sense of a fate's "warping" or "measuring" a warp as it is placed on a loom (in light of related imagery of Old English *hefeldian* and Latin *ordior*) is a plausible material image for a metaphor for beginning life (and mirrors imagery found in other cultures, as discussed later in this chapter).[120] However, there are other elements of the proposed metaphor that do not mirror material or textual evidence. A minor point is that *wyrd* as shuttle cannot be posited as a visual image for the early medieval English because we cannot prove definitively that they used shuttles until a later time; a bobbin or a loaded spindle might have been used instead. More importantly, however, Oda imagines two kinds of fate in conflict, with *wyrd* as weft defeating *metod* as warp if the weft thread is too short, resulting in death by the destruction of the web before it is complete.[121] Beyond lacking textual support, the imagery of warp fighting weft is somewhat mind-boggling from a material point of view, as such a relationship would prove counterproductive in a hurry. A weaver would naturally never want the weft to run short of the warp (or the textile would remain unfinished, which is like death), but neither would she be satisfied if the "beneficent" warp threads (creative *metod*) "defeated the weft," in a way that is, from

[115] *Ibid.*, p. 23, §41.

[116] I would like to thank David McDougall, then of the *Dictionary of Old English* staff, for his assistance in suggesting the possible grammatical origin of *metten*.

[117] *King Alfred's Old English Version of Boethius*, Sedgefield, p. 102, lines 21–5. For the definition of *metena* as "Fates" see Bosworth and Toller, *s.v. metten*.

[118] Discussed in *Semantic Borrowing*, p. 56. He does not extend this argument to *metena*, however, an interesting omission.

[119] *Ibid.*, pp. 56–7.

[120] The warping of a two-beam loom, in particular, would require such measuring.

[121] *Ibid.*, p. 57.

a textile point of view, conceptually impossible. The second defeat (in which the "positive" *metod* "wins") would also hardly be more life- or web-prolonging than the first. In addition, in the textual instances that *metod* might be considered a "fatal figure," *wyrd* and *metod* are rendered apposite, meaning, two varying terms referring to the same concept, rather than two competing forces.

What can be determined by textual and material evidence is that the word *metod*, literally "measurer," represents some kind of cosmic force, both before and after conversion. It is rendered in apposition to *wyrd* in unusual but consistent ways, largely in heroic poetry. As with other words with "fate" connections in Old English, *metod* is also very easy to imagine in a textile role, given its inherent meaning as a "measurer" and a sense of the material textile world of its time. Measuring takes place in just about every moment of the textile process: a spinner measures how much fiber to dress on a distaff, how much spin and twist are needed to create the right thickness of thread or yarn desired, how much thread can fit on a spindle before stopping to remove it, and how much thread has been spun to equal a standard measure (whether by eye, reel, or swift) or meet the need for a project before the final cut; a weaver measures the warp threads carefully to stretch them at equal lengths between beams, heddle rods, weights, and dividing planks, as well as measuring which types of warp threads (by color or by number) to attach to heddle rods to produce patterns or images. Eventually, the weaver measures when to cut the weft thread and tie it off in preparation for the finished web to be cut from the loom. Finishing textiles requires just as much measuring for stretching, dyeing, tailoring, and embroidering, among other processes. In short, textile work requires considerable skill in measurement in order for a final product to be completed successfully. Such a process is visually both creative and marvelous. A link to a divine "measurer" who allots the starting and ending of the "fabric" of a human life is, therefore, not far-fetched, whether the measuring is measurement of spun thread or a web in a loom. As it happens, closely similar metaphors of measuring fates are found in the cultures that are most likely to influence early medieval English tradition, as will be discussed in the closing sections of this chapter. Given the corpus itself, however, they are only tantalizing possibilities among many that may or may not explain what *metod* meant for the ancestors of the early medieval English people.

ARCHAEOTEXTUAL EVIDENCE: FATE AND TEXTILES?

Though not often considered in this light, one final piece of evidence which may (or may not) connect fatal figures and textiles among the early medieval English people is the written and visual text of the Franks Casket. Unlike most of the textual evidence discussed thus far, which dates from the eighth to the eleventh centuries, the Franks Casket is thought to come from early in the eighth century and is therefore one of the oldest visual and textual artifacts in the early medieval English corpus.[122] The casket's iconogra-

[122] Consensus seems to point to *c.*AD 700, Northumbria; David Howlett, "Calculus in Insular Artistic Design," *The Antiquaries Journal*, 103 (2023), 135–61, at p. 143.

Fig. 6. The Franks Casket, right panel, early eighth century. © British Museum.

phy appears to parallel Germanic myth and legend (which are not typically identified by inscriptions) and classical and biblical legend (which usually are) in ways that suggest more familiarity with pre-Christian legends and traditions than new ones.[123] The right panel, in an interesting extension of this pattern, juxtaposes older, encrypted rune forms alongside regularized rune forms of the conversion period. Leslie Webster notes, "The presence of the older forms in the encoded inscription on the right end suggests that the carver chose them for a particular purpose, perhaps to associate the older, outmoded runic style with a pagan Germanic past."[124] The imagery with which these encrypted rune forms are associated appears on the far right side of the right panel of the casket (see Figure 6): three hooded figures stand in a group with something resembling an orb in their hands and trailing threads or ropes falling below.[125]

Speculation on their identity over the years has been wide-ranging, but Gale R. Owen-Crocker points out that they are wearing the "usual feminine head-dress, consisting of a voluminous hood, and a long garment."[126] Although men were also known to wear

[123] As Leslie Webster notes in *The Franks Casket* (British Museum Press, 2012), p. 8.
[124] Ibid., pp. 47–8.
[125] Figure 6 is found in "The Franks Casket," *The Anglo-Saxon Minor Poems*, ASPR 6, p. 117.
[126] First noted in Gale R. Owen, "Wynflæd's Wardrobe," *ASE*, 8 (1979), 195–222, at p. 217, n. 1.

hooded cloaks, they would be wearing shorter garments than the figures in question. Owen-Crocker notes that the women are peculiar in the details of their dress in that their hoods are pointed, unlike the hoods of the other two women depicted (Beaduhild and an attendant on another panel).[127] Second, the unusual women stand next to a barrow over which a grieving figure and a horse stand.

The encrypted inscription on the casket reads as follows: *Her Hos sitæþ on hærmbergæ, / agl[.] drigiþ, swæ hiri Ertae gisgraf / særden sorgæ and sefa tornæ* "Here sits a company (or Hos) on the evil barrow; she endures misery, as *Ertae* ordained for her, heart rendered miserable and aggrieved."[128] Since the casket includes depictions of a Roman legend, of Germanic legends such as Weland's torment and revenge, and of the adoration of the Magi, it is challenging to pinpoint from which tradition(s) this image derives, but one convincing if inconclusive suggestion is that the images are linked to the highly popular Sigurd cycle of Germanic legend.[129] Thus, Sigurd's famous horse Grani mourns alongside a female figure, perhaps his wife Gudrun or valkyrie-lover Brynhild. Such a theory explains the warrior-figures to the left as Brynhild's husband and his brother, the killer of Sigurd. On the other hand, David Howlett has argued recently that the mourners instead involve Woden standing over the grave of Balder with others of the northern pantheon.[130] Alternately, the scene might also just as easily be the prototypical tableaux of a mourning Germanic wife and horse, with companions nearby to celebrate funeral rites. Any of these contexts would explain the bulk of the inscription and the mournful images on the left side of the panel. What remains unexplained, however, is the cluster of images associated with the hooded women by the barrow, as well as the rest of the encrypted, old-runic inscription.

The hooded women are depicted adjacent to the death-barrow, a liminal place, as discussed in Chapter 3, often associated in Germanic cultures with other-worldly experiences during which a mortal (usually a mourner) sees mythic or, in post-conversion terms, demonic beings such as valkyries or fate-spirits.[131] The portion of the inscription which seems related to them and their actions in the scene, which may shed additional light on their identity, is vague, but it links *Ertae* with *gisgraf*, which I read as *gescraf*. The verb *gescrifan* "to ordain, allot, provide for" is a word very commonly associated with *wyrd* and other fatal figures. In the Old English corpus, the verb form *gescreaf/gescraf*

[127] Owen-Crocker, *Dress*, p. 149.

[128] "Franks Casket," p. 116, lines 1–3.

[129] Dobbie, "Introduction" to "The Franks Casket" (*The Anglo-Saxon Minor Poems*, ASPR 6), pp. cxxvii–cxxviii.

[130] Howlett, "Calculus," p. 151.

[131] Citing Hilda Ellis Davidson, Alfred K. Siewers argues the "ritual associations" of tumuli remained active long into the period, during and long after the time of the construction of the Franks Casket, meaning such liminal associations would be active in this scene ("Landscapes of Conversion," p. 22).

appears five times, three of those times as *wyrd gescreaf/gescraf*.[132] *Ertae* is not attested elsewhere and its meaning is obscure, although Elliott Van Kirk Dobbie comments that the word is "evidently a feminine proper name."[133] What evidence there is, then, suggests we are looking at three unique, hooded female figures, the *Ertae*, who are standing near a funeral barrow and "allotting" an unhappy fate next to a woman who has lost someone she loves to the forces of death. In other words, the preponderance of evidence suggests we are looking at cosmic, female, fatal figures.

Commentators appear not to have noticed that the *Ertae* also seem to be either spinning or unrolling a ball of thread with their hands. The two women in profile handle an orb in their hands that trails threads beneath it. They have one hand near the top and another near the bottom of the orb, near the threads, which suggests that they are drawing down the threads from the orb which the central figure may or may not be holding (her actions behind the others are more difficult to see). The image is evocative of mythic women working with thread, perhaps spinning. Although Howlett argues they are very probably three Norns attending Woden, in keeping with how he reads the rest of the scene,[134] the identification is not necessarily quite that straightforward; as I will discuss shortly, classical, Germanic, and Celtic mythologies all contain references to fates working the threads of mortal life.

In statements roughly contemporary to the Franks Casket, Bede writes in *De Temporum Ratione* that the early medieval English (or at least the early Northumbrians) worshipped female goddesses prior to conversion. In Bede's account of the important festivals of the pagan period, he lists month names, two of which are named after female goddesses: *Rhed-monað a Dea illorum Rheda cui in illo sacrificabant, nominator*[135] "Rheda-month is named for a goddess of theirs, *Rheda*, to whom at that point, they used to sacrifice." The other month is named *Eostre, a Dea illorum quae Eostre vocabatur*[136] "for a goddess of theirs who was called *Eostre*." The second name survives in Easter, a clear example of initially conscious, but now linguistically unconscious holiday syncretism. Bede also lists a grouping of holy women or goddesses, who may or may not include *Rheda, Eostre,* and/or even *wyrd/wyrda*, a grouping associated with another syncretic holiday: Yule. He explains what Yule had once meant and celebrated, as opposed to what it meant in his day: *Et ipsam noctem nunc nobis sacrosanctam, tunc gentili vocabulo Modranicht, id est, matrum noctem appellabant: ob causam ut suspicamur ceremoniarum,*

[132] *Elene*, line 1046; *Beowulf*, line 2574b; and *Meters of Boethius*, no. 1, line 29 (*The Paris Psalter and the Meters of Boethius*, ASPR 5 (Columbia University Press, 1932)). The subjects of the two other instances are God (*Andreas*, line 843) and the evil Egyptian pharaoh pursuing the Israelites (*Exodus*, line 136); *Concordance, s.vv. gescraf, gescreaf*.

[133] Dobbie, "Notes" to "The Franks Casket," p. 206.

[134] Howlett, "Calculus," p. 151.

[135] Bede, *De Temporum Ratione, The Miscellaneous Works of Venerable Bede in the Original Latin*, ed. J. A. Giles, Scientific Tracts and Appendix, 6 (Whitaker, 1843), p. 179. Translations are mine.

[136] *Ibid.*, p. 179.

quas in ea pervigiles agebant[137] "And the same night now to us most holy, then in the words of the people *Modranicht*, that is, they called it 'Mothers' Night': we suspect because of the ceremonies, those in which they led, ever-watchful." The Anglo-Latin can be interpreted that the "Mothers" are holy women leading the ceremonies, or that people are leading ceremonies for the holy "Mothers." The distinction may be irrelevant, however; if the rest of the ancient world is any guide, "Mothers" are quite likely to have served "Mother" goddesses.

Owen connects Bede's "Mothers" of *Modranicht* to the earth-mother goddesses worshipped in Roman, Germanic/Scandinavian, and Celtic traditions. She suggests likewise that they may be represented in the three mysterious figures on the Franks Casket.[138] The line of argument is entirely possible. Hooded figures (often male) are associated with mother goddesses and at times appear to be mother goddesses in carved figures from Celtic or Romano-Celtic finds in Gaul, the area near Hadrian's Wall, and the Cotswolds (generally first century AD). Those from British or Romano-British contexts are particularly linked with triads of hooded figures, although some of these figures, as stated, are very often interpreted as male "protectors" of accompanied mother goddesses. They are typically depicted from the front, and some carry what appear to be eggs or other objects.[139] These figures appear to be connected to "mother goddesses" of continental Germanic and Celtic origin, who may or may not have developed "fatal functions" from syncretic association with the Roman *Parcae* and whose images have been found holding "a spindle, distaff and scroll."[140] A triad of Celtic mother goddesses in Britain (Carlisle) that seems to be related to this continental tradition is named *Parcae* in one instance.[141] The similarities between these hooded mothers and the Franks Casket iconography are certainly suggestive. On the other hand, the earlier British Celtic images are rather distant chronologically from the Franks Casket and distinct in other significant ways, including consistently different visual orientation and "carried" object (it is difficult to imagine their orb with trailing threads as an egg). They may just as likely represent a related tradition as a source tradition for the Franks Casket.

A number of scholars have also speculated that the female figures are the visual, early English equivalents to the Germano-Scandinavian fatal triad, the Norns.[142] In the absence of direct iconographical parallels, it is impossible to determine if this speculation is likely or not. The casket's focus on distinctive Roman and biblical imagery in panels structurally

[137] *Ibid.*, p. 178.

[138] *Rites and Religions*, p. 34.

[139] See J. M. C. Toynbee, "Genii Cucullati in Roman Britain," *Collection Latomus*, 28 (1957), 456–69; and Miranda Green, *Symbol and Image in Celtic Religious Art* (Routledge, 1989), pp. 175–87.

[140] Miranda J. Green, "Fates," *Dictionary of Celtic Myth and Legend* (Thames and Hudson, 1992), p. 95.

[141] *Ibid.* Green does not provide the provenance or dating of the Carlisle instance.

[142] See, for example, A. C. Bouman, who likewise cites R. W. V. Elliott ("The Franks Casket," *Neophilologus*, 49.1 (1965), 241–9).

SPINNING, WEAVING, AND FORCES OF NATURE

opposed to panels which appear to use distinctive Germanic imagery would provide an argument in favor of the triad intending to represent important aspects of Germanic myth, but a Roman parallel is also possible.

Whatever the source of inspiration for the three "spinning," fatal women on the Franks Casket, they are very early indicators of what the later textual sources document, as already discussed: powerful, supernatural figures of fate formed a fearsome part of the imaginative universe of the early medieval English people, and in that universe, fatal figures were associated with textile production. The image on the Franks Casket, if it is any indication of folk belief of the time, shows that a triad of liminal, spinning "weird women" was familiar to at least some of the early medieval English people, as three "weird sisters" were to their descendants in Shakespeare's time.[143] Compelling evidence for mythological spinners and weavers of fate can be found in classical Greek and Latin and Germanic and Scandinavian traditions, and either or both traditions could have influenced the textile imagery associated with fatal figures in Old English and Anglo-Latin literature. I will turn now to a discussion of each.

GREEK AND ROMAN FATES

Perhaps the most famous spinning fates are the Greek *Moirai*. In Greek mythology, the three immortal *Moirai* are female, and they are responsible for assigning mortals their destinies at birth; they do so by spinning the strands of destiny for each human born. Hesiod (*c*.700 BC) describes the individual names of the *Moirai*, their origin, and their role as daughters of Night, "Avenging Fates, Clotho, Lachesis, and Atropos, / Who give mortals at birth good and evil to have," and who also "prosecute transgressions of mortals and gods," although the latter may indicate a confusion of the *Moirai* with their sisters the furies.[144] The *Moirai* have individual roles and names: Lachesis is the measurer and assigner of the lot, Clotho its spinner, and Atropos its cutter and binder. The inexorable sister is thus Atropos, cutter of the thread of life.[145]

[143] The three "weird sisters" accurately prophecy Macbeth's fate as future king, setting his ambition (and his destruction) into motion (*Macbeth*, Act 1, Scene 3).

[144] Hesiod, *Works and Days and Theogeny*, trans. Stanley Lombardo (Hackett, 1993), lines 218–20. It is interesting the *Moirai*, as sisters to the *Erinyes* (the Furies), were dedicated altars alongside the Eumenides (domesticated Furies). See Erich Neumann, *The Great Mother: An Analysis of the Archetype*, trans. Ralph Manheim, 2nd edn (Princeton University Press, 1991; 1955), p. 231. Even the Greek gods have their own "fates" (cf. pp. 468, 479). Hesiod's equation of the *Moirai* with the will of Zeus (similar to at least one instance in Homer) is mirrored in his explanation that they were some of Zeus's wives (lines 909–11). Zeus characteristically married goddesses whose powers he desired, such as Metis; in her case, he consumed her and thus had her powers within him.

[145] Barber, *Women's Work*, p. 235; Richard Broxton Onians, *The Origins of European Thought about the Body, the Mind, the Soul, the World, Time, and Fate: New Interpretations of Greek, Roman and Kindred Evidence, also of Some Basic Jewish and Christian Beliefs* (Cambridge University Press, 1951), pp. 416–17.

The earliest classical Greek texts describe the *Moirai* in action. In the *Iliad*, Hekabe tells Priam: "Let us sit apart in our palace / now, and weep for Hektor, and the way at the first strong Destiny / spun with his life line when he was born."[146] The role of the fates of traditional Greek mythology is also mentioned by the Phaiakian Alkinoos in the *Odyssey*: "but there in the future / he shall endure all that his destiny and the heavy Spinners / spun for him with the thread at his birth."[147] Although Zeus occasionally partakes of the role of "weaving" destiny, the textile image associated with the action may indicate that he has assimilated the function of the female fates.[148]

Plato's *Republic* also includes a description of the roles of the *Moirai* from a dream of a friend in which he travels with the dead to be reincarnated and observes the process of being fated to a new life. As they travel towards their allotment, the souls come where they can see the center light of the universe, within which is found the "spindle of Necessity" turning the universe within a whorl of several concentric circles (374.616c-d).[149] There are three women "sitting on thrones which were evenly spaced around the spindle. They were the Fates, the daughters of Necessity ... they were Lachesis, Clotho, and Atropos ... with Lachesis singing of the past, Clotho of the present, and Atropos of the future" (375.617c). Each soul chooses a lot drawn from Lachesis's lap (375.618a), then receives its guardian deity from her and passes under Clotho's hand near the spindle "to ratify the destiny the soul had chosen" (378–79.620e). The soul is then led "to Atropos and her spinning, to make the web woven by Clotho fixed and unalterable" (379.620e). As translated, the textile process involved is confusing: why is there a second spinning by Atropos after weaving? Spinning is the precursor to weaving. The answer lies in the translator's conflation of spinning and weaving (a common error by translators at this place in the text, and more generally): the Greek original for Clotho's web is ἐπικλωσθέντα, roughly translated as "that which has been spun," meaning Atropos ratifies that which Clotho has spun.[150]

The connection of Atropos and by extension the *Moirai* with inexorable death is reminiscent of *wyrd* as death-bringer. The poet Stobaeus (fifth century AD), possibly quoting earlier Greek poetry, describes the "Fates" with reverence and fear, "ye Fates who sit nearest of Gods to the seat of Zeus and weave with shuttles adamantine [αδαμαντιναις

[146] Homer, *Iliad*, trans. Richmond Lattimore (Chicago University Press, 1961; 1951), book 24, lines 208–10. Lattimore's "Destiny" is Fate in these instances.

[147] Homer, *Odyssey*, trans. Richmond Lattimore (Harper Perennial, 1991; 1965), book 7, lines 196–8.

[148] "Easily recognized is the line of that man, for whom Kronos' son weaves good fortune in his marrying and begetting" (*Odyssey*, book 4, lines 207–8).

[149] Plato, *Republic*, trans. Robin Waterfield (Oxford University Press, 1993). Except where noted, in this and all other instances, the translator has translated Κερκις (kerkis) "spindle" and translates forms of *Moirai* as "Fates."

[150] The Greek text is easily accessible at the Perseus Project website, http://www.perseus.tufts.edu/hopper/text?doc=Perseus%3Atext%3A1999.01.0167%3Abook%3D10%3Apage%3D620 (accessed 6 March 2024). Translation here is based on information taken from the Perseus Project's word study tool application.

ὑφαίνετε κερκίσιν] numberless and inevitable devices of all manner of counsels, Destiny, Clotho, and Lachesis, Night's daughters of the goodly arms, listen to our prayers, ye all-dreaded deities both of heaven and hell."[151]

The *Moirai* are also associated with childbirth. In Pindar, Apollo sends all three *Moirai* with Eileithyia (goddess of childbirth) to the childbirth of Pitana the nymph.[152] In Old English, *gebyrd* "birth" occurs as a synonym of *wyrd*,[153] and Oda, as discussed, sees a similar connection between birth and the "old" *metod*. Linguistically, the uses of *moira* and *wyrd* are also similar in that sometimes *moira* seems to mean a single "Fate," and *moirai* sometimes means lower-case "fate" or the "thread spun."[154] Another similarity between the Greek and Germanic fates (and *wyrd* as well) is the struggle between the male ruling deity and female fate(s), over which supernatural being takes precedence.[155] One major difference between the Greek fates and *wyrd* is a subtle but important one: the *Moirai* are more often spinners; *wyrd* is almost universally a weaver.

Determining which, if any, Greek texts would have been directly accessible to the pre-Conquest English, meaning which might be considered a "source" for images of fate in early medieval English literature, is presently impossible. Bede demonstrates a limited knowledge of Greek and Greek texts, and he further informs us that some of the early Christian leaders from Rome brought texts in Greek to England and taught Greek to monastic pupils.[156] These leaders, Theodore and Hadrian, profoundly influenced pupils of the Canterbury school such as Aldhelm.[157] However, the knowledge of Greek does not appear to have been long-lived: "after the generation of students trained by Theodore and Hadrian, there was scarcely a single Anglo-Saxon scholar before the

[151] In J. M. Edmonds (ed. and trans.), *Lyra Graeca* (3 vols, William Heinemann, 1952; 1922), vol. 3, p. 449. Original Greek from p. 448, line 5; Edmonds's translations of textile terms appear accurate. Edmonds does not list a source for Stobaeus's lines, but Stobaeus's work generally draws on and honors earlier Greek poetic lines and sayings he wished to transmit to his son.

[152] Pindar, *Olympian Odes, Pythian Odes*, ed. and trans. William H. Race, Loeb Classical Library, 56, 485 (Harvard University Press, 1997), vol. 2, p. 107, line 42. Pindar wrote in Thebes in the fifth century BC.

[153] *Concordance, s.v. gebyrd. The Dictionary of Old English* defines *gebyrd* in this sense, "what is allotted by or ordained from birth: fate, destiny" (Fascicle B, *s.v. gebyrd* noun, sense B).

[154] Onians, *Origins of European Thought*, p. 379.

[155] See a comparative analysis in Kemble, *The Saxons in England*, pp. 396–7, as well as examples in this chapter where God and Zeus rule over the decrees of fate (*Beowulf* and the *Odyssey*, respectively).

[156] J. D. A. Ogilvy, *Books Known to the English, 597–1066* (Medieval Academy of America, 1967), pp. 146–8. Ogilvy points out that the Celtic monastic orders who had so much influence on early medieval English monastic development had access to some Greek materials, as well, which may have been another point of access.

[157] Bernhard Bischoff and Michael Lapidge, *Biblical Commentaries from the Canterbury School of Theodore and Hadrian* (Cambridge University Press, 1994), pp. 2, 268. However, Lapidge indicates that the extent of the leaders' influence on Aldhelm is problematic because Aldhelm "spent a relatively short period of time (two years?) at Canterbury in the school of Theodore and Hadrian" (p. 2).

Norman Conquest who could have read a Greek manuscript."[158] Even if manuscripts and knowledge of Greek had survived, there is some question whether or not religious leaders would have encouraged borrowing from overtly pagan, classical materials such as works by Homer, Hesiod, and Pindar.[159]

On the other hand, references to Homer's works in Old English texts such as Alfred's version of Boethius's *De Consolatione* show that early medieval English writers probably had some contact with Greek poetry, although likely through the medium of early Latin translations and allusions found in the works of early medieval Latin writers. The same medium is probably responsible for their awareness of Aesop, a number of important Greek medical texts, and Aristotle, among others.[160] A clear example of such mediated transmission of Greek ideas occurs in the Old English translation of "The Letter of Alexander to Aristotle," which glosses the names of the Greek fates used in a Latin source: "Clothos Lachesis Atropos" become *wyrde*.[161] Thus, through the Latin source, the early medieval English translator of the "Letter" is aware of the names of the Greek fates and their role as "Fate," although the Latin source does not otherwise allude to their roles or attributes.

The Romans were naturally very familiar with Greek texts, and they seem to have understood and equated the *Moirai* with their *Parcae* or *Parcas*, who started out as minor goddesses of childbirth.[162] The *Parcae* came to share many of the attributes of the *Moirai*, including their dispensing of fate through metaphorical spinning. At some stage, the *Parcae* also became synonymous with other minor deities involved with the fate of a mortal, including *Fortuna* and *Fata*. In particular,

> the neuter plural word *fata* – "those things which have been spoken" (therefore equated with destiny) – was reanalyzed as a feminine singular noun (both end in *a*) and consequently personified as a woman. This divine lady Fate then eveloped [sic]

[158] *Ibid.*, p. 241.

[159] Michael Lapidge suggests that the texts must have included biblical and patristic materials, rather than pagan odes and classical epics, since a few Greek prayers and glosses of Greek words from biblical sources are to be found in early medieval English manuscripts, and the influence of these materials on some early Anglo-Latin and Old English religious texts also seems profound (Bischoff and Lapidge, *Biblical Commentaries*, pp. 169–70, 241, 261).

[160] Ogilvy, *Books*, pp. 54, 58, 77, 143. See also Frederick M. Biggs, Thomas D. Hill, and Paul E. Szarmach, with the assistance of Karen Hammond (eds), *Sources of Anglo-Saxon Literary Culture: A Trial Version* (Center for Medieval and Early Renaissance Studies, SUNY Binghamton, 1990), pp. 140–1.

[161] In Orchard, *Pride and Prodigies*, pp. 221 and 252, §40. The mention of the "Fates" occurs as two mythic trees tell Alexander his fate, the first time in "Indian" (given in Latin) with the "Fates" called *fata* (also glossed as *wyrd*) (pp. 220 and 250, §37) and the second in Greek (given in Latin with the Greek names for the "Fates," as previously cited). It is not at all certain that Alexander wrote the "Letter."

[162] Barber, *Women's Work*, p. 236.

SPINNING, WEAVING, AND FORCES OF NATURE

a host of identical sisters (the Fates) and took over [or rather, shared] the duties and attributes of the *Parcae*.[163]

Catullus describes their role at the wedding of Peleus and Thetis, where the *Parcae* perform a song that describes how they predict the future for the couple:

> laeua colum molli lana retinebat amictum,
> dextera tum leuiter deducens fila supinis
> formabat digitis, tum prono in police torquens
> libratum tereti uersabat turbine fusum[164]

> The left hand held the distaff clothed with soft wool; then the right hand lightly drawing out the threads with upturned fingers shaped them, then with downward thumb twirled the spindle poised with rounded whorl.[165]

The imagery of their spinning and their song is brought together by a repeating refrain: *currite ducentes subtegmina, currite, fusi*[166] "hasten, guiding threads, hasten, spindles," which sounds like a weaving or spinning song in its rhythmic quality. The *Parcae* in this instance grant the lovers a constructive destiny, but the *Parcae* were more often considered to be figures of death, as epitaphs illustrate: *stamina ruperunt subito tua candida Parcae*[167] "The *Parcae* suddenly broke your shining threads." Another inscription reads, *cunctis fila parant Parcae nec par<c>itur ullis*[168] "The *Parcae* dispose the thread for all things; none is spared by them."

As inexorable "Fates," the *Parcae* and the *Fata* feature frequently and extensively in the Latin corpus. Virgil's Eclogue 4 connects the *fata* or *Parcae* to the spinning of destiny through their *fusis* or "spindles," *"Talia saecla" suis dixerunt "currite" fusis / concordes stabili fatorum numine Parcae* "'Such an age,' they declared, 'hasten,' with their spindles / agreed, with the fixed, divine will of the Fates, the *Parcae*."[169] In the *Aeneid*, Virgil makes dozens of references to harsh fates, including a handful of references to turning and spinning fates, who from the beginning of the epic poem are powerful and ever-watchful as they determine how Aeneas's destiny (and everyone else's) will be accomplished and each triumph and hardship realized; as the text states, *sic volvere Parcas* "so turn the

[163] *Ibid.*, p. 245.

[164] Latin text taken from Catullus, *Catullus: A Bilingual Edition*, ed. and trans. Peter Whigham (University of California Press, 1983), p. 303.

[165] Translation by Scheid and Svensbro, *The Craft of Zeus*, p. 105.

[166] *Catullus*, p. 304. Translation here is mine.

[167] Latin epitaph quoted in Onians, *Origins of European Thought*, p. 350. Translation is mine.

[168] *Ibid.*, p. 351. Translation is mine.

[169] Virgil, *The Eclogues and Georgics of Virgil*, lines 46–7. The Latin is drawn from Lewis's edition; translation is mine. The word *currite* in association with the actions of the "Fates" makes one wonder if Virgil was influenced by Catullus's poem, cited above.

Parcas" (1.22).[170] Thus, when the last day of his life arrives for the character Lausus, the "Fates" end their spinning of his thread, *extremaque Lauso / Parcae fila legunt* "the *Parcae* gathered the last thread for Lausus" (10.814–15). As is so frequently the case with fatal figures, the appearance of the *Parcae* means death far more often than life.

In his poem *Tristia*, Ovid questions the harshness of the "Fates" in his own life. He asks *nubila nascenti seu mihi Parca fuit* "whether a clouded Fate attended my birth" (5.3.14) and wonders *dominae fati quicquid cecinere sorores, / omne sub arbitrio desinit esse dei?* "is it true that whatever the sisters, mistresses of fate, have ordained, ceases wholly to be under a god's power?" (5.3.17–18).[171] He further suggests that Bacchus, to whom his appeal is addressed, is under their power, *hanc legem nentes fatalia Parcae / stamina bis genito bis cecinere tibi. / me quoque, si fas est exemplis ire deorum, / ferrea sors vitae difficilisque premit* "Such doubtless was the law twice ordained for thee by the *Parcae* who spun the fated threads at thy double birth" (5.3.25–8).[172] As he laments his exile, Ovid singles out Lachesis (by her Greek name), *o duram Lachesin, quae tam grave sidus habenti / fila dedit vitae non breviora meae!* "Ah! cruel Lachesis, when my star is so ill-fated, not to have granted my life a shorter thread!" (5.10.45–6).

Subsequent Latin writers, perhaps emulating Virgil and Ovid or their contemporaries or drawing on the same religious and literary mythology, cite similar, inexorable fatal goddesses as the actors behind the calamities of gods and men. Writing in the first century AD, Statius names the fates in Greek as well as Latin forms, *dura* "hard" Lachesis (2.249), *ferrea* "iron" Clotho (3.556), and *ferrea* "iron" Atropos (4.601) in the *Thebaid*.[173] These fates, like Virgil's and the Greek fates before them, are generally visualized as spinners who cut threads to end life. Statius explains that the "Fates" give success to one warrior, but death to another, whose *extrema iam fila colu* "last thread [is] already at the distaff" (6.380).[174] In another example, when a warrior/prophet descends alive through a

[170] As stated in Chapter 2, all references to the *Aeneid* are cited from Virgil, *The Aeneid of Virgil, Books I–VI* and *The Aeneid of Virgil, Books VII–XII*, both edited by T. E. Page, by book and line. Translations are my own.

[171] All references to *Tristia* and *Ex Ponto* come from Ovid, *Tristia, Ovid in Six Volumes: VI: Tristia, Ex Ponto*, trans. Arthur Leslie Wheeler, 2nd edn, Loeb Classical Library, 151 (Harvard University Press/William Heinemann, 1988; 1924). Translations for this work are Wheeler's unless otherwise noted and are listed by volume, section, and line.

[172] It is interesting that Ovid uses *stamina* in reference to the threads of the "Fates" for the birth of Bacchus. Although the word is quite frequently associated with the distaff and with spinning in poetry (and with the *Parcae*) as "thread," it can also mean "warp thread."

[173] As indicated at note 6, references to Statius are drawn from *Thebaid, Books 1–7* and *Thebaid, Books 8–12, Achilleid*. Translations are mine, and references include book and line numbers.

[174] There is a possibility that he is confusing distaff with spindle, as the finished thread should end at the spindle, rather than the distaff (see the example from Catullus, above). Conflation is possible in his work; elsewhere, he seems to use terms such as *fila, stamina,* and *licia* interchangeably for the threads employed by the "Fates" (6.380, 8.11–13, 8.382, respectively); all three, however, are technically different kinds of thread from different moments in the textile production process, the first the generic and common term for spun "thread," the second "warp thread," and the third, "heddle thread." Such indiscriminate interchange of

SPINNING, WEAVING, AND FORCES OF NATURE

gap in the earth to the underworld, startling everyone as he lands, *quin comminus ipsa / Fatorum deprensa colus, visoque paventes / augure tunc demum rumpebant stamina Parcae* "close by the same, surprising even the distaff of the Fates, and seeing the diviner, the startled *Parcae* at last, then, severed the threads" (8.11–13), perhaps hastily making his death official. Further imagery links the "Fates" of Statius with spinning, with their *nigraeque ... colus* "dark distaffs" (3.241, 242), including an unusual detail that may be related to spinning. Statius explains that *Fata ferunt animas et eodem police damnant* "The Fates bring the souls and judge them with the same thumb" (8.26). Hand spinners can develop a malady that I call "Spinner's Thumb," the enlargement of the thumb from constant twisting of thread during spinning and the resultant calluses.[175] Perhaps "Spinner's Thumb" explains the connection made between the "Fates" of Statius and the role of their thumb in the allotting of fate.

The Christian Latin writers of Late Antiquity also discuss the "Fates." In his "A Reply to Address of Symmachus," Prudentius explains his disdain for both the "false" fatal goddesses of the ancients and his credulous contemporaries' resort to such forces, claiming his peers think the fatal goddesses control even the stones and beams of their own homes: *adscribunt saxis Lachesis male fortia fila, / tectorumque trabes fusis pendere rotates* "They wickedly assign to stones the strong threads of Lachesis, and the beams of our roofs on spindles hang whirling" (454–5).[176] Indeed, he states, his pagan Roman neighbors blame *ferrea fata* "the iron Fates" (463) for all that happens. Why not just prosecute the mighty "Fates" for all of their sins and crimes? After his mockery, Prudentius adds decisively, *nil sunt fatalia: vel si / sunt aliqua, opposito vanescunt irrita Christo* "That which is ordained by fate is nothing; or, if it is something, it vanishes, void in opposition to Christ" (486–7). His contemporary Paulinus of Nola is similarly unimpressed, writing in a letter that, *nec minore mendacio Fata simulantur uitas hominum nere de calathis aut trutinare de lancibus*[177] "By a lie of equal proportions the Fates are supposed to spin out human lives from a basket, or weigh them on scales."[178] In his case, Paulinus blames the influence of Plato's passage from his *Republic*, cited above.[179]

"thread" terms is somewhat common in Latin poetry and may suggest that Statius, among others, has a rather vague idea of the textile process, but associates it, nonetheless, with the "Fates."

[175] The malady features in folk stories such as the Brothers Grimm story of "The Three Spinning Women," in which a newly married prince forbids his wife from spinning upon seeing three women misshapen by such work: one with an enlarged foot from pedaling the pedal on her spinning wheel, one with a hanging lip from licking flax thread tips, and one with a grossly enlarged thumb from rolling the spinning thread (Lucy Crane (trans.), *Household Stories from the Collection of the Bros. Grimm* (McGraw Hill, 1966; 1886), pp. 82–4).

[176] *Prudentius*, Thomson, vol. 2; see note 7.

[177] Latin text here and below from Paulinus, *Paulinus of Nola: Epistolae*, ed. Wilhelm Hartel, CSEL, 29 (G. Freytag, 1894), here, p. 155.

[178] Translation here and below from Paulinus, *Letters of St. Paulinus of Nola*, ed. and trans. P. G. Walsh, Ancient Christian Writers, 35 (2 vols, Newman Press, 1966), vol. 1, p. 155.

[179] *Ibid.*

160 TEXTILES & TEXTILE IMAGERY IN EARLY MEDIEVAL ENGLISH LITERATURE

Their contemporary Augustine claims that even the pagans themselves know and knew stories about the "Fates" were just fables or poetic inventions, as when they say,

> tria fata in colo et fuso digitis que filum ex lana torquentibus propter tria tempora, praeteritum, quod in fuso iam netum atque inuolutum est, praesens, quod inter digitos nentis traicitur, futurum in lana, quae colo inplicata est, quod adhuc per digitos nentis ad fusum tamquam per praesens ad praeteritum traiciendum est[180]

> there are three Fates, with distaff, and spindle, and fingers spinning wool into thread, because there are three times, – the past, already spun and wound on the spindle; the present, which is passing through the fingers of the spinner; and the future, still in wool bound to the distaff, and soon to pass through the fingers to the spindle, that is, through the present into the future[181]

The "Fates" mocked by all three passed rapidly from vogue as conversion continued throughout the empire.

As is quite obvious from the examples discussed in this section, early Latin texts overwhelmingly assign "Fate" or the "Fates" as *Fata* or *Parcae* the role of textile deities, but there are nuances to this depiction. Analysis of clusters of terms associated with the "Fates" in Latin texts, including examples cited above, shows, for example, that although *Fata* and *Parcae* have connection after connection with textile words, *Fortuna* has none.[182] Another significant finding is that, while *parcae* + *nere* "to spin" has three early Latin instances, and *fata* + *nere* one more, in the excerpt from Paulinus of Nola cited above,[183] there are no collocations of *parcae* + *texere* (or variants) and only two of *fata* + *texere*, both referencing Plato. While there are a few instances of fates or fatal imagery being connected to "weaving" through *texere* in other ways, as I will discuss shortly, the majority of the early references make them spinners. The collocations connecting the "Fates" and *nectere* might be expected to rectify the lack of *texere* connections, but *nectere*, as already indicated, can be problematic from a textile perspective: the primary sense for *nectere* is more often "to bind" or "to connect/intertwine" than "to weave." When the "Fates" *nectunt*, then, only context can determine what textile image is intended. Among the six examples (all classical) of *fata* + *nectere*, the context is too vague to determine whether intertwining threads or more specific spinning or weaving is meant, though each seems to mean something textile-related. In the one instance of *parcae* + *nectere*, a

180 Text from *LLTO*, *s.vv. fata + fusum*; "Contra Faustum," book 20, part 9, lines 17–20.

181 Translation from "Reply to Faustus the Manichæan," in Augustine, *St. Augustin: The Writings against the Manichæans and against the Donatists*, trans. Philip Schaff, Nicene and Post-Nicene Fathers of the Christian Church, 4 (Wm. B. Eerdmans, 1989; T. and T. Clark, 1887), p. 256.

182 All findings in this section are based on comprehensive searches and analyses of results from *LLTO*, in this instance, based on analysis of collocations of *fortuna + nere, fortuna + nectere, fortuna + texere, fortuna + fusus, fortuna + stamina*, and *fortuna + subtemen*.

183 The reference in Paulinus is the most straightforward use of the verb, with all other references deriving from collocations of *parcae/fata + nentes digitos* (and variants).

SPINNING, WEAVING, AND FORCES OF NATURE 161

line (supposedly) from Seneca's *Hercules Oetaeus*, *nectere* is linked with spinning, *nulli non colus / parcas stamina nectere*[184] "The Fates intertwine/spin the threads of the distaff eager for all." The other instances may (or may not) reflect spinning or weaving, but at least appear to connect twisting threads with the fates.

All remaining collocations identify the Fates or fate as spinners: *parcae/fata + fusus* "spindle," *parcae/fata + colus* "distaff," and *parcae/fata + stamina* "thread." There are four classical instances of *parcae + fusus* (including a line from Virgil and two commentaries on his line), eight classical and patristic instances of *fata + fusus* (including the same Virgilian references), six classical and patristic instances of *parcae + colus*, and eleven classical and patristic instances of *fata + colus*. There are also collocations for *parcae + stamina* and *fata + stamina*, with twelve early Latin examples of the former, and nine of the latter, respectively. The word *stamina* can also be confusing from a textile perspective, since within the range of Latin texts it can mean "warp," "(warp) thread," "thread (hanging from the distaff)," or simply, "thread."[185] More often than not, *stamina* is linked with *fusus* or *colus*, as in the example of the surprise arrival of the diviner of Statius, discussed above, or, the emphasis in the text falls on the thread, as in one collocation of *fata + stamina* in the work of Claudius Claudianus. In his panegyric to the emperor, Claudius reflects on the fall of Alaric, facing a different fate (*diuersi stamina fati*) than the one which *reuoluit* "unwound" or "turned" his initial success.[186] The image is similar to Virgil's emphatic statement, *sic volvere Parcas* (1.22) "so turn the *Parcas*," and the reference is to the turning thread on the cosmic spindle of the "Fates."

It is thus fair to say that a heavy preponderance of the references to fates in early Latin texts characteristically align the "Fates" with the spinning of thread, rather than weaving. Indeed, in the early Latin works of the classical and patristic corpus, there are only two instances of which I am aware in which *texere* relates to the work of the "Fates," the first in an example from Paulinus of Nola, which describes the passage cited above from Plato's *Republic*, and the second a possible reference in Cicero's "De Fato," where he summarizes the many arguments of philosophers and thinkers over the necessity of fate in opposition to free will, and where he asks whether events do indeed take place in *colligatione naturali conserte contexteque* "a closely knit web of natural interconnexion" related to fate.[187]

[184] *LLTO*, verse 1090.

[185] Lewis and Short, *Latin Dictionary*, *s.vv.* There are similar references to *parcae + subtemen* "weft" or "thread," one in Horace's *Epodes*, another in a commentary on the *Epodes*, and the third example in Catullus, discussed earlier in this section (*LLTO*).

[186] *LLTO*: "Panegyricus dictus Honorio Augusto sextum consuli" (= Carm. maiora, 27–8), line 250.

[187] Cicero, *Cicero in Twenty-Eight Volumes: IV. De Oratore, De Fato, Paradoxa Stoicorum, De Partitione Oratoria*, ed. and trans. H. Rackham (Harvard University Press, 1977; 1942), part 13, line 36, pp. 226–7.

162 TEXTILES & TEXTILE IMAGERY IN EARLY MEDIEVAL ENGLISH LITERATURE

This straightforward picture becomes far more complicated in the transition to the Latin corpus of the early Middle Ages, however. In his encyclopedic *Etymologiae*, Isidore's commentary on *fatum* and the *Parcae* is as follows:

> Fatum dicunt esse quicquid dii effantur. Fatum igitur dictum a fando, i.e., loquendo. Tria autem fata finguntur in colo, in fuso, digitisque fila ex lana torquentibus, propter trina tempora: praeteritum, quod in fuso jam netum atque involutum est, praesens, quod inter digitos nentis trahitur, futurum in lana quae colo implicata est, et quod adhuc per digitos nentis ad fusum tanquam praesens ad praeteritum trajiciendum est. Parcas κατ' ἀντίφρασιν appellatas, quod minime parcant. Quas tres esse voluerunt, unam quae vitam hominis ordiatur, alteram quae contexat, tertiam quae rumpat.[188]

> *Fatum* is said to be whatever is uttered by the gods. Therefore, *fatum* is named from "saying," i.e. from "speaking." But the *tria fata* are represented in a distaff, a spindle, and a thread from wool and twisting fingers, because of the three divisions of time: past, on the grounds that [the thread] is already fastened and rolled on the spindle, present, on the grounds that it is drawn between the fingers of the spinner, future, in the wool which is entwined on the distaff, also because it is cast towards the spindle through the fingers of the spinner, just as the present to the past. The *Parcas* are called κατ' ἀντίφρασιν, that spare so minimally. These are believed to be three in number, one who begins (lays the warp of) the life of man, another who weaves it together, a third who breaks it.[189]

He further distinguishes *Fortuna* as a separate goddess, but condemns all such beliefs as *gentilium fabulosa figmenta*[190] "fabulous fictions of the people." He states somewhat cryptically *Quod nisi hoc nomen iam in alia re solerent intellegi* "And if this term [*fata*] is now often understood in another way" then that particular understanding of *fata* is equally false, and *quo corda hominum nolumus inclinare*[191] "we do not wish to incline any of the hearts of men" towards such beliefs. Most of his entry, from *Tria fata* to *trajiciendum est*, is taken directly from Augustine (cited above). However, the short definition of the *Parcae* themselves is not from Augustine and finds a parallel only in the Virgilian commentary of Junius Philargyrius. Junius cites sections of the same passage of Augustine twice, once when commenting on the meaning of *PARCAE* and once when explaining Virgil's line *Currite fusis* in connection to both *parcae* and *fata*, as cited above. It is in the first instance that Junius adds a line virtually identical to that found in Isidore: *PARCAE idest Parcas κατὰ ἀντίφρασιν appellatas, quod minime parcant, quas tres esse voluerunt:*

[188] Isidore, *Isidori Hispalensis Episcopi: Etymologiarvm Sive Originvm, Libri XX*, ed. W. M. Lindsay, Scriptorum Classicorum Bibliotheca Oxoniensis (Oxford University Press, 1911), 8.11.90, 92. All citations from Isidore list book, section, and line.

[189] Translation is mine for this and all other citations of Isidore's work.

[190] *Isidori*, 8.11.89.

[191] *Ibid.*, 8.11.90.

SPINNING, WEAVING, AND FORCES OF NATURE 163

unam, quae vitam hominum ordinat, alteram, quae contexit, tertiam, quae rumpit.[192] What is readily evident from both early medieval authors is that the dominant image of classical spinning "Fates" transfers to a medieval audience, but for both authors, there is also a space for an image of fates who lay a warp, weave it together, and break its threads. Given the insecure dating of the work of Junius Philargyrius, it is hard to tell if Isidore borrowed the weaving line from him, or vice versa, or whether both drew on a common, earlier source. In any event, it is somewhat surprising to see an image of a weaving fate here after a complete dearth in classical references, which do not include any clear-cut examples of fatal weaving imagery.

After these two writers, there are very few examples indeed of early medieval writers who continue to link fates and textile imagery, with only six examples extant for any textile collocations from the entire Latin corpus.[193] What is particularly interesting is that three of those six references are found in the works of Aldhelm of Malmesbury.

ROMAN FATES AND THE EARLY MEDIEVAL ENGLISH

Tracing the availability of classical and later Latin texts, and therefore the appearances of textile-producing "Fates," among the early medieval English is, of course, considerably easier than tracing the Greek. There is a well-documented profusion of references to classical, patristic, and early medieval Latin in pre-Conquest manuscripts, particularly to texts such as the works of the church fathers (Augustine, Jerome, Ambrose, and Gregory); biblical texts and commentaries; psalters; scattered references to secular works of Cicero, Virgil and commentaries on Virgil, Horace, Ovid, Statius,[194] Tacitus, and Priscian; and frequent references to religious works such as the writings of Prudentius,[195] Paulinus of Nola, and Isidore (among others).[196] It is undoubtedly significant that we can document that there were many among the early medieval English who had access to imagery of fatal figures and fatal textile imagery in the works of these authors. At least some references to the "Fates" from Old English and Anglo-Latin texts must be related to these sources, including the dozens of glossary entries that parallel *wyrd* with forms of *parca*.

[192] *LLTO*, "Explanatio in Bucolica Uergilii" (recensio I – excerpta contaminata), poem 4, verse 46, line 17.

[193] *LLTO*: two instances of *parcae* + *stamina* (Priscian and Aldhelm, both citing a line from Lucan), two of *fata* + *fusus* (Aldhelm and a Virgilian commentary, both citing a line from Virgil), and one instance of *fata* + *stamina* (a Carolingian text).

[194] Catherine Karkov cites an instance in which Dunstan quotes the *Thebaid*, for example (*The Art of Anglo-Saxon England*, p. 170).

[195] As indicated in Chapter 3, his hymns were known among the early medieval English, but his "Reply to Address of Symmachus" was, as well; it is cited by both Aldhelm and Bede (Lapidge, *Anglo-Saxon Library*, p. 329).

[196] Ogilvy, *Books*, pp. 55, 66, 111, 132, 164, 194, 222, 227, 245, 247, 258. See also Biggs *et al.*, *Sources*, pp. 1–16, 22–71, 135–40, 146–9; and Lapidge, *Anglo-Saxon Library*, p. 323.

164 TEXTILES & TEXTILE IMAGERY IN EARLY MEDIEVAL ENGLISH LITERATURE

In his work, Aldhelm connects fatal figures and textile production in ways which also seem related to earlier Latin sources. Aldhelm's Anglo-Latin Riddle 45 (Spindle) associates the *Parcae* with spinning in their role as "Fates":

> In saltu nascor ramosa fronde virescens,
> Sed fortuna meum mutaverat ordine fatum,
> Dum veho per collum teretem vertigine molam:
> Tam longa nullus zona praecingitur heros.
> Per me fata virum dicunt decernere Parcas;
> Ex quo conficitur regalis stragula pepli.
> Frigora dura viros sternant, ni forte resistam[197]

> I was born in the forest, green on a leafy bough, but fortune changed my condition in due course, since I move my rounded shape twirling through the smooth-spun thread; from this is made the royal covering of a robe. No hero (anywhere) is girded by a belt as long as mine. They say that the *Parcae* decree the fates of men through me – yet severe cold would destroy men if I did not withstand it.[198]

His juxtaposition of imagery of the spindle *fusus* with reference to the *Parcae* mirrors earlier Latin tradition closely, and that Aldhelm was well aware of this earlier tradition of spinning fates is without doubt, given that in his "De Metris," he cites the passage from Virgil discussed above: *"Talia" iniquit "saecla" suis dixerunt "currite" fusis / concordes stabili fatorum numine Parcae*[199] "'Such an age,' they declared, 'hasten,' with their spindles / agreed, with the fixed, divine will of the Fates, the *Parcae*." Within the same work, Aldhelm also cites a line from Lucan, *Nunc, inquit, plenas posuere colos et stamina Parcae / Multaque delatis haeserunt saecula filis*[200] "Now, he says, 'The Fates set full distaffs and threads, and after the threads had been destroyed, fixed many ages.'"[201] In ways reminiscent of later writers such as Alfred and Ælfric, Aldhelm introduces the first quotation with the observation that *mathematici fatum fortunam vel genesim aut suprema Parcarum fila*[202] "the astrologers in their laughable stupidity think they are able to divine or have

[197] *Aldhelmi Opera*, Ehwald, p. 117, lines 1–7.

[198] Translation from Lapidge and Rosier, *Aldhelm: The Poetic Works*, p. 79. I have not included the suggested, "[*scil.* the distaff]" after "a belt as long as mine" from the translation by Lapidge and Rosier, however; as noted in the introduction, I suspect the long "belt" of the riddle does not mean the distaff, but rather, the length of "smooth-spun thread" already wound around the spindle just above the whorl, parallel today to thread wrapped around the center of a spool.

[199] As noted above, Virgil's Eclogue 4, lines 46–7. Aldhelm's version has *iniquit* "he said" added, undoubtedly meaning Virgil. The reference in "De Metris" can be found in *Aldhelmi Opera*, Ehwald, p. 73, lines 8–9.

[200] *Aldhelmi Opera*, Ehwald, p. 159, lines 25–6.

[201] Translation mine.

[202] *Aldhelmi Opera*, Ehwald, p. 73, line 6.

knowledge of fate, fortune, or birth, or the last threads of the *Parcae*."[203] There is no way to discern whether Aldhelm is ridiculing the astrologers among the ancients of the Mediterranean, those with similar beliefs in his own sphere, or both.[204]

Alfred's translation of the *De Consolatione* makes it quite clear that early medieval English scholars of his generation also had access to Latin texts which reference both fatal figures and textile imagery. As discussed above, such imagery in Alfred's Latin source includes a weaving Lady Philosophy and a woven "fatal" chain of events, both apparently excised by Alfred. Alfred's text also contains subtle "turning" imagery associated with *wyrd* through verbs assigned to it: *hweorfan/hwyrfan* and *wendan*. In one case, the Latin of Boethius may inspire the word pairing, with Boethius pairing *Fortuna* and *versat* from *versare* (10–11) "to turn" or "to whirl." If the image is a spinning "Fate," Boethius's Latin terms may relate to Alfred's version of that image. However, the *wendan/wyrd* correspondence in *The Ruin* may disprove a Latin source for what appears an alliterative formula in Old English. Alfred's text also contains reference to the *Parcae*, and he calls them *metena*, which may or may not be a textile image, as earlier discussed. If so, it is an image he has not derived from his Latin model, as it is an interpolation.

As a result of these correspondences, there are many who have assumed that all fatal textile imagery and even the notion of the "F/fates" themselves may be a borrowing by the early medieval English from classical Greek and Latin sources or later Christian Latin sources. The classical Greek literary sources, as earlier stated, are the least likely to be a source of influence except through Latin translation, as very few early medieval English writers knew Greek, and little evidence remains that suggests classical Greek epics and pagan odes (where imagery of spinning fates predominates) were ever studied or known among them. The Latin texts, unlike the Greek, are much more likely to be a source or an influence on such Old English imagery. In some cases, such as those just discussed, the source or influence is, in fact, demonstrable. However, it seems rather unlikely that *all* references to fate, fatalism, and even fatal textile imagery in Old English literature and the Anglo-Latin corpus would be a product of such textual influence, for several reasons. The first and perhaps most important is that Latin texts only directly influenced the early medieval English after their conversion to Christianity, at which point they were in "rejection mode." At that moment, they were much more likely to side with Prudentius, Paulinus of Nola, and Augustine in eschewing "fate/Fate" references rather than imitating and adopting them and a related belief from classical pagan culture. Alfred's interpolations lambasting the concept of "Fate" confirm their rejection of such an idea, as do statements written a generation earlier by Aldhelm.[205]

[203] Translation from Lapidge and Rosier, *Aldhelm: The Poetic Works*, p. 43.

[204] The latter is possible; Scott Gwara argues convincingly that Aldhelm wrote much of his work from an actively anti-paganist perspective uniquely suited to his era and position. See "Introduction," *Aldhelmi Malmesbiriensis*, pp. 41–57.

[205] In his *Carmen de Virginitate*, for instance, Aldhelm states that he rejects the classical Muses as his source of inspiration, preferring the Word *Corde patris genitum* "engendered in the heart

Aldhelm reserves most of his allusions to classical paganism in his metrical treatises for examples of beautiful metrical lines in Latin, such as the two cited above from "De Metris." His derision for the notion of the "Fates" and fatalism is overt when he discusses at least one of these (Virgil's example of spinning *Parcae*, as discussed above), and that derision also finds voice in his related Anglo-Latin Riddle 7 (often answered *Fatum* in manuscript glosses). In this poetic riddle, after he cites a line from Virgil which mentions *Fortuna*, he adds, *Me veteres falso dominam vocitare solebant / Sceptra regens mundi dum Christi gratia regnet*[206] "The ancients were accustomed – wrongly! – to call me mistress, as being the one who ruled the sceptres of the world – until (the advent of) Christ's grace which shall rule forever."[207] His responses to the meanings behind the "fate" and "fate spinning" lines he borrows from classical texts thus mirror Alfred's emphatic rejection and alteration of references to paganism and even fatal textile imagery found in his Boethian source text, and suggest they were both of the same mind: reference to the Latin "Fates" was a literary exercise, with a corresponding belief to be rejected, not inherited.

In an interesting twist, some scholars have asserted that fate and fatalism (and by extension fatal textile imagery) in early medieval English culture and Old English literature are due, then, not to pagan classical Latin sources, but to the influence of Boethius.[208] In his assessment of such claims, Roper examines the relationship of the Boethian sense of fate in Alfred, compares it to fate in *Beowulf*, and finds that the treatment of fate (or fortune) in each is rather dissimilar.[209] Perhaps a more weighty argument is that it is quite difficult (and frankly, implausible) to credit the work of one Latin author for the fatalism present in thousands of lines of traditional heroic poetry and some prose in the early and late secular vernacular traditions of every culture of Scandinavian or Germanic background, early medieval English culture included. Moreover, the text in contention is Boethius's *rejection* of just such a mindset. Inherited native fatalism is more likely to explain the influence of Boethius in northern Europe in the Middle Ages and provides a reason why Boethius might come to be translated at all as an author who elegantly demonstrates the struggle and eventual triumph in the southern European theater against the pervasive belief in pagan "Fate/Fates" in favor of Christian Providence many years before his northern counterparts begin to do the same. Such an interpretation confirms the impact of the thought of Boethius on the early medieval English in their attempt

of the father" (*Aldhelmi Opera*, Ehwald, p. 354, line 34; translation from Lapidge and Rosier, *Aldhelm: The Poetic Works*, p. 104).

[206] *Aldhelmi Opera*, Ehwald, p. 101, lines 3–4.

[207] Translation from Lapidge and Rosier, *Aldhelm: The Poetic Works*, p. 72.

[208] Stanley, *Search*, p. 94; Brodeur quoted in *ibid.*, p. 99; J. D. A. Ogilvy, "Beowulf, Alfred, and Christianity," in M. H. King and W. M. Stevens (eds), *Saints, Scholars and Heroes: Studies in Medieval Culture in Honour of Charles W. Jones* (2 vols, Hill Monastic Manuscript Library, St John's Abbey and University, 1979), vol. 1, pp. 59–66, at p. 59.

[209] "Boethius," pp. 386–400.

SPINNING, WEAVING, AND FORCES OF NATURE

to redefine their notions of the universe in Christian terms, but suggests he would be an influence on rather than a source of ideas about fate and fatalism.

If fatalism is indeed a native early medieval English tradition inherited along northern lines, and it may be so, then the question of Latin influence on fatal textile imagery becomes much more complicated. As discussed, the Latin tradition is most definitely a source of some of the fatal textile imagery discussed: the Latin-Old English glosses (perhaps including biblical "deathweaving" imagery, such as that glossed in the Lambeth Psalter), Aldhelm's Latin quotations from Virgil and Lucan, and at least some of what little remains of fatal textile imagery in the Old English version of the *De Consolatione*. It is also very likely the source tradition or inspiration for Aldhelm's Anglo-Latin "Spindle" riddle. The influence of Latin sources on Old English "fate-weaving" texts in *Beowulf* and the Exeter Book, however, is far less certain. The "web of good fortune in battle" which the narrator attributes to God in *Beowulf* (696b–97a) resembles to some extent the good fortune "woven" by Zeus in the *Odyssey* discussed above. It also has some resonance with the "woven course" of fated matters in Boethius which Alfred rejects and one similar image in Cicero. The first is a closer parallel, as the role of a fate is subsumed in the power of a male god, but it is not particularly likely for the Greek wording to have influenced the Old English. The second set of parallels is indeed a parallel, but not a particularly close one. It is only within the references in Isidore and Junius Philargyrius that a potential parallel appears, in the one "Fate" of the three who *contexit* "weaves" the web of a person's life.

At the same time, there is one observation that must be made about these early medieval parallel references: they themselves are clear outliers in the Latin and early medieval English traditions of the "Fates." The mass preponderance of evidence for Latin fates suggests that the Romans saw them almost exclusively as spinners, and almost never as weavers. Isidore and Junius's entries are unusual and uncharacteristic of classical Greek and Latin "Fates," and may even be inspired by biblical "deathweaving." But the *wefen wyrd-stafum* "woven *wyrd*-staves" (1351a) of *Guðlac* and the grave-digging task which *wyrd gewæf* "*wyrd* wove" (70a) for the speaker of the *Riming Poem* mirror something the author of Exeter Riddle 35 states overtly: for the early medieval English, weaving is predominantly *wyrda cræftum* "the skill of the *wyrda*" (9b).[210] Even the *gewif* of *Beowulf*, as earlier discussed, is linguistically associated with weaving, not spinning. The point is rather an important one: other than the unusual attributions (perhaps biblically inspired), classical and patristic Mediterranean fates are typically envisioned as spinners, while their early medieval English counterparts *always* weave. Cultures steeped in textile tradition might well have their scholars confuse wooden tools and kinds of thread, but they would know the difference between spinning and weaving, two regularly visible, dramatically different, and well-understood tasks of the material world of their day.

Ultimately, of course, no possible source can be proven in the absence of direct evidence: the early medieval English authors of Old English texts in which fate "weaves"

[210] As previously discussed, the riddle differs from its Anglo-Latin, Aldhelmian source in making the *Wyrda* its weavers, rather than *Seres* "silkworms."

may well have devised a metaphor to mirror "deathweaving" references in biblical text or "fate-weaving" references in two early medieval Latin texts, as they had access to both,[211] or they may have drawn from a native tradition of *wyrda* who weave, generally unlike their rough counterparts the Roman *Parcae*, whom they knew (and Aldhelm described) as spinners. A third possibility is, of course, that multiple factors syncretically influenced or reinforced the creation of the metaphor for weaving "Fates" in Old English poetry.

GERMANO-SCANDINAVIAN TEXTILE GODDESSES AND FATES

Evidence for Germanic or Scandinavian analogues for a native tradition of "F/fate/s" and fatal textile imagery among the pre-Conquest English is often viewed with some skepticism, thanks no doubt to the romanticized and uncritical assumptions of "pagan-ists" about a pan-Germanic religion and culture across space and time. That skepti-cism is well-founded; any culture that might have been or might have considered itself "Germanic" or "Scandinavian" in origin can hardly be considered entirely identical to any other culture that considered itself the same across significant spans of time. In other words, we cannot equate seventh- or tenth-century early medieval English culture with thirteenth-century Norse culture without serious qualification.

At the same time, it is undeniable that across the early Middle Ages, the early medieval English overtly identified a linguistic, cultural, and familial "relatedness" to their conti-nental counterparts to the North: they knew well they had come across the seas from the North.[212] Moreover, in addition to contact with christianized Gaul and Rome, the early medieval English had long-standing contact with other Germanic and Scandinavian groups. Early English ecclesiasts served as missionaries to the Saxons, Frisians, and other continental Germanic peoples from early in the period (late seventh century to ninth century). International contacts (both friendly and unfriendly) occurred during Alfred's time (ninth century), as well, with the early medieval English living side by side with pagan Viking invaders across the boundary lines of West Saxon and Mercian terri-tory and the Danelaw for two generations at least before full conversion and "assimila-tion" of the Danish hordes. Close ties with cultures to the North continued to persist. In addition to having contacts with Flanders and Germany, Athelstan took Hakon, son

[211] Isidore's works were particularly influential among the early medieval English. See Michael Lapidge, "The Career of Aldhelm," *ASE*, 36 (2007), 15–69, at pp. 29–30. The *LLTO* database information for the work of Junius postulates Irish transmission of his commentaries on Virgil, which may explain how lines from the commentaries made their way alongside the whole of Isidore's body of work to early medieval English manuscripts.

[212] Indeed, as Roberta Frank points out, early medieval English authors exploited and depicted that heritage thoughtfully and used it rhetorically, "The *Beowulf* poet's reconstruction of a northern heroic age is chronologically sophisticated, rich in local color and fitting speeches. The poet avoids obvious anachronisms and presents such an internally consistent picture of Scandinavian society around A.D. 500 that his illusion of historical truth has been taken for the reality" ("The *Beowulf* Poet's Sense of History," in Larry D. Benson and Siegfried Wenzel (eds), *The Wisdom of Poetry: Essays in Early English Literature in Honor of Morton W. Bloomfield* (Medieval Institute Publications, 1982), pp. 53–65, 271–7, at p. 54).

SPINNING, WEAVING, AND FORCES OF NATURE

169

of King Harold Fairhair of Norway, as a foster-son in the early tenth century.[213] The saga of Gunnlaug Wormtongue, an Icelander, shows his visit to Æthelred in early medieval England (late tenth, early eleventh century) and his recitation of Norse poetry, which won him a place of honor at the king's court.[214] Not long after, Cnut and his descendants became the rulers of the early medieval English (early eleventh century). Clearly, important points of contact existed which allowed the early medieval English access to the cultures (and metaphors) of Germanic and Scandinavian peoples.[215] The oral and possibly textual traditions shared in this way should neither be discounted lightly, nor accepted uncritically. Just as I have examined the tradition of Greek and Roman fates, fatalism, and fatal textile imagery for evidence of possible shared concepts and bases for metaphor, I will examine and consider traditions of fate in Germano-Scandinavian texts, as well as Celtic texts in a following section, although no direct correlation will be suggested where none is demonstrable.

The oldest Germanic textual analogue to be discussed, a synthesis of the Gospels in Old Saxon, the *Heliand*, is similar in language, culture, and time period to the early Old English corpus. Contact between the Saxons and the early medieval English is demonstrable, and the *Heliand* is considered a close analogue for Old English literature.[216] Written in the first half of the ninth century in Old Saxon by an anonymous author, the *Heliand* shares many common features of Old English poetry, including use of alliterative half-lines and poetic formulae.[217] The *Heliand* does not contain overt textile imagery, but it may contain subtle textile imagery connected to its use of fate imagery in its cognates to both *wyrd* and *metod*.[218] Although, like *Beowulf*, it is undoubtedly written by a devout Christian, the *Heliand* contains strong evidence that the author uses native terminology to help his audience learn the Gospels in terms they understand, such as using the pagan word for temple or depicting a sinister, powerful version of fate, Old Saxon *uurd*. Although other near-contemporary syntheses of the Gospels appear in cognate languages, the *Heliand* is unique in this approach, as "other gospel harmonies of the ninth and tenth centuries like *Otfrid's Evangelienbuch* contain no references to *wurd*,"

[213] Owen-Crocker, *Dress*, p. 30.

[214] Jones, *Eirik the Red*, pp. 188–9.

[215] A point which Nora Chadwick makes through reference to *Beowulf*: "It is surely remarkable that our only great Anglo-Saxon narrative poem on a secular theme should be about a hero from southern Scandinavia and in a Danish and Swedish setting, with no English interests, or personnel, or background" ("The Monsters and Beowulf," p. 201).

[216] Ogilvy indicates that the early medieval English knew the *Heliand*, and states that passages from it occur in early medieval English manuscripts (*Books*, pp. 144, 156).

[217] G. Ronald Murphy, *The Heliand: The Saxon Gospel* (Oxford University Press, 1992), p. xiii.

[218] Samuel Berr lists Old English *wyrd* as a cognate for the Old Saxon *wurd*, defining both as "fate" (*An Etymological Glossary to the Old Saxon Heliand* (Herbert Lang, 1971), *s.v. wurd*). Edward H. Serht also defines the cognate *wurd* as "fate" (Edward H. Serht, *Vollständiges Wörterbuch zum Heliand und zur Altsächsischen Genesis*, 2nd edn, Hesperia, Schriften zur Germanischen Philologie, 14 (Vandenhoeck and Ruprecht, 1966; 1925), *s.v. wurd*).

while the *Heliand* contains several, leading some scholars to suggest that in the *Heliand*, "Christianity is translated into a medieval Germanic worldview."[219]

In this context, we find an angel telling Zacharias about his son John's unusual calling in the world, indicating that *so habed im uurdgiscapu / metod gimarcod endi maht godes* "so have the workings of *uurd*, *metod* formed him and the power of God" (127b–28).[220] The text thus associates *uurd* and *metod* and then differentiates both from the power of God (as does *Beowulf*, 2526b–27a, as discussed). In the description of Anna at the temple, the two words are similarly conflated: *Tho gefragn ic that iru thar sorga gistod, / that sie thiu mikila maht metodes tedelda, / uured uurdigiscapu* "Then I have heard it told that sorrow came to her, that the mighty power of the Measurer [*metod*] separated them, the cruel workings of fate [*uurdigiscapu*]" (511b–12).[221] The wording of both inverts a similar wording in *Beowulf*, 2814b–15, where *wyrd* is equated to *metodsceafte*.

Another parallel between Old English and Old Saxon usage is that *uurd* is a death-bringer: *uurd fornam / Herodes thana cuning* "*uurd* took Herod the king" (761b–62a).[222] Likewise, the poor widow's son is her only happiness *anttat ina iru uurht benam, / mari metodogescapu* "until fate [*uurht*] took him from her, the great Measurer's doings [*metodogecapu*]" (2189–90).[223] The connection of *uurd* and *fornam/benam* in these passages from the *Heliand* (found as well in *uurd farnimid* (3633b)) is similar to a common formula found in Old English poetry which connects *wyrd* and varieties of the same verb, as in *Beowulf*, *hyne wyrd fornam* "*wyrd* seized him" (1205b). In the passage from the *Heliand*, *metod* is thereafter placed in conflict to Christ, who chooses to raise her son from the dead: the widow "fell at Christ's feet and praised the people's Chieftain before the crowd, because He had protected a life-spirit so dear to her against the workings of the measurer" or *metodigisceftie* (2210a).[224] The scene is reminiscent of *Beowulf*, 1055b–57a, when *wyrd* is prevented by God from slaying more of Hrothgar's thanes. The equation of *metodigisceftie*, literally, "the workings of the measurer" with "death" also mirrors the contextual meanings for *wyrda gesceaft* and *metodgesceaft* as "death" in many lines of Old English poetry.[225] At the same time, as Prisca Augustyn points out, there are at least two passages in the *Heliand* where the *uurdgiscapu* "shapings of *uurd*" are associated with

[219] Prisca Augustyn, "*Wurd* in the *Heliand*: Fate in Old Saxon," *Interdisciplinary Journal for Germanic Linguistics and Semiotic Analysis*, 4.2 (1999), 267–84, at pp. 270 and 268, respectively.

[220] All passages of the original language *Heliand* are taken from *Heliand*, ed. Eduard Sievers, Germanistische Handbibliothek, 4 (Buchhandlung des Waisenhauses G. M. B. H., 1935) and cited by line number in text. Where not noted, the translation is mine.

[221] Translation from *Heliand*, Murphy, p. 20.

[222] Translation mine. See also *Heliand*, Sievers, line 3633b.

[223] Translation from *Heliand*, Murphy, p. 72.

[224] *Ibid.*, p. 73.

[225] Including *The Wanderer*, line 107a, and *Beowulf*, lines 2814b–15, among several others.

the miraculous birth of John.[226] If Augustyn's reading is correct, then Old Saxon *uurd* is both a life- and death-bringer.

As in Old English poems *Daniel* and *Andreas*, "F/fate" in the *Heliand* in the form of *uurd* is the "death-bringer" for the sinful more often than the righteous; when death comes for Lazarus, the poor man of the parable, Lazarus is informed of *reganogiscapu* "the decisions or workings of the ruler" (3347b), but his wicked, rich neighbor is called to death through *uurdegiscapu* "the decisions or workings of fate" (3354b). The use of *uurd* is also similar to *wyrd* in that *uurd* can also be translated as "events" in some contexts, such as when Judas *thea uurdi farsihit* "sees these events" (4581b), meaning the results of his actions in betraying his Lord, and responds by taking his life.

As in *Beowulf* and other Old English texts discussed, when the Old Saxon *uurd* carries any sense of "F/fate" about it, it is often subjugated to God's power. Twice in the *Heliand*, Jesus says *Thiu uurd is at handun* (4619b, 4778b), both times in reference to events surrounding his impending death. The full context of his words indicates that *uurd* occurs here as the will of God, "Fate is at hand, so that everything will go just as God the Father in His might has determined it."[227] Thus, at Jesus's death, fate approaches (in wording which reminds one of Beowulf's death) as an extension of God's will: *Thiu uurth nahida thuo, / mari maht godes endi middi dag, / that sia thia ferahquala frummian scoldun* "Fate was coming closer then, the great power of God, and midday, when they were to bring His life-spirit to its death agony" (5394b–96).[228] The striking similarities between the *wyrd*- and *metod*-usage in both Old English poetry and the Old Saxon *Heliand* indicate that similar layers of meaning for the word *wyrd-uurd* were present in a very closely related, contemporary, continental culture, including the sense of a fatal figure and the association of *metod* the "measurer" with *wyrd*.[229] There is not sufficient evidence to determine if the "measurer" envisioned in the *Heliand* as a death-bringer is associated with textiles or textile imagery (in "measuring" the threads of life), but the rather close parallels to Old English usage suggest that, whatever the metaphor meant to either group, it probably resonated within both Saxon groups.

Contemporary "fate" language mirroring that of the *Heliand* and Old English texts discussed can be found in the fragmentary, Old High German lay *Das Hildebrandslied*. The enigmatic poem only survives in sixty-eight lines, is dated to *c*.AD 830, and is written in the same alliterative poetic tradition as Old English poetry and the *Heliand*. Like *Beowulf*, the poem alludes to heroic figures of the sixth century, including Hildebrand, who cannot avert a fight with an overeager, warlike son who refuses to recognize him. In this context, Hildebrand bemoans to *got* "God" that *wewurt skihit* "wewurt [wyrd]

[226] *Semiotics of Fate, Death, and the Soul in Germanic Culture: The Christianization of Old Saxon* (Peter Lang, 2002), pp. 74, 76.

[227] Translation from *Heliand*, Murphy, p. 157.

[228] *Ibid.*, pp. 177–8.

[229] Berr, *Etymological Glossary to the Old Saxon Heliand*, seems to suggest such a connection in the definition of both Old Saxon and Old English *metod* as both "God" and "fate" (*s.v. metod*). Serht, *Vollständiges Wörterbuch zum Heliand*, also defines *metod* as "fate" (*s.v. metod*).

overcomes" him (49b).[230] He knows that his fight will result in death for him or for his son. The *Hildebrandslied*, like the *Heliand*, is an analogue which reinforces the notion that "fate" and fatalism were a common heritage echoed in the writings of both continental Germanic and early medieval English authors.

A later analogue for references to "figures of fate," a most interesting one, is the early eleventh-century penitential of Burchard of Worms, which, as discussed in Chapter 3, comes from a tradition of Frankish penitentials which draw on Irish and early medieval English penitential canons, alongside Roman ones. Among the acts he lists as requiring penance, he includes belief in the "Fates":

> Hast thou believed what some are wont to believe, either that those who are commonly called the Fates [*parcæ*] exist, or that they can do that which they are believed to do? That is, that while any person is being born, they are able even then to determine his life to what they wish, so that no matter what the person wants, he can be transformed into a wolf, that which vulgar folly calls a werewolf [*weruvolff*], or into any other shape.[231]

Such a belief is to be expiated by ten days of bread and water, but acting on such a belief invokes a much heavier penance. In a set of questions directed particularly to women, Burchard asks,

> Has thou done as some women are wont to do at certain times of the year? That is, hast thou prepared the table in thy house and set on the table thy food and drink, with three knives, that if those three sisters whom past generations and old-time foolishness called the Fates [*parcas*] should come they may take refreshment there; and hast thou taken away the power and name of the Divine Piety and handed it over to the devil, so, I say, as to believe that those whom thou callest "the sisters" can do or avail aught for thee either now or in the future? If thou hast done or consented to this, thou shalt do penance for one year on the appointed days.[232]

Like his fellow authors across the channel, Burchard is writing for a post-conversion period audience, in his case, people who are apparently still struggling with superstitions and beliefs in fatal figures. Burchard is less likely to be a source for the early medieval English; indeed he is one who might have drawn on their traditions himself. But he does serve as an analogue for early medieval English authors such as Ælfric, contending against similar superstitious beliefs among long-christianized peoples.

Unlike these earlier materials, the *Poetic Edda* or *Edda Saemundar* is unlikely to be a direct analogue for early medieval English authors, although, if indeed, as thought, the work was composed (orally) before the Icelandic conversion to Christianity in AD 1000,

[230] "Lay of Hildebrand," ed. Klaeber, *Beowulf*, 3rd edn, pp. 290–2, at p. 291.

[231] In McNeill and Gamer, *Medieval Handbooks of Penance*, p. 338. Latin for this source is drawn from Burchard, *Burchardi Wormaciensis*, p. 971.

[232] In McNeill and Gamer, *Medieval Handbooks of Penance*, pp. 338–9.

SPINNING, WEAVING, AND FORCES OF NATURE

its ancestor text may have been an analogue. Contact clearly existed between the two regions from at least Alfred's day through the end of the period, thanks to both trade and two hundred years' worth of Scandinavian invaders (some Norwegian, some Danish), many of whom settled north of and among the subjugated Northumbrian and Mercian survivors. Danes and Norwegians likewise lived among the early medieval English to the south during and after Cnut's reign, as discussed. The text as we have it, however, was most probably written down after 1100,[233] and the manuscript dates from the 1270s.[234] Nonetheless, it documents a tradition similar to Old Saxon, early medieval English, and continental German fatal figures.

An account in the opening poem of the *Poetic Edda*, *Voluspá*, gives the genesis of the Norse fates. From the gathering of the gods come three women from "the lake which stands under the tree," known as Urthr's well.[235] They allot the fates of men and are known as Urth, Verthandi, and Skuld.[236] The shapings of the three goddesses, *scopom norna* "decrees of the Norns" settle everything.[237] The reactions of the heroes of Norse legend toward these *grimmar urðir* "grim Fates" are clear examples of fatalist attitudes.[238] Following the prophecies of Gripir, Helgi says, "one can't overcome fate."[239] Although both Brynhild and Gudrun rage against the "hateful norns," and Gudrun even tries to kill herself contrary to their will, both ultimately submit to the Norns' decrees concerning them.[240] Hamdir likewise states in the "Lay of Hamdir," "after the norns have given their verdict, no man outlasts the evening."[241] Some confusion prevails in the depiction of the Norse fates. When Fafnir tells Sigurd about Norns, he says they are more than three in number, and come from "very different tribes ... some are of the Æsir, some are of the elves, some are daughters of Dvalin."[242] In the "Lay of Regin," Andvari says, "a norn of misfortune shaped my fate," an allusion which is reminiscent of Ovid and which leaves one wondering which sort of Norn is which.[243]

[233] "Introduction," Henry Adams Bellow (trans.), *The Poetic Edda* (American-Scandinavian Foundation, 1923), pp. xviii, xxi.

[234] "Introduction," *Poetic Edda*, Larrington, p. xi.

[235] *Poetic Edda*, Larrington, p. 6, no. 20, lines 1–2.

[236] *Poetic Edda*, Bellows, p. 9, stanza 20, n. 20. The last two are argued to be a later interpolation, perhaps arising from classical influence.

[237] *Edda: Die Lieder des Codex Regius Nebst Verwandten Denkmälern*, ed. Hans Kuhn (2 vols, Carl Winter, Universitätsverlag, 1962; 1927), p. 184, stanza 44, line 4b.

[238] *Edda*, Kuhn, p. 207, stanza 5, line 4.

[239] *Poetic Edda*, Larrington, p. 150, no. 53, line 1.

[240] *Ibid.*, p. 183, no. 7, line 3, and p. 236, no. 13, line 1.

[241] *Ibid.*, p. 242, no. 30, line 4.

[242] *Ibid.*, p. 159, no. 13, lines 1–4.

[243] *Ibid.*, p. 152, no. 2, line 3.

The Norns are also closely associated with textiles. Thus, Frey's servant Skirnir says, "on one day all my life was shaped, all my span laid down."[244] The fatal spinners are visible in their association with the birth of Helgi Hundingsbani: "Night fell on the place, the norns came, those who were to shape fate for the prince."[245] After describing the kind of life he will have, they "twisted very strongly the strand of fate [*ørlogþátto*[246]] and they prepared the golden thread and fastened it in the middle of the moon's hall."[247] Regin also says of Sigurd that "the threads of fate [*ørlogsímo*[248]]" spread across several lands. A related episode illustrates that textile production was considered the proper role for legendary and mythical females, as well as mortal women; Brynhild meets a giantess on her way to Hel who tells her "it would befit you better to be at your weaving."[249] In the original, this reads, *betr semði þér borða at rekia*,[250] which strongly resembles the Exeter Book *Maxims* I statement cited in Chapter 1, *fæmne æt hyre bordan geriseð* "a woman belongs at her embroidery" (63b). As scholars have long noted, heroic legends told in the *Poetic Edda* are paralleled in Old English works such as *Beowulf*, *Waldere*, *Widsið*, and *Deor*. Such close parallels suggest a shared tradition at some earlier point; whether or not fatal spinning figures were also part of that common tradition is harder to determine.

Snorri Sturluson's *Edda* (the *Prose Edda*), which draws on the *Poetic Edda* and which elucidates some of the material in the *Poetic Edda*, was written much later, between 1179 and 1241.[251] Sturluson explains that the three maidens who dwell with the gods are Weird, Verdandi, and Skuld, and that they "shape men's lives"; however, "There are also other norns who visit everyone when they are born to shape their lives, and these are of divine origin" or elvish and dwarfish origin.[252] Some mortals are allotted bad fate and others good because "Good norns, ones of noble parentage, shape good lives, but as for those people that become the victims of misfortune, it is evil norns that are responsible."[253] His work further indicates that there is some confusion of valkyries and Norns; after listing

[244] *Ibid.*, p. 63, no. 13, lines 3–4. In modern English, the term "life span" may derive from the same textile metaphor. "Span" is the participial form of *spinnan* and can mean "something spun" (C. T. Onions, G. W. S. Friedrichsen, and R. W. Burchfield (eds), *The Oxford Dictionary of English Etymology* (Clarendon, 1966), *s.v.* "spin"). On the other hand, life "span" may derive from a noun "span" which means the "distance from tip of thumb to extended tip of little finger" (*s.v.* "span").

[245] *Poetic Edda*, Larrington, p. 114, no. 2, lines 1–2.

[246] *Edda*, Kuhn, p. 130, stanza 3, line 1.

[247] *Poetic Edda*, Larrington, p. 115, no. 3, lines 3–4.

[248] *Edda*, Kuhn, p. 176, stanza 14, line 4.

[249] *Poetic Edda*, Larrington, p. 192, no. 1, line 3. As in the Old English that follows, *borða* may also mean "embroidery" or "tapestry work."

[250] *Edda*, Kuhn, p. 219, stanza 1, line 3.

[251] *Poetic Edda*, Larrington, p. xii.

[252] Snorri Sturluson, *Prose Edda*, trans. Anthony Faulkes (David Campbell Publishers, 1987; J. M. Dent and Sons for Everyman's Library, 1992), p. 18.

[253] *Ibid.*, p. 18.

valkyries, including Hild and Skuld, the text identifies them, "They are called norns who shape necessity."[254] Sturluson's work is obviously too late to be considered a source or even an analogue for Old English literature, but it is interesting to see how he harmonizes and explains older material and confusion of fates, a problem endemic to all fatal traditions discussed. It is also perhaps significant that these later Norse texts show a connection of fatal figures with birth, death, and textile production.[255]

Another late work that claims to draw on much earlier tradition (through reference to supposed earlier Danish sources), Saxo Grammaticus's *Gesta Danorum* contains ubiquitous references to *fata* which preserve a surprisingly strong touch of fatalism for a post-conversion, Christian text. The *Gesta* records how the great warrior Starkather sings that, "The Fates gave a child to Frothi," and in a later lyric how, "Fate, / as I recall, appointed me at my birth / to pursue battle and fall in battle."[256] The linking of birth and the "Fates" corresponds with features of Greek, Roman, and Germanic fatal traditions. In a similar song/poem, Hildiger indicates, "Whatever foreknown links are fastened by the Fates, / whatever the mysteries of divine reason sketch out, / whatever events are foreseen and held in the sequence / of destiny, no change in our transitory world will cancel."[257] The *Parcae* and the *fata* are equated in this instance, and the "links" are suggestive of threads. The work of Saxo Grammaticus is in this way a curious example of a Danish author using Latin terms (and perhaps sources) to tell fate-filled stories from his own purported cultural background. In other words, his work may reflect Danish custom, Latin tradition, or both, as a syncretic text.

The *Gesta Danorum* also offers an unusual glance at stories of much earlier, overt, "pre-Christian" worship of the "Fates."[258] Danish King Fridlef (perhaps mythical, fifth-century) visits the "oracles of the Fates," the *Parcarum oracula*,[259] to obtain predictions about his son's life, and "having offered solemn vows approached the goddesses'

[254] *Ibid.*, p. 157.

[255] As Michele Hayeur Smith observes about the North Atlantic Norse world, "textile production was a very gendered occupation, controlled by women, that intersected with all aspects of political, economic, and domestic life and gave rise to beliefs that connected textiles with women's lives, activities, and beliefs. Textiles wove their way into all aspects of human existence, from birth to death and, more importantly, in the determination of fate. Cloth and its production became symbolically gendered and associated with a women's world and with female power" (*The Valkyries' Loom*, p. 15).

[256] As noted in Chapter 3, I am using the edition of *Saxo Grammaticus: The History of the Danes* by Hilda Ellis Davidson (ed.) and Peter Fisher (trans.), pp. 192, 248. The Latin term is *fata* in both instances.

[257] *Ibid.*, p. 224. The Latin reads, *Sed quecunque ligat Parcarum prescius ordo, / Quecunque arcanum supere racionis adumbrat, / Seu que fatorum serie preuisa tenentur, / Nulla caducarum rerum conuersio tollet* (*Saxonis Grammatici*, Holder, vol. 7, p. 45, lines 4–7).

[258] Although Saxo Grammaticus's avowed intention is to describe a pagan Danish religious experience, it is possible that his account may be influenced by classical texts. See discussion below.

[259] *Saxonis Grammatici*, Holder, vol. 6, p. 181, line 22.

temple in prayer; here, peering into the shrine, he recognised the three maidens sitting in their respective seats."[260] Although these three maidens are difficult to identify (are they the oracles or the goddesses themselves?), their promises and predictions to Fridlef come true, including the negative prophecies of the third maiden (the inexorable third figure). Did early Danish peoples worship the "Fates" as Fridlef seems to do? There are archaeological finds roughly contemporary to the purported events of the story, including bracteates discussed earlier in this chapter in the context of the earth/creation goddesses, that may lend credibility to his assertions of worship of some type of goddesses at the temple. The possibility that Saxo Grammaticus describes this earlier Danish history with any degree of accuracy makes such descriptions tantalizing, of course, given the long-term impact of the Danes on the history of the early medieval English peoples across the period.

Whatever weight is given to the later textual evidence, what is clear is that analogues for Old English literature, the *Heliand* and *Das Hildebrandslied*, suggest a strong native tradition of fate and fatalism, with cognates of *wyrd* inexorably cutting off the life of "fated" individuals. In a few instances, *wyrd* is also associated with *metod* and is possibly associated with birth. Neither of the latter two analogues, however, contains direct evidence of fatal textile imagery. Later works of Germano-Scandinavian origin, the Norse *Eddas* and Saxo Grammaticus's *Gesta Danorum*, are likewise examples of the pervasiveness of fate and fatalism in their respective cultural traditions and provide examples of fatal textile imagery, the Norse works in particular. However, it is noteworthy that the Norse examples do not directly reference weaving fates; they allude only to fates working with and cutting threads. As with Latin examples, the imagery involved may allude to weaving, since weaving involves threads, but it may also allude to spinning. The only clear evidence in the Northern world connecting weaving and divinities (perhaps including the fates) is the archaeological record for early Germany.[261]

[260] *Saxo Grammaticus*, Davidson and Fisher, p. 169.

[261] As with the early medieval English, there are those who would attribute all fatal imagery among the northern European peoples to early Roman influence along the frontiers of the North, or to post-conversion exposure to Latin texts. The earlier and the farther north one goes, the less likely such an assertion seems, for many of the same reasons as noted for the early medieval English. The textual influence, perhaps the more probable scenario, would have been introduced rather late to have inspired such a pervasive northern European mindset, a mindset documented earlier than many of the northern conversions. It is also incredibly unlikely that Christian missionaries would have introduced pagan Latin beliefs in fate (orally or textually) as they evangelized the northern peoples. Creating a second and third fate to mirror Latin texts might well be an example of ways Latin texts influenced Norse poetry, but it is unlikely an entire fatal tradition would be imported so thoroughly into the cultural traditions of northern Europe without some initial, parallel set of beliefs.

FATE IN CELTIC AND OTHER CULTURES

The texts of another group of neighbors to the early medieval English, the Celts, demonstrate a similar connection between cosmic operations and textiles (although, as is the case in early medieval England and elsewhere, the influence of Latin texts here cannot be ruled out). The early Irish text "Prayer for Long Life," which is attributed to "an abbot Conry in Westmeath named Fer fio (died 762)," includes the lines: "I invoke the seven Daughters of the Sea, / who fashion the threads of the sons of long life."[262] A wounded warrior named Congal says, "It is the cutting of the thread of life and a change of time to me, that the person from whom I least expected it should thus attack and mutilate me."[263] As discussed in Chapter 3, in the eleventh-century, Old Irish recension of "The Cattle-Raid of Cooley," a prophetess appears to warn troops of impending carnage, carrying what may be a weaver's beam or a distaff and seven strips, "threads woven together, then interpreted to read the future."[264] Other similarities are found in a triad of Celtic war/fertility goddesses called the Morrigna, who were known as "prognosticators of doom" and who functioned as battle furies who awaited the bodies of the slain as their due.[265] Miranda Green suggests similarities of the triad with both Roman "Fates" and Germanic valkyries.[266] All of these fatal figures mirror other analogues in a focus primarily on threads, although in one case, the threads are interwoven.[267] Celtic interaction with the early medieval English was, of course, of very long standing and is demonstrable in archaeology, sculpture, manuscript art, abundant textual references, and even genetics. Could their "Daughters of the Sea" with their threads of life have influenced Old English fatal textile imagery? As in so many other instances, the similarities between Celtic and early medieval English metaphors are tantalizing and indirect, and ultimately inconclusive, if suggestive.

Perhaps because of the intertwining Greek, Roman, Germanic, Scandinavian, and Celtic evidence, a number of scholars have long thought that fatal textile figures may have been widespread among Indo-European cultures more generally. Richard Onians, for example, notes fate-spinning and -weaving associations in the *Artharva Veda*, "'They (goddesses) who spun, wove and stretched the web, let them wrap thee in order to old

[262] Quoted in Eleanor Hull, *Folklore of the British Isles* (Methuen, 1977; 1928), p. 170.

[263] Quoted in Onians, *Origins of European Thought*, p. 357.

[264] Sayers, "Old Irish *Fert* 'Tiepole', *Fertas* 'Swingletree' and the Seeress Fedelm," p. 178. Sayers is commenting on the translation of the story by Cecile O'Rahilly.

[265] Green, *Celtic Goddesses*, pp. 42–3.

[266] *Ibid.*, pp. 72, 77.

[267] If, as discussed above, the *Genius cucullatus* or very early "hooded" figures of Britain, the triadic version of which Miranda Green argues is "essentially Gallo-British," are connected to the *Ertae* of the Franks Casket, and if the *Ertae* are indeed spinning, then Celtic tradition would be even more similar to the Old English imagery of centuries later. The separation across time makes the possibility remote, but thought-provoking. Quotation taken from Green, "God in Man's Image: Thoughts on the Genesis and Affiliations of Some Romano-British Cult-Imagery," *Britannia*, 29 (1998), 17–30, at p. 25.

age; as one long lived, put about thee this garment,'"[268] although the Vedic poem may be alluding to creation goddesses as well as or in place of fatal goddesses in this instance. According to Jakob Grimm, a similar fate- and textile-related myth exists among the Lithuanians:

> The *dieves valditoyes* were seven goddesses, the first one spun the lives of men out of a distaff given her by the highest god, the second set up the warp, the third wove in the woof ... the sixth cut the threads, the seventh washed the garment and gave it to the most high god, and it became the man's winding-sheet.[269]

If indeed an older tradition, the seven sea daughters of the Irish Celts and the seven Lithuanian fate goddesses are an interesting parallel, if Grimm's story is accurate. For her part, Elizabeth Barber proposes that the Greeks inherited the mythological associations of the loom and spindle (perhaps also the "Fates") from Balkan natives. Ultimately, divergent scholarly arguments included here underscore a simple fact: the lines of possibility for determining the "source" of all fatal textile imagery are without number. Greek peoples could have introduced the images to Celtic (or Roman) peoples who could have influenced Germanic, Scandinavian, and Slavic peoples, early or late, or early Celtic peoples could have introduced the imagery to the Greeks, the Romans, and other groups. Alternately, the idea for fatal textile goddesses could have been a common heritage for all the groups concerned, from Scandinavia to India (and perhaps beyond). The wider world connections between the forming of destiny and textile production may simply result from a common, salient idea suggested by the material culture of textile production. We can guess why it is that female fatal figures are associated with spinning or weaving textiles in related ways in a variety of cultures across Europe and other parts of the world, but textual and archaeological evidence to date does not and may not ever point to a documentable, historically indisputable conclusion to explain the source or sources for all varieties of fatal textile imagery discussed. They remain a web of possible connections for the textile metaphors created by the writers of early medieval England.

CONCLUSIONS

Two kinds of textile imagery accompany references in Old English and Anglo-Latin literature to "F/fate." The first is the imagery of spinning, and where overt, it is generally associated by name with the Roman *Parcae* and demonstrably connected to early Latin sources such as the works of Virgil and Lucan and the patristic authors and poets. Only one of these instances, Aldhelm's Latin Riddle 45, is creative (and quite beautiful), with the rest comprised of borrowed phrases or glossed words. Spinning fates such as the *Parcae* were clearly considered a fair equivalent for the Old English *wyrd(a)* within the glosses and in Alfred's translation of Boethius, perhaps because of related (grammatical or mythological) genders, pagan undertones, and/or functions. However,

[268] Quoted in Onians, *Origins of European Thought*, p. 361.

[269] *Teutonic Mythology*, vol. 1, p. 416.

where *wyrd(a)* and its related term *gewif* appear in the traditional vernacular poetry of the early medieval English, they are envisioned quite differently from allusions to the *Parcae*. There, both *wyrd* and *gewif* are linked directly through imagery (in the first case) and etymology (in the second) to metaphorical weaving. This second type of fatal textile imagery, imagery of a weaving "F/fate," is certainly unusual in early European textual sources, finding no parallels in Roman texts, a few counterparts in early medieval Latin contexts (Isidore and/or Junius), and no direct counterparts in Germanic and Scandinavian evidence outside early continental Germanic archaeological evidence for weaving goddesses. There is no definitive way to tell if these Old English poetic weaving metaphors derive inspiration from one or the other of the early medieval Latin texts, but it is quite likely that the underlying associations that connected weaving and the old fates must have been of very long standing indeed, to have remained entrenched in Old English poetry long after conversion to a worldview that must certainly have opposed a notion of an external, feminine force weaving the fortunes of all men in opposition to God. That the tradition of *fatalism* itself was old is evident by the difficulties faced by Alfred, Ælfric, and others trying to root it out in its subtle forms long after conversion. The tradition of *weaving* fatal forces is likely to be old for the same reason, and it remains a good question whether or not the elegiac poets of early medieval England would have adopted a creative metaphor associated with pagan worldviews (whatever their derivation) so extensively after conversion. This question is highlighted by the ridicule and rejection evident in Aldhelm's treatment of fate-weaving's parallel, the fate-spinning metaphors he cites twice and uses once: he accepts and rejoices in the beautiful poetics and an august tradition, but he rejects any implications of the metaphor.

Whatever the source culture or cultures of the metaphor for "female weaving fate(s)," there are compelling reasons that may explain *why* it may have been invented or adapted and adopted as a resonant image in the first place. The first reason can be explained in an observation that applies to spinning fates, as well as weaving ones: to date, textile production and female gender are the sole provable commonalities connecting early fatal figures across cultures. Textile production is associated normatively with women in most of these cultures, and this connection may prove an easy explanation for the association between spinning and weaving and fates who seem to have been designated as female (grammatical or otherwise) very early in their traditions.[270] It is perhaps more difficult to assess the reasons behind that designation of fatal figures as female in gender (and therefore spinners and weavers).

Women's biological and traditional roles in pregnancy, childbirth, and childcare readily explain the personification of birth goddesses as female, a personification evident in cultures worldwide. Greek, Roman, and Germanic/Scandinavian fate goddesses all seem to be associated with birth as well as death; perhaps the connection of female and fate arises from this association. A birth attended largely by women, as most pre-industrial births would have been, might have suggested any number of interesting visual analogues

[270] Indeed, Old English *gewif* "fate" and *wif* "woman" are visually linked and etymologically related.

that relate threads, in turn, to the beginning of life. Women attendant at a birth could have been spinning, an occupation generally undertaken during any and all spare moments in pre- and non-industrial societies. Such spinning would have provided a good visual analogue for the idea of spinning of a new thread of life at birth. An even more compelling visual analogue would be the physical link connecting a newborn infant and its mother, the umbilical cord, a thread or cord connecting women to new life and present at childbirth. The connections of female fates to moments of *both* birth and death may likewise not be as paradoxical as they might seem. Birth and death are, after all, two opposing but related moments on a continuum, the giving and taking of life. Women's gender roles in many early cultures, including early medieval English culture, included the winding of cloth around both newborn children and the dead, a visual analogue of this continuum, as the presence of both the women and the textiles marked the transition into both the world of the living and the dead; as Gale R. Owen-Crocker states, in early medieval England, "Food, clothes and furnishings, birth and mourning, were female matters."[271] Certainly the evolution of a raw thread into a finished thread which is cut from its source, or a web woven and then cut down from its loom, would suggest another metaphor of creation and fatal completion which could be applied beautifully to human destiny, as it is in the Lambeth Psalter and in the book of Job (see Chapter 3). It is probably not a coincidence that most of the compelling reasons which might explain such metaphoric connections are best understood through the lens of the material culture that formed part of the daily life of the women from these early periods.

The material culture of textiles played a central role in the lives of the early medieval English people across the period, just as other early peoples. The material imagery of textiles, process and product, was familiar to them and would have rendered beautiful and resonant the fatal textile imagery of *wyrd* and *gewif* (and perhaps the imagery for Aldhelm's *Fusus* as well). It is almost certain that the fatal weaving imagery, however, must have been a distant echo of its former self by the time we see it in Old English texts: it seems highly unlikely they would have adopted, translated, or rendered overtly fatal textile imagery post-conversion from any source, Latin, Germanic, Celtic, or Scandinavian. It seems far more likely that the fatal textile imagery in Old English poetry, both indirect poetic (and direct medicinal) echoes of spinning and direct references to weaving, represents a unique, fossilized tradition of fate, a fearsome figure of life and death from an elegiac past brought under the sway of the Christian God.

Like their continental cousins, the early medieval English wrote their vernacular poetry in alliterative lines, and both *wyrd* and *gewif* alliterate nicely with *wefan*, creating attractive poetic formulae. There are, of course, other "w" words with which *wyrd*

[271] "Anglo-Saxon Women, Woman, and Womanhood," in Scheck and Kozikowski (eds), *New Readings on Women and Early Medieval English Literature*, pp. 23–42, at p. 25. In early medieval English art, for example, women consistently appear as attendants in both birth and death scenes in manuscript illustrations such as those in the Old English Hexateuch. Kelley Wickham-Crowley documents a variety of instances in early medieval English contexts in which people are depicted as donating and/or wrapping shrouds around the dead, and the bulk of those she identifies are women ("Buried Truths," p. 306).

SPINNING, WEAVING, AND FORCES OF NATURE 181

might alliterate; verbs *wealdan* "to wield" and *wendan* "to turn" are fine alternatives attested in the corpus. In fact, if the early medieval English had meant to render *wyrd* solely as a classical spinner, *wendan* or *windan* could and should have been the universal choice. However, poets from the *Beowulf* and Exeter compilations chose to have *gewif* and *wyrd* weave destiny in their texts, and perhaps for more than alliterative effect. If a *scop* or shaper wished to use "old," traditional poetic words and formulae to talk about harsh "fate" (or to have his (often pagan) characters do so), what appears to have come to mind was the *gewif* or the "weaving" *wyrd*," lovely-sounding, fearsome metaphors redolent of old loss and tragic destiny in a world apart from God.[272] Their alliterative beauty and the resonances of "old days lost" could explain why "weaving *wyrd*" and *gewif* remain at all in the corpus, in particular in elegies or distinctly elegiac moments, but also why they do not appear more often. They may have come to be perceived as remnants of an old and increasingly unsavory way, much like references to the *Parcae* by the days of Prudentius, and later, the days of Aldhelm. Ultimately, other traditions may indeed have influenced cosmic textile metaphors, but whatever the nature of external influence, early medieval English authors found such metaphors so resonant that they created, borrowed, and/or perpetuated images that describe and conceptualize the actions of cosmic forces personified in the feminine, weavers of both life and death, in the likeness of their mortal counterparts.

[272] As Augustyn points out, many of us still use the (possibly) related expression, "His fate hung by a thread," to produce the same effect: a dark sense of impending doom (*Wurd*, p. 276).

CHAPTER 5

Woven Words[1]

wordcræftum wæf ond wundrum læs,
þragum þreodude ond geþanc reodode
nihtes nearwe.

(*Elene*, 1237–39a)[2]

I wove with word-skills and selected marvels,
deliberated at times and searched out ideas carefully through the night.

"WORDWEAVING" IN OLD ENGLISH TEXTS

The textile metaphors discussed thus far have chiefly involved associations between women and the spinning and weaving of abstract elements: peace, death, creation, and fate. Another image related to textiles, the subject of this chapter, is that of "wordweaving," or literary composition. The most direct equation of weaving and the composition of text in the Old English corpus comes in the poem *Elene*, as the poet-narrator Cynewulf says that, despite his aged mind and body, he *wordcræftum wæf ond wundrum læs, / þragum þreodude ond geþanc reodode / nihtes nearwe* "wove with word-skills, deliberated at times and searched out ideas carefully through the night" (1237–39a). Cynewulf elaborates on the nature and source of his inspiration: *gife unscynde / mægencyning amæt ond on gemynd begeat, / torht ontynde, tidum gerymde, / bancofan onband, breostlocan onwand, / leoðucræft onleac* "the Mighty King bestowed a glorious gift and anointed the intellect, revealed a brightness, prolonged the hours, unbound bodily frame, unwound the mind, unlocked poetic skill" (1246b–50a). Similar metaphors appear in the Anglo-Latin corpus as well.

What might have inspired an equation between weaving and compositional skill for early medieval English audiences? There are many possible answers, but the most likely are the nature of early medieval English poetics ("word"), its affinities to textile

[1] Elements of this chapter were presented as an address at the "Text-Textile-Texture" Collegium, Stanford University, 18–19 May 2017, and later appeared in abbreviated form in "Text/Textile: 'Wordweaving' in the Literatures of Anglo-Saxon England," *Medieval Clothing and Textiles*, 15 (2019), 33–51. The promised expanded version is delivered here.

[2] *The Vercelli Book*, ASPR 2, pp. 66–102.

182

production ("weaving"), powerful parallel metaphors in Latin and analogical cultures, or what is most likely, some combination of these. Each contributing influence will be discussed in turn.

"WordWEAVING": EARLY MEDIEVAL ENGLISH POETICS AND THE "WOVEN" TEXT

Cynewulf's description of the skill required for his labors sounds unusual to the modern ear: while the images are beautiful, do modern poets think of "weaving" and "choose marvels" when they compose? Do they think of "unwinding the mind" or "unlocking skill" to produce poetic text? Such images and metaphors, nonetheless, made sense to Cynewulf, which tells us something about the conceptualization of poetry and the poetic process for the mind of an early medieval English poet. According to Cynewulf, such poetry requires *wordcræftum* "word-skills" as a poet blends together words and *wundrum* "marvels" to create the text and texture of a cohesive poem. It also requires careful thought and arrangement, meaning long hours of consideration. The gift of poetic skill, the ability to "wordweave," is, in the poet's mind, a glorious gift of the intellect from God.

Such descriptions of the poetic process do in fact mirror the construction of *Elene*. Like most of the Old English poetic corpus and as evident in these lines, *Elene* is comprised of half-lines interlinked across caesurae by carefully selected, alliterating words in metrical patterns:

> wordcræftum wæf ond wundrum læs (1237)
> bancofan onband, breostlocan onwand (1249)

As in other Old English poems, many of the poet's chosen half-lines include specialized poetic words and poetic formulae, or paired-word expressions, that are recognizably repeated from poem to poem.[3] The half-lines may be comprised of images and descriptions that vary slightly (known as semantic variation), building to an imaginative landscape for Cynewulf's audience to see and hear the story in action.[4] Like many of the narrative poems of its time, *Elene* likewise demonstrates the poet's careful selection and arrangement of "marvels" from traditional source narratives, events intended to demonstrate the heroic nature of the character and the divine involvement in the story. Constructing a lengthy poem, 1300 lines in the case of *Elene*, with words and ideas so carefully chosen, balanced, and intertwined would indeed require considerable skill and thoughtful arrangement. The skill of telling a story successfully through lilting rhythms, interwoven sounds, words, and images would represent a "glorious gift." The poet's

[3] In his extensive analysis, for example, Andy Orchard documents many of the common formulae found in *Elene* and a wide assortment of other Old English texts ("Both Style and Substance: The Case for Cynewulf," in Catherine E. Karkov and George Hardin Brown (eds), *Anglo-Saxon Styles* (SUNY Press, 2003), pp. 271–305).

[4] See, for example, the additive accretion of epithets describing Constantine (11–14a) or the profoundly beautiful variations on words for a sailing ship (243–46a).

composition of *Elene*, or any other poem in the traditional Old English style, is thus aptly described as a feat of "word skills."

Cynewulf's discussion of his poetics, the "wordweaving" used in composing *Elene*, comes after the *Finit* of the narrative at line 1235 and is itself unique from the rest of *Elene* in some curious ways. First, a handful of alternating endwords appear to rhyme: *unscynde / gerymde* (1246b/1248b) and *gewiteð / nimeð* (1277b/1279b). However, even more half-line endwords and line endwords quite intentionally rhyme: *fus / hus* (1236), *þreodude / reodode* (1238), *nearwe / gearwe* (1239), *onband / onwand* (1249), etc. A few cases are less than perfect rhymes (and are assonances), such as *wæf / læs* (1237) and *onlag / had* (1245), but the skillful internal rhymes continue through line 1250, clearly not a coincidence; the line is the end of the poet's discussion of how God *leoðucræft onleac* "unlocked [his] poetic skill" (1250a). The rhyming words are an anomaly; Old English poetry almost never rhymes. Cynewulf concludes *Elene* with an acrostic riddle skillfully woven into twenty lines of text, eight runic characters that spell "Cynewulf" (1256b–76a).

A passage in *Beowulf* also describes the creation of poetry, and it contains images quite similar to Cynewulf's discussion of poetics in *Elene*. After Beowulf has slain Grendel, a great celebration is held in Heorot. As part of that celebration,

> Hwilum cyninges þegn,
> guma gilphlæden, gidda gemyndig,
> se ðe eal fela ealdgesegena
> worn gemunde, word oþer fand
> soðe gebunden; secg eft ongan
> sið Beowulfes snyttrum styrian,
> ond on sped wrecan spel gerade,
> wordum wrixlan (867b–74a)

> Sometimes a thane of the king, an exultant warrior mindful of poems/ songs, one who remembered a great many of the ancient traditions, arranged other words properly bound; the man then began wisely to rehearse Beowulf's undertaking, and fluently to tell the adapted story, to vary words.

In defining the phrase *soðe gebunden*, the *Dictionary of Old English* indicates that it is figurative, "either 'bound in truth' or perhaps, as has been suggested, 'correctly joined by the device of alliteration' (attested in late Middle English; cf. *Sir Gawain and the Green Knight* 35: *with lel letteres loken*)."[5] The variation of words, *wordum wrixlan*, suggests the technique of semantic variation. The *Beowulf* poet's description of the composition of poetry thus includes elements similar to Cynewulf's: the aural poetry of the *scop* of Hrothgar's hall, like the written poetry of *Beowulf* itself, is built and bound by skillful linguistic wordplay (meter and alliteration), carefully-selected and stacked details (variation of words), and adapted "marvels" from older narrative sources. While the *Beowulf*

5 *Dictionary of Old English*, Fascicle B, *s.v. (ge)bindan*, A.2.

WOVEN WORDS

poet's *soðe gebunden* may or may not be textile imagery, the image of binding disparate elements into a poetic whole seems very similar to the weaving of words described in *Elene*, where a body must be *onband* "unbound" and a mind *onwand* "unwound" for words to be bound or "woven" together (1249).

In his analysis of the *Battle of Brunanburh*, James C. Addison argues the case that such "interwoven" or "interlace" poetics may extend beyond individual alliterative lines, stretching across entire sections of poetry and interconnected by similar sounds and related ideas.[6] He gives as an example the first section of the *Battle of Brunanburh*, in which lines one, three, and seven "exhibit the interlace of theme, semantics, and sound."[7] In the lines *Æþelstan cyning, eorla dryhten* "Athelstan king, lord of earls" (1), *Eadmund æþeling, ealdorlangne tir* "Eadmund prince, eternal glory" (3), and *afaran Eadweardes, swa him geæþele wæs* "sons of Edward, as was natural for them" (7),[8] the focus on the men's names as the alliterative determinant for each line is probably not a coincidence; the poem links the names of two royal sons and their father, the heroes of the poem. Lines one and three also place each brother in his relationship to the other through parallel syntax: Athelstan, the king, and Eadmund, the prince. The second half of each of these lines also seems linked across the passage by alliteration, *eorla dryhten* and *ealdorlagne tir*. These interwoven connections within and across lines are reminiscent of Cynewulf's "wordweaving" section in *Elene*, with its elements of rhyme within and across lines.

Addison also points out the close semantic relationships, among other words, of *Æþelstan, æþeling*, and *geæþele*. All three words are connected by the underlying meaning "noble." Semantic interlace in particular aids the poet in emphasizing the important message of the poem: the nobility of the heroic royalty being praised. Addison asserts that such complex interlacing on several levels is not unusual: rather, it is "typical" of this poem and others.[9] He likewise argues that the complex interlace found in the *Battle of Brunanburh* is part of a larger Old English poetic "phenomenon ... so widespread as to warrant full-length study"[10] and is a logical feature, as the "recurrent aural, alliterative signals would have doubtless facilitated both retention and comprehension" for both the poet and readers or listeners as they moved from one related idea to the next.[11]

[6] James C. Addison, "Aural Interlace in 'The Battle of Brunanburh,'" *Language and Style: An International Journal*, 15 (1982), 267–76, at p. 267.

[7] *Ibid.*, p. 268.

[8] *The Battle of Brunanburh, Anglo-Saxon Minor Poems*, ASPR 6, pp. 16–20.

[9] Addison, "Aural Interlace," p. 270. He includes analysis of an interesting second group of lines: *Sceotta leoda and scipflotan* (11), *secga swate, siðþan sunne up* (13), *sah to setle. Þær læg secg mænig* (17), and *ofer scild scoten, swilce Scittisc eac* (19). The interlinear, interlaced alliteration of *sc* and *s* words is obvious. *Sceotta* and *Scittisc* set off this section of the poem in an alliterative envelope of sorts, words "similar in both etymology and sound."

[10] *Ibid.*, p. 267.

[11] *Ibid.*, p. 269.

Addison's argument for the "conscious artistry of the poet" in interlacing "related strands – alliterative, thematic, syntactic, and semantic"[12] within lengthier poetic sections of the *Battle of Brunanburh* builds consciously on the well-known analysis of "interlace poetics" by John Leyerle. In his article, "The Interlace Structure of *Beowulf*," Leyerle asserts that *Beowulf* reveals a pattern of interlacing (or interweaving) thematic material that extends across and unites the entire narrative poem. As exasperated undergraduates may observe, *Beowulf* is not always linear; Leyerle states that the recursive nature of the poem is a "poetic analogue of the interlace designs common in Anglo-Saxon art of the seventh and eighth centuries."[13] Within the text of *Beowulf*, thematic interlace occurs as past actions (or in common jargon, "episodes") are intertwined with actions of the narrative present in thematically significant ways. Leyerle outlines several examples of thematic interlace within *Beowulf*, including lines which allude to the episode of Hygelac's Frisian expedition.[14] The first allusion occurs as the Danes give the magnificent necklace of the Brosings to Beowulf; the text refers immediately to its loss when Hygelac is killed in the raid on the Frisians. Thus, the treasure is linked to disaster, perhaps a foreshadowing of Beowulf's experience with the dragon hoard. The second reference occurs as Beowulf prepares to meet the dragon. The episode parallels the two rash actions, both of which result in the death of a king. The third allusion takes place in the same context

[12] *Ibid.*, pp. 274–5.

[13] "The Interlace Structure of *Beowulf*," *University of Toronto Quarterly*, 37 (October 1967), p. 1. Leyerle posits a connection between the early interlace art of illustrated manuscripts and interlace poetics, suggesting both originate from the example of interwoven textiles: "literary interlace has a counterpart in tapestries where positional patterning of threads established the shape and design of the fabric, whether the medium is thread in textile or words in a text" ("Interlace," p. 5). In many ways, I agree with Leyerle and think it quite likely that textile art originally influenced interlace themes in manuscript illumination and sculpture. A particularly good example can be found in the borders of the eighth-century Durham Cassiodorus page known as "David Victor" (Durham, Cathedral Library, MS B. II. 30, fol. 172IV): among the other interlaced patterns is a distinct twill weave. Elizabeth Coatsworth reaches a similar conclusion in her examination of interlace decoration in metal and textiles, "It is possible to pursue the links between textiles and other contemporary media such as metalwork and sculpture quite a long way within the pre-Conquest period, using internal evidence from the artifacts themselves. This is particularly the case when looking at the edges, borders, and trimmings of textiles" ("Design in the Past: Metalwork and Textile Influences on Pre-Conquest Sculpture in England," in Karkov and Damico, *Aedificia Nova*, pp. 139–61, at pp. 142, 146). "Interlace" is thus an attractive metaphor for elements of composition in Old English texts, although there are caveats for some of the points discussed. Not all interlace design is geometric, and not all geometric design has the appearance of interlaced thread. The techniques necessary to produce some interlace designs, including serpentine lettering, differ markedly from techniques used to produce weave patterns or different types of interlaced embroidery. Geometric interlace itself also evolves as an art form in its own right in ways quite unlike what may have begun or co-existed in a textile medium. In all other respects, however, Leyerle's metaphor remains an attractive one, one quite close to the "wordweaving" metaphor elected by Cynewulf.

[14] See lines 1202–14, 2354–68, 2501–9, and 2913–21.

as Beowulf recalls how he took revenge on Hygelac's killer at the Frisian raid without a sword; he is emphatic that he will always act the same, whether he is alone or not, until his sword fails him. These lines are thoroughly prophetic of the upcoming scene with the dragon, in which Beowulf chooses to fight alone and trust in himself and his sword. The last allusion comes after Beowulf's death, as mourners recall the feud begun by Hygelac's raid and worry about the destruction awaiting them as a result. As Hygelac's rash choice caused the destruction of his fighting troop, so now it may extend destruction to all the Geats. The narrative thread of Hygelac's episodes weaves through the entire text, foreshadowing Beowulf's final doom. The subtle correlations between the main narrative thread and the episodic thread are striking: a treasure, a rash action which results in the death of a king, swords failing and Beowulf standing alone, and resulting destruction all neatly parallel the end of Beowulf's life.[15]

Other critical thematic threads include monsters vanquished in underwater fights, as well as the episodes such as Hildeburh's which describe or allude to feuds and destroyed bonds of peace. Francis Leneghan traces additional, perhaps central, interwoven dynastic threads that cross in and out of the narrative across the poem.[16] For his part, Leyerle imagines the intertwinings as a different type of weaving than with warp and weft, seeing instead the straightforward braiding or interweaving of narrative threads as the correct narrative analogue.[17] Both potential analogies thus rely on images of interwoven threads, but with different types of techniques. Either or both could be what an early medieval English "wordweaver" imagined when using "weaving" as a word to describe composing Old English poetry, or, as I will discuss, Anglo-Latin poetry or prose.

In addition to Addison's identification of interlaced aural and topical threads across lines and sections and Leyerle and Leneghan's analyses of thematic interlace across entire lengths of narrative poetry, Pauline E. Head argues that interlace occurs at an inter- as well as an intra-poetic level in the Old English poetic corpus. Thus, recurrent images in Old English poetry such as the beasts of battle or "hero on the beach" indicate a similar sense of associative continuity between and beyond individual poems: they "would have reflected and renewed depictions of carnage in stories previously told, binding the new to the old and drawing the past into the present. The poet's recollection and repetition of the theme would have signified continuity and the cyclic movement of time."[18] This continuity suggests a poetics of interlacing or interweaving of words, lines, events, and themes stretching not only within, but also throughout different texts within the Old English (and perhaps Anglo-Latin) corpus, from *Judith* and *Beowulf* to *Juliana*.

[15] Leyerle, "Interlace," pp. 7–8.

[16] *Dynastic Drama*, pp. 29, 184.

[17] Gale R. Owen-Crocker (in private communication) has pointed out that even for today's craftpersons and textile scholars there may be a distinction between "weaving" which involves the insertion of a weft between the warp threads and "braiding" or "interlace" which requires no weft and is constructed only by the manipulation of warp threads.

[18] *Representation and Design: Tracing a Hermeneutics of Old English Poetry* (SUNY Press, 1997), p. 161.

If even half of these poetic interconnections were as evident to early medieval English poets as they are to contemporary scholars, Cynewulf and the *Beowulf* poet could hardly be blamed for seeing interlacing threads as a resonant metaphorical way of envisioning the complex and beautiful composition of Old English poetry. As will be discussed in later sections, the same may also be said of the other poetry of early medieval England: Anglo-Latin poetry.

"WORD<u>weaving</u>": CONNECTIONS OF MATERIAL CULTURE

Just as the metaphor and kenning "<u>word</u>weaving" asks us to consider the resonance of early medieval English poetics in explaining its meaning, so "word<u>weaving</u>" invites examination of the material culture of textiles in the same light. As it existed among most early Western cultures, including pre-Conquest England, textile production was experientially resonant with the construction of text – oral or written. The parallels are easy to imagine: a skilled weaver plans and measures carefully for color and weave pattern long before she stretches the warp threads on the loom or decides the number of leashes and heddles she will use. A poet acts similarly, planning the structures, sequences, and events to be included as the basic "warp" or "threads" of the narrative. The weaver interweaves weft threads – perhaps in differing colors – across the warp, skillfully creating a texture and a design. The poet makes similar, thoughtful selection of varying words, images, and sounds to produce a written texture and design that gives poetic life and color to the larger narrative of the work. The result for both arts is a creation meant to be noted for its design, its interwoven beauty, and its technical prowess, all a testament to the skill of its creator.

"Wordweaving" is thus a metaphor that would have resonated on beautiful material levels for early medieval English audiences. Resonance requires familiarity; as I argue in Chapter 1 and Gale R. Owen-Crocker and I argue elsewhere, the processes of textile production, including weaving, were ubiquitous and highly visible parts of everyday life in early medieval England across time, region, social station, and religious status.[19] Even more pervasive was the product of textile production, the woven cloth that touched every life, every day, in a myriad of ways. It would thus not be surprising if textile work influenced the conceptualization of wordplay among early medieval English people.

A handful of other interesting confluences between wordcraft and textile craft are evident among the early medieval English. As discussed in Chapter 1, the noble lady Æthelwynn once invited Dunstan to come and entertain the embroideresses in her household with his harp and his words during rest periods from their textile work, an image which evokes the harps referenced in the poetic exploits of Cædmon and the scops in *Beowulf*. The layering of storytelling is a compelling image as both textile workers and Dunstan take part: embroiderers tell stories in textile (one imagines the Bayeux Tapestry or similar works for which early medieval English women were famous, though stories through vestments like those at Durham would be equally evocative), while Dunstan's

[19] "Woven Works," pp. 157–84.

storytelling takes place through poem and song. We know stories and working songs accompanied spinning and weaving because of scattered evidence that remains. Even today, we sing one of the surviving textile-working songs that pre-dates industrial spinning: "All around the mulberry bush, the monkey chased the weasel, the monkey thought it all in fun, POP goes the weasel." The song is a spinning song and a children's song, with the POP indicating that the yarn-winder (probably a swift or wheel) is full. We also continue to use expressions in English which connect textile production and storytelling: an old sailor, after all, likes to entertain others as he tells a tale, or "spins a yarn." The song of the valkyries in Chapter 3 is an instance of a weaving song (with the typically repetitive rhythm and wording associated with textile songs) from a cognate culture, one we can only hope was not everyday fare, but rather modeled on everyday working songs that probably were. If stories and songs were in fact shared as entertainment and education over the spindles, distaffs, looms, and needles of early medieval England, as we think they were, such word- and songcraft could indeed have suggested or strengthened a connection between weaving and other textile tasks and words in the minds of men and women, once children in related domestic settings.[20]

Erika von Erhardt-Siebold identifies a different type of intersection between harps and looms well-known to have inspired "the ancients" to connect them poetically – the threads that thrummed in each:

> the swiftly travelling shuttle will, in striking the taut warp-threads, cause them to vibrate and produce low notes, a sort of irregular humming or buzzing. The ancient writers, especially the poets, at times speak of the sounding or singing of the shuttle or warp-threads ... "Singing," no doubt, is a poetical phrase and metaphor; we know that because of their similarity loom and lyre were closely associated in the minds of the ancients.[21]

She is not alone in noting these connections. According to Scheid and Svenbro, the "singing shuttle" is a common expression in Greek literature,[22] and Hoffmann mentions reconstructions of Egyptian ground looms which have recreated the humming effects associated with them in ancient poetry when a shuttle or bobbin was passed through the threads.[23] As von Erhardt-Siebold also points out, Riddle 35 of the Exeter Book implies that an early medieval English audience noticed the "singing" loom. Lines 6–7 describe

[20] In her discussion of the loom imagery used by Aldhelm in his riddle *De Lorica*, Gale R. Owen-Crocker comments that "it is interesting to find a male scholar, Aldhelm, using the technical terms of the woman's craft of weaving" (*Dress*, pp. 279–80). See also her article "Aldhelm," in Owen-Crocker *et al.*, *Encyclopedia of Medieval Dress and Textiles*. Such familiarity is most likely to have been gained within a domestic environment.

[21] "The Old English Loom Riddles," in Thomas A. Kirby and Henry Bosley Woolf (eds), *Philologica: The Malone Anniversary Studies* (Johns Hopkins, 1949), pp. 9–17, at p. 11.

[22] *Craft of Zeus*, p. 139.

[23] Hoffmann, *Warp-Weighted*, p. 320.

how the riddled subject differs from a textile in a loom and does not hum when a tool (likely a shuttle or bobbin) passes through its center,

> ne þurh þreata geþræcu þræd me ne hlimmeð,
> ne æt me hrutende hrisil scriþeð[24]

> nor does thread resound in me through the pressure of many forces, nor does the humming [bobbin/shuttle] glide through me.[25]

The thread in line six likely refers to the taut warp threads. The "pressure of many" which makes the thread "resound" or "hum" may refer to the tension created by loom weights, a tension which would cause a shuttle or bobbin to resound in the shed, or it may refer to the number of rods and posts, particularly shed rods, which would also be responsible for tension.[26] Thus, in the riddle, the loom "sings." The Northumbrian version of the riddle (the "Leiden" riddle) reads differently at line 7: *ne me hrutendu hrisil scelfath*[27] "nor does the humming [bobbin/shuttle] make me tremble." According to von Erhardt-Siebold, this "can only refer to a wavy motion in the rows of warp-threads or to their acoustic vibrations, both produced by the shuttle."[28] The musicality of both lines in their different versions seems overt onomatopoeia, a suggestion of the musical sound created within the loom by passage of a weaving tool (shuttle or bobbin).[29] She argues that Riddle 70 of the Exeter Book focuses on a related textile tool, one that *Singeð þurh sidan* "sings through sides" (2a), which she solves as "shuttle." As she states, "This is what a shuttle does; for it produces sounds through the lateral warp-threads."[30] Very

[24] ASPR 3, p. 198.

[25] The *hrisil* may very well be "shuttle," and indeed, I think it is, as does von Erhardt-Siebold. However, I am cautious in translating the term so definitively and leave both "shuttle" and "bobbin" as options in discussion here. There is as yet no conclusive evidence in archaeological contexts that the early medieval English had "shuttles" as we understand them. It does not help archaeologists that most shuttles would likely have been carved of perishable materials and might be easily misidentified as a "worked stick" even if found. The word *hrisil*, like many other textile tools, is also not clearly defined by its users, and so may mean a variety of different textile tools. In any event, either a shuttle or a bobbin might create the same kinds of vibrations in moving through the shed; the shuttle would be the more musical of the two by far.

[26] Von Erhardt-Siebold, "Old English Loom Riddles," p. 14.

[27] ASPR 6, p. 109.

[28] Von Erhardt-Siebold, "Old English Loom Riddles," p. 14.

[29] Cavell objects to the idea that sounds of the loom might have influenced a connection between weaving and poetry, arguing that poetry is too high-status a context for so prosaic an association (*Weaving Words and Binding Bodies*, pp. 236–7). Given that Old English riddles (intentionally) depend on the prosaic for their understanding, however, I think the association is entirely feasible.

[30] Von Erhardt-Siebold, "Old English Loom Riddles," p. 16. Craig Williamson and others solve the riddle with another musical object, the harp or the lyre (see, for example, Williamson's *A Feast of Creatures*, pp. 204–5). That conflation is possible because the descriptions of a singing

WOVEN WORDS

few scholars have agreed with this interpretation of Riddle 70, however, and most of its lines are hotly contested. Evidence from Riddle 35, however, confirms the idea of a "singing" loom, an idea which could connect the loom metaphorically with the singing harp of the poets.

In the final analysis, what can be proven without doubt is that the people of early medieval England saw weaving and woven cloth often; textiles were a regular part of their environment; and textiles and their production provided poets a set of images that would be resonant and accessible not only to themselves, but also to their audiences when poets explained the workings of (and appreciation due to) talented "wordweavers."

"WORDWEAVING" IN ANGLO-LATIN TEXTS

As it happens, Cynewulf's evocative "wordweaving" is not the only "wordweaving" from early medieval England. Old English "wordweaving" is mirrored in Anglo-Latin poetry and prose, and both Old English and Anglo-Latin literature are certain to have been influenced by classical Latin "wordweaving" images that preceded them. Instances of Anglo-Latin "wordweaving" within early medieval England occur as early as the late seventh century in the highly influential works of Aldhelm of Malmesbury.[31] Aldhelm's *Epistola ad Acircium*, a work thought to have been dedicated to Aldfrith, king of Northumbria, describes the beginning of the book of Job as *prosa contexitur* "woven in prose," indicating the rest is written in poetry.[32] In his prose *De Virginitate*, Aldhelm similarly envisions how the book of Daniel *de divina incarnatione oraculorum seriem texuisse dinoscitur*[33] "is recognised as having woven together a series of oracular sayings concerning the divine incarnation."[34] He imagines his own process of composition in weaving terms, but a slightly different kind of weaving; in the same text, he states his goal: *pulcherrimam virginitatis coronam Christo favente contexere nitar*[35] "I will strive to weave with Christ's favour a most beautiful crown of virginity."[36]

Aldhelm imagines poetic composition in parallel terms. In "De Metris," a section of his *Epistola ad Acircium*, he describes *legitimos septies quaternos metrorum pedes, quibus*

 bobbin or shuttle in the loom and a harp or lyre reiterate the visual and aural similarities between the images.

[31] Aldhelm is drawn frequently to textile imagery and metaphor and could be considered the father of the "wordweaving" tradition within Anglo-Latin poetry and prose. For an elaboration of his unique and central role, see Hyer, "Text, Textile, Context: Aldhelm and Word-Weaving as Metaphor in Old English," in Hyer and Frederick, *Textiles, Text, Intertext*, pp. 121–38. My arguments in that article are mirrored in this discussion, but with a great deal of additional evidence here.

[32] *Aldhelmi Opera*, Ehwald, p. 63, lines 15–16. Translation from *Aldhelm: The Prose Works*, Lapidge and Herren, p. 35.

[33] *Aldhelmi Opera*, Ehwald, p. 251, line 7.

[34] *Aldhelm: The Prose Works*, Lapidge and Herren, p. 77.

[35] *Aldhelmi Opera*, Ehwald, p. 249, lines 14–15.

[36] *Aldhelm: The Prose Works*, Lapidge and Herren, p. 76.

universa non solum principalia octo genera progrediuntur verum etiam species, quae ex eadem stirpe pululantes centuplis metrorum frondibus contexuntur[37] "the twenty-eight regular metrical feet from which stem not only all eight principal types (of metre) but also the kinds which, growing from the same bough, are woven with the hundred-fold leaves of metre."[38] In the first two instances that may be "wordweaving," Aldhelm does not indicate whether he is referencing textile weaving or not, but the second two appear to reference a different kind of weaving, the intertwining of branches, in one case, into a crown. Aldhelm's use of *texere/contexere* in each instance, however, quite clearly demonstrates how he envisions composition: the weaving together of pliant threads or branches into a greater whole, one meant to adorn and beautify. Aldhelm takes direct inspiration for the first example of "wordweaving" from Jerome, as I will discuss in a later section.[39] Aldhelm's distinct interest in textiles and textile imagery factor in other ways in his famous and influential riddle collection, as already noted, but no "wordweaving" appears there.

In discussing rhetoric a century later, Alcuin also uses language which seems similar to "wordweaving." Drawing directly from Julius Victor's fourth-century *Ars Rhetorica* to construct his own pedagogical dialogue on rhetoric, a "discussion" between Alcuin and Charlemagne, Alcuin states one must memorize prepared arguments that have been *inveneris et disposueris et oratione vestieris* "invented and arranged and clothed in words."[40] Leyerle takes such expressions in Alcuin to imply more than simple comparative metaphor, citing similar passages to connect both Aldhelm and Alcuin's interwoven compositional styles with the "interlace" style he finds characteristic of Old English literature:

> Stylistic interlace is a characteristic of Aldhelm and especially of Alcuin. They weave direct statement and classical tags together to produce verbal braids in which allusive literary references from the past cross and recross with the present subject. The device is self-conscious and the poets describe the technique with the phrases *fingere serta* or *textere serta*, "to fashion or weave intertwinings." ... In basic meaning, then, a poetic text is a weaving of words to form, in effect, a verbal carpet page.[41]

Michael Winterbottom characterizes Aldhelm's compositional style in some similar ways, though with different attribution. In addition to noting Aldhelm's elaborate grecisms, neologisms, and acrostic wordplay, he observes that Aldhelm has a "peculiar interweaving of words" and an "interlaced order" of words, characteristic of the "rhe-

37 *Aldhelmi Opera*, Ehwald, p. 77, lines 19–21.

38 Translation from *Aldhelm: The Poetic Works*, Lapidge and Rosier, p. 191.

39 Jerome, *S. Eusebii Hieronymi, Stridonensis Presbyteri Opera Omnia*, ed. J.-P. Migne, *PL*, 28 (Migne, 1890), col. 1141. Text located at www.archive.org/stream/patrologiaecurs13goog#page/n4/mode/1up (accessed 7 March 2024). An image roughly similar to Aldhelm's third and fourth examples is found in Prudentius ("Crowns of Martyrdom," *Prudentius*, vol. 2, p. 154, lines 208–9), but woven crowns are ubiquitous features in Greek and Latin poetry.

40 In *The Rhetoric of Alcuin and Charlemagne*, ed. and trans. Wilbur Samuel Howell (Russell and Russell, 1965), pp. 70–1.

41 "Interlace," p. 4.

WOVEN WORDS

torical schools" of ancient Rome.[42] Winterbottom argues that the strong emphasis on alliteration and interlaced wording, with its related variation, also suggests that Aldhelm is the inheritor of classical traditions.[43]

Many aspects of these descriptions of Aldhelm's poetic style in Anglo-Latin, however, are strikingly similar to those used to describe Cynewulf's, though they write in different languages and potentially different poetic idioms. Winterbottom's argument in light of Leyerle's claim could be taken to imply that not only Aldhelm, but all subsequent early medieval English writers took the stylistic features which are characteristic of Old English poetry (alliteration, interlace, variation) from classical tradition. Such a position, however, is quite probably more extreme than either Winterbottom or Leyerle would themselves accept or intend.[44] While Aldhelm's use of "wordweaving" metaphors and his Anglo-Latin stylistics bear brilliant witness to his awareness of and interest in the stylistics of Rome, the alliteration, interlaced wording, and variation in one language mirror the same techniques common to the traditions of early medieval northern Europe, his native tradition, as well. It is more likely that Aldhelm represents a hybrid poet, one who we are told composed beautiful poetry in traditional Old English form as well as Anglo-Latin forms.[45] Andy Orchard credits Aldhelm, moreover, with having not only made extensive use of Latin compositional techniques, but also having sown "the seeds for the introduction of vernacular poetic elements into [contemporary] Latin verse."[46] In other words, Orchard suspects, as I do, that Aldhelm likely drew from both traditions of which he was part, developing the hybrid, dramatic array of poetic techniques for which he became known. I have observed in prior chapters that early medieval English culture appears to have been remarkably syncretic; the same may be true in its poetics.

The years between and after Aldhelm and Alcuin include a variety of examples of Anglo-Latin "wordweaving," and most examples are found, as it happens, among those

[42] "Aldhelm's Prose Style and Its Origins," *ASE*, 6 (1977), 39–76, at p. 41.

[43] *Ibid.*, pp. 41, 44, 64.

[44] Indeed, Winterbottom's avowed object was to argue that features of Aldhelm's prose were more likely to derive from classical than Irish sources, rather than any more extensive statement.

[45] In discussing Aldhelm's literary career, William of Malmesbury praises his Latin works, but adds, *Litteris itaque ad plenum instructus, natiuae quoque linguae non negligebat carmina; adeo ut, teste libro Eldfredi, de quo superius dixi, nulla umquam aetate par ei fuerit quisquam poesim Anglicam posse factere, cantum componere, eadem apposite uel canere uel dicere* "Filled full of letters as he was, he did not neglect the poetry of his native tongue either. Indeed, as we are told in the book by Alfred I mentioned before, no one has ever in any age rivalled him in the ability to write poetry in English, to compose songs, and to recite or sing them as occasion demanded" (*GESTA PONTIFICVM ANGLORVM: The History of the English Bishops*, trans. and ed. M. Winterbottom with R. M. Thomson (Clarendon, 2007), book 5, chapter 190, paragraph 3 (pp. 506–7)). William adds the information that Aldhelm put his native tradition's poetic skills to good use, singing traditional poetry and songs to crowds, while sneaking religious content into his compositions, as well.

[46] *Poetic Art*, pp. 49 and 52–3.

known to be influenced by Aldhelm. One of the most fascinating examples is Tatwine, the riddler. As I have discussed elsewhere,[47] Tatwine, an early eighth-century archbishop of Canterbury, wrote his own collection of riddles, with opening and closing lines worthy of his inspiration, Aldhelm. Tatwine begins his collection with a compositional riddle, stating, *Sub deno quarter haec diuerse enigmata torquens / Stamine metrorum exstructor conserta retexit* "Within a threaded warp of metrical verses, the author, turning in different ways, weaves/composes these entwined forty riddles." He closes with another clue to his meaning: he has written all of his riddles *Versibus intextis* "with interwoven verses."[48] Michael Lapidge elucidates the meaning of Tatwine's overarching riddle: "Aldhelm had prefaced his collection of *Enigmata* with an acrostic prologue; Tatwine surpassed Aldhelm by linking the first and last letters of each of his forty *enigmata* in a vast acrostic and telestich."[49] The acrostic letters combined are identical to Tatwine's initial statement: he has wordwoven (threading the letters through each riddle) and intertwined his riddles into a cleverly-constructed whole. "Wordweaving" for Tatwine clearly implies dexterous wordplay and compositional skill. Similar images of weaving and interweaving as a metaphor for composition occur in the works of one of Tatwine's contemporaries. Felix, also influenced by Aldhelm,[50] begins his *vita* of St Guthlac by claiming humbly it is *simplici verborum vimine textum*[51] "woven with plain slender branches of words." Such an image, while not a textile image, is still a kind of "wordweaving," with classical and Aldhelmian precedent.[52]

Some of the writers of the next generation within Boniface's circle, like Boniface himself, are known to have been influenced by Aldhelm; "wordweaving" images are found in their works, as well.[53] During his mission to Germany in the mid-eighth century, for example, Willibald wrote a *vita* for his relative, Boniface, the *Vitae Sancti Bonifatii Archiepiscopi Moguntini*. Willibald states that he will do his best *stamine innectere ac*

47 A full discussion of the textile imagery in Tatwine's work, as well as the work of the other early medieval English riddlers in the Anglo-Latin and Old English tradition can also be found in Hyer, "Riddles of Anglo-Saxon England." Additional elaboration of Tatwine's imagery and that of Felix and the circle of Boniface, all discussed here, can also be found in Hyer, "Aldhelm and Word-Weaving as Metaphor," pp. 121–38.

48 Tatwine, *Tatvini Opera Omnia: Variae Collectiones Aenigmatvm Merovingicae Aetatis*, ed. Franciscus Glorie, CCSL, 133A (Brepols, 1968), pp. 165 and 208. Translations are mine.

49 *Aldhelm: The Poetic Works*, Lapidge and Rosier, p. 66.

50 In his edition of *Felix's Life of St. Guthlac*, Bertram Colgrave indicates that Felix borrows at least one phrase directly from Aldhelm (Cambridge University Press, 1956), p. 15.

51 Felix, *Vita sancti Guthlaci*, in *Felix's Life of Saint Guthlac*, ed. and trans. Colgrave, p. 60. The translation here is mine.

52 Felix's phrase may come from a source he shares with Aldhelm; the wording is quite similar to a poem by Venantius Fortunatus in which he describes weaving of a simple basket to hold a gift for his friends, one *vimine texta* "woven with slender branches" (*Venanti Fortunati*, p. 264, no. 13, line 1).

53 *Aldhelm: The Prose Works*, Lapidge and Herren, p. 2.

simplici historiae tegmine[54] "to weave [or join], by means of a thread/warp and a simple covering of narrative" in an effort to commemorate the deeds of the saint. He adds that he will prosecute his composition *congregata verborum raritate texendo*[55] "by weaving/composing with a collected sparsity of words." His subsequent compositional style includes grecisms, neologisms, and other complex diction, suggesting that he may be equating "wordweaving" with the construction of elaborate text (perhaps, *à la* Aldhelm). Within a few years, Willibald himself is commemorated in a *vita* written by an early medieval English nun in Germany at the latter end of the eighth century, Hygeburg. Discussing her compositional approach to her *Vita Willibaldi episcopi Eichstetensis*, Hygeburg states that it is her goal *gracilem opusculi huius coniecturam glomerando ordire ... ordinandoque texere*[56] "to begin [or, to lay the warp] by gathering [or, winding into a ball] the slender conjecture of this little work ... to compose/weave by arranging [it]." Her work shows distinct evidence of Aldhelmian influence, perhaps directly through the existence of his works in continental monastic libraries, or perhaps through the intermediary of Willibald's influence. It is worthy of note that some prominent and influential authors from this same period do *not* appear to have used "wordweaving" metaphors, perhaps not coincidentally, those less inclined to favor Aldhelm's writing style.[57]

Other kinds of textile metaphors are linked to composition in the latter half of the period, as well, and may be related to the influence of Aldhelm there. In his late tenth- or early eleventh-century life of St Oswald, Byrhtferth of Ramsey, well-known for his allusions to and imitation of Aldhelm's work and style, uses an extended version of a metaphor which may connect compositional style and clothing. He begins the fourth section of his work on the life of St Oswald by describing his own writing as *niuea carens claritate et pollens candida rusticitate, induta pauperina ueste finem expetit* "devoid of snow-white clarity and abounding in plain boorishness, clothed in peasants' apparel."[58] The simplicity of his style is debatable and his statement very likely a rhetorical "humility" gesture, but clearly, he equates his writing style with "dressing words in clothing," a variation or a cousin, perhaps, of "wordweaving."

Writing in the latter half of the eleventh century for an English audience, the Flemish writer Goscelin of St Bertin uses images more explicitly related to "wordweaving" in his instructions to a young anchoress. In his *Liber Confortatorius*, he teaches, *Cum telam psalterii retexeris, ita cane sicut in conspectu angelorum et sicut ipsa uerba saluatoris coram ipso Domino maiestatis*[59] "When you reweave the cloth of the psalms, sing them knowing

54 Willibald, *Vitae Sancti Bonifatii Archiepiscopi Moguntini*, ed. Wilhelm Levison, MGH, Scriptores in Folio, 15.1 (Hahn, 1905), vol. 1, p. 4. Translation for this work is mine.

55 *Ibid.*

56 Hygeburg, *Vita Willibaldi episcopi Eichstetensis*, ed. O. Holder-Egger, MGH, Scriptores in Folio, 15.1 (Hanover, 1887), vol. 1, p. 88. Translation is mine.

57 Bede is a prominent example.

58 *Byrhtferth of Ramsey*, Lapidge, pp. 144–5; translation by Lapidge.

59 Goscelin of St Bertin, "The *Liber Confortatorius* of Goscelin of Saint Bertin," ed. C. H. Talbot, *Analecta Monastica*, 37 (1955), 1–117, at p. 82, lines 16–18.

that you are singing the Savior's own words under the eyes of the angels and before God's own majesty."[60] This "wordweaving" is striking and visually evocative, providing the young, early medieval English woman an image she can see in her mind as she meditates on the Psalms, a *telam* or warp/cloth she can re-weave with each contemplation or repetition of the Psalms in her anchoritic solitude. That Goscelin should choose the same kind of textile imagery for his female religious auditor as Aldhelm did for his in his prose and poetic *De Virginitate* (usually thought to have been dedicated to the instruction of the nuns at Barking Abbey in Essex[61]) is probably significant; Goscelin, like Aldhelm, uses a visual metaphor that includes weaving for someone whose societal role outside (and possibly inside) her cloistered life included such a task. Goscelin himself quotes from Aldhelm's *Carmen de virginitate* in the *Liber Confortatorius*,[62] and it is well-known that he was influenced by Aldhelm, like most of his contemporaries. He may have been influenced by Aldhelm's "wordweaving" imagery, as well, or he may have drawn it from the same potential sources as Aldhelm. Although Goscelin's "wordweaving" differs from the other descriptions in some ways, it may or may not be a coincidence that Goscelin is well-known, for his part, for his "overwhelming poeticism," including use of dense and difficult poetic vocabulary. In other words, his own compositional style is difficult and elaborate, like Aldhelm's, though not necessarily equivalent.[63]

Similar images related to "wordweaving" occur in contemporary texts often attributed to Goscelin, the first, the *Vita Ædwardi Regis*, commissioned by Edith, wife to King Edward. Reflecting on his method of composition in writing the work, the author explains the way (and why) he draws together the facts of Edward's life, *Vnde inter cetera materiæ tela contexitur qua ad tanti regis amorem populus dei diuino igne succendatur* "For from these, among other things, the web of the stuff is woven with which God's people may by the divine fire be kindled to love so great a king."[64] The author's imagery for "wordweaving" is of particular interest if the word *tela* is interpreted as "warp," one possible meaning. If so, then the author imagines his composition as an imaginative warp through which a people can interweave threads of love and memory to celebrate the passing of a holy king. Another text often ascribed to Goscelin is part of a *vita* for St

[60] Goscelin of St Bertin, *Goscelin of St Bertin: The Book of Encouragement and Consolation [Liber Confortatorius], The Letter of Goscelin to the Recluse Eva*, trans. Monika Otter (D. S. Brewer, 2004), p. 98.

[61] See note 39 in Chapter 1 of this volume.

[62] Rosalind Love (ed. and trans.), *Goscelin of Saint-Bertin: The Hagiography of the Female Saints of Ely* (Oxford University Press, 2004), p. 97, no. 68.

[63] Rosalind Love, "'Et quis me tanto oneri parem faciet?': Goscelin of Saint-Bertin and the Life of St Amelberga," in Katherine O'Brien O'Keeffe and Andy Orchard (eds), *Latin Learning and English Lore: Studies in Anglo-Saxon Literature for Michael Lapidge* (2 vols, University of Toronto Press, 2005), vol. 2, pp. 232–52, at p. 242.

[64] *The Life of King Edward*, pp. 98–9. The translation is Barlow's.

Æthelthryth called *Miracula Sancte Ætheldrethe Virginis*.[65] As the author summarizes the writings of Bede on Æthelthryth in the prologue, he states that Bede *uirginitatis ymnum elegiaco compositum metro subnexuit* "also wove a hymn on virginity in elegiac metre."[66] The "weaving word" chosen, *subnexo*, most often means "to fasten" or "to bind," but here, definitely means "to weave."

Old English and Anglo-Latin glossaries reassure us that the play of meaning inherent to *texere, textum*, and *ordior* was understood across the span of all the Anglo-Latin "wordweaving" examples, from the days of Aldhelm and Alcuin to the tenth and eleventh century; the terms do not appear to have lost either their textile meanings or their textual-textile meanings across time. In a ninth-century Latin-Old English glossary, for example, silk worms are called *uermes qui texunt* "worms that weave."[67] In late tenth- to early eleventh-century glosses, *texo* is *ic wefe, texta* is *gewefen*, and *ordior* is *ic hefaldige* (a logical translation, as attaching heddle rods and leashes to warp threads is part of laying a warp).[68] In an eleventh-century gloss, we find the text-textile connection, where *Texuisse* is *dæt he awrite*.[69]

Lapidge and Herren state that, "The intensive study of Aldhelm in the tenth and eleventh centuries is reflected in virtually all the Latin literature produced in England at that time."[70] It is perhaps not coincidental that the eleventh-century glossary entry which indicates that *texere* was still understood as both "to weave" and "to write" (*texuisse*) is very likely based on an instance of "wordweaving" in Aldhelm's prose *De Virginitate*. The correlation between "wordweaving" and Aldhelmian influence continues into the twelfth century in the writings of William of Malmesbury, champion of Aldhelm as the founder of his monastic house. In the *Gesta Regum Anglorum*, William comments on an interruption that has taken place in his narrative, *difficilius contexo interrupta quam absoluo institute*[71] "it is more difficult to weave together/compose a work interrupted

65 Relevant arguments about authorship by Rosalind Love are found in *Goscelin of Saint-Bertin: The Hagiography of the Female Saints of Ely*, pp. lxiv–lxv.

66 *Miracula Sancte Ætheldrethe Virginis*, in *Goscelin of Saint-Bertin: The Hagiography of the Female Saints of Ely*, Love, pp. 100–1. The translation is Love's.

67 Ed. J. H. Hessels, *An Eighth-Century Latin-Anglo-Saxon Glossary Preserved in the Library of Corpus Christi College, Cambridge (MS. no.144)* (Cambridge University Press, 1890), B151, 25; S230, 107. Text located at http://openlibrary.org/books/OL13498294M/An_eight-century_Latin-Anglo-Saxon_glossary (accessed 7 March 2024).

68 Ed. Thomas Wright and Richard P. Wülcker, *Anglo-Saxon and Old English Vocabularies*, 2nd edn (Trübner, 1884), cols 188.8, 188.9, and 188.3. Text located at www.archive.org/stream/anglosaxonandoloowlgoog#page/n243/mode/1up and http://openlibrary.org/books/OL23380193M/Anglo-Saxon_and_Old_English_vocabularies W and W 1 (accessed 7 March 2024).

69 *Ibid.*, col. 492.17.

70 *Aldhelm: The Prose Works*, p. 3.

71 William of Malmesbury, *Gesta Regvm Anglorvm: The History of the English Kings*, ed. and trans. R. A. B. Mynors with R. M. Thomson and M. Winterbottom (2 vols, Clarendon, 1998), vol. 1, p. 124. The translation is mine.

than to finish what one has begun." In a later section, he uses a similar transitional metaphor, commenting that *huc usque contexui*[72] "up to now, I have woven/composed without interruption," in his discussion of the early medieval English kings; at this point, he wishes to move to a discussion of the early medieval English saints, instead.

Cynewulf, in whatever century we place him, would have been hard-pressed to have escaped the impact of the many culturally influential early medieval English writers like Aldhelm and other Anglo-Latin "wordweavers," who span the entirety of the early medieval English period. Like most of the other authors writing in the period, including all of the Anglo-Latin "wordweavers," he was also an inheritor of a strong Latin tradition of "wordweaving" metaphors. Any or all of these sources could have inspired him to adopt and adapt a metaphor he himself found resonant and apt as a description of his poetic craft in *Elene*. I turn to this set of possibilities in the subsequent section.

GREEK AND CLASSICAL LATIN "WORDWEAVING"

A metaphor like "wordweaving" was known among the ancient Greeks and can be seen as early as Pindar, himself a poet known for use of alliteration, rhythm, riddles, and kennings. He describes his poetic art, "I weave for spearmen / my varied hymn."[73] According to Scheid and Svenbro, Bacchylides and other choral poets likewise use weaving as a metaphor for their lyric poetic songs, and they argue the metaphor begins earlier in the works of Homer, where he describes the crafty weaving of spoken political speeches by Odysseus and his companions, rather than poetic weaving.[74] However, none of the works of these Greek poets is thought to have been known directly among the pre-Conquest English.

A far more likely influence is Roman culture, which inherited the metaphor from the Greeks and used it extensively, in turn. In Latin, the metaphor became deeply embedded in language itself: *texere* "to weave" and *textum* "a web" also implied *texere* "to compose" and *textum* "text" at least as early as the pre-Augustan days of Rome.[75] The related word *ordior* "to lay out a warp" also developed a related double meaning "to begin (a work)."

[72] *Ibid.*, vol. 1, p. 386. The translation is mine. Mynors's translation of the passage reads: "Hitherto, I have woven into my narrative the public acts and military exploits of the English kings" (vol. 1, p. 387). While it may be a coincidence, William's "wordweaving" mirrors a final cluster of Latin "wordweaving" collocations roughly contemporary with his own. There are two eleventh-century instances of *carmen + contexere* and one twelfth-century example of *carmen + texere*, with four additional instances of *litteras + texere*, three from the late eleventh century, and one from the twelfth (including one from Abelard's *Commentaria in epistulam Pauli ad Romanos*) (*LLTO*). Of these examples, one comes from an Italian context, one from German, and one from a Flemish/French area. The other five are all French. No other cluster occurs thereafter, with most of the remaining few scattered examples coming from the following century (including examples from Dante's *De uulgari eloquentia*) and the century thereafter.

[73] Pindar, *Olympian Odes, Pythian Odes*, vol. 1, pp. 28–9, and p. 115, lines 86–7.

[74] *Craft of Zeus*, pp. 21, 117, and 119, and 113, respectively.

[75] *Ibid.*, p. 141–55.

WOVEN WORDS

As I have argued elsewhere, examples that seem to evoke "wordweaving" appear with some frequency in the works of Latin authors.[76] For example, in the letters of Cicero, he writes of his prose style, *epistulas vero quotidianis verbis texere solemus*[77] "truly, we are accustomed to weave epistles from everyday words," in marked contrast to the Sophists of his day, who, according to Cicero, both *intexunt fabulas* "interweave stories" and incorporate elaborate wording into their writings.[78] Similar imagery appears in a roughly contemporary, pseudo-Virgilian work entitled *Ciris*, imagery which makes clear that its poet overtly exploits the double meanings inherent to *texere*. The invocation at the outset of *Ciris* includes the poet's praise for his or her patron and the poet's intent: not to craft simple verses, *sed magno intexens ... peplo*[79] "but interweaving a great robe" to compose a great narrative in praise of "Messalla." The poet compares the composition of his or her narrative poem to the weaving of another set of narratives, the mythic stories woven by Athenian women into the great robes of state for Pallas Athena:

> ergo Palladiae texuntur in ordine pugnae,
> magna Giganteis ornantur pepla tropaeis,
> horrida sanguine pinguntur proelia cocco.[80]

> In such a way the battles of Pallas are woven in a series,
> the great robes are ornamented with the trophies of the Giants,
> savage combats are dyed in bloody scarlet.

The narrative threads are literal as well as figurative, in this instance. The poet further elaborates:

> Tale deae velum sollemni tempore portant;
> tali te vellem, iuvenum doctissime ...
> naturae rerum magnis intexere chartis;
> aeternum ut sophiae coniunctum carmine nomen
> nostra tuum senibus loqueretur pagina saeclis.[81]

[76] "Aldhelm and Word-Weaving as Metaphor," pp. 121–38.

[77] "Epistulae ad familiares: ad M. Varronem et ceteros," in Cicero, *Cicero: The Letters to His Friends*, trans. and ed. W. Glynn Williams, Loeb Classical Library, 26 (3 vols, Harvard University Press, 1965), vol. 2, p. 262. The translation is mine.

[78] "Orator," in Cicero, *Cicero: Brutus; Orator*, trans. and ed. G. L. Hendrickson and H. M. Hubbell (respectively), Loeb Classical Library, 342 (Harvard University Press, 1971), p. 352. The translation is mine.

[79] *Ciris*, in *Virgil: Aeneid VII–XII, The Minor Poems*, ed. and trans. H. Rushton Fairclough, Loeb Classical Library, 64 (Harvard University Press, 1928), lines 21 and 54. The translation of this text throughout is mine.

[80] *Ibid.*, lines 29–31.

[81] *Ibid.*, lines 35–41.

> Such a cloth for the goddess they carry at the appointed time; such for
> you would I, most well-instructed youth … weave great pages of the
> things of nature; eternity and wisdom joined together in song, your
> name by our page would be spoken among generations in later ages.

The graceful pairing of woven narratives in cloth and in verse is a clear play on *texere*, both to write and to weave narratives that will bring fame to the poet's admired patron through the ages.

Later works from the period also use the image of "wordweaving." In Statius's *Thebaid* (first century AD), Hypsipyle of Lemnos narrates the tragic tale of her people, musing *quid longa malis exordia necto* "why do I construct such a long beginning for evil things," or alternately translated, "why do I interweave such a long warp for evil things," before finally confessing her identity to her listeners (5.36).[82] It is intriguing that, in this instance, such double meaning comes in the form of a woman telling her story, someone who, in Greek and Roman societies, as in early medieval English society, would have been characteristically connected to weaving and thus more likely to use its terminology metaphorically. It is also interesting that a metaphor involving "wordweaving" appears in the combination of *nectere*, which does not always mean "to weave," with *exordia*; even in the absence of *texere*, the construction of a narrative text is connected subtly with "wordweaving."

LATE LATIN "WORDWEAVING"

Subsequent writers in the fourth and fifth century, perhaps influenced by Cicero and Statius and their peers, also use the metaphor inherent in *texere* and related forms. In his commentary on the book of Kings, Jerome, for example, explains that some of the Psalms are *eiusdem numeri texuntur* "woven/composed with the same number" of the letters of the Hebrew alphabet, referring to the acrostics of Psalms 37, 111, 112, 119, and 145.[83] As in earlier Latin examples, for Jerome, *texere* represents the process of linguistic composition, particularly the bringing together of words in elaborate ways, such as the blending of poetry and prose, or acrostics in verse. Aldhelm was clearly influenced by Jerome's statement, which, as referenced earlier in this chapter, he quoted. Augustine of Hippo uses *texere* similarly. In describing the works of Homer, for example, he states that *Homerus peritus texere tales fabellas et dulcissime vanus est* "Homer is skilled at weaving/composing such idle tales, and is empty in the sweetest way."[84] Their contemporary Prudentius uses parallel language in telling the story of the martyr Lawrence, as he

[82] As indicated in Chapter 4 of this volume (note 6), references to Statius are drawn from *Thebaid, Books 1–7* and *Thebaid, Books 8–12, Achilleid*. Translations are mine, and references include book and line numbers.

[83] Jerome, *S. Eusebii Hieronymi*, Migne, col. 597.

[84] Augustine, *St. Augustine's Confessions*, ed. G. P. Goold, trans. William Watts, Loeb Classical Library, 26 (Harvard University Press, 1977), p. 42. The translation here is mine.

wonders *quo passionem carmine / digne retexens concinam?*[85] "how, in weaving a worthy song/poem, shall I sing [his] passion?" Although none of these authors uses *texere* and related terms in ways that determine that he was definitely aware that he was alluding to textile imagery of weaving, as is clearly the case in *Ciris*, the meaning of *texere* "to weave" was well-known in their day, and all use the term to discuss the process of composition. They could have chosen *componere* "to compose" or *compositio* "composition" to describe writing, but chose *texere* (and perhaps its rhetorical "cachet" of "weaving the word"), instead.[86]

The examples discussed thus far are not particularly unique: *texere* as "weaving/composing of words" is found widely in early Latin literature in a high number of collocations, including *carmen + texere, carmen + contexere, carmen + nectere, cantus + texere, cantus + contexere, litteras + texere,* and *litteras + contexere*. There are dozens of examples,[87] many from authors whose works are well-known to have had considerable influence on the later Latin literary traditions of the early Middle Ages, such as Cicero, Donatus, Statius, Augustine, Ambrose, Jerome, and Paulinus of Nola. Thus, Augustine compares the passage of time to the passage of stanzas and metrical feet, stating, *longum carmen est, nam tot uersibus contexitur*[88] "A poem is long, for with so many verses it is composed/woven." Also speaking of the poetic process, Paulinus of Nola reflects on what he should say about his patron saint, St Felix of Nola, *unde igitur faciam texendi carminis orsum?* "Where, then, shall I begin the weaving/composing of my song?"[89]

EARLY MEDIEVAL LATIN "WORDWEAVING"

The influence of these early metaphors on the subsequent Latin literature of the early Middle Ages is also easily demonstrated. The metaphor appears a century later, for example, in the influential writings of Venantius Fortunatus, an Italian writing in Merovingian Gaul in the sixth century. In an elegy mourning the death "De Gelesuintha," Fortunatus

[85] "Crowns of Martyrdom" in Prudentius, *Prudentius*, vol. 2, p. 110, lines 35–6. Translation is mine.

[86] Isidore, for example, does not use *texere* when discussing composition, preferring *componere* throughout his discussions of poetics, poetry, or poets in the *Etymologiae*. See book 1, sections 39 and 40, and book 8, section 7, most particularly.

[87] Even by fairly conservative interpretive estimates, this number includes two classical examples (one each) for *cantus + texere* and *cantus + contexere*, with the bulk of the examples appearing for *carmen + texere* (20+), *carmen + contexere* (4), *carmen + nectere* (5), *litteras + texere* (4), *litteras + contexere* (3), and *litteras + nectere* (2) (*LLTO*). There are no instances of collocations of any of these types that include *detexere* or other close *texere* ("to weave") variants.

[88] *LLTO: Confessionem libri tredecim* (CPL 0251), book 11, chapter 26, line 9. Translation is mine.

[89] *LLTO: Carmina* (CPL 0203), carmen 21, verse 47. Translation: Paulinus, *The Poems of St Paulinus of Nola*, ed. and trans. P. G. Walsh, Ancient Christian Writers, 40 (Newman Press, 1975), p. 174.

laments, *quis valet ordiri tanti praesagia luctus? / stamine quo coepit texere flenda dolor*[90] "Who can begin weaving the web/composing of the presages of such great grief? With what thread can sorrow begin to weave what is to be mourned?"[91] As in *Ciris*, the lines appear to hinge directly upon the double meanings of *texere*. Who can bear to watch as the threads are laid out (*ordiri*), the warp (*stamine*) ready to weave (*texere*), when the woven product narrates the death of a beloved person? Who can bear to lay the narrative thread to compose such a poem?[92] Fortunatus appears well aware of the play on meanings of *texere* and *ordior* (indeed, his passage is difficult to translate any other way), and he links that play to poetics. What is suggestive in "De Gelesuintha" becomes more overt in another elegy, for "Eusebia," where Fortunatus, like Statius, compares the weaving of women and the poetry of poets, *docta tenens calamos, apices quoque figere filo, / quod tibi charta valet hoc sibi tela fuit*[93] "Skilled at holding a shuttle, and also at marking out the patterns in thread, a web was to her what a sheet of paper is to you."[94] Similar paired meaning seems inherent to a description of how a poet works in his verses "Ad clerum Parisiacum," *stamina psalterii lyrico modulamine texens / versibus orditum Carmen amore trahit*[95] "composing/weaving the threads/warp of the psalter with lyric melody / with love he draws a song undertaken (laid down/warped, from *ordior*) with verses."[96]

Such collocations, which appear with significant frequency in earlier Latin texts, continue to appear in Latin texts from the early and later Middle Ages, but in smaller numbers and what seem to be clusters. One cluster belongs entirely to Venantius Fortunatus, with at least four uses of *carmen* + *texere* (interpreting conservatively) and one of *litteras* + *texere*,[97] in addition to the passages quoted above. He clearly had a predilection for textile imagery in his writing, particularly for "wordweaving." A second cluster, as discussed earlier in this chapter, is dominated by Anglo-Latin author Aldhelm and anyone influenced by him, including the circle of Boniface. A final possible cluster appears in the works of six authors writing in the first and second half of the ninth century: Walafrid Strabo, Wandelbert of Prum, the anonymous author of the *Vita metrica beati Leudegarii*, and Sedulius Scottus (*carmen* + *texere*); John Scottus (*litteras* + *contexere*); and Remigius

90 Venantius Fortunatus, *Venanti Honori Clementiani Fortunati, Presbyteri Italici: Opera Poetica*, ed. Friedrich Leo, MGH, Auctorum Antiquissimorum, 4 (Weidmann, 1881), p. 137, lines 21–2.

91 Translation: Venantius Fortunatus, *Venantius Fortunatus: Personal and Political Poems*, trans. Judith George (Liverpool University Press, 1995), p. 41.

92 That the poem's "wordweaving" commemorates the death of a woman is compelling, since, as stated previously, the link between women and weaving would have been operative for Fortunatus, as it was for his predecessors.

93 *Venanti Honori*, p. 100, lines 9–10.

94 *Venantius Fortunatus*, p. 15.

95 *Venanti Honori*, p. 39, lines 53–4.

96 The translation here is mine.

97 All evidence drawn from passages excerpted in searches in *LLTO* for each collocation.

of Auxerre (*litteras + nectere*).[98] Although the collocations among the third group are slightly different, the imagery is largely the same, an interesting coincidence that parallels perhaps more weighty coincidences. All six purported authors were associated with the Carolingian court at one point or another, five of the six with the palace school. The first three authors were probably contemporaries, and two of the three later authors were, as well. Two of the latter were Irish, both with reputations for classical learning. Indeed, all five of the named authors were renowned for the depth of their learning in Latin literature. For his part, Remigius, the latest of the authors, is well-known for having borrowed extensively from his scholarly grandfather (teacher of his teacher) John Scottus, as well as Sedulius Scottus.[99]

A final, potentially important coincidence is the interrelationships between all six authors and the early medieval English scholarly community, both on the Continent and in England: all six are known to have been influenced by early medieval English writers. The anonymous author borrowed from Aldhelm and Boniface;[100] one of Walafrid's most influential teachers had been taught by Alcuin;[101] Walafrid and Sedulius Scottus both borrowed lines from Alcuin;[102] Wandelbert and Remigius both wrote on Bede; and John Scottus was influenced by him.[103] In turn, a number of the works of these Carolingian writers were found in early medieval English manuscript collections in later centuries, including Sedulius Scottus and Remigius,[104] and John Scottus.[105] The potential lines of influence are interesting. Aldhelm and the circle of Boniface could have and probably did influence the Carolingian authors in their use of "wordweaving" imagery, though the

[98] Listed in *LLTO* as follows: for Sedulius Scottus: Carmen 1 of *Carmina Sedulii Scotti*; for John Scottus: *Excerpta Macrobii* (available at https://archive.org/stream/grammaticilatino2hagagoog#page/n625/mode/1up, authorship disputed); and for Remigius: Epistula 3 of *Epistulae III Remigio Autissiodorensi attributae* (authorship disputed).

[99] John Marenbon, *From the Circle of Alcuin to the School of Auxerre: Logic, Theology, and Philosophy in the Early Middle Ages* (Cambridge University Press, 1981), p. 10.

[100] See the notes, for example, for *Vita metrica beati Leudegarii*, in MGH, Poetae Latini aevi Carolini, 3 (Weidmann, 1896), pp. 5–6: within the first two pages, there are several parallels to Aldhelm's works and one parallel to Alcuin's noted.

[101] Eleanor Shipley Duckett, *Carolingian Portraits: A Study in the Ninth Century* (University of Michigan Press, 1963), pp. 121–60.

[102] Andy Orchard, "Wish You Were Here: Alcuin's Courtly Poetry and the Boys Back Home," in Sarah Rees Jones, Richard Marks, and Alastair J. Minnis (eds), *Courts and Regions in Medieval Europe* (York Medieval Press, 2000), pp. 21–43, at p. 27.

[103] For an overview of the scholarship for this contention, see John J. Contreni, "John Scottus and Bede," in Michael Dunne and J. J. McEvoy (eds), *History and Eschatology in John Scottus Eriugena and His Time: Proceedings of the Tenth International Conference of the Society for the Promotion of Eriugenian Studies, Maynooth and Dublin, August 16–20, 2000* (Leuven University Press, 2002), pp. 91–140.

[104] Lapidge, *The Anglo-Saxon Library*, pp. 143 and 134, respectively.

[105] Barbara C. Raw, *Trinity and Incarnation in Anglo-Saxon Art and Thought* (Cambridge University Press, 1997), p. 96.

latter could have learned the expressions from the same classical and patristic sources. Later writers in early medieval England could have had the same types of possibilities open to them: to draw from classical, patristic, early Anglo-Latin, and/or Carolingian sources for metaphors for the "weaving of words." Thus, when Sedulius Scottus commands, *texito carmen* "You will weave/compose [future imperative] a poem," the overlapping communities that may have influenced him and which in turn he may have influenced are complex, indeed.

The same range of possibilities is open for Cynewulf and his early medieval English predecessors and successors; "wordweaving" is an idea with a very robust genealogy in the larger textual Latin culture Cynewulf and his fellows inherited. References to works by Cicero, for example, can be found in early medieval English manuscripts,[106] and Alcuin quotes from the rhetorical work of Cicero at length, if often through an intermediary source.[107] At the same time, Michael Lapidge argues that "polite discussions by Roman gentlemen of political, moral, and literary matters" are "unrepresented" in early medieval English libraries, and he includes in the number the dialogues of Cicero from which "wordweaving" examples can be drawn.[108] Andy Orchard likewise lists *Culex* among the Virgiliana that the ultimate Anglo-Latin poet Aldhelm cites, but not *Ciris*.[109] The works of Statius, on the other hand, are cited in Aldhelm, Bede, and Alcuin, among others,[110] and although *texere* as "wordweaving" does not occur in the works of Statius, *nectere* "wordweaving" does. Later Latin writers such as Jerome, Augustine, Prudentius, and Paulinus of Nola, who use *texere* in ways suggestive of "wordweaving," are well-known for their extensive influence on early medieval English authors throughout the period.[111] They were also influenced by the works of Venantius Fortunatus, the most conscious user of the metaphor "wordweaver" of all the early medieval Latin sources.[112] It is thus entirely likely and in fact demonstrable that the early medieval English knew the metaphor of "weaving words" in classical, patristic, and/or early medieval Latin sources. However,

[106] Ogilvy, *Books*, p. 112.

[107] See source notations for Alcuin's *Disputatio de Rhetorica et de Virtutibus Sapientissimi Regis Karli et Albini Magistri*, in *The Rhetoric of Alcuin and Charlemagne*, Howell, pp. 66–155. Howell estimates a full 80 percent of the treatise is taken from quotations and paraphrases of Cicero's *De Inventione*, in some cases directly, and in others, through the medium of the quotations and paraphrases of Cicero by fourth-century rhetorician Julius Victor in his *Ars Rhetorica* (p. 25).

[108] Lapidge, *Anglo-Saxon Library*, pp. 128–9.

[109] *The Poetic Art of Aldhelm* (Cambridge University Press, 1994), p. 219.

[110] Lapidge, *Anglo-Saxon Library*, p. 333. Dunstan also quotes Statius; see note 194 in Chapter 4 of this volume.

[111] The influence of the writings of both Jerome and Augustine on Aldhelm, Bede, and the early medieval English in general is a well-known fact. Andy Orchard similarly identifies the influence of Prudentius in the work of Aldhelm (*Poetic Art of Aldhelm*, pp. 172–8).

[112] Orchard, *Poetic Art of Aldhelm*, pp. 191–5.

as Joyce Hill has long argued,[113] and as Aldhelm, Boniface, Alcuin, and the Carolingian authors demonstrate, potential intermediary sources should never be discounted. Anglo-Latin authors are just as likely as earlier authors to have influenced one another or Cynewulf in his evocative Old English "wordweaving." "Wordweaving" clearly had a long pedigree, with many points of potential influence for later writers.

ADDITIONAL REGIONAL EVIDENCE

In discussing the etymology of "text" as both "text" and "textile," Scheid and Svenbro comment that the history of the word "could quickly grow to immense proportions given that other Indo-European languages besides Greek and Latin used similar ones."[114] The linguistic metaphor is attested in Vedic sources, as well as classical Latin.[115] Moreover, the *Beowulf* passage earlier cited describes the oral-formulaic tradition of the northern European peoples, which suggests that the poetic language associated with "wordweaving" images there was thought to apply to the native traditions of the northern European peoples. Had they developed the metaphorical connection independently as textile-producing cultures or found the metaphor resonant for the same reason, if it was drawn from the influence of an early Latin tradition among their neighbors?

The multiplicity of possibilities is evident in the much later work, the *Poetic Edda*, which describes oral eloquence, "Speech-runes you must know if you want no one to repay sorrow with enmity; wind them about, weave them about, set them all together at that meeting where people must go to fully constituted courts."[116] The image may be inspired by Latin sources, or it may be a native tradition related to the magic of written runes, weaving, and binding. Similarly, the *Gesta Danorum* of Saxo Grammaticus, written in Latin, but claimed to be based on early Danish sources, uses a number of metaphors of "wordweaving" that may come from either Roman or native tradition, or be a hybrid of both: when Balder (the Norse god) argues his suit, human Nanna is so clever that *Hac responsi cauillacione elusis Balderi precibus, detrectandi coniugii prudens argumenta texebat*[117] "[she] wove arguments for declining Balder's proposal and so dodged his entreaties."[118] Amleth, king of the Danes (source of Shakespeare's Hamlet), delivers a similarly eloquent speech to his people to assuage their anger over his murder of his uncle/

[113] Most recently, in "Weaving and Interweaving: The Textual Traditions of Two of Ælfric's Supplementary Homilies," in Hyer and Frederick, *Textiles, Text, Intertext*, pp. 211–23.

[114] Scheid and Svenbro, *Craft of Zeus*, p. 111. They point out that the etymology occurs in non-Indo-European languages, as well (see pp. 204–5, n. 1).

[115] H. Moisl, "Celto-Germanic *W_tu- W_tu- and Early Germanic Poetry," *Notes and Queries*, 225 (1980), 98–9, at p. 98. The article documents efforts of scholars to link a proposed Indo-European word group which explains similarities between Celtic and Germanic words and further connects prophecy, song, and weaving etymologically.

[116] *Poetic Edda*, Larrington, p. 168.

[117] *Saxonis Grammatici*, Holder, vol. 3, p. 73, lines 15–16.

[118] *Saxo Grammaticus*, Davidson and Fisher, vol. 1, p. 72. Translations here will be Peter Fisher's.

stepfather and a castle full of nobles, listing his motives for revenge until he no longer wishes to *retexam miserias*[119] "weave my miseries anew."[120] Later in the Danes' history, upon believing no royal heir remains to claim the throne, they award it to Hiarni, "a bard expert in Danish poetry," upon which the narrator comments, *Ita ab eis epitaphium regno repensum imperiique pondus paucarum literarum contextui donatum est*[121] "So an epitaph was reimbursed with a kingdom and the weight of an empire granted for the weaving together of a few letters."[122] After the rightful heir, Fridlef, returns and later seeks a bride, he finds himself in the path of a giant, whom Fridlef defeats and despoils of a great treasure; in triumph *hoc alacri carmen uoce subtexuit*[123] "in a lively voice [he] wove this song,"[124] replete with victorious poetic lyrics.

Since Saxo Grammaticus composed the history in Latin, and he likely received an education which included the works of Cicero and other early Latin writers, he may have adopted the "wordweaving" metaphor from them.[125] On the other hand, the author of the *Gesta Danorum* insists that his history is Danish, and his attitude towards his people's history attests his pride in that association. Much of his source material in the *Gesta Danorum* is clearly native in origin (much of it pre-Christian), and the values of the heroic code common to Germanic and Scandinavian works more generally are manifest in the stories which Saxo Grammaticus includes in his narrative. Hilda Ellis Davidson states that in his work Saxo displays a "wide knowledge and enjoyment of northern literature and of the oral culture of his time,"[126] with the tone and tenor of his work epic heroic or skaldic in nature, and that style does not match the styles of the Latin "wordweaving" contexts: these range from the polite rhetorical examples of Cicero to the patristic discussions of scriptural style and the hagiographical and elegiac references in Prudentius and Venantius Fortunatus.[127] Only the oblique *nectere* reference in the *Thebaid* bears any resemblance to Saxo's context, and the metaphor there is spoken from the perspective of a murdering female character. If Saxo adapts from a Latin version of the metaphor, it is a syncretic hybridization, indeed.

It may also be relevant that all four instances of "wordweaving" in his work refer to a gift for oral eloquence, the last two clearly referring to an oral poetic eloquence which is characteristic of the oral-formulaic poetry of the northern European peoples. Hiarni himself is identified as an expert in Danish poetry. It may thus be a significant

[119] *Saxonis Grammatici*, Holder, vol. 3, p. 98, line 38.

[120] *Saxo Grammaticus*, Davidson and Fisher, vol. 1, p. 95.

[121] *Saxonis Grammatici*, Holder, vol. 6, p. 172, lines 21–2.

[122] *Saxo Grammaticus*, Davidson and Fisher, vol. 1, p. 162.

[123] *Saxonis Grammatici*, Holder, vol. 6, p. 179, line 12.

[124] *Saxo Grammaticus*, Davidson and Fisher, vol. 1, p. 167.

[125] *Ibid.*, vol. 2, p. 6.

[126] *Ibid.*, vol. 2, p. 7.

[127] Perhaps significantly, "wordweaving" *texere* is not used in the *Aeneid* or any other Roman epic context.

coincidence that in *Beowulf* the same kind of oral poetic eloquence of its Danish poet is what is described in what seem to be textile terms. In spite of its late date, the word- and song-weaving of the *Gesta Danorum* may reflect a northern European poetic textile tradition (or a northern predilection for poetic textile imagery), of which Cynewulf and the *Beowulf* poet may (or may not) also form a part.

CONCLUSIONS

Cynewulf had resonant and powerful influences that might have inspired him to employ the "wordweaving" metaphor for poetic composition in Old English. Most obviously, it is certain that he knew the works of at least some of the early Latin writers, Aldhelm, and probably at least Alcuin and Tatwine, and it is very difficult to imagine that he was not influenced by them. The contexts in the case of Cynewulf's "wordweaving" also match these types of influences precisely: the "wordweaving" of Cicero, *Ciris*, the patristic authors, and later Latin writers implies, in a general sense, the rhetorical fashioning of words in a literary context (elaborately, in the case of the Psalms); so does the "wordweaving" of Cynewulf. The Anglo-Latin "wordweaving" of Aldhelm and Tatwine and their successors seems to imply something even more specific: the rhetorical fashioning of words in complex ways, from acrostics and metrical pyrotechnics to complex syntax and elaborate vocabulary. Cynewulf's self-identified "wordweaving" includes complicated and complex patterns of alliteration, meter, syntax, and vocabulary, with internal rhyme and even an acrostic as a flourishing finish.

At the same time, it is reasonable to assume that some native traditions beyond Anglo-Latin texts probably influenced Cynewulf's choice of "wordweaving" as a compositional metaphor, as well. It cannot be ruled out that references to "woven" songs and runes would have had a place in the native tradition of the *scops*. That native tradition was distinct and existed in its own right, separate from, even if related to, Latin poetics. Closely parallel heroic poetic traditions, in theme and style, appear among the northern European relatives of the early medieval English peoples, century after century. The native tradition of Old English poetry is at its core highly complex and capable of expressing elaborate vernacular riddles and acrostics, metrical and syntactical complexities, and a distinct and elaborate poetic vocabulary that employed original kennings and compounds, poetic formulae, and thousands of evocative visual and alliterative lines. Its narrative passages blend and interweave elaborate threads and meaningful themes. The skill required to create it is aptly described as "wordweaving." If it were not, Cynewulf would hardly have seen a correlation and used or translated the metaphor to describe his compositional style for poetry he chose to create in Old English.

Cynewulf's own poem *Elene* may provide the best answer as we weigh the tensions among different poetic traditions available to him. In his final section of the poem in which he discusses "wordweaving," the passage with which this chapter began, he includes traditional Old English meter, alliteration, and poetic words and formulae. He uses a compounded kenning, "wordweaving," a metaphor that would probably remind his audiences of multiple and influential parallels in Latin and Anglo-Latin texts. He

includes rhyme, a technique not characteristic of Old English poetic tradition, but also not characteristic of classical Latin literature. Rhyme is instead characteristic of early medieval Latin poetry. Cynewulf then closes with an acrostic riddle written in runes scattered within the text. Acrostics are prized in the Latin tradition; Aldhelm excelled at using them, drawing inspiration in part from the Latin acrostics of Jerome. Riddles also have a long and deep tradition, both in northern European culture and in medieval Latin culture. This acrostic riddle is written in a northern European runic script. Cynewulf's ending for his poem seems, then, profoundly syncretic.[128]

Whatever our conclusions about his sources of inspiration for the metaphor of "word-weaving," it does seem quite significant that Cynewulf himself does not distinguish between or separate the traditions, as we often do, that inspire his "word skills." Perhaps he considered all his poetic techniques, those born from Old English poetic conventions and those potentially born from Anglo-Latin (and older Latin) traditions, elements of his own style. Perhaps he was right. All of the poetics at his command, both Old English and Latin, could be considered inherited or native early medieval English traditions subsequent to the pioneering pyrotechnics of Aldhelm; Cynewulf may not have seen the need for such a separation of influences, or have perceived a separation, as we do.

In his discussion of Cynewulf's poems in the Exeter Book, John D. Niles makes similar observations, arguing that Cynewulf and his peers created a "hybrid poetics, based on Latinate and Germanic models yet striving to achieve expansive new forms of expression in the medium of Old English alliterative verse."[129] Such a set of hybrid threads would be difficult indeed to separate, as Michael Lapidge notes:

> We should always remember that works in Latin and the vernacular were copied together in Anglo-Saxon scriptoria, and were arguably composed together in Anglo-Saxon schools. What is needed, therefore, is an integrated literary history which treats Latin and vernacular productions together as two facets of the one culture, not as isolated phenomena.[130]

Such an understanding of Cynewulf's own poetics and his perception of them may explain precisely what we see in his use of textile metaphors across his poetic works: he appropriates an Old English peaceweaver metaphor more characteristic of the realm of women to the realm of the Latin angels; he borrows the Latin metaphor of wordweaving

[128] These findings agree squarely with Andy Orchard's as he argues that Cynewulf's work in general is a blend of Latinate and Old English methods of composition, with elements characteristic of Anglo-Latin verse – rhyme and acrostics – alongside elements found within the Old English poetic tradition – alliterative lines, predominantly Old English metrical patterns, semantic variation, common poetic formulae, and standard Old English poetic imagery (Orchard, "Both Style and Substance," p. 272).

[129] *God's Exiles*, p. 5.

[130] "Schools, Learning and Literature in Tenth-Century England," *Il secolo di ferro: mito e realtà del secolo X*, Settimane de studio del centro italiano di studi sull'alto medioevo, 38 (Spoleto, 1990), pp. 951–98; reprinted in Lapidge's *Anglo-Latin Literature 900–1066* (Hambledon, 1993), pp. 1–48, at p. 2, n. 1. I am indebted to John Niles for this reference (*God's Exiles*, p. 49, n. 24).

into his description of his Old English poetics. What did Cynewulf mean by "wordweaving" in Old English? He was a skillful and intelligent reader of his sources, Latin and Old English, and an extraordinarily gifted Old English poet. He probably saw his efforts as one whole.

As we weigh the force of Old English and Anglo-Latin poetics, the possibilities of the "word" in "wordweaving," we do well, as always, to remember the "weaving," the second half of the compound and metaphor. Whether we are looking at an Old English or Anglo-Latin or Latin set of influences, or more likely, a shifting and hybrid poetic ethos, the metaphor of "wordweaving" is not a solitary, evocative textile metaphor in the early medieval English tradition. It is, in fact, one of a significant and wide-ranging body of textile metaphors in the pre-Conquest English tradition, as this volume demonstrates. Cynewulf, like the other poets of early medieval England, lived in a culture with a famous and prominent tradition of textile work. Spinning, weaving, sewing, and embroidery were part of the daily world of his people. Otherwise, "wordweaving" (and the other weaving metaphors discussed in this volume) would hardly have been intelligible, let alone resonant. It is clear that he saw "wordweaving" as both.

A final observation remains that may relate to or grow out of the material culture of textiles and those who dominated it, for each of the textual traditions discussed in this chapter. A significant number of the "wordweaving" examples in the Old English, Anglo-Latin, and Latin traditions are associated with women.[131] Cynewulf's poem centers on Elene. Aldhelm uses "wordweaving" twice (of the four times he uses it at all) in a work written for the edification of holy women, the prose *De Virginitate*. About half of the later Anglo-Latin works in which "wordweaving" later appears have no clear relation to women, including the works of Tatwine, Felix, Willibald, and William of Malmesbury. The remaining Anglo-Latin and Old English texts, however, all do: Hygeburg is author to one and a woman; Goscelin (or a compatriot) writes either for or about women in all three texts attributed to him in which "wordweaving" appears. Although such associations are not correlated with the earlier Latin version of the metaphor in Cicero or the patristic authors, there is a strong correlation in the pseudo-Virgilian *Ciris* between "wordweaving" and Pallas Athena. Venantius Fortunatus's use of the metaphor occurs two out of three times in elegies written on the deaths of women and one of two times in a *vita* written about a female saint. The correlation may be a coincidence, but it is a striking one, given the high correlation between female gender and the wider array of literary textile metaphors more generally. Perhaps it is fitting that Cynewulf "wordweaves," then, in an Old English poem about the great *ides* and queen, Elene.

[131] Discussed in Hyer, "Aldhelm and Word-Weaving as Metaphor," pp. 137–8, as well as here.

Conclusion

Forcorfen is swylce fram wefendum wife lif min þa gyt þe ic wæs gehefaldad

My life is cut off, just as by a weaving woman;
while yet I was being warped/beginning[1]

Among the widespread finds of spindle whorls in bone, clay, lead, and other prosaic materials in early medieval English graves are crystal spindle whorls. They are a footnote to history, often mentioned only because of the possibility that they might represent amuletic objects because of their unique nature. In many respects, they are like the "textile" half of the early medieval English textile metaphors: noted in passing, but rarely understood or considered in any depth. When crystal whorls are spun, however, a different story and set of possibilities emerge. When spun, the "faceted crystals would give a very pretty display of rainbow lights, adding interest to what must have often been a very tedious task."[2] The spinning, rainbow lights must have made the daily task of spinning seem magical, and certainly poetic. The interest such spinning created may also have served very practical functions, stimulating the young or the old to spin more thread, and promising the very young distraction and entertainment whenever the spinner was allowed to work uninterrupted at her task. Such whorls may have sparked the envy of others or increased the respect accorded their owners. For any of these reasons, or perhaps others, crystal spindle whorls became so treasured as personal possessions that they accompanied their owners to the grave, identifying them, at the very least, as women, forever after.

An understanding of the practical realities of the material culture of textiles, as Chapter 1 demonstrates, opens our eyes to these possibilities and meanings in the textile metaphors that belonged to those who used the spindle whorls and warp-weighted looms, the early medieval English peoples. As with the flashing whorls, when we consider the material conditions surrounding textiles, it is hardly surprising how widespread and evocative textile metaphors are in Old English and Anglo-Latin texts. Preparing fibers, spinning and weaving, cleaning and dyeing, finishing, and embroidering and tablet-weaving fabrics provided nearly all of the color and most of the warmth the early medieval English

[1] *Der Lambeth-Psalter*, gloss of Latin Vulgate, Isaiah 38:9, at 1.236.

[2] Meaney, *Anglo-Saxon Amulets*, p. 78.

CONCLUSION 211

knew beyond their natural surroundings. Textiles were the colorful hangings on the wall which commemorated treasured deeds. They were the softly glowing vestments that inspired awe and reflection in the faithful at each visit to church. They were the pillows, the warm cloaks, and the shirts on their backs. The early medieval English were proud of their reputation for beautiful textile work: they were famous for, identified by, and made wealthier through precisely that textile work. One need only examine the beautiful, extant, early medieval English textiles or imagine the textiles behind Aldhelm's embroidered metaphors to understand that pride and to begin to see what associations might have rendered textiles and their production such a fruitful source of metaphorical meaning for early medieval English authors.

The work of producing textiles was linked powerfully and metaphorically with those who were most frequently involved in the process: women. Textiles defined their makers in turn, as women across the early medieval English period were identified as the *spinlhealfe* in their families and were expected to take on a role as textile producer, many of them as a *wif* expected *wefan* "to weave." It is natural to wonder if assigned roles became assigned perspectives. When Penelope seeks to rid herself of her problems in the *Odyssey*, she has very few resources on which she can draw. What finally remains to her is her prescribed role as a weaver, and this is how she copes with her problem: she weaves and unweaves Laertes's shroud to buy herself time to avoid remarriage. But Penelope is also depicted as *thinking* as a weaver. When asked about her stratagem, she states, "I weave my own wiles" (19.137–56).[3] Her weaving is her strategy, but it is also her chosen perspective. The ancient Greek poet extends her actions as a domestic weaver to her thoughts and actions of subterfuge.

Such transference may explain the metaphorical identities assigned to or assumed by female characters in Old English and Anglo-Latin texts. We underestimate today just how powerful and long-standing the connection was that existed between spinning, weaving, and other textile work and women in the ancient world, including early medieval English women. It stretched hundreds, and perhaps thousands of years, reinforced by similar identifications in all cultures within or adjacent to the northern European world (including Penelope's). When we consider the strength of that connection, it is suddenly less surprising, but far more significant that culturally idealized women such as Mary are touted as excellent weavers, alongside their other sterling qualities. At the early end of the period, Aldhelm assumes (in complimentary fashion) that his virtuous female audience is likewise comprised of skillful embroiderers. At the latter end of the period, the work written to praise and please Edith gives extended descriptions of her personal skill in making the stunning, gold-adorned robes worn by the king. "Good women" spin, weave, and work cloth in the early medieval English world, and indeed, are known for it. These associations also shift what we understand in Chapter 2, when Thryth is criticized for behaving in what is apparently an inappropriate fashion, what the *Beowulf* narrator states is behavior not fitting of a *freoðuwebbe*, a "peaceweaver" (1942a). She is *not* weaving peace. She is, instead, creating *wælbende* "slaughter bonds" (1936a), bonds made by hand, reminiscent of the

3 Homer, *Odyssey*, trans. Richmond Lattimore.

interwoven wiles of the cursed Mermedonians of *Andreas* of Chapter 3. Her contrasting foil Hygd and her powerful counterpart *friðusibb* "peace-pledge" Wealhtheow are praised for opposite behavior, for creating the bonds of social unity and defending the interests of their people, like the angel (who may have stolen his robe and his epithet, like others before him), Ealhhild, Alcuin, and perhaps even Esther. Thryth is able to change, but such a possibility is not accorded to Grendel's Mother, the hag-mother who is remembered for her destructive choices, rather than the constructive, communal work for which peace-weavers Hygd, Ealhhild, and perhaps also Mary are known.

Grendel's Mother and others who stand in active opposition to those who might be identified as peaceweavers are part of a group, examined in Chapter 3, who are viewed with clear ambivalence among the early medieval English: those who invoke magical or magico-medical power to exert control over others, often in concert with textile and binding imagery. There are those who appear to be healers in this group, users of practical tools and textiles such as spindle whorls, cloth, and thread, which alongside herbs, appear to form part of the range of healing remedies available to the early medieval English. Other threads and their users, however, bring men and women to physical harm through curses, nets, bonds, and knots, and to spiritual harm through invocations of demonic forces. Although both categories – healing and harming – might be justly called "magical," the first is clearly but ambivalently considered generative and helpful to society (particularly when accompanied by prayer), while the second is considered destructive, from lover's knot to elfshot and deadly spell-binding. What is also compelling about this divide is how frequently women figure across it, from the woman who gives away her sadness over her lost child with a black cloth, to the woman who makes a love charm. That women might be associated with magico-medical healing would be unsurprising in many respects; women are often first responders and caretakers within the domestic environments of many cultures. Women in early medieval English culture would also be those who made the cloths and worked the threads, and perhaps those who grew and gathered herbs, as well. The penitentials and homiletic texts, however, also place consistent emphasis on berating women for superstitious magical practices. It is unclear whether such criticism was couched in institutionalized misogyny, based on discrediting "wise women" who might compete with male religious leaders for societal respect and attention, or whether it existed for other reasons, such as women clinging to long-held traditions displeasing to their religious leaders. If the *wiccan 7 wælcyrian* similarly criticized in Wulfstan's homily represent even a sense of the "valkyries" as well as "witches" and "sorcerers," then the analogical evidence for magical connections between such women, magic, and weaving becomes tantalizing, particularly in the light of the significant number of villainized literary and historiographical individuals who are described as magic users, are often associated with weaving and binding, are often women, and are placed among the death-bringers who haunt the Old English and Anglo-Latin corpus and analogical traditions.

Chapter 4 sketches a similar divide between generative and destructive working of threads, although not always in oppositional ways. On one side of the divide are creation and water as weavers. Both are assigned feminine grammatical gender and personified

poetically in Old English riddles, neither appears as a weaver in Anglo-Latin texts considered the riddles' sources, and yet, both are personified as weavers when placed in an Old English context. They are envisioned as life-producing and productive, and both stand in marked contrast to destructive fate. Many of the literary traditions from which the early medieval English might have drawn inspiration assign some generative role to "f/Fate," in the sense of presence at birth. However, texts written by early medieval English writers themselves are by far less ambivalent. Anglo-Latin texts describe a poetic "f/Fate/s" borrowed from literary sources, but Old English texts, when *wyrd* does not mean "event," describe a "f/Fate" who is a powerful cosmic force synonymous with death. This "f/Fate" is grammatically feminine, occasionally listed in the plural, and often personified poetically. Whenever personified to any degree, *wyrd* is universally destructive and is several times linked to weaving.

In some ways, the apparent dichotomy between weaving forces of creation and a weaving fate associated with death differs from those assessed in Chapters 2 and 3. The "good" and the "bad" peaceweavers and death-bringers or -weavers are indeed placed in parallel oppositions in text, and acceptable practices of magical healing are placed in opposition to unacceptable practices, as well. In this context, however, the feminized cosmic agents are not necessarily placed in clear opposition to one another. Like the other possibly oppositional agents of Chapters 2 and 3, they share gender, and they share assignment to textile tasks, in this case weaving. Unlike the other agents, however, their opposition is circumstantial, though like the others, they may represent poles of generative and destructive (female) agency. What is particularly notable about these clusters of (possibly) related metaphors is how often the metaphors result in an opposition, and how strongly textile metaphors are associated with female gender, whether grammatical or biological. Such a correlation across the evidence does not appear coincidental. It far more likely demonstrates social realities and resulting cultural roles assigned for millennia among the early medieval English, their ancestors, and their neighbors.

Examination of this cluster of metaphors as a whole reveals one additional, significant pattern. Early medieval English writers demonstrate a powerful predilection for weaving metaphors over all other types of textile metaphor, and this preference may be genealogical or regional. In describing the role expected of generative peace-makers, the early medieval English authors thus call them peace*weavers*, a metaphor sufficiently common to appear in three of the four major poetic manuscripts from the period, with a related image in the Anglo-Latin correspondence of Alcuin. This metaphor, as far as my three decades of extensive research in parallel traditions can determine, is unique to the early medieval English people. When describing the opposite, they depict the making of wily or destructive stratagems as death-binding as often as wile-weaving, an association common to all of the traditions with which the early medieval English people were in contact. But when "weaving of death" appears in a biblical text, its Old English glossator uniquely makes the one who cuts off life "as a weaver" a "weaving woman." Death*weaving* explicitly connected to web and loom is itself by far most overt and dramatic in Germano-Scandinavian texts, particularly in the destructive magical arena of the valkyries and their devotees.

In contrast, Mediterranean traditions put greater emphasis on binding metaphors for both death-bringing and magical mischief-making. Such a divergence in the tradition of destructive magical textile metaphors may be related to differing preferences in the depiction of "f/Fate/s" in each of the cultures addressed. Across hundreds of textual references, the Mediterranean Fates spin, weaving in only a pair of late Latin cases. The Germanic and Scandinavian traditions are more ambivalent on this divide between spinning thread and weaving loom. But the early medieval English themselves are not. Other than oblique references to a "winding" *wyrd,* when personifying "f/Fate/s," they make her a weaver, without exception. Although there are related traditions for personifying creation and water as weavers, given the clear early medieval English predilection for weaving over spinning and binding in the majority of instances and the strong correlation between weaving and the female (grammatical or biological), it would hardly be surprising if they had personified cosmic creationary forces as weaving females without respect to outside influence.

Metaphorical spinning does appear in the early medieval English literary tradition, however, as we should expect it to. The introduction to this volume begins with Aldhelm's beautiful and evocative Anglo-Latin *colus* "spindle" riddle imagery, and the conclusion begins similarly, with an examination of an extant crystal spinning whorl from the early medieval English period, both for the same reason. Spinning was far more universal a textile task than weaving across the female population of early medieval England, and more spindle whorls have survived that help us understand the centrality and gender-normative nature of textile production in early medieval English contexts than any other metric. Weavers cannot exist without humble spinners. But spinning seems less high-status and appears less frequently among the poetic textile metaphors of early medieval England. Nonetheless, it does appear, and it is useful to examine those spinning metaphors in light of one another. King Alfred's will supplies the spinning metaphor in Chapter 1, as he identifies his maternal line as the *spinlhealfe* "spindle-side" compared to the "weapon" half. Just as *wif* "woman" and *wefan* "to weave" are linguistically related, so *spinlhealfe* represents a similar linguistic metaphor of identity, with spinning also equaling woman. Likewise, Chapter 2 highlights high-status and idealized women as those who weave, but Mary, the best of all weavers and women, is also represented as a spinner on multiple occasions in early medieval English art. So is Sarah.

Chapter 2 presents another image that I consider a potential spinning metaphor. As Wealhtheow works peace in her community, in gnomic and communal peaceweaving fashion, she *geondhwearf* "passed among" or "throughout" her group. As I note there, the verb *geondhwearf* is related both to the verb *hweorfan* "to turn" or "to spin," and the noun *hweorfa* or "spindle whorl." The textile associations of the verb are highly likely to have been present for the poem's audiences, based on the noun alone. Wealhtheow's gender and association with peaceweaving imagery are also weighty confluences. Interestingly, the same verb family appears in what I consider another potentially embedded spinning metaphor in Alfred's translation of Boethius. As noted in Chapter 4, Alfred's interpolations in the Old English version of the text include much complaint about the power allowed to *wyrd* by God. His Boethius narrator bemoans, *seo wyrd swa hweorfan mot on*

CONCLUSION

yfelra manna gewill, 7 þu heore nelt stiran "wyrd so may turn on the wish of evil men, and you will not rule her" (10.24–5). The linking of *wyrd* and *hweorfan* is reinforced in the same text by links between *wyrd* and *wendan*, another verb "to turn" (11.3–7). The same word family appears in *The Ruin*, as the narrator in that text laments a community that prospered happily *oþþæt þæt onwende wyrd seo swiþe* "until *wyrd* the mighty overturned that/turned that around" (24b). Words like *hweorfan* paired with a F(f)ate are particularly striking, given the prolific references in the Latin corpus (and the later northern European corpus, as well) to fates who always spin. The *Ertae* pictured on the Franks Casket likewise have several distinct identifying characteristics of F(f)ates; their iconography is convincing, and they appear to be spinning. Spinning had a magical power in their hands, perhaps one reason that, in Chapter 3, the magico-medical attendant takes *þone hweorfan þe wif mid spinnað* "that whorl with which a woman spins" to create an amulet to help in healing.

Spinning and weaving metaphors thus carried many of the same valences, even though it is weaving metaphors that dominate across Old English poetry. Weaving was the highest-status portion of the textile process within a household, second only to embroidery, one which took expertise and material resources. It provided a powerful example of generative craft, the creation of something lovely and stunning from simple plant and animal matter. Such associations may explain why the final major metaphor discussed in Chapter 5, "wordweaving," proved so resonant to early medieval English writers such as Aldhelm, with his marked predilection for textile metaphors more generally. There is no question that "wordweaving" is a metaphor that Aldhelm, Cynewulf, and other early medieval English writers noted in Latin texts they inherited as part of early medieval Christian culture. The metaphor may also have paralleled oral "wordweaving" images in their own poetic backgrounds. Either way, when the early medieval English writers used "wordweaving" as a metaphor, from Aldhelm to Cynewulf, they made it their own. That adaptation is well-demonstrated in Chapter 5 and may trace back to and parallel the style of Aldhelm. He shaped the subsequent Anglo-Latin poetics of many early medieval English and continental authors (with a clear example in Carolingian circles). It is easy to see the same adaptation in the work of Cynewulf, who may himself have been influenced by Aldhelm, and who seems to have drawn together the interlacing poetics of Old English literary style (alliteration, meter, compounding, variation, and interconnecting narrative techniques) and techniques he learned from Anglo-Latin and Latin verse (rhyme, riddling acrostics, and some versification). These are all part of a style that he says he *wordcræftum wæf* "wove with word-craft" (1237a).

The evidence gathered in this work suggests that the "wordweaving" metaphor provides one way to identify authorial "families," or clusters of influence, among writers inside and outside of early medieval England. "Wordweaving" metaphors cluster notably around those influenced by Aldhelm: Tatwine, Boniface and his circle, Alcuin and later members of the Carolingian Renaissance, and later authors affected by the Benedictine Revival by means of the influence of Aldhelm in their curriculum. Those influenced may include the cluster of Flemish authors writing in the last decades of the early medieval English period, such as Goscelin of St Bertin, who himself reflects a written style similar

to the early medieval English "wordweavers" and who announces his debt to Aldhelmian tradition in a handful of allusions.

In the eighth century, Paul the Deacon stated that *Anglisaxones habere solent, hornata instititis latioribus vario colore contextis* "The Anglo-Saxons are accustomed to have [clothing] adorned with wide borders woven with diverse color."[4] Early medieval English dress for elites, with its characteristic tablet-woven borders and well-woven cloth, is a fitting microcosm for the textile process, a concentrated set of intersections among spun, woven, dyed, and embroidered threads evident in finished garments of glorious hue and dense ornamentation, still apparent even today. They are also as good a metaphor as any for the early medieval English peoples themselves: strong, practical, beautiful, colorful, clever, and a syncretic blend of every kind of thread they deemed useful. The early medieval English saw their world in and through their textiles; we can see them the same way.

4 Quoted in Owen-Crocker, *Dress*, p. 171. Translation is mine.

Bibliography

MANUSCRIPTS

Brussels, Bibliothéque royale, MS 8558-63
Cambridge, Corpus Christi College, MS 190
Cambridge, Corpus Christi College, MS 265
Cambridge, Gonville and Caius College, MS 428/428
Cambridge, Trinity College, MS R.17.1
Durham, Cathedral Library, MS B. II. 30
London, British Library, MS Cotton Claudius B. IV
London, British Library, MS Cotton Vespasian A. VIII
London, British Library, MS Harley 585
London, Lambeth Palace, MS 427
Oxford, Bodleian Library, MS Junius 121
Oxford, Bodleian Library, MS Laud Misc. 381
Oxford, Bodleian Library, MS Laud Misc. 482

PRIMARY SOURCES

Ælfric, *Ælfric's Catholic Homilies: The First Series*, ed. Peter Clemoes, EETS ss, 17 (Oxford University Press for EETS, 1997).

—— *Ælfric's Catholic Homilies: The Second Series*, ed. Malcolm Godden, EETS ss, 5 (Oxford University Press for EETS, 1979).

—— *Ælfrics Grammatik und Glossar*, ed. Julius Zupitza (Weidmannsche Buchhandlung, 1880).

—— *Ælfric's Lives of Saints*, ed. Walter W. Skeat, EETS os, 76, 82, 94, 114 (Oxford University Press for EETS, 1966; 1881).

—— *Homilies of Ælfric*, ed. John C. Pope, EETS os, 259, 260 (Oxford University Press for EETS, 1967–68).

Æthelgifu, *The Will of Æthelgifu*, ed. and trans. Dorothy Whitelock, Neil R. Ker, and Francis James Lord Rennel of Rodd (Roxburghe Club, 1968).

Alcuin, *Disputatio de Rhetorica et de Virtutibus Sapientissimi Regis Karli et Albini Magistri*, in Wilbur Samuel Howell (ed. and trans.), *The Rhetoric of Alcuin and Charlemagne* (Russell & Russell, 1965), pp. 66–155.

―― *Epistolae Karolini Aevi, Tomus II*, ed. Ernest Dummler, MGH, Epistolae, 4 (Weidmann, 1925).

Aldhelm, *Aldhelmi Opera*, ed. Rudolfus Ehwald, MGH, Auctorum Antiquissimorum, 15 (Weidmann, 1919).

―― *Aldhelm: The Poetic Works*, ed. and trans. Michael Lapidge and James L. Rosier (D. S. Brewer, 1985).

―― *Aldhelm: The Prose Works*, ed. and trans. Michael Lapidge and Michael Herren (D. S. Brewer, 1979).

Alfred, *De Consolatione*, in Walter John Sedgefield (ed.), *King Alfred's Old English Version of Boethius: De Consolatione Philosophiae* (Wissenschaftliche Buchgesellschaft, 1968).

―― "King Alfred's Will," in F. E. Harmer (ed.), *Select English Historical Documents of the Ninth and Tenth Centuries* (Cambridge University Press, 1914), pp. 15–19.

Assmann, Bruno (ed.), *Angelsächsische Homilien und Heiligenleben*, Bibliothek der Angelsächsischen Prosa, 6 (Wissenschaftliche Buchgesellschaft, 1964; 1889).

Anglo-Saxon Minor Poems, ed. Elliott Van Kirk Dobbie, ASPR 6 (Columbia University Press, 1942).

Apuleius, *Apuleius: The Golden Ass*, ed. G. P. Goold, trans. W. Adlington, and rev. S. Gaselee, Loeb Classical Library, 44 (Harvard University Press, 1977).

Aristophanes, *Lysistrata: Aristophanes*, trans. Douglass Parker (Signet, 2001).

Atharva Veda, in Dominic Goodall (ed. and trans.), *Hindu Scriptures* (University of California Press with J. M. Dent, 1996).

Augustine of Hippo, *De Doctrina Christiana*, ed. and trans. R. P. H. Green (Clarendon, 1995).

―― *St. Augustine's Confessions*, ed. G.P. Goold and trans. William Watts, Loeb Classical Library, 26 (Harvard University Press, 1977).

―― "Reply to Faustus the Manichæan," in Philip Schaff (trans.), *St. Augustin: The Writings against the Manichæans and against the Donatists*, Nicene and Post-Nicene Fathers of the Christian Church, 4 (Wm. B. Eerdmans, 1989; T. and T. Clark, 1887).

Bede, *Bede's Ecclesiastical History of the English People*, ed. and trans. B. Colgrave and R. A. B. Mynors (Clarendon, 1969).

―― *De Temporum Ratione*, in J. A. Giles (ed.), *Scientific Tracts and Appendix, The Miscellaneous Works of Venerable Bede in the Original Latin*, 6 (Whitaker, 1843).

―― Life of St Cuthbert [see Bertram Colgrave].

Beowulf, trans. E. Talbot Donaldson (W. W. Norton, 1966).

Beowulf and the Fight at Finnsburg, ed. Fr. Klaeber, 3rd edn (Heath, 1950; 1922).

Beowulf and the Fight at Finnsburg, eds Fr. Klaeber, R. D. Fulk, Robert E. Bjork, and John D. Niles, 4th edn (University of Toronto Press, 2008).

The Bible, *The Vulgate Bible: Douay-Rheims Translation* (Harvard University Press, 2010).

Boethius, *Boethius: Tractates, The Consolation of Philosophy*, ed. and trans. H. F. Stewart, E. K. Rand, and S. J. Tester, Loeb Classical Library, 74 (Harvard University Press, 1962; 1918).

Burchard of Worms, *Burchardi Wormaciensis Ecclesiæ Episcopi: Decretorum*, ed. J. P. Migne, *PL*, 140 (Migne, 1853).

Byrhtferth of Ramsey, *Byrhtferth of Ramsey: The Lives of St Oswald and St Ecgwine*, ed. and trans. Michael Lapidge (Clarendon, 2009).

Caesar, Julius, *Caesar: The Gallic War*, ed. and trans. H. J. Edwards, Loeb Classical Library, 72 (Harvard University Press, 1979; 1917).

Catullus, *Catullus: A Bilingual Edition*, ed. and trans. Peter Whigham (University of California Press, 1983).

Chaucer, Geoffrey, *The Riverside Chaucer*, ed. Larry Benson, 3rd edn (Houghton Mifflin, 1987).

Cicero, *Cicero in Twenty-Eight Volumes: IV. De Oratore, De Fato, Paradoxa Stoicorum, De Partitione Oratoria*, ed. and trans. H. Rackham (Harvard University Press, 1977; 1942).

—— "Epistulae ad Familiares: Ad M. Varronem et Ceteros," *Cicero: The Letters to His Friends*, trans. and ed. W. Glynn Williams, Loeb Classical Library, 26 (3 vols, Harvard University Press, 1965).

—— "Orator," *Cicero: Brutus; Orator*, trans. and ed. G. L. Hendrickson and H. M. Hubbell (respectively), Loeb Classical Library, 342 (Harvard University Press, 1971).

Ciris, in *Virgil: Aeneid VII–XII, The Minor Poems*, ed. and trans. H. Rushton Fairclough, Loeb Classical Library, 64 (Harvard University Press, 1928).

Cockayne, T. O. (ed.), *Leechdoms, Wortcunning, and Starcraft of Early England*, Rerum Britannicarum Medii Ævi Scriptores, 35 (3 vols, Longman, Green, Longman, Roberts, and Green, 1864–66).

Colgrave, Bertram (ed. and trans.), *Two Lives of Saint Cuthbert* (Praeger, 1968; 1940).

Dümmler, E. (ed.), "S. Bonfatii et Lulli epistolae," MGH, Epistolae, 3, Merovingici et Karolini Aevi, 1 (Weidmann, 1892), pp. 215–433.

Edda: Die Lieder des Codex Regius Nebst Verwandten Denkmälern, ed. Hans Kuhn, 3rd edn (2 vols, Carl Winter, Universitätsverlag, 1962; 1927).

Eddius Stephanus, *The Life of Bishop Wilfrid by Eddius Stephanus*, ed. and trans. Bertram Colgrave (Cambridge University Press, 1985).

Edmonds, J. M. (ed. and trans.), *Lyra Graeca* (3 vols, William Heinemann, 1952; 1922).

The Exeter Book, eds G. P. Krapp and E. Van Kirk Dobbie, ASPR 3 (Columbia University Press, 1936).

Felix, *Felix's Life of St. Guthlac*, ed. and trans. Bertram Colgrave (Cambridge University Press, 1956).

Goscelin of St Bertin, *Goscelin of St Bertin: The Book of Encouragement and Consolation [Liber Confortatorius], The Letter of Goscelin to the Recluse Eva*, trans. Monika Otter (D. S. Brewer, 2004).

—— *Goscelin of Saint-Bertin: The Hagiography of the Female Saints of Ely*, ed. and trans. Rosalind Love (Oxford University Press, 2004).

—— *Le Légende de Sta. Edith en prose et verse par le moine Goscelin*, ed. André Wilmart, *Analecta Bollandiana*, 56 (1938), 5–101, 265–307.

—— "The *Liber Confortatorius* of Goscelin of Saint Bertin," *Analecta Monastica*, 37 (1955), 1–117. Ed. C. H. Talbot.

Gregory I (Pope), *Morals on the Book of Job*, trans. James Bliss and Charles Marriott, Library of the Fathers of the Holy Catholic Church, 18 (3 vols, J. H. Parker, 1844).

Haddan, Arthur West, and William Stubbs (eds), *Councils and Ecclesiastical Documents Relating to Great Britain and Ireland* (Clarendon, 1869).

Heliand, ed. Eduard Sievers, Germanistische Handbibliothek, 4 (Buchhandlung des Waisenhauses G. M. B. H., 1935).

The Heliand: The Saxon Gospel, trans. G. Ronald Murphy (Oxford University Press, 1992).

Hesiod, *Works and Days and Theogeny*, trans. Stanley Lombardo (Hackett, 1993).

Hessels, J. H. (ed.), *An Eighth-Century Latin-Anglo-Saxon Glossary Preserved in the Library of Corpus Christi College, Cambridge* (Cambridge University Press, 1890).

Homer, *Iliad*, trans. Richmond Lattimore (Chicago University Press, 1961; 1951).

—— *Odyssey*, trans. Richmond Lattimore (Harper Perennial, 1991; 1965).

Hygeburg, *Vita Willibaldi Episcopi Eichstetensis*, ed. O. Holder-Egger, MGH, Scriptores in Folio, 15.1 (Hanover, 1887).

Isidore of Seville, *Etymologiae, Etymologiarvm Sive Originvm, Libri*, ed. W. M. Lindsay, Isidori Hispalensis Episcopi, 20, Scriptorum Classicorum Bibliotheca Oxoniensis (Oxford University Press, 1911).

Jerome, *S. Eusebii Hieronymi, Stridonensis Presbyteri Opera Omnia*, ed. Jacques-Paul Migne, *PL*, 28 (Migne, 1890).

Jones, Gwyn (ed.), *Eirik the Red and Other Icelandic Sagas* (Oxford University Press, 1980; 1961).

The Junius Manuscript, ed. George Philip Krapp, ASPR 1 (Columbia University Press, 1931).

Lambeth Psalter, *Der Lambeth-Psalter: eine altenglische Interlinearversion des Psalters in der Hs. 427 der erzbischöflichen Lambeth Palace Library*, Acta Societatis scientiarum fennicae, 35.1, ed. U. Lindelöf (Druckerei der Finnischen Litteraturgesellschaft, 1909–14).

"The Lament of Oddrún," in *Poetic Edda*, vol. 2 of *Sources and Analogues of Old English Poetry: The Major Germanic and Celtic Texts in Translation*, ed. and trans. Daniel G. Calder, Robert E. Bjork, Patrick K. Ford, and Daniel F. Melia (2 vols, D. S. Brewer, 1983), p. 33.

Laxdæla Saga, trans. Magnus Magnusson and Hermann Pálsson (Penguin, 1969).

"Lay of Hildebrand," in *Beowulf and the Fight at Finnsburg*, ed. Fr. Klaeber, 3rd edn (Heath, 1950; 1922), pp. 290–2.

Liber Eliensis: The History of the Isle of Ely, ed. and trans. Janet Fairweather (Boydell, 2005).

Liber Psalmorum: The West-Saxon Psalms, Being the Prose Portion, or the 'First Fifty' of the So-Called Paris Psalter, eds James Wilson Bright and Robert Lee Ramsay (D. C. Heath, 1907).

Liebermann, F. (ed.), *Die Gesetze der Angelsachsen* (3 vols, M. Niemeyer, 1903–16).

BIBLIOGRAPHY

The Life of King Edward Who Rests at Westminster, ed. and trans. Frank Barlow (Clarendon, 1992).

Liuzza, Roy M. (ed. and trans.), *Anglo-Saxon Prognostics* (D. S. Brewer, 2010).

Metrical Dindshenchas, ed. and trans. Edward Gwynn, Todd Lecture Series, 8–12 (5 vols, Academy House, 1903–35).

Miracula Sancte Ætheldrethe Virginis, in *Goscelin of Saint-Bertin: The Hagiography of the Female Saints of Ely*, ed. and trans. Rosalind Love (Oxford University Press, 2004).

Nibelungenlied, trans. A. T. Hatto (Penguin, 1969).

Njal's Saga, trans. Magnus Magnusson and Hermann Pálsson (Penguin, 1960).

Ovid, *Ovid in Six Volumes: III. Metamorphoses*, ed. and trans. Frank Justus Miller, Loeb Classical Library, 42 (Harvard University Press, 1977).

—— *Tristia. Ovid in Six Volumes: VI: Tristia, Ex Ponto*, 2nd edn, trans. Arthur Leslie Wheeler, Loeb Classical Library, 151 (William Heinemann, 1988; 1924).

The Paris Psalter and the Meters of Boethius, ed. George Philip Krapp, ASPR 5 (Columbia University Press, 1932).

Paulinus of Nola, *Letters of St Paulinus of Nola*, ed. and trans. P. G. Walsh, Ancient Christian Writers, 35 (2 vols, Newman Press, 1966).

—— *Paulinus of Nola: Epistolae*, ed. Wilhelm Hartel, CSEL, 29 (G. Freytag, 1894).

—— *The Poems of St Paulinus of Nola*, trans. P. G. Walsh, Ancient Christian Writers, 40 (Newman Press, 1975).

Pindar, *Olympian Odes, Pythian Odes*, ed. and trans. William H. Race, Loeb Classical Library, 56 and 485 (Harvard University Press, 1997).

Plato, *Plato in Twelve Volumes: The Statesman. Philebus. Ion*, ed. and trans. Harold N. Fowler and W. R. M. Lamb, Loeb Classical Library, 164 (Harvard University Press, 1975).

—— *Republic*, trans. Robin Waterfield (Oxford University Press, 1993).

Pliny, *Pliny: Natural History*, ed. and trans. W. H. S. Jones, Loeb Classical Library, 418 (10 vols, Harvard University Press, 1975; 1963).

—— *Pliny: Natural History III Libri VIII–XI*, ed. and trans. H. Rackham, Loeb Classical Library, 353 (Harvard University Press, 1967; 1956).

Poetic Edda, ed. and trans. Carolyne Larrington (Oxford University Press, 1996).

The Poetic Edda, trans. Henry Adams Bellows (American-Scandinavian Foundation, 1923).

Proclus of Constantinople, *Proclus of Constantinople and the Cult of Virginity in Late Antiquity: Homilies 1–5, Texts and Translations*, trans. Nicholas Constans, Vigiliae Christianae, 66 (Brill, 2003).

Propertius, *Propertius*, ed. and trans. H. E. Butler, Loeb Classical Library, 18 (W. Heinemann, 1976; 1912).

Prudentius, *Prudentius*, ed. and trans. H. J. Thomson, Loeb Classical Library, 387 and 398 (2 vols, Harvard University Press, 1979; 1949).

Rigveda Brahmanas, ed. and trans. Arthur B. Keith (Harvard University Press, 1920).

Saxo Grammaticus, *Saxo Grammaticus: The History of the Danes*, ed. Hilda Ellis Davidson and trans. Peter Fisher (2 vols, D. S. Brewer, Rowman, and Littlefield, 1979).

—— *Saxonis Grammatici: Gesta Danorum*, ed. Alfred Holder (Karl J. Trübner, 1886).

Statius, *Thebaid: Books 1–7*, ed. and trans. D. R. Shackleton Bailey, Loeb Classical Library, 207 (Harvard University Press, 2003).

—— *Thebaid: Books 8–12, Achilleid*, ed. and trans. D. R. Shackleton Bailey, Loeb Classical Library, 498 (Harvard University Press, 2003).

Stubbs, William (ed.), *Memorials of Saint Dunstan, Archbishop of Canterbury*, Rerum Britannicarum Medii Aevi Scriptores, 63 (Kraus, 1965; 1874).

Sturluson, Snorri, *Prose Edda*, trans. Anthony Faulkes (J. M. Dent and Sons for Everyman's Library, 1992; 1987).

Tacitus, *Tacitus in Five Volumes: I Agricola, Germania, Dialogus*, ed. and trans. M. Hutton with E. H. Warmington, Loeb Classical Library, 35 (Harvard University Press, 1980).

Tatwine, *Tatvini Opera Omnia: Variae Collectiones Aenigmatvm Merovingicae Aetatis*, ed. Franciscus Glorie, CCSL, 133A (Brepols, 1968).

Venantius Fortunatus, *Venanti Honori Clementiani Fortunati, Presbyteri Italici: Opera Poetica*, ed. Friedrich Leo, MGH, Auctorum Antiquissimorum, 4 (Weidmann, 1881).

—— *Venantius Fortunatus: Personal and Political Poems*, trans. Judith George (Liverpool University Press, 1995).

The Vercelli Book, eds George Philip Krapp and Elliott Van Kirk Dobbie, ASPR 2 (Columbia University Press, 1932).

The Vercelli Homilies and Related Texts, ed. D. G. Scragg, EETS os, 300 (Oxford University Press for EETS, 1992).

Virgil, *The Aeneid of Virgil, Books I–VI*, ed. T. E. Page (Macmillan, 1964).

—— *The Aeneid of Virgil, Books VII–XII*, ed. T. E. Page (Macmillan, 1964).

—— *The Eclogues and Georgics of Virgil*, trans. C. Day Lewis (Anchor/Doubleday, 1964).

Vita Ædwardi Regis: The Life of King Edward Who Rests at Westminster Attributed to a Monk of Saint-Bertin, ed. and trans. Frank Barlow, 2nd edn (Clarendon, 1992).

Vita metrica beati Leudegarii, in MGH, Poetae Latini aevi Carolini, 3 (Weidmann, 1896).

Waldere, ed. Arne Zettersten, Old and Middle English Texts (Manchester University Press, 1979).

Widsið, ed. Kemp Malone (Methuen, 1936).

William of Malmesbury, *GESTA PONTIFICVM ANGLORVM: The History of the English Bishops*, ed. and trans. M. Winterbottom with R. M. Thomson (Clarendon, 2007).

—— *Gesta Regvm Anglorvm: The History of the English Kings*, ed. and trans. R. A. B. Mynors with R. M. Thomson and M. Winterbottom (2 vols, Clarendon, 1998).

Willibald, *Vitae Sancti Bonifatii Archiepiscopi Moguntini*, ed. Wilhelm Levison, MGH, Scriptores in Folio, 15.1 (Hahn, 1905).

Wright, Thomas, and Richard P. Wülcker (eds), *Anglo-Saxon and Old English Vocabularies*, 2nd edn (Trübner, 1884).

Wulfstan, *Sermo Lupi ad Anglos*, ed. Dorothy Whitelock, 3rd edn (Appleton Century Crofts, 1966).

Wulfwaru, "The Will of Wulfwaru," ed. and trans. Dorothy Whitelock, *Anglo-Saxon Wills* (AMS, 1973; 1930), pp. 62–5.

BIBLIOGRAPHY

Wynflæd, "The Will of Wynflæd," ed. and trans. Dorothy Whitelock, *Anglo-Saxon Wills* (AMS, 1973; 1930), pp. 10–15.

SECONDARY SOURCES

Acker, Paul, "Horror and the Maternal in *Beowulf*," *PMLA*, 121.3 (2006), 702–16.

Addison, James C., "Aural Interlace in 'The Battle of Brunanburh,'" *Language and Style: An International Journal*, 15 (1982), 267–76.

Arnold, C. J., *An Archaeology of the Early Anglo-Saxon Kingdoms* (Routledge, 1988).

Augustyn, Prisca, *Semiotics of Fate, Death, and the Soul in Germanic Culture: The Christianization of Old Saxon* (Peter Lang, 2002).

—— "*Wurd* in the *Heliand*: Fate in Old Saxon," *Interdisciplinary Journal for Germanic Linguistics and Semiotic Analysis*, 4.2 (1999), 267–84.

Baker, Peter S., *Honour, Exchange and Violence in Beowulf* (D. S. Brewer, 2013).

Barber, E. J. W., *Women's Work: The First 20,000 Years: Women, Cloth, and Society in Early Times* (W. W. Norton, 1994).

Barbiera, Irene, "Material Culture, Gender and the Life Cycle in Early Medieval Europe," in Enrica Asquer *et al.* (eds), *Ving-Cinq Ans après* (Publications de l'École française de Rome, 2019), https://doi.org/10.4000/books.efr.36447.

Bédat, Isabelle, and Béatrice Girault-Kurtzeman, "The Technical Study of the Bayeux Tapestry," in Pierre Bouet, Brian Levy, and François Neveux (eds), *The Bayeux Tapestry: Embroidering the Facts of History* (Presses universitaires de Caen, 2004), pp. 83–109.

Berr, Samuel, *An Etymological Glossary to the Old Saxon* Heliand (Herbert Lang, 1971).

Biggs, Frederick M., Thomas D. Hill, and Paul E. Szarmach, with Karen Hammond, *Sources of Anglo-Saxon Literary Culture: A Trial Version* (Center for Medieval and Early Renaissance Studies, SUNY Binghamton, 1990).

Bischoff, Bernhard, and Michael Lapidge, *Biblical Commentaries from the Canterbury School of Theodore and Hadrian*, 10 (Cambridge University Press, 1994).

Blackburn, F. A., "The Christian Coloring in *Beowulf*," in Lewis E. Nicholson (ed.), *An Anthology of Beowulf Criticism* (Books for Libraries, 1972; 1897), pp. 1–21.

Blair, Peter Hunter, *An Introduction to Anglo-Saxon England* (Cambridge University Press, 1959).

Bosworth, Joseph, and T. Northcote Toller, *An Anglo-Saxon Dictionary: With revised and enlarged addenda by Alistair Campbell* (2 vols, Oxford University Press, 1983; 1898).

Bouman, A. C., "The Franks Casket," *Neophilologus*, 49.1 (1965), 241–9.

Brather-Walter, Susanne, "Military Equipment in Late Antique and Early Medieval Female Burial Evidence: A Reflection of 'Militarisation'?" in Ellora Bennett *et al.* (eds), *Early Medieval Militarisation* (Manchester University Press, 2021), pp. 266–82.

Bredehoft, Thomas A., *Early English Metre* (University of Toronto Press, 2005).

Brodeur, Arthur Gilchrist, *The Art of Beowulf* (University of California Press, 1959).

Brown, Shirley Ann, *The Bayeux Tapestry. Bayeux Médiatheque Municipale: MS 1. A Source Book* (Brepols, 2013).

—— "Bibliography of Bayeux Tapestry Studies: 1985–1999," in Pierre Bouet, Brian Levy, and François Neveux (eds), *The Bayeux Tapestry: Embroidering the Facts of History* (Office Universitaire d'Études Normandes and Presses Universitaires de Caen, 2004), pp. 411–18.

Bruce-Mitford, Rupert, *The Sutton Hoo Ship-Burial, Vol. 2: Arms, Armour, and Regalia* (Published for the Trustees of the British Museum by British Museum Publications Limited, 1978).

Budny, Mildred, and Dominic Tweddle, "The Early Medieval Textiles at Maaseik, Belgium," *Antiquaries Journal*, 65 (1985), 353–89.

Cameron, Esther, and Quita Mould, "Devil's Crafts and Dragon's Skins? Sheaths, Shoes and Other Leatherwork," in Hyer and Owen-Crocker, *Material Culture*, pp. 93–115.

Cameron, M. L., *Anglo-Saxon Medicine* (Cambridge University Press, 1993).

Cavell, Megan, "Formulaic *Friþuwebban*: Reexamining Peace-Weaving in the Light of Old English Poetics," *The Journal of English and Germanic Philology*, 114.3 (2015), 355–72.

—— *Weaving Words and Binding Bodies: The Poetics of Human Experience in Old English Literature* (University of Toronto Press, 2016).

Chadwick, H. M., *The Heroic Age* (Cambridge University Press, 1912).

Chadwick, Nora K., "The Monsters and Beowulf," in Peter Clemoes (ed.), *The Anglo-Saxons: Studies in Some Aspects of Their History and Culture Presented to Bruce Dickins* (Bowes and Bowes, 1959), pp. 171–203.

Chadwick, Sonia E., "The Anglo-Saxon Cemetery at Finglesham, Kent," *Medieval Archaeology*, 2 (1958), 1–71.

Chance, Jane, "The Structural Unity of *Beowulf*: The Problem of Grendel's Mother," in Damico and Olsen, *New Readings*, pp. 248–61.

—— *Woman as Hero in Old English Literature* (Syracuse University Press, 1986).

Cherniss, Michael D., *Ingeld and Christ: Heroic Concepts and Values in Old English Christian Poetry* (Mouton, 1972).

Christie, A. G. I., *English Medieval Embroidery* (Clarendon, 1938).

Clover, Carol J., "The Germanic Context of the Unferth Episode," *Speculum*, 55 (1980), 444–68.

Coatsworth, Elizabeth, "Cloth-Making and the Virgin Mary in Anglo-Saxon Literature and Art," in Gale R. Owen-Crocker and Timothy Graham (eds), *Medieval Art: Recent Perspectives: A Memorial Tribute to C.R. Dodwell* (Manchester University Press, 1998), pp. 8–25.

—— "Cushioning Medieval Life: Domestic Textiles in Anglo-Saxon England," *Medieval Clothing and Textiles*, 3 (2007), 1–11.

—— "Design in the Past: Metalwork and Textile Influences on Pre-Conquest Sculpture in England," in Karkov and Damico, *Aedificia Nova*, pp. 139–61.

Coatsworth, Elizabeth, and Gale R. Owen-Crocker, *Medieval Textiles of the British Isles AD 450–1100: An Annotated Bibliography*, BAR British Series, 445 (Archaeopress, 2007).

Collins, Derek, *Magic in the Ancient Greek World* (Blackwell, 2008).

Contreni, John J., "John Scottus and Bede," in Michael Dunne and J. J. McEvoy (eds), *History and Eschatology in John Scottus Eriugena and His Time: Proceedings of the Tenth International Conference of the Society for the Promotion of Eriugenian Studies, Maynooth and Dublin, August 16–20, 2000* (Leuven University Press, 2002), pp. 91–140.

Cox, Elizabeth, "Ides Gnornode/Geomrode Giddum: Remembering the Role of a Friðusibb in the Retelling of the Fight at Finnsburg in Beowulf," in Elizabeth Cox, Liz Herbert McAvoy, and Roberta Magnani (eds), *Reconsidering Gender, Time and Memory in Medieval Culture* (D. S. Brewer, 2015), pp. 61–78.

Cramp, Rosemary, "Analysis of the Finds of Whitby Abbey," in David M. Wilson (ed.), *The Archaeology of Anglo-Saxon England* (Methuen, 1976), pp. 453–7.

—— "The Insular Tradition: An Overview," in Catherine Karkov, Michael Ryan, and Robert T. Farrell (eds), *The Insular Tradition* (SUNY Press, 1997), pp. 283–95.

Crane, Lucy (trans.), "The Three Spinning Women," *Household Stories from the Collection of the Bros. Grimm* (McGraw Hill, 1966; 1886).

Crowfoot, Elisabeth, "The Braids," in C. F. Battiscombe (ed.), *The Relics of Saint Cuthbert* (Oxford University Press, 1956), pp. 433–63.

Crowfoot, Elisabeth, and Sonia Chadwick Hawkes, "Early Anglo-Saxon Gold Braids," *Medieval Archaeology*, 11 (1967), 42–86.

Dales, David, *Alcuin: His Life and Legacy* (James Clarke, 2012).

Damico, Helen, *Beowulf and the Grendel-Kin* (West Virginia University Press, 2015).

—— *Beowulf's Wealhtheow and the Valkyrie Tradition* (University of Wisconsin Press, 1984).

—— "The Valkyrie Reflex in Old English Literature," in Damico and Olsen, *New Readings*, pp. 176–90.

Damico, Helen, and Alexandra Hennessey Olsen (eds), *New Readings on Women in Old English Literature* (Indiana University Press, 1990).

Damsholt, Nanna, "The Role of Icelandic Women in the Sagas and in the Production of Homespun Cloth," *Scandinavian Journal of History*, 9 (1984), 75–90.

Davidson, Hilda Ellis, "The Hill of the Dragon," *Folklore*, 61.4 (1950), 169–85.

Davidson, Hilda Ellis, and Alfred K. Siewers, "Landscapes of Conversion: Guthlac's Mound and Grendel's Mere as Expressions of Anglo-Saxon Nation Building," *Viator*, 34 (2003), 1–39.

Day, Agnes, "Afterword," *Peaceweavers*, in Lillian Thomas Shank and John A. Nichols (eds), *Medieval Religious Women* (2 vols, Cistercian Publications, 1987), vol. 2, pp. 373–5.

Desmond, Marilynn, "The Voice of Exile: Feminist Literary History and the Anonymous Anglo-Saxon Elegy," *Critical Inquiry*, 16.3 (1990), 572–90.

Detienne, Marcel, and Jean-Pierre Vernant, *Cunning Intelligence in Greek Culture and Society*, trans. Janet Lloyd (Chicago University Press, 1978; 1974).

Dickinson, T., "An Anglo-Saxon 'cunning woman' from Bidford-on-Avon," in M. Carver (ed.), *In Search of Cult: Archaeological Investigations in Honour of Philip Rahtz* (Boydell, 1993), pp. 45–54.

Dictionary of Old English, Fascicle A, ed. Antonette diPaolo Healey, Joan Holland, David McDougall *et al.* (Pontifical Institute of Mediaeval Studies, 1994).

Dictionary of Old English, Fascicle B, ed. Ashley Crandell Amos, Antonette diPaolo Healey, Joan Holland *et al.* (Pontifical Institute of Mediaeval Studies, 1991).

Diener, Laura Michele, "Sealed with a Stitch: Embroidery and Gift-Giving among Anglo-Saxon Women," *Medieval Prosopography*, 29 (2014), 1–22.

Digby, George Wingfield, "Technique and Production," in Frank Stenton (ed.), *The Bayeux Tapestry: A Comprehensive Survey* (Phaidon, 1965; 1957), pp. 37–55.

Dockray-Miller, Mary, *Motherhood and Mothering in Anglo-Saxon England* (St. Martin's, 2000).

Dodwell, C. R., *Anglo-Saxon Art* (Cornell University Press, 1982).

Duckett, Eleanor Shipley, *Carolingian Portraits: A Study in the Ninth Century* (University of Michigan Press, 1963).

Eliade, Mircea, and Charles J. Adams, *The Encyclopedia of Religion* (Macmillan, 1987).

Elliott, R. W. V., "The Franks Casket," *Neophilologus*, 49.1 (1965), 241–9.

Enright, Michael J., "The Goddess Who Weaves," *Frühmittelalterliche Studien*, 24 (1990), 54–70.

—— *Lady with a Mead Cup: Ritual, Prophecy and Lordship in the European Warband from La Tene to the Viking Age* (Four Courts, 1996).

Eshleman, Lori, "Weavers of Peace, Weavers of War," in Diane Wolfthal (ed.), *Peace and Negotiation: Strategies for Coexistence in the Middle Ages and the Renaissance* (Brepols, 2000), pp. 15–37.

Faulkner, Amy, *Wealth and the Material World in the Old English Alfredian Corpus* (Boydell, 2023).

Fell, Christine, *Women in Anglo-Saxon England* (British Museum Press, 1984).

Firth, Matthew, *Early English Queens, 850–1000: Potestas Reginae* (Routledge, 2024).

Fisher, Genevieve, "'Her Fitting Place': Women, Weaving, and Power in Early Anglo-Saxon England," Society for American Archaeology, Minneapolis, Minnesota, 7 May 1995 (unpublished conference paper).

Fitzgerald, Jill, "*Angelus Pacis*: A Liturgical Model for the 'fæle friðowebba' in Cynewulf's *Elene*," *Medium Ævum*, 83 (2014), 189–209.

Flint, Valerie I. J., *The Rise of Magic in Early Medieval Europe* (Princeton University Press, 1991).

Frakes, Jerold C., *The Fate of Fortune in the Early Middle Ages: The Boethian Tradition* (Brill, 1988).

Frank, Roberta, "The *Beowulf* Poet's Sense of History," in Larry D. Benson and Siegfried Wenzel (eds), *The Wisdom of Poetry: Essays in Early English Literature in Honor of Morton W. Bloomfield* (Medieval Institute Publications, 1982), pp. 53–65, 271–7.

Frantzen, Allen J., *Desire for Origins: New Language, Old English, and Teaching the Tradition* (Rutgers University Press, 1990).

—— "Prologue: Documents and Monuments: Difference and Interdisciplinarity in the Study of Medieval Culture," in Allen J. Frantzen (ed.), *Speaking Two Languages:*

Traditional Disciplines and Contemporary Theory in Medieval Studies (SUNY Press, 1991), pp. 1–33.

Frederick, Jill, "The Weft of War in the Exeter Book Riddles," in Hyer and Frederick, *Textiles, Text, Intertext*, pp. 139–52.

Fulk, Robert D., "The Name of Offa's Queen: *Beowulf* 1931–2," *Anglia*, 122.4 (2004), 614–39.

Fuller, Susan D., "Pagan Charms in Tenth-Century Saxony? The Function of the Merseberg Charms," *Monatshefte*, 72 (1980), 162–70.

Gilchrist, Roberta, *Gender Archaeology: Contesting the Past* (Routledge, 1999).

Gneuss, Helmet, "The Study of Language in Anglo-Saxon England," in Donald G. Scragg (ed.), *Textual and Material Culture in Anglo-Saxon England: Thomas Northcote Toller and the Toller Memorial Lectures* (D. S. Brewer, 2003).

Goldsmith, Margaret, "Allegorical, Typological, or Neither? Three Short Papers on the Allegorical Approach to *Beowulf* and a Discussion," *ASE*, 2 (1973), 285–302.

—— *The Mode and Meaning of 'Beowulf'* (Athlone Press of the University of London, 1970).

Green, Miranda, *Celtic Goddesses: Warriors, Virgins and Mothers* (George Braziller, 1996; 1995).

—— *Dictionary of Celtic Myth and Legend* (Thames and Hudson, 1992).

—— "God in Man's Image: Thoughts on the Genesis and Affiliations of Some Romano-British Cult-Imagery," *Britannia*, 29 (1998), 17–30.

—— *Symbol and Image in Celtic Religious Art* (Routledge, 1989).

Grein, C. W. M., and F. Holthausen, *Sprachschatz der Angelsächsischen Dichter*, rev. J. J. Köhler (Carl Winter, 1912; 1861–64).

Griffith, Mark S., "Does *Wyrd Bið Ful Aræd* Mean 'Fate is Wholly Inexorable'?" in Toswell and Tyler, *Studies in English Language and Literature*, pp. 133–56.

Grimm, Jakob, *Teutonic Mythology*, 4th edn, trans. James Stallybrass (Dover, 1966; 1844).

Gwara, Scott, "Introduction," in Scott Gwara (ed.), *Aldhelmi Malmesbiriensis Prosa de Virginitate cum Glosa Latina atque Anglosaxonica*, CCSL, 124 (Brepols, 2001), pp. 41–57.

Hamilton, Marie Padgett, "The Religious Principle in *Beowulf*," *PMLA*, 61 (1946), 309–31.

Harrington, Susan, *Aspects of Gender Identity and Craft Production in the European Migration Period: Iron Weaving Beaters and Associated Textile Making Tools from England, Norway and Alamannia*, BAR, International Series, 1797 (John and Erica Hedges, 2008).

Head, Pauline E., *Representation and Design: Tracing a Hermeneutics of Old English Poetry* (SUNY Press, 1997).

Hennequin, Wendy, "We've Created a Monster: The Strange Case of Grendel's Mother," *English Studies*, 89.5 (2008), 503–23.

Herbert, Kathleen, *Peace-Weavers and Shield Maidens: Women in Early English Society* (Anglo-Saxon Books, 1997).

Higgins, J. P. P., *Cloth of Gold: A History of Metallised Textiles* (Buckland Press, 1993).

Hill, Joyce, "Ælfric's Sources Reconsidered," in Toswell and Tyler, *Studies in English Language and Literature*, pp. 362–86.

—— "'Þæt Wæs Geomuru Ides!' A Female Stereotype Examined," in Damico and Olsen, *New Readings*, pp. 235–47.

—— "Weaving and Interweaving: The Textual Traditions of Two of Ælfric's Supplementary Homilies," in Hyer and Frederick, *Textiles, Text, Intertext*, pp. 211–23.

Hodges, Henry, *Artifacts: An Introduction to Early Materials and Technology* (John Baker, 1964).

Hoffmann, Marta, *The Warp-Weighted Loom* (Universitetsforlaget, 1964).

Holthausen, F., *Altenglisches Etymologisches Wörterbuch*, 2nd edn (Carl Winter, 1963; 1934).

Howlett, David, "Calculus in Insular Artistic Design," *The Antiquaries Journal*, 103 (2023), 135–61.

Hull, Eleanor, *Folklore of the British Isles* (Methuen, 1977; 1928).

Hyer, Maren Clegg, "Adorning Medieval Life: Domestic and Dress Textiles as Expressions of Worship in Early Medieval England," in Gale R. Owen-Crocker and Maren Clegg Hyer (eds), *Art and Worship in the Insular World: Papers in Honour of Elizabeth Coatsworth* (Brill, 2021), pp. 100–20.

—— "Aldhelm and Word-Weaving as Metaphor in Old English and Anglo-Latin Literature," in Hyer and Frederick, *Textiles, Text, Intertext*, pp. 121–38.

—— "Recycle, Reduce, Reuse: Imagined and Re-Imagined Textiles in Anglo-Saxon England," *Medieval Clothing and Textiles*, 8 (2012), 49–62.

—— "Riddles of Anglo-Saxon England," in Gale R. Owen-Crocker, Elizabeth Coatsworth, and Maria Hayward, *Encyclopedia of Medieval Dress and Textiles of the British Isles c. 450 to 1450* (Brill, 2011).

—— "Textiles and Textile Imagery in *The Exeter Book*," *Medieval Clothing and Textiles*, 1 (2005), 29–39.

—— "Textiles and Textile Imagery in Old English Literature" (PhD dissertation, University of Toronto, 1998).

—— "Text/Textile: 'Wordweaving' in the Literatures of Anglo-Saxon England," *Medieval Clothing and Textiles*, 15 (2019), 33–51.

Hyer, Maren Clegg, and Jill Frederick (eds), *Textiles, Text, Intertext: Essays in Honour of Gale R. Owen-Crocker* (Boydell, 2016).

Hyer, Maren Clegg, and Gale R. Owen-Crocker (eds), *The Material Culture of Daily Living in the Anglo-Saxon World* (University of Exeter Press, 2011).

Hyer, Maren Clegg, and Gale R. Owen-Crocker, "Woven Works: Making and Using Textiles," in Hyer and Owen-Crocker, *Material Culture of Daily Living*, pp. 157–84.

Irvine, Susan, "Ulysses and Circe in King Alfred's *Boethius*: A Classical Myth Transformed," in Toswell and Tyler, *Studies in English Language and Literature*, pp. 387–401.

Irvine, Susan, and Malcolm R. Godden, "Introduction," *The Old English Boethius* (Harvard University Press, 2012).

Irving, Edward B., Jr., "Christian and Pagan Elements," in Robert E. Bjork and John D. Niles (eds), *A Beowulf Handbook* (University of Nebraska Press, 1997), pp. 175–92.

Jolly, Karen, Catharina Raudvere, and Edward Peters, *Witchcraft and Magic in Europe: The Middle Ages* (Athlone Press, 2002).

Joplin, Patricia Klindienst, "The Voice of the Shuttle Is Ours," *Stanford Literature Review*, 1 (1984), 25–53.

Karkov, Catherine E., *The Art of Anglo-Saxon England* (Boydell, 2011).

—— "The Franks Casket Speaks Back: The Bones of the Past, the Becoming of England," in Eva Frojmovic and Catherine E. Karkov, *Postcolonising the Medieval Image* (Routledge, 2017), pp. 37–61.

—— *Imagining Anglo-Saxon England: Utopia, Heterotopia, Dystopia* (Boydell, 2020).

Karkov, Catherine, and Helen Damico (eds), *Aedificia Nova: Studies in Honor of Rosemary Cramp* (Medieval Institute Publications, 2008).

Keiser, Albert, *The Influence of Christianity on the Vocabulary of Old English Poetry, Pt. 1* (University of Illinois Press, 1919).

Kemble, John Mitchell, *The Saxons in England: A History of the English Commonwealth till the Period of Norman Conquest*, ed. Walter de Gray Birch (2 vols, AMS, 1971; 1876).

Ker, W. P., *Epic and Romance: Essays on Medieval Literature* (Dover, 1957; 1897).

Kesling, Emily, *Medical Texts in Anglo-Saxon Literary Culture* (D. S. Brewer, 2020).

Kieckhefer, Richard, *Magic in the Middle Ages* (Cambridge University Press, 2000; 1989).

Klein, Stacy S., *Ruling Women: Queenship and Gender in Anglo-Saxon Literature* (University of Notre Dame Press, 2006).

Kleist, Aaron J., *Striving with Grace: Views of Free Will in Anglo-Saxon England* (University of Toronto Press, 2008).

Kluge, Friedrich, *Nominale Stammbildungslehre der Altgermanischen Dialekte*, 3rd edn, eds Ludwig Sütterlin and Ernst Ochs, in *Sammlung Kurzer Grammatiken Germanischer Dialekte, Ergänzungsreihe*, ed. Wilhelm Braune (Max Niemeyer, 1926).

Kors, Alan Charles, and Edward Peters, *Witchcraft in Europe, 400–1700: A Documentary History*, 2nd edn (University of Pennsylvania Press, 2001).

Kruger, Kathryn Sullivan, *Weaving the Word: The Metaphorics of Weaving and Female Textual Production* (Susquehanna University Press, 2001).

Lakoff, George, and Mark Johnson, *Metaphors We Live By* (University of Chicago Press, 1980).

Lapidge, Michael, *Anglo-Latin Literature 600–899* (Hambledon, 1993).

—— *The Anglo-Saxon Library* (Oxford University Press, 2006).

—— "The Career of Aldhelm," *ASE*, 36 (2007), 15–69.

—— "Schools, Learning and Literature in Tenth-Century England," *Il secolo di ferro: mito e realtà del secolo X*, Settimane de studio del centro italiano di studi sull'alto medi-oevo, 38 (Spoleto, 1990), pp. 951–98; reprinted in Lapidge's *Anglo-Latin Literature 900–1066* (Hambledon, 1993), pp. 1–48.

Lavelle, Ryan, "Towards a Political Contextualization of Peacemaking and Peace Agreements in Anglo-Saxon England," in Diane Wolfthal (ed.), *Peace and Negotiation:*

Strategies for Coexistence in the Middle Ages and the Renaissance (Brepols, 2000), pp. 39–55.

Lee, Christina, "Embroidered Narratives," in R. Norris, R. Stephenson, and R. R. Trilling (eds), *Feminist Approaches to Early Medieval English Studies* (Amsterdam University Press, 2023), pp. 53–82.

Lees, Clare, and Gillian Overing, *Double Agents: Women in Anglo-Saxon Clerical Culture* (University of Philadelphia Press, 2001).

Lehmann, Winfred P., *A Gothic Etymological Dictionary*, based on Sigmund Feist, *Vergleichendes Wörterbuch der Gotischen Sprache*, 3rd edn (Brill, 1986).

Leneghan, Francis, "Beowulf, the Wrath of God and the Fall of the Angels," *English Studies: Special Edition on Morality, Exemplarity, and Emotion in Old English Literature*, 105.3 (2024), 383–403.

The Dynastic Drama of Beowulf (D. S. Brewer, 2020).

Lester-Makin, Alexandra, *The Lost Art of the Anglo-Saxon World: The Sacred and Secular Power of Embroidery* (Oxbow, 2019).

Lewis, Charlton T., and Charles Short, *A Latin Dictionary* (Oxford University Press, 1879).

Lewis, Michael J., Gale R. Owen-Crocker, and Dan Tekla (eds), *The Bayeux Tapestry: New Approaches* (Oxbow, 2011).

Leyerle, John, "The Interlace Structure of *Beowulf*," *University of Toronto Quarterly*, 37 (1967), 1–17.

Leyser, Henrietta, *Medieval Women: A Social History of Women in England 450–1500* (Weidenfeld and Nicolson, 1995).

Louis-Jensen, Jonna, "A Good Day's Work: *Laxdæla saga*, Ch. 49," in Sarah M. Anderson and Karen Swenson (eds), *Cold Counsel: Women in Old Norse Literature and Mythology* (Routledge, 2002), pp. 189–99.

Louviot, Elise, *Direct Speech in Beowulf and Other Old English Narrative* (D. S. Brewer, 2016).

Love, Rosalind, "'*Et quis me tanto oneri parem faciet?*': Goscelin of Saint-Bertin and the Life of St Amelberga," in Katherine O'Brien O'Keeffe and Andy Orchard (eds), *Latin Learning and English Lore: Studies in Anglo-Saxon Literature for Michael Lapidge* (2 vols, University of Toronto Press, 2005), vol. 1, pp. 231–52.

Loyn, H. R., *Anglo-Saxon England and the Norman Conquest*, 2nd edn (Longman, 1991).

Malone, Kemp, "Beowulf," in Lewis E. Nicholson (ed.), *An Anthology of Beowulf Criticism* (Books for Libraries, 1972; 1948).

Marenbon, John, *From the Circle of Alcuin to the School of Auxerre: Logic, Theology, and Philosophy in the Early Middle Ages* (Cambridge University Press, 1981).

McNeill, John T., and Helena M. Gamer, *Medieval Handbooks of Penance: A Translation of the Principal libri poenitentiales and Selections from Related Documents* (Columbia University Press, 1938).

Meaney, Audrey L., *Anglo-Saxon Amulets and Curing Stones*, BAR, 96 (BAR, 1981).

—— "Ælfric's Use of Sources in His Homily on Auguries," *English Studies*, 6 (1985), 477–95.

Michelet, Fabienne L., *Creation, Migration, and Conquest: Imaginary Geography and Sense of Space in Old English Literature* (Oxford University Press, 2006).

Middle English Dictionary, eds Robert E. Lewis, Mary Jane Williams, G. W. Abernethy, Joseph P. Pickett *et al.* (University of Michigan Press, 1989).

Miller, William I., "Choosing the Avenger: Some Aspects of the Bloodfeud in Medieval Iceland and England," *Law and History Review*, 1.2 (1983), 159–204.

Moisl, H., "Celto-Germanic *W_tu- W_tu- and Early Germanic Poetry," *Notes and Queries*, 225 (1980), 98–9.

Moorman, Charles, "The Essential Paganism of *Beowulf*," *Modern Language Quarterly*, 28 (1967), 3–18.

Neidorf, Leonard, *The Art and Thought of the Beowulf Poet* (Cornell, 2022).

—— (ed.), *The Dating of* Beowulf: *A Reassessment* (D. S. Brewer, 2014).

—— "The Dating of Widsith and the Study of Germanic Antiquity," *Neophilologus*, 97 (2013), 165–83.

—— "Hildeburh's Mourning and the Wife's Lament," *English Studies*, 89 (2017), 197–204.

Neumann, Erich, *The Great Mother: An Analysis of the Archetype*, trans. Ralph Manheim (Princeton University Press, 1991; 1955).

Niles, John D., *God's Exiles and English Verse: On the Exeter Anthology of Old English Poetry* (Exeter University Press, 2019).

—— "Pagan Survivals and Popular Belief," in Malcolm Godden and Michael Lapidge (eds), *The Cambridge Companion to Old English Literature* (Cambridge University Press, 1991), pp. 126–41.

North, Richard, *Heathen Gods in Old English Literature* (Cambridge University Press, 1997).

O'Briain, Helen Conrad, "Listen to the Woman: Reading Wealhtheow as Stateswoman," in Helene Scheck and Christine E. Kozikowski (eds), *New Readings on Women and Early Medieval English Literature and Culture: Cross-Disciplinary Studies in Honour of Helen Damico* (Amsterdam University Press, 2020), pp. 191–208.

O'Brien, Elizabeth, "Literary Insights into the Basis of Some Burial Practices in Ireland and Anglo-Saxon England in the Seventh and Eighth Centuries," in Karkov and Damico, *Aedificia Nova*, pp. 283–99.

Oda, Tetsuji, *Semantic Borrowing of Wyrd with Special Reference to King Alfred's Boethius* (PhD diss., Tokyo University, 2000; Nodus Publikationen, 2004).

Ogilvy, J. D. A., "Beowulf, Alfred, and Christianity," in M. H. King and W. M. Stevens (eds), *Saints, Scholars and Heroes: Studies in Medieval Culture in Honour of Charles W. Jones* (Hill Monastic Manuscript Library, St. John's Abbey and University, 1979).

—— *Books Known to the English, 597–1066* (Medieval Academy of America, 1967).

Olsen, Alexandra Hennessey, "Cynewulf's Autonomous Women: A Reconsideration of Elene and Juliana," in Damico and Olsen, *New Readings*, pp. 222–34.

—— "Gender Roles," in Robert E. Bjork and John D. Niles, *A* Beowulf *Handbook* (University of Nebraska Press, 1997), pp. 311–24.

Onians, Richard Broxton, *The Origins of European Thought about the Body, the Mind, the Soul, the World, Time, and Fate: New Interpretations of Greek, Roman and Kindred Evidence, also of Some Basic Jewish and Christian Beliefs* (Cambridge University Press, 1951).

Onions, C. T., G. W. S. Friedrichsen, and R. W. Burchfield (eds), *The Oxford Dictionary of English Etymology* (Clarendon, 1966).

Orchard, Andy, "Both Style and Substance: The Case for Cynewulf," in Catherine E. Karkov and George Hardin Brown (eds), *Anglo-Saxon Styles* (SUNY Press, 2003), pp. 271–305.

—— *The Poetic Art of Aldhelm* (Cambridge University Press, 1994).

—— "Poetic Inspiration and Prosaic Translation: The Making of 'Caedmon's Hymn,'" in Toswell and Tyler, *Studies in English Language and Literature*, pp. 402–22.

—— *Pride and Prodigies: Studies in the Monsters of the Beowulf-Manuscript* (D. S. Brewer, 1995).

—— "Wish You Were Here: Alcuin's Courtly Poetry and the Boys Back Home," in Sarah Rees Jones, Richard Marks, and Alastair J. Minnis (eds), *Courts and Regions in Medieval Europe* (York Medieval Press, 2000).

Overing, Gillian R., *Language, Sign, and Gender in* Beowulf (Southern Illinois University Press, 1990).

Owen, Gale R., *Rites and Religions of the Anglo-Saxons* (David and Charles, 1981).

—— "Wynflæd's Wardrobe," *ASE*, 8 (1979), 195–222.

Owen-Crocker, Gale R., "Aldhelm," in Gale R. Owen-Crocker, Elizabeth Coatsworth, and Maria Hayward (eds), *Encyclopedia of Medieval Dress and Textiles of the British Isles c. 450–1450* (Brill, 2011), pp. 31–4.

—— "Anglo-Saxon Women, Woman, and Womanhood," in Scheck and Kozikowski (eds), *New Readings on Women and Early Medieval English Literature*, pp. 23–42.

—— (ed.), *The Bayeux Tapestry: Collected Papers* (Ashgate, 2012).

—— *Dress in Anglo-Saxon England: Revised and Enlarged Edition* (Boydell, 2004).

—— (ed.), *King Harold II and the Bayeux Tapestry* (Boydell, 2005).

—— "'Seldom ... does the deadly spear rest for long': Weapons and Armour in Anglo-Saxon England," in Hyer and Owen-Crocker, *The Material Culture of Daily Living*, pp. 201–30.

The Oxford English Dictionary, 2nd edn (Oxford University Press, 1989).

Pape, Eleanore, and Nicola Ialongo, "Error or Minority? The Identification of Non-Binary Gender in Prehistoric Burials in Central Europe," *Cambridge Archaeological Journal*, 34 (2024), 43–63.

Pastan, Elizabeth Carson, and Stephen D. White with Kate Gilbert, *The Bayeux Tapestry and Its Contexts* (Boydell, 2014).

Payne, Anne, *King Alfred and Boethius: An Analysis of the Old English Version of the "Consolation of Philosophy"* (University of Wisconsin Press, 1968).

Pedersen, David, "*Wyrd ðe Warnung* ... or God: The Question of Absolute Sovereignty in *Solomon and Saturn II*," *Studies in Philology*, 113.4 (2016), 713–38.

Phillpotts, Dame Bertha, "Wyrd and Providence in Anglo-Saxon Thought," *Essays and Studies*, 13 (1928), 7–27.

Pokorny, Julius, *Indogermanisches Etymologisches Wörterbuch* (2 vols, A. Francke, 1969).

Pollack, Susan, "Engendering *Wyrd*: Notional Gender Encoded in the Old English Poetic and Philosophical Vocabulary," *Neophilologus*, 90 (2006), 643–61.

Pollington, Stephen, *Leechcraft: Early English Charms, Plantlore, and Healing* (Anglo-Saxon Books, 2000).

Porck, Thijs, "The Ages of Man and the Ages of Woman in Early Medieval England: From Bede to Byrhtferth of Ramsey and the *Tactatus de quaternario*," in Thijs Porck and Harriet Soper (eds), *Early Medieval English Life Courses: Cultural-Historical Perspectives* (Brill, 2022), pp. 17–46.

Price, Neil, et al., "Viking Warrior Women? Reassessing Birka Chamber Grave Bj.581," *Antiquity*, 93.367 (2019), 181–98.

Puskar, Jason R., "*Hwa þas fitte fegde?* Questioning Cynewulf's Claim of Authorship," *English Studies*, 92 (2011), 1–19.

Raw, Barbara C., *Trinity and Incarnation in Anglo-Saxon Art and Thought* (Cambridge University Press, 1997).

Rendall, Thomas, "Bondage and Freeing from Bondage in Old English Religious Poetry," *Journal of English and Germanic Philology*, 73 (1974), 497–512.

Ricouer, Paul, *The Rule of Metaphor*, trans. Robert Czerny, Kathleen McLaughlin, and John Costello (University of Toronto Press, 1991).

Robertson, D. W., "The Doctrine of Charity in Mediaeval Literary Gardens: A Topical Approach through Symbolism and Allegory," *Speculum*, 27 (1951), 29–49.

Robinson, Fred C., "*Beowulf*," in Malcolm Godden and Michael Lapidge (eds), *The Cambridge Companion to Old English Literature* (Cambridge University Press, 1991), pp. 142–59.

—— *Beowulf and the Appositive Style* (University of Tennessee Press, 1985).

—— "*Beowulf* in the Twentieth Century," *Proceedings of the British Academy*, 94 (1997), 45–62.

—— "History, Religion, Culture," in Jess B. Bessinger, Jr., and Robert F. Yeager (eds), *Approaches to Teaching Beowulf* (MLA, 1984), pp. 36–51.

—— "The Prescient Woman in Old English Literature," in Fred C. Robinson (ed.), *The Tomb of Beowulf and Other Essays on Old English* (Blackwell, 1993), pp. 155–63.

Roper, Alan H., "Boethius and the Three Fates of *Beowulf*," *Philological Quarterly*, 41 (1962), 386–400.

Russell, Jeffrey Burton, *Witchcraft in the Middle Ages* (Cornell University Press, 1984).

Sayers, William, "Old Irish Fert 'Tiepole', Fertas 'Swingletree' and the Seeress Fedelm," *Études Celtiques*, 21 (1984), 171–83.

Scheck, Helene, *Reform and Resistance: Formations of Female Subjectivity in Early Medieval Ecclesiastical Culture* (SUNY Press, 2008).

Scheid, John, and Jesper Svenbro, *The Craft of Zeus: Myths of Weaving and Fabric*, trans. Carol Volk (Harvard University Press, 1996).

Sebo, Erin, and Cassandra Schilling, "Modthryth and the Problem of Peace-Weavers: Women and Political Power in Early Medieval England," *English Studies*, 102 (2021), 637–50.

Serht, Edward H., *Vollständiges Wörterbuch zum Heliand und zur Altsächsischen* Genesis, 2nd edn, Hesperia, Schriften zur Germanischen Philologie, 14 (Vandenhoeck & Ruprecht, 1966; 1925).

Shippey, T. A., *Old English Verse* (Hutchinson University Library, 1972).

Siewers, Alfred K., "Landscapes of Conversion: Guthlac's Mound and Grendel's Mere as Expressions of Anglo-Saxon Nation Building," *Viator*, 34 (2003), 1–39.

Sklute, L. John, "*Freoðuwebbe* in Old English Poetry," in Damico and Olsen, *New Readings*, pp. 204–10 (originally published in *Neuphilologische Mitteilungen*, 71 (1970), 534–41).

Smith, Michele Hayeur, *The Valkyries' Loom: The Archaeology of Cloth Production and Female Power across the North Atlantic* (University of Florida Press, 2020).

Smith, William, and Samuel Cheetham, *A Dictionary of Christian Antiquities: Being a Continuation of the "Dictionary of the Bible"* (2 vols, J. B. Burr, 1880).

Smithers, G. V., "Destiny and the Heroic Warrior in *Beowulf*," in James L. Rosier (ed.), *Philological Essays: Studies in Old and Middle English Language and Literature* (Mouton, 1970), pp. 65–81.

Stafford, Pauline, *Queen Emma and Queen Edith: Queenship and Women's Power in Eleventh-Century England* (Blackwell, 2001).

—— *Queens, Concubines, and Dowagers: The King's Wife in the Early Middle Ages* (Leicester University Press, 1998).

Stanley, E. G., *In the Foreground: Beowulf* (D. S. Brewer, 1994).

—— *The Search for Anglo-Saxon Paganism* (D. S. Brewer, 1975).

Stanton, Robert, *The Culture of Translation in Anglo-Saxon England* (Boydell, 2002).

Stenton, F. M., *Anglo-Saxon England* (Clarendon, 1988).

Storms, G., *Anglo-Saxon Magic* (Martinus Nijhoff, 1948).

Talbot, C. H. (ed. and trans.), *The Anglo-Saxon Missionaries in Germany* (Sheed and Ward, 1954).

Taylor, C. Tidmarsh, "A Christian *Wyrd*: Syncretism in *Beowulf*," *English Language Notes*, 32.3 (1995), 1–10.

Thordike, Lynn, *A History of Magic and Experiential Science during the First Thirteen Centuries of Our Era* (Columbia University Press, 1964; 1923).

Tietjen, Mary C. Wilson, "God, Fate, and the Hero of *Beowulf*," *Journal of English and Germanic Philology*, 74 (1975), 155–71.

Timmer, B. J., "A Note on *Beowulf*, ll. 2526b–2527a and l. 2295," *English Studies*, 40 (1959), 49–52.

—— "*Wyrd* in Anglo-Saxon Poetry and Prose," *Neophilologus*, 26 (1941), 24–33, 213–28.

Tolkien, J. R. R., "*Beowulf*: The Monsters and the Critics," in Lewis E. Nicholson (ed.), *An Anthology of* Beowulf *Criticism* (Books for Libraries, 1972; 1936), pp. 51–103.

Toswell, M. J., and E. M. Tyler (eds), *Studies in English Language and Literature: "Doubt wisely," Papers in Honour of E. G. Stanley* (Routledge, 1996).

Toynbee, J. M. C., "Genii Cucullati in Roman Britain," *Collection Latomus*, 28 (1957), 456–69.

Tuso, Joseph F., "Beowulf's Dialectal Vocabulary and the Kiernan Theory," *South Central Review*, 2.2 (1985), 1–9.

Venezky, R. L., and A. diPaolo Healey, *A Microfiche Concordance to Old English*, Publications of the Dictionary of Old English, 1 (Pontifical Institute of Mediaeval Studies, 1980).

von Erhardt-Siebold, Erika, "The Old English Loom Riddles," in Thomas A. Kirby and Henry Bosley Woolf (eds), *Philologica: The Malone Anniversary Studies* (Johns Hopkins, 1949), pp. 9–17.

Vowell, Alison, "Grendel's Mother and the Women of the Völsung-Nibelung Tradition," *Neophilologus*, 107 (2022), 239–55.

Wallace-Hadrill, J. M., "War and Peace in the Earlier Middle Ages," *Transactions of the Royal Historical Society*, 5th series, 25 (1975), 157–61.

Walton, Penelope, *Textiles, Cordage and Raw Fibre from 16–22 Coppergate* (CBA, 1989).

Walton Rogers, Penelope, *Cloth and Clothing in Early Anglo-Saxon England* (CBA, 2007).

Webster, Leslie, *The Franks Casket* (British Museum Press, 2012).

Weiskott, Erik, "The Meter of Widsith and the Distant Path," *Neophilologus*, 99 (2015), 143–50.

Whallon, William, "The Idea of God in *Beowulf*," *PMLA*, 80 (1965), 19–23.

Whitelock, Dorothy, *The Beginnings of English Society*, The Pelican History of England, 2 (The Anglo-Saxon Period) (Penguin, 1954; 1952).

Wicker, Nancy L., "Mapping Gold in Motion: Women and Jewelry from Early Medieval Scandinavia," in Tracy Chapman Hamilton and Mariah Proctor-Tiffany (eds), *Moving Women, Moving Objects, 400–1500* (Brill, 2019), pp. 13–32.

Wickham-Crowley, Kelley M., "Buried Truths: Shrouds, Cults, and Female Production in Anglo-Saxon England," in Karkov and Damico, *Aedificia Nova*, pp. 300–24.

Williamson, Craig, *A Feast of Creatures: Anglo-Saxon Riddle Songs* (University of Pennsylvania Press, 1982).

Wilson, David M., *Anglo-Saxon Art* (Thames and Hudson, 1984).

—— "Craft and Industry," in David M. Wilson (ed.), *The Archaeology of Anglo-Saxon England* (Methuen, 1976), pp. 253–81.

Wilson, James H., *Christian Theology and Old English Poetry* (Mouton, 1974).

Winterbottom, Michael, "Aldhelm's Prose Style and Its Origins," *ASE*, 6 (1977), 39–76.

Wodzak, Victoria, "Of Weavers and Warriors: Peace and Destruction in the Epic Tradition," *Midwest Quarterly*, 39 (1998), 253–64.

Wragg, Stephanie, *Early English Queens, 650–850* (Routledge, 2022).

Index

Special thanks to Mary Nikki Roop for her assistance in compiling this index. Page numbers in **bold** denote pages containing an image.

Abbesses 21–2, 56 n.51, 64 n.76, 81–2
Abraham, biblical character 32 n.92
Acca, St and bishop of Hexham 25
Acker, Paul 93 n.88, 94 n.94
Acrostics 184, 194, 200, 207–8, 215
Adalhard, associate of Alcuin 56, 58
Adam, biblical character 59, 61
Addison, James C. 185–6
Adoration of the Magi 129, 150
Ælfflæd, queen to Edward the Elder, stepmother
 of Athelstan 17
Ælfgifu of Northampton / Alfifa, first wife Cnut,
 king of England, mother to Harold
 Harefoot 94, 97
Ælfric, abbot of Eynsham 5 n.7, 25 n.57, 29, 60,
 74, 79, 80, 89, 91, 140 n.89, 143–4, 164,
 172, 179
Ælfthryth, queen of England, mother of
 Æthelred, king of England 94, 95 n.98,
 96, 97
Ælfwine, son of Wulfwaru (beneficiary) 27
Æschere, character in *Beowulf* 92–4
Aeschylus, playwright of *Agamemnon* 104
Æsir, Northern gods 98, 173
Aesop 156
Æthelflæd, "Lady of the Mercians" 95
Æthelgifu, testatrix 33
Æthelthryth, St and abbess of Ely 82, 87, 197
Æthelwulf, king of Wessex 34
Æthelwynn, matron of textile workshop 19, 188
Age and textile production 11, 32
Ahasuerus, king of Persia, husband of Esther 60
Alaric I, king of the Visigoths 161
Alcuin of York 55–9, 67, 70–2, 192–3, 197,
 203–5, 207, 212, 213, 215
Aldfrith, king of Northumbria 191
Aldhelm, bishop of Sherborne 1, 6, 19, 20,
 25–30, 56, 155, 163, 167, 168, 179, 181,
 191–2, 200, 202, 204–5, 207–9, 211, 215
 Carmen de virginitate 196

De Virginitate 21–3, 191, 197
Epistola ad Acircium 191
Riddles 1–2, 11–12, 118, 134–5, 164–6, 167,
 178, 180, 189 n.20, 194
Style 192–8, 202–3, 207, 214, 215, 216
Alexander the Great 156
Alfred, "The Great," king of Wessex 34, 74, 164,
 168, 173, 179, 193 n.45
 Laws of 80
 "Translation" of Boethius' *De Consolatione*
 136–44, 146–7, 156, 165–7, 178, 214
 Will of 13, 29, 214
Alliteration 139, 142, 165, 169, 171, 180–1, 183–6,
 193, 198, 207–8, 215
Ambrose of Milan, St 163, 201
Amleth, King of the Danes (Hamlet), character
 in *Gesta Danorum* 205
Amulet, amuletic 74–5, 78–9, 83, 85, 86, 102–3,
 115, 205, 210, 215
Anchorite, anchoritic 196
Anderson, Sarah M. 2 n.4
Andreas 91, 95, 96, 108, 133, 146 n.112, 151 n.132,
 171, 212
Angel 37, 39, 52–9, 66, 74, 92, 142, 195–6, 208
Anglia 52, 58 n.53
Anglo-Latin poetics 187–8, 191–8, 205, 207–9,
 215
Animals 5 n.6, 9, 20, 21, 79, 103, 140 n.91, 172,
 187, 215
Anna, biblical character 170
Annunciation 121 n.17
Aphrodite 95 n.99
Apollo 155
Apple 59, 86
Apuleius, *The Golden Ass* 108
Arator, early Italian poet 70, 71 n.95
Aristophanes, *Lysistrata* 69-70
Aristotle 6, 156
Arnold, C. J. 14 n.15, 28
Athelstan, king of Wessex 17, 21, 81 n.27, 168, 185

INDEX

Athena 95 n.99, 199, 209
Athens 69-70, 105
Augustine of Hippo, St 70, 71 n.95, 75, 78 n.8,
 102, 160, 162, 163, 165, 200, 201, 204
Augustyn, Prisca 170–1, 181 n.272
Austerity in dress 25–6, 28

Bacchus 158
Bacchylides, early Greek lyric poet 198
Baker, Peter S. 36, 37, 43, 44, 54 n.44, 61 n.62,
 95 n.98
Balder 150, 205
Barber, Elizabeth J. W. 178
Barking Abbey (Essex) 22, 196
Barrow, *see* Burials, burial mound
Battle of Brunanburh 185–6
Battle of Clontarf 109
Battle of Maldon 17 n.21
Bayeux "Tapestry" **Front cover,** 19, 21, 24 n.53,
 63, 188
Beaduhild, depicted on the Franks Casket 150
Beasts of battle 187
Bede 24, 25–6, 87, 155, 163 n.195, 195, 197, 203, 204
 De Temporum Ratione 151–2
 Historia ecclesiastica gentis anglorum 15
 n.19, 40, 54, 81–2, 88
Bees 99
Benedictine Revival 215
Beowulf
 Deathweaving 82, 89, 91, 92–7, 99–101, 105,
 106, 112, 113
 Fate 124–5, 127–9, 131–4, 135 n.69, 145–7,
 151 n.132, 155 n.155, 166–71, 174, 181
 Peaceweaving 36, 38, 44–51, 57–8, 60, 64
 n.76, 65–6, 68, 70
 Poetics 184–8, 205, 207, 211
Berhthun, abbot of Beverly 40
Berr, Samuel 169 n.218
Bewindan, see Textile words, Old English
Bible, biblical 4, 30, 32 n.92, 54, 59–61, 68, 87–9,
 92, 106–8, 115–16, 118–19, 124, 149, 152, 156
 n.159, 163, 167–8, 213
Bidford-on-Avon (Warwickshire) 85
Binding, bonds 3, 4 n.5, 34, 39–40, 45–6, 49,
 53–4, 61, 63 n. 75, 64, 66, 69–73, 83, 85,
 86–9, 90–2, 93 n.92, 95–7, 100–3, 105–8,
 112, 115–17, 119, 135, 153, 160, 182, 184–5,
 187, 197, 205, 211-14
Bless, blessing 73–4, 75, 102, 122
Boethius, *De Consolatione* 130, 136–47, 156,
 165–7, 178, 214
Bolli, character in *Laxdœla Saga* 113–14
Boniface, St 20, 25, 56 n.51, 102 n.129, 194
 Bonifatian circle 194–5, 202–3, 205, 215

Bracteates 120–2, 176
Bregdan, see Textile words, Old English
Brosings, necklace of, in *Beowulf* 186–7
Brown, Shirley Ann 21
Bruder, Reinhold 81
Brynhild, valkyrie and lover of legendary Sigurd
 111–12, 114, 150, 173–4
Budny, Mildred 17
Bugga, friend of Boniface 56 n.51
Burchard of Worms, *Corrector* 110–11, 172
Burials 29, 32, 85, 120 n.12, 129, 135 n.71, 144
 n.102, *see also* Graves and grave goods
 Barrows 98, 139, 150–1
 Burial mound 99
Byrhtferth of Ramsey 11 n.8, 28, 30, 31, 195
Byrhtnoth, ealdorman of Essex 17 n.21
Byzantine 121 n.17

Cædmon, *Caedmon's Hymn* 128, 188
Caesarius of Arles, St 75
Cain, biblical character 96
Cambridge, Gonville and Caius College, MS
 428/428, *see* Manuscripts
Cambridgeshire 31 n.85, 32, 122 n.21
Cameron, M. L. 83
Canterbury school 155
Canterbury style 19
Carolingian court 71 n.95, 111, 116, 121 n.17, 163
 n.193, 203–5, 215
Casula and *velamen* at Maaseik, Belgium **16,** 17,
 19, 21, 24, 26
"The Cattle-Raid of Cooley" 112, 177
Catullus 157, 161 n.185
Cavell, Megan 4 n.5, 34 n.98, 53 n.42, 87 n.59,
 89 n.70, 135 n.73, 190 n.29
Celts, Celtic 4, 5 n.6, 68, 112, 114–15, 122 n.21,
 129, 131, 141, 142, 151, 152, 155 n.156, 169,
 177–8, 180, 205 n.115
Chadwick, Nora K. 99 n.114, 100, 169 n.215
Chadwick, Sonia E. 32 n.89
Chance, Jane 39–44, 50, 52, 59–61, 64 n.76, 66,
 93–4
Charlemagne 34, 55, 56, 192
Charms 74, 75, 79, 80, 86, 88, 98, 102, 103, 122,
 135 n.73
 "For a Sudden Stitch" 98, 110
 "For a Swarm of Bees" 99
 "Nine Herbs Charm" 76–7
Childbirth, birth and textiles – see Textile
 metaphors
Childcare 179, 210
Christie, A. G. I. 17
Church (Christian) 20, 22, 25, 28, 55, 56, 63, 77,
 78 n.8, 129, 211

INDEX

Cicero 161, 163, 167, 199, 200, 201, 204, 206–7, 209
Ciris, pseudo-Virgilian work 199, 201, 202, 204, 207, 209
Claudianus, Claudius 71, 161
Clofesho, ecclesiastical council 77, 78
Cloth, clothing
 Cloth 3, 13, 20–1, 25, 26, 27, 33–4, 85–7, 91, 104–5, 108, 110–11, 114–16, 123, 175 n.255, 180, 188, 191, 195, 196, 200, 211–12, 216
 Clothing or garments 2, 8–9, 17, 19–22, 23–6, 30, 31, 48, 49, 55–6, 60, 68–70, 87–88, 89 n.70, 91, 115, 135, 149–50, 178, 180, 192, 195, 216
Clytemnestra, character in Aeschylus' *Agamemnon* 104
Cnut, king of England, Denmark, and Norway 94, 169, 173
Coatsworth, Elizabeth 26, 60, 186 n.13
Cockayne, T. O. 88
Colcu, associate of Alcuin 56, 58
Coldingham Monastery (Berwickshire) 25
Colgrave, Bertram 194 n.50
Collins, Derek 102
Colus, see Textile words, Latin
Confessional of Egbert 144 n.102
Congal, Irish poetic character 177
Constantine the Great, emperor 39, 53–4, 183 n.4
Cotswolds 152
Cramp, Rosemary 5 n.6
Creed 74, 77, 87
Crowfoot, Elisabeth 84
Crystal balls 32 n.89, 75, 79
Culex, pseudo-Virgilian work 204
Cupid 108
Curse, cursing 73, 79, 87, 89, 102, 103, 212
Cuthbert, archbishop of Canterbury 25
Cuthbert, St 24, 87
 Vestments, *see* Durham vestments
Cynewulf 54, 58, 182–5, 188, 191, 193, 198, 204, 205, 207–9

Dales, Douglas 56
Damico, Helen 50 n.34, 64 n.76, 94, 99–100
Damsholt, Nanna 114
Danelaw 168
Daniel, poem 133, 171
Daniel, biblical book 191
Darraðarljóð, Norse poem in *Njal's Saga* 109
Das Hildebrandslied, Old High German poem 171–2, 176
Davidson, Hilda Ellis 150 n.131, 206
Day, Agnes 67
Deathweaving, *see* Textile metaphors, and death

Denmark, Danes, Danish 46–7, 49, 65, 92, 93, 112–13, 120, 122, 141, 144 n.101, 168, 169 n.215, 173, 175–6, 186, 205–7
Deor 174
Detienne, Marcel 104, 118
Devil, demon 74, 75, 77, 80, 88–92, 97 n.102, 98–101, 111, 113–14, 133, 142, 150, 172, 212
Dictionary of Old English 91, 147 n.116, 184
Dido, character in the *Aeneid* 63
Distaff, spinning tool 1 n.2, 9, 11, 30, 112, 122, 148, 152, 157, 158–62, 164, 177–8, 189
Divination 78, 79, 81–2
Dobbie, Elliott Van Kirk 151
Dockray-Miller, Mary 82, 92 n.83
Dodwell, C. R. 21 n.35, 34
Domesday Book 19 n.30
Domestic 14, 26, 37, 54 n.42, 175 n.255, 189, 211, 212
Donaldson, E. Talbot 38
Donatus, Aelius, late Roman writer 104 n.141, 201
Dragon, in *Beowulf* 132, 145, 186–7
Dress 8, 20, 31, 63, 141, 149–50, 195, 216
 Religious or ecclesiastical 23-6
 Secular 23–6
Dunstan, St 19, 163 n.194, 188
Durham 56 n.51
Durham Cassiodorus (Durham, Cathedral Library, MS B. II. 30), *see* Manuscripts
Durham vestments 17, **18**, 19, 20, 26, 56 n.51
 Durham E, or the maniple **18**
Dwarves 74, 174
Dye, dyeing 13, 15, 19–23, 25, 31, 68, 86, 111, 148, 199, 210, 216

Eadburg, friend of Boniface 56 n.51
Eadgyfu, beneficiary 33
Eadmer, English ecclesiast and visitor to Benevento 34
Eadmund, prince and brother to King Athelstan 185
Ealhhild, Anglian princess, queen of Eormanric, king of the Ostrogoths 38, 52–3, 54, 67–8, 212
Earth mother goddesses, *see* Nature goddesses
Easter, *Eostre* 151
Eddius Stephanus 25, 87, 102 n.128
Edgar, king of England 24 n.53
Edith, queen, wife of Edward the Confessor **Front cover,** 38, 62–4, 66, 68, 196, 211
Edith, St, of Wilton 21
Edward the Confessor, king of England 23–4, 38, 62–3, 66, 196
Edward "the Elder," king of England 81 n.27, 185

INDEX 239

Edward "the Martyr," king of England 94–6
Elegy, elegiac 104, 201–2
Eleithyia, Greek goddess of childbirth 155
Elene 39, 52–6, 58, 67, 151 n.132, 182–5, 198, 207
 Elene, character 54, 95, 209
Elves 74, 98, 113, 173
Elfshot 74, 98, 212
Eliade, Mircea 123 n.23
Eligius, St 111
Ely Abbey (Cambridgeshire) 17 n.21, 26, 82, 87
Embroidery, embroiderer **Front cover,** 7,
 16–23, **18,** 24, 26, 30–1, 33–5, 63, 84, 148,
 174, 186 n.13, 188, 209, 210, 211, 215, 216
 Metaphors – see Textile metaphors
Emma, also called Ælfgifu, queen, wife of
 Æthelred II and Cnut 38 n.8, 50 n.34,
 64 n.76
Enright, Michael J. 43 n.25, 47 n.32, 114 n.175,
 120, 121, 122 n.20
Eormanric, character in *Beowulf* 52
Epiphanius, St 59
Eros 95 n.99
Eshleman, Lori 112 n.167
Essex 22
Esther, biblical character and book 60, 212
Etruscus, Maximianus 71
Eumenides 153 n.44
Eve, biblical character 59–60
Exeter Book 30, 38, 41, 42, 49 n.33, 52, 57, 82, 89,
 117, 134–5, 167, 174, 189–90, 208
Exodus, poem 146 n.110, 151 n.132
Exodus, biblical book 20, 22 n.42, 80

Faith 74, 136, 211
Fate
 Association with female 123, 131, 132, 138,
 179–81
 Greek *Moirai,* Fates - Moirai, Clotho,
 Lachesis, Atropos 153–5, 156, 158
 Latin *Fata, Fatum* 156–66, 175
 Latin *Fortuna* 156, 162
 Latin *Parcae* 156–66, 168, 172, 175, 178
 Lithuania(n) fate goddesses 178
 The Norns 173-4
 Norse fates, Urth, Verthandi, and Skuld
 173–4
 Weird, Verdandi, and Skuld, in the *Prose
 Edda* of Snorri Sturluson 174
 Weird sisters, Shakespearean 153
 Wyrd 155, 167–8, 179–81
 and Ælfric 143–4
 and *De Consolatione* 136–43
 and the Franks Casket 148–53
 and the *Helaind* 169–72, 176

 and *metod* 144–8
 Critical discussion 123–30
 Old English evidence 130–1
 Textile associations 131–6
 Wheel of fate 131
Fate weaving, *see* Textile metaphors
Faulkner, Amy 136 n.75, 137 n.79, 139 n.85, 140
 n.87, 141 n.94
Felix of Nola, St 201
Felix, life of St Guthlac 194, 209
Fell, Christine 13 n.13, 29, 33, 66, 79, 97
Fila, see Textile words, Latin
Finishing of textiles 7, 13 n.14, 15–23, 24, 25, 31,
 87, 210
Finn, king of the Jutes, character in *Beowulf* 65
First Merseburg Charm 108
Firth, Matthew 61–2, 95 n.98
Fitzgerald, Jill 54
Flanders, Flemish 20, 24, 63, 168, 195, 198 n.72,
 215
Flax 9, 15, 121, 159 n.175
Fortunes of Men 146 n.112
Frakes, Jerold C. 125
France, French, Franks 55, 110, 111, 172, 198 n.72
Frank, Roberta 168 n.212
Franks Casket 129, 148–53, **149,** 177 n.267, 215
Frantzen, Allen J. 77 n.7, 78 n.9
Freawaru, daughter of Hrothgar, character in
 Beowulf 50–1, 65, 67
Fridlef, king of the Danes, character in *Gesta
 Danorum* 175–6, 206
Frisia, Frisian 168, 186–7
Fulk, Robert D. 44
Furies, fury 97–8, 140 n.91, 153, 177
Fusus, see Textile words, Latin

Garments, *see* Cloth, clothing
Gaul 152, 168, 201
Geats, Beowulf's tribe 44, 46–7, 134, 187
Gender 2, 39, 51, 52, 54, 71–2, 83, 132, 139, 178
 and archaeology 28–9
 and textiles 30–4, 53, 54–5, 83–4, 106, 115,
 123, 141, 175 n.255, 179, 209, 212–4
Gender norms 28–34, 53, 54–5, 72–84, 93–5,
 123, 141, 180
Genesis A 54 n.44, 92
Genesis B 59
The *Gerefa* 13 n.14
Germanic tribes 4, 5 n.6, 37, 39, 40 n.15, 41, 42,
 52 n.37, 54, 57 n.52, 64, 66, 68, 81, 82, 99
 n.116, 109, 111, 118, 120–2, 124, 125 n.29,
 126, 129, 131, 133, 135 n.73, 142, 146 n.113,
 149–53, 155, 166, 168–72, 175–80, 194–5,
 205 n.115, 206, 208, 214

Gesta Danorum 112–13, 175–6, 205–7
Gift exchange (ceremonial) 40–1, 43–4, 47–9, 52, 56 n.51, 61–2, 64–5, 91, 93, 182–3, 206
Gilchrist, Roberta 29 n.74, 54 n.42
Girdle 17, 23, 28, 87
Gloucestershire 31 n.85
Goddess, *see* Fate *and* Nature goddesses
Godweb / godeweb, see Textile words, Old English
Godwin, Earl 38, 66
Gorgons 97–8
Goscelin of St Bertin 20–1, 22, 23–4, 25, 26–8, 63, 195–7, 209, 215
Gospels 169, *see also* Matthew *and* Luke
Goth, Gothic 145
Graham, Timothy 60 n.58
Grani, legendary horse of Sigurd 150
Graves and grave goods 5 n.6, 28–9, 32, 75, 79–80, 83, 84, 86, 117, 120–2, 129, 134, 150, 167, 210
Greece, Greek 4, 59, 61, 68–70, 95 n.99, 97, 101–2, 104, 106, 108, 115, 118, 123 n.24, 131, 146 n.113, 153–6, 158, 163, 165, 167, 169, 175, 177–9, 189, 192 n.39, 198–200, 205, 211
Green, Miranda 122 n.21, 177
Gregory I, St and Pope 119–20, 122, 163
Grendel, character in *Beowulf* 46, 92, 94–7, 98 n.107, 100, 132–3, 146
Grendel's Mother, character in *Beowulf* 92–7, 98 n.107, 99–101, 110, 113, 146, 212
Grimm, Brothers 159
Grimm, Jakob 99, 178
grubenhäuser or pit-houses 14
Guthlac, St 54 n.44, 194
Gudrun / Kriemhild
 wife of legendary Sigurd / Siegfried 41 n.19, 113–14, 150, 173
 character in *Laxdæla Saga* 113–14
Gunnlaug Wormtongue, Icelander 169
Gwara, Scott 22 n.39, 165 n.204

Hadrian of Canterbury, St 155–6
Hadrian's Wall 152
Hagar, biblical character **Frontispiece**, 11, 29, 32 n.92
Hagiography 19, 24–5, 30, 64 n.76, 87, 194–5, 206, 209
Hakon, son of king Harold Fairhair of Norway 168
Hangings, *see* Textiles
Harold II, king of England 24 n.53
Harrington, Susan 31 n.85, 32 n.90
Haymo of Auxerre, St 144
Head, Pauline E. 187

Healing 12, 40, 73, 74–7, 88, 108, 213
 and textile tools 13, 85–7, 115, 212, 215
 and women 13, 80 n.26, 85, 115, 212, 215
Heathen 53, 78, 80, 90, 138
Heatho-bards, tribe in *Beowulf* 51
Hebrew, Hebrews, biblical peoples 22, 200
Hecate 103
Heddle, heddle thread 14, 15, 30, 85–6, 103, 106, 109, 116, 148, 158 n.174, 188, 197
Hefeld, hefeldian, see Textile words, Old English
Hel, Norse goddess 174
Heliand 169–72, 176
Henderson, Thomas 55 n.49
Heorot, Hrothgar's hall in *Beowulf* 44, 47, 49, 91, 92, 93, 134, 184
Hephaestus 95 n.99
Herbs, herbal remedy 74, 75–7, 85, 212
Hercules, knot of 102
Heremod, character in *Beowulf* 51 n.35
Heresy, heretical 143, 144 n.99
Hermes 95 n.99
Herod, king of Judea 170
Heroic Age 52, 57, 58, 72, 112, 168 n.212
Heroic code 41, 42, 206
Herren, Michael 197
Hesiod 153, 156
Hiarni, Danish bard, character in *Gesta Danorum* 206
Hild, St and Abbess of Whitby 81–2
Hild, valkyrie and fate 112 n.167, 175
Hildebrand, character in *Das Hildebrandslied* 171–2
Hildeburh, character in *Beowulf* 65–7, 187
Hildelith, Abbess of Barking (Essex) 22
Hill, Joyce 5 n.7, 66, 144, 205
Hincmar, archbishop of Rheims 111
Holofernes, character in *Judith* 95
Homer 153 n.144, 156, 200
 The *Iliad* 154
 The *Odyssey* 95 n.99, 154, 198, 211
Homily (homilies, homiletic) 30, 60–1, 67, 71 n.95, 74, 77, 79–81, 88–9, 91, 98, 100, 111, 130, 143–4, 212
Homilia de Sacrilegiis 111
Horace, Roman poet 161 n.185, 163
Household textiles, *see* Textiles
Howlett, David 150, 151
Hrabanus 79
Hrothgar, king of the Danes, character in *Beowulf* 46–51, 82, 91, 132, 133, 145, 147, 170, 184
Hrothulf, character in *Beowulf* 47–9, 82, 112
Humility gesture 195
Hweorfa(n), see Textile words, Old English
Hybrid poetics 5, 6, 129–30, 193, 206, 208–9

INDEX

Hygd, queen of the Geats, character in *Beowulf* 44, 45, 49, 53, 55, 67, 91, 92, 101, 212
Hygeburg, English nun and hagiographer in Germany 195, 209
Hygelac, king of the Geats, character in *Beowulf* 50, 91, 94, 132, 186–7
Hypsipyle of Lemnos 200

Ialongo, Nicola 29 n.74
Iceland, Icelandic 113, 169, 172
Ides 36, 38, 39, 42–3, 45–6, 49–52, 59, 64–6, 72, 82, 92–3, 97, 99–100, 109, 209
Inciting oaths 42, 46, 50, 60, 113–14
Ingeld of the Heatho-Bards, character in *Beowulf* 51
Interlace 5 n.6, 185–8, 192–3, 215
Ireland, Irish 5 n.6, 41, 55–6, 58, 109, 110, 112, 114, 168 n.211, 172, 177–8, 193 n.44, 203
Irvine, Susan 139
Irving, Edward B., Jr 128 n.40
Isaiah, biblical book 88, 106, 210 n.1
Isidore of Seville, St, *Etymologiae* 75, 78 n.8, 102, 162–3, 167, 168 n.211, 179, 201 n.86
Israelites 151 n.132
Italy, Italian 34, 198 n.72, 201

Jerome, St 6, 104 n.141, 163, 192, 200, 201, 204, 208
Jesus Christ 87, 88, 121 n.17, 135, 143, 171
Jews, Jewish 54, *see also* Hebrews
Job, biblical book 59, 107, 115, 119, 125 n.29, 191
John Scottus 202–3
John, Bishop of York 40
John the Baptist, biblical character 170–1
Johnson, Mark 6
Joplin, Patricia 105
Joseph Scottus 55–6, 58
Judas, biblical character 171
Judas, character in *Elene* 95
Judgment Day II 88
Judith
 Character 95
 Poem 187
Juliana
 Character 95
 Poem 187
Julius Caesar 81, 140 n.89
Julius Victor, *Ars Rhetorica* 129, 192, 204 n.107
Junius Philargyrius 162–3, 167
Jutes 65

Karkov, Catherine E. 5, 163 n.194
Kemble, John Mitchell 99 n.116
Kempston box 84
Ker, W. P. 129

Kesling, Emily 80 n.26
Kings, book 1, biblical book 200
Kjartan, character in *Laxdæla Saga* 113–14
Klaeber, Frederick 44, 128
Klein, Stacy S. 54, 60 n.58, 61, 68 n.87, 82, 93 n.92
Kluge, Friedrich 146
Knots 20, 84, 87, 118
 and death 89, 91–2, 105, 115, 212
 and magic 87–8, 101, 102–4
Kriemhild, *see* Gudrun

L'Isle, William 60
Lacnunga 76 n.6, 86
Lakoff, George 6
Lambeth Psalter (London, Lambeth Palace, MS 427), *see* Manuscripts
Lana, see Textile words, Latin
Lapidge, Michael 106, 155 n.157, 156 n.159, 194, 197, 204, 208
Larrington, Carolyne 99 n.113
Lavelle, Ryan 55
Laws 40, 79, 80, 81 n.27
Lawrence, St 200
Laxdæla Saga 113–14
Lazarus, biblical character 171
Lee, Christina 26 n.62, 85
Leech, *see* Healing
Leechbook 88
Lees, Clare 7
Leiden Riddle 134, 190
Lemuel, king, biblical character 30
Leneghan, Francis 92 n.86, 97 n.102, 187
Lester-Makin, Alexandra 17 n.21, 19 n.30, 20, 84–5
Lexis of Cloth and Clothing 9 n.2, 13 n.14, 15 n.17, 23 n.45
Leyerle, John 186–7, 192–3
Liber Cathemerinon 107
Liber Eliensis 95
Licia, see Textile words, Latin
Liminality 93, 95–7, 99 n.114, 139, 150, 153
Linen **10**, 11 n.5, 15, 20, 21, 23, 30, 31, 87, 112
Liuzza, Roy M. 83–4
London, British Library, MS Cotton Vespasian A. viii, *see* Manuscripts
London, British Library, MS Harley 585, *see* Manuscripts
Loom 1, 3, 16, 56, 61, 67, 73, 83–6, 90, 104, 106, 108, 111, 115–16, 121, 147–8, 178, 180, 188–91, 213, 214
 Treadle 30
 Two-beam **Back cover**, 13, 120 n.9, 147 n.120
 Warp-weighted 13, **14**, 15, 30–1, 56, 109–10, 210

Weight **10**, 11, 13–15, **14**, 109
Louviot, Elise 47 n.32
Love charms 78, 103, 212
 Knots 102, 212
 Potions 79, 80, 87
Loyn, H. R. 34
Lucan, Roman poet 163 n.193, 164, 167, 178
Luke, biblical book 63 n.73, 88
Lysistrata, see Aristophanes

Magic *see* Chapter 3.
 and faith 74
 and medicine 74
 and textiles 83–7, 101, 104–16
 and women 79–83, 115–16
 Definition 73–5
 Destructive/evil 74–5, 77–9, 89–101,
 104–5, 108–15
Mailshirt (byrnie) 135
Male textile workers 30, 33, 34
Malone, Kemp 44, 52
Manuscripts
 Brussels, Bibliothéque royale, MS 8558-63
 78 n.10, 80 n.22
 Cambridge, Corpus Christi College, MS
 190 78 n.9
 Cambridge, Corpus Christi College, MS
 265 78 n.13
 Cambridge, Gonville and Caius College, MS
 428/428 11 n.8, **12**, 32 n.92
 Cambridge, Trinity College, MS R.17.1
 Back cover, 13
 Durham Cassiodorus (Durham, Cathedral
 Library, MS B. II. 30) 186 n.13
 Lambeth Psalter (London, Lambeth Palace,
 MS 427) 106–8, 167, 180, 210
 London, British Library, MS Cotton
 Vespasian A. viii 24 n.53
 London, British Library, MS Harley 585 76
 Old English Hexateuch (London, British
 Library, Cotton MS Claudius B.
 IV.) **Frontispiece**, 11, 29, 32 n.92,
 33, 180 n.271
 Oxford, Bodleian Library, MS Junius 121
 80 n. 23
 Oxford, Bodleian Library, MS Laud Misc.
 381 60 n.58
 Oxford, Bodleian Library, MS Laud Misc.
 482 77 n.7, 78 n.12, 80 n.24
Mary, St, mother of Jesus Christ 8, 20, 30, 60,
 67, 121 n.17, 211, 212, 214
Matthew
 biblical character 90–1, 95, 96
 book 63 n.73, 87, 88

Maxims I 30, 41, 42, 45, 46, 82, 96, 174
McDougall, David 147 n.116
Mead, ceremonial passing of a cup 40, 43, 44,
 45–9, 51, 112 n.167
Meaney, Audrey L. 75, 79, 80, 84, 85, 86, 98
Medea 102–4
Medicine, medical 73, 78, 83, 85–6, 97, 180
Mediterranean traditions 121, 141, 165, 167, 214
Menelogium 146 n.112
Mercia 56, 58, 95, 168,173
Mercury 140–1
Mermedonians, characters in *Andreas* 90–1,
 95–7, 110, 113, 133, 212
Merovingian Gaul 201
Metis, Greek goddess 118, 153 n.144
Metod 47, 127, 130, 132–3,144–8, 155, 169–71, 176
Metrical Dindshenchas 114
Miracula Sancte Ætheldrethe Virginis 197
Miscarriage 86
Missionary, missionaries 78, 168, 176 n.261
Monsters. monstrous 46, 95, 99 n.114, 187
Moon 78, 81, 174
Moorman, Charles 125
Moralia in Job, see Jerome
Morrigna, Celtic goddesses 177
"Mothers Night" 152
Mourning 63, 66 n.79, 150, 180, 201

Nanna, character in *Gesta Danorum* 205
Nature 72, 74, 83, 117–22, 142, 200
Nature goddesses (earth mother) 120–2, 151–2,
 177–9
Nebuchanezzer II, king of Bablyon, biblical
 character 133
Nectere, see Textile words, Latin
Needle 11 n.5, 34, 120 n.12, 121, 189
Neidorf, Leonard 66 n.79, 129 n.43
Nets 50, 91, 93 n.92, 96, 115, 212
Neumann, Erich 123 n.24
Nibelungenlied 41 n.19, 113
Niles, John D. 57 n.52, 208
Normans, Normandy 5 n.6, 26, 64 n.76, 156
Norns, *see* Fate
Northumbria 11 n.6, 24, 25, 40, 56, 58, 60, 87,
 88, 134, 148 n.122, 151, 173, 190, 191
Norway, Norse 40 n.15, 94, 97, 99 n.113 and 114,
 100, 109, 111, 112 n.167, 113–14, 120 n.12,
 124, 129, 131, 145, 168–9, 173, 175–6, 205
Nun's clothing, *see* Dress, Religious or
 ecclesiastical

O'Brien, Elizabeth 144 n.102
Oberwerschen (Germany) 121
Oda, Tetsuji 130–1, 136–7, 141–2, 145, 147, 155

INDEX 243

Odysseus, *see* Homer
Offa, king of Mercia 34, 44, 51, 56, 100
Ogilvy, J. D. A. 155 n.156, 169 n.216
Old English Herbarium 88
Old English Hexateuch (London, British
Library, Cotton MS Claudius B. IV.), *see*
Manuscripts
Old High German 108–9, 131, 171
Old Norse 100, 109, 131, 145
Old Saxon, Saxon 110, 116, 131, 145, 168–71, 173
Old Testament, *see* Bible
Olsen, Alexandra Hennessey 42
Onians, Richard Broxton 177
Opus Anglicanum 35
Oral formulaic 142, 205, 206
Orchard, Andy 128, 183 n.3, 193, 204, 208 n.128
Ordior, see Textile words, Latin
Orpheus 140, 146
Osbern 25 n.57
Osbert of Clare 63 n.73
Oswald, St and bishop of Worcester and
archbishop of York 28, 30, 31, 195
Overing, Gillian R. 7, 37 n.3, 65
Ovid 106, 163, 173
 Metamorphoses 105
 Tristia 158
Owen-Crocker, Gale R. 19 n.26, 20 n.31, 88
 n.62, 114 n.173, 135 n.70, 149, 150, 152, 180,
 187 n.17, 188, 189 n.20
 *Dress in Anglo-Saxon England, Revised and
 Enlarged Edition* 23, 24 n.54
Oxford, Bodleian Library, MS Laud Misc. 381, *see*
Manuscripts

Pagan 75–7, 87, 94, 97–8, 108, 111, 120–1, 124,
 126, 128 n.40, 129, 131, 133, 138, 140–1, 144 n.101,
 145–6, 149, 151, 156, 159–60, 165–6, 168–9, 175
 n.258, 176 n.261
Pape, Eleanore 29 n.74
Parcae, see Fate, Latin *Parcae*
Paternoster 74, 87
Patristic authors, *see also* Augustine, Jerome,
 and Gregory 4, 6, 54, 59, 68, 81, 125
 n.29, 127, 129, 144, 156 n.159, 161, 163, 167,
 178–9, 181, 204, 206, 207, 209
Paul the Deacon (Paulus Diaconus) 24, 103
 n.133, 144, 216
Paulinus of Nola 159, 160, 161, 163, 165, 201, 204
Peaceweaver (*freoðuwebbe*) / peaceweaving
 Biblical and historical possibilities 59–64
 Communal (incl. marital) 44–53
 Critical reception 43–4
 Definitions 36–43, 53
 Ecclesiastical 53–9

Failed 64–8
Gender associations 51, 54–5, 72, 211, 213
Pedersen, David 128 n.41, 135, 136 n.74, 137
 n.79, 144 n.99
Peleus and Thetis 157
Penelope, character in the *Odyssey* 211
Penitentials 74, 75, 77–81, 87, 110–11, 116, 122,
 144 n.102, 172, 212
Penitential of Silos 111
Philargyrius, Junius 162–3, 167
Philomela, character in Ovid's *Metamorphoses*
 105
Philosophy, Lady, character in Boethius' *De
 Consolatione* 141, 165
Phillpotts, Dame Bertha 128, 133 n.57, 136
Pindar, early Greek poet 155, 156, 198
Pitana, nymph 155
Plato 70, 106, 160
 Republic 154, 159, 161
 "Statesman" 68–9
Pliny the Elder 102–4, 106
Poetic Edda or *Edda Saemundar* 98 n.107, 99
 n.113, 100 n.121, 112, 113 n.172, 114, 172–4,
 205
Poison 76, 78
Pollack, Susan 127, 129, 139, 141 n.94
Pollington, Stephen 89
Pompeius Festus 103
Porck, Thijs 11 n.8
"Prayer for Long Life" by Abbot Conry in
 Westmeath (Fer Fio) 177
Pregnancy 179
Priscian, Roman writer 163
Proclus of Constantinople, St 61
Procne, character in Ovid's *Metamorphoses* 105
Prognostics 75, 83–4
Propertius 104, 106
Proverbs, biblical book 30
Prudentius 107, 119, 159, 163, 165, 181, 192 n.39,
 200–1, 204, 206
Psalms, biblical book 115, 122, 195–6, 200, 207
Pseudo-Matthew 8, 30, 60
Psyche 108
Purple 15, 17, 19, 21, 22, 25, 84

Queens, *cwen* 36, 38, 40–5, 50–2, 55, 60–4, 68,
 82, 95 n.98, 113, 209

Rashi, historian 30
Reel, textile tool 148
Remigius of Auxerre 202, 203
Rheda 151
Richard of Cirencester 62 n.69, 63 n.73
Ricoeur, Paul 6–7

Riddles 1–2, 6, 11–12, 89–91, 109, 117–18, 120, 123, 134–5, 164, 166–7, 178, 184, 189–91, 192, 194, 198, 207–8, 213, 214
Riming Poem 117, 134, 167
Ripon 25
Robinson, Fred C. 41, 44, 72, 81, 82, 128, 145
Rogers, Penelope Walton 11 n.5 and 6, 13 n.14, 15 n.18, 24, 28
 Cloth and Clothing in Early Anglo-Saxon England AD 450–700 23
Rolf, character in *Gesta Danorum, see also* Hrothulf 112–13
Romano-British 152
Romano-Celtic 152
Rome, Roman 4, 5 n.6, 34, 35, 68 n.87, 71, 81, 95 n.99, 97, 98, 102, 119, 121–2, 129, 131, 140–1, 143 n.97, 150, 152–3, 155–6, 159, 163, 167–8, 169, 172, 175, 176 n.261, 177, 178–9, 193, 198, 200, 204–5, 206 n.127
Romulus and Remus 129
Roper, Alan H. 133, 166
The Ruin 134, 142, 165, 215
Runes 77, 88, 111, 129, 149, 205, 207–8

Saga of the Volsungs 111, 113 n.172
Saints, saints' lives, *see* Hagiography
Sarah, biblical character **Frontispiece**, 11, 29, 32 n.92, 33, 214
Satan 88, 89, 92, 135
Saxo Grammaticus, *Gesta Danorum* 112–13, 175–6, 205–6
Scandinavia, Scandinavian 4, 5 n.6, 52 n.37, 68, 99, 112 n.167, 114 n.175, 118, 120, 152–3, 166, 168–9, 173, 176–80, 206, 213, 214
Schilling, Cassandra 51 n.35
Scop, Old English poet 65, 181, 184, 188, 207
Scotland 5 n.6, 109
The Seafarer 127, 146
Sebo, Erin 51 n.35
Sedulius Scottus 41, 104 n.141, 202–4
Seneca 103–4, 161
Sew, sewing 15, 17, 20, 30, 67, 91, 111, 115, 209
Shakespeare, William, *Macbeth* 153, 205
Shed (within a loom), shed rods 14, 30, 190, *see also* Heddle
 Shed rods 14, 30, 190
Shippey, T. A. 127
Shroud 70, 89 n.70, 180 n.271, 211
Shuttle, textile tool 14–15, 61, 109, 147, 154, 189–91, 202
Siewers, Alfred K. 93 n.89, 150 n.131
Sigurd, legendary Germanic hero 114, 150, 173–4
Silk 9, 17, 20, 23, 25–6, 31, 86, 118 n.2, 134, 167, 197

Silkworms 118 n.2, 167, 197
Sklute, L. John 37, 39, 53–4
Skuld
 Character in *Gesta Danorum* 112–13
 Valkyrie and fate 173, 174, 175
Slickstone, textile tool **10**, 11 n.5
Smaragdus 70, 71 n.95, 144
Smith, Michele Hayeur 114 n.175, 175 n.255
Smithers, G. V. 125
Social class 33–4, 54 n.42, 188
 and dress 23, 31–2
 Status 32–4, 49, 50, 61, 64, 82, 84, 86, 141, 190, 214–15
Socioeconomics and textiles, trade 30–5
Socrates 68
Solomon, biblical character, temple of 20, 63
Solomon and Saturn 135–6
Sophists 199
Sorcery 74, 78, 80 n.23, 94, 97, 113
Spain 111
Sparta 69–70
Spell 75, 77–8, 80, 89, 96, 102, 184, 212
Spindle, spinning tool **Frontispiece**, 1 n.2, 2, 6, 9, **10**, 11, **12**, 13, 30, 69, 86, 103, 120–1, 142, 147–8, 152, 154, 157, 158 n.174, 159–60, 161, 162, 164, 167, 178, 189, 214
Spindle whorl, spinning tool **Frontispiece**, 1 n.2, 2, 9, **10**, 11, **12**, 32, 50, 83, 86, 115–16, 121, 142, 210, 212, 214
Spindle-half or *spinlhealfe* 13, 29, 214
Spinnan, see Textile words, Old English
Spinning **Frontispiece**, 1–3, 6–7, 9–11, **12**, 13, 29–34, 50, 53, 60, 68–70, 114 n.173, 115–16, 130, 142, 147, 189, 214
 and fate(s) 117, 118 n.2, 120–3, 131–6, 141, 143, 151–68, 174–81, 214, 215
 and magico-medicine 83–4, 102–4, 111–12, 212, 215
 and women 53, 86, 112, 179–80, 211
 Metaphors – see Textile metaphors
 Songs 110, 157, 189
St Mary's Church, Malmesbury (Wiltshire) 20
St Peter's Monastery (Bath) 27, 34
Stafford, Pauline 38 n.8, 64 n.76
Stamen, Stamina, see Textile words, Latin
Stanley, E. G. 124–6
Stars 74, 78, 142, 143, 158
Statius 63, 104 n.141, 105, 119, 158–9, 161, 163, 200–2, 204
Stephanus, Eddius 25, 87–8, 102 n.128
Stobaeus 154–5
Sturluson, Snorri, *Prose Edda* 174
Sussex, South Saxons 87
Sutton Hoo 135 n.71

INDEX 245

Sweden, Swedish 120 n.12, 169 n.215
Swift, textile tool 120, 148, 189
Sword beater / weaving sword / weaving batten,
 weaving tool **14**, 15, 31–2, 33, 83, 90,
 109, 120, 122
Symphosius 118
Syncretism 5 n.7, 75, 121–2, 128–30, 136, 151–2,
 168, 175, 193, 206, 208, 216

Tablet weaving 15 n.18, **16**, 17, **18**, 21, 23–4, 210, 216
Tacitus 41, 64, 81, 140 n.89, 163
Tatwine, archbishop of Canterbury 194, 207,
 209, 215
Taylor, C. Tidmarsh 129
Texere, textum, see Textile words, Latin
Textile metaphors
 and birth 111–12, 147, 153–6, 158, 165, 170–1,
 174–6, 179–80, 212, 213
 and creation 117–23, 212–13
 and death 3, 70, 73, 87, 89–101, 101–15,
 115–16, 117–20, 132, 134, 151, 154,
 180–1, 211–13
 and fate 123, 131–6, 141–2, 148, 151, 153–63
 (Old English), 163–5 (Greek/
 Roman), 174–6 (Germanic/
 Scandinavian), 177 (Celtic), 178–81,
 212–15
 and magic / healing 3, 13, 85–7, 115, 212, 215
 and peace, *see* Peaceweaver / peaceweaving
 and weaving cloth 22–3, 211, 216
 and women 3, 51, 54–55, 72, 87, 179–80,
 209, 211, 213
 and words, *see* Wordweaving
 Embroidery 21–3
 Expressions
 "Hanging by a thread" 181 n.272
 Lifespan 174 n.244
 Spinning 3–4, 13, 117, 174 n.244, 179, 181,
 189, 209, 210, 214–15
 Unique early medieval English weaving
 metaphors 59, 71–2, 118, 167, 213
Textiles
 Hangings 19, 22, 26–7, 31, 34, 211, *see also*
 Bayeux "Tapestry"
 Household 11, 14 n.15, 26–8, 32–4
 Production, *see* Chapter 1.
Textile words, Latin
 Colus (distaff) 159, 161, 214
 Fila (thread) 111, 157–9, 162, 164
 Fusus (spindle) 160 n.182, 161, 163 n.193,
 164, 180
 Lana (wool) 22, 25, 30, 157, 160, 162
 Licia (thread, heddle-thread / leashes)
 103–4, 158 n.174

Nectere (to twist, weave, bind) 63 n.75,
 70–1, 102–5, 160–1, 194, 200, 201, 203,
 204, 206
Ordior (to arrange, lay the warp) 106, 147,
 197, 198, 202
Stamen, stamina (thread(s), warp thread(s),
 spinning thread(s)) 22, 55, 111,
 157–9, 160 n.182, 161, 163 n.193, 164,
 194, 202
Texere (and variants; to weave) 63 n.75,
 70, 102–6, 160–1, 191–2, 195, 197–202,
 204, 206 n.127
Textum (text, web, something woven)
 107, 194, 197–8
Textile words, Old English
 Bewindan, windan, wendan (to wind) 86,
 91, 142, 165, 181, 215
 Bredgan (to braid, plait, or interweave) 91
 Godweb, godeweb (fine cloth, silk?) 86, 134
 Hefeld, hefeldian (heddle, to attach heddles)
 15, 106, 147
 Hweorfa, hweorfan (spindle whorl, to spin)
 12, 50, 83, 136, 142, 165, 214–5
 Spinnan (to spin) 13, 30, 174, 215
 Wefan (to weave) 92, 106–7, 134, 167, 180,
 197, 210, 211, 214
Thebes 155 n.152
Theodore of Tarsus, St 78, 80, 144 n.102, 155
Thread 1–3, 9–13, 14–15, 16–17, 20–2, 24, 26,
 30–2, 40, 53, 55–7, 61, 67, 69–70, 72,
 83–7, 90, 102–4, 106, 108, 111–12, 115–16,
 118–21, 123, 135, 141–2, 147–9, 151–5,
 157–65, 167, 171, 174–8, 180–1, 186–90,
 192, 194–7, 199, 202, 207–8, 210, 212, 214,
 216
Thryth / Modthryth 44–5, 51, 92–4, 100–1, 105,
 211, 212
Tiberius style 19
Timmer, B. J. 126–8, 138, 140, 145
Timothy, biblical book 88
Tolkien, J. R. R. 128
Trade and textiles, *see* Socioeconomics and
 textiles
Trolls 99 n.114
Troyes 30
Tweddle, Dominic 17

Ulysses 140
Unferth, character in *Beowulf* 45–6
Upanishads 123 n.23

Valhalla 101, 124
Valkyrie, *wælcyrige* 79, 97–101, 108, 109–10, 112,
 114, 116, 150, 174–5, 177, 189, 212, 213

Veda, Vedic, *Artharva Veda* 123 n.23, 177
Venantius Fortunatus 201–2, 204, 206, 209
Vengeance 65, 66 n.79, 92, 94, 105, 113–14
Venus 97, 104
Vercelli Book 90
Vernant, Jean-Pierre 104, 118
Vestments 17, 19–22, 24, 26–8, 31, 33, 35, 55–7, 188, 211
Viking 64 n.76, 79, 98 n.107, 109, 112 n.167, 168
Virgil 6, 106, 158, 161–3, 166–8, 178
 Aeneid 63, 105, 157–8, 164
 Eclogues 102–4, 157, 164 n.199
Vita Ædwardi Regis 62, 196
Vita metrica beati Leudegarii 202
von Erhardt-Siebold, Erika 189–90

Walafrid Strabo 202–3
Waldere 42, 146, 174
Walhstod, bishop of Hereford 25–6
Wallace-Hadrill, J. M. 68 n.87
Wandelbert of Prum 202–3
The Wanderer 124, 127 n.38, 139, 170 n.225
Warp 13, **14**, 15, 30, 39, 56–7, 67–9, 90, 106, 108–9, 111, 147–8, 158 n.172, 161–3, 178, 187–90, 194–8, 200, 202, 210
Wealhtheow, character in *Beowulf* 45–51, 55, 62, 64 n.76, 67, 82, 91–3, 101, 114, 145, 212, 214
Weaver, Weaving, *see also* Textile metaphors; Textiles, Production; *and* Textile words, Old English, *Wefan*
 and women 28, 30, 33, 34 n.98, 67
 Goddesses 71, 120–2, 123 n.24, 124, 126, 131, 140, 147, 151–2, 155–6, 158–9, 176–9
Weaving sword, *see* Sword beater
Web of life 53 n.41, 106–8, 120
Webster, Leslie 149
Wefan, see Textile words, Old English
Weft, woof **14**, 15, 31, 39, 68–9, 90, 109, 111, 147–8, 161 n.185, 178, 187–8
Weland 112, 129, 150
Werewolf 172
West Saxon 19–21, 144 n.101, 168
Wherwell Abbey (Hampshire) 66
Whitby Abbey (Yorkshire) 11 n.6, 81
Wicker, Nancy L. 120 n.12
Wickham-Crowley, Kelley M. 33, 180 n.271
Widsið 38, 49 n.33, 52, 57–8, 174
Wif (woman/wife), *Gewif* (fate) 8, 12, 13, 30, 42, 45, 51, 80–2, 83, 92–3, 98–9, 106–7, 118, 134, 167, 179–81, 210, 211, 214, 215
Wilfrid, St 87–8, 102 n.128
William of Malmesbury 193 n.45, 197–9, 209
William of Poitiers 34

Williamson, Craig 190 n.30
Willibald, English ecclesiast in Germany and hagiographer 194–5, 209
Wilson, David M. 14 n.15, 19 n.27
Wilson, James H. 130
Wilton Abbey (Wiltshire) 20–1
Wiltshire 27
Winchester school 19 n.27
Winchester style 19
Winterbottom, Michael 192–3
Wisdom, character in Boethius' *De Consolatione* 137, 139, 141
Wise women 47 n.32, 74, 80, 82, 212
Witch (*hægtessan, wicce*), witchcraft 74, 75, 78–81, 89, 95 n.98, 98–9, 140 n.91, 212
Wizard, warlock 78, 91, 96
Woden 76–7, 101, 124, 140, 144 n.101, 150–1
Wolf, wolves 140 n.91, 172
Women, *see also* Healing, and women; Magic, and women; *and* Textile metaphors, and women.
 Power of speech acts 80–1, 82–3
 Prophetic abilities 41, 80–1, 82–3, 110, *see also* Divination.
"Wonders of the East" 97–8
Wool, woollen 9, **10**, 11 n.5, 15, 21, 22, 23, 25, 30, 31, 61, 68, 83, 84, 86–7, 104, 111, 157, 160, 162
Wordweaving 3, 182–8 (Old English text and poetics), 188–91 (weaving resonances), 191–8 (Anglo-Latin examples), 198–200 (Greek and Roman examples), 200–5 (other Latin examples), 205–7 (Germanic and Scandinavian examples), 207–9 (hybrid poetics), 215–16
 and women 209
Work-boxes 84–5, 122 n.21
Woven crowns 71, 191–2
Wragg, Stephanie 61
Wulfmær, son of Wulfwaru (beneficiary) 27
Wulfstan, bishop of Worcester and archbishop of York 79, 140 n.89, 212
Wulfwaru, testatrix 27
Wynflæd, testatrix 24, 33
Wyrd, *see* Fate

York 11 n.6, 40, 55–6, 58, 79
Yule 151

Zacharias, biblical character 170
Zettersten, Arne 42 n.24
Zeus 153 n.144, 154, 155 n.155, 167

MEDIEVAL AND RENAISSANCE CLOTHING AND TEXTILES

Previous volumes in this series:

I
The Troyes Mémoire: The Making of a Medieval Tapestry
Translated by Tina Kane

II
Medieval Dress and Textiles in Britain: A Multilingual Sourcebook
Edited by Louise M. Sylvester, Mark C. Chambers and Gale R. Owen-Crocker

III
Dressing the Scottish Court, 1543–1553:
Clothing in the Accounts of the Lord High Treasurer of Scotland
Melanie Schuessler Bond

IV
Refashioning Medieval and Early Modern Dress:
A Tribute to Robin Netherton
Edited by Gale R. Owen-Crocker and Maren Clegg Hyer

V
Textiles of Medieval Iberia: Cloth and Clothing in a Multi-Cultural Context
*Edited by Gale R. Owen-Crocker with María Barrigón,
Naḥum Ben-Yehuda and Joana Sequeira*

VI
The Dutch Hatmakers of Late Medieval and Tudor London:
with an edition of their bilingual Guild Ordinances
Shannon McSheffrey and Ad Putter

VII
Textiles of the Viking North Atlantic
Edited by Alexandra Lester-Makin and Gale R. Owen-Crocker

Printed in the United States
by Baker & Taylor Publisher Services